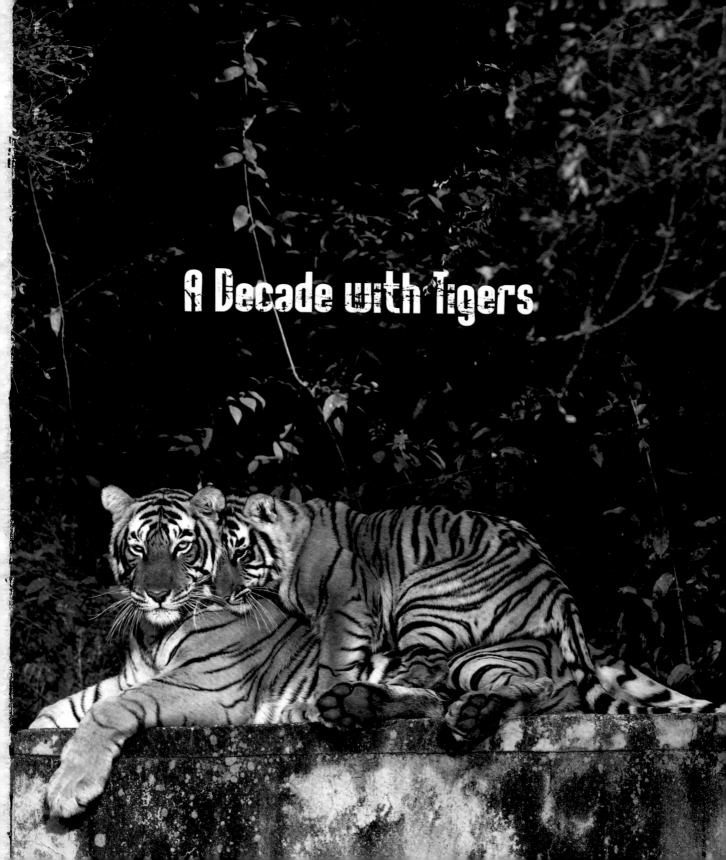

A Decade with Tigers

A Decade with Tigers

Supremacy · Solitude · Stripes

Shivang Mehta

Foreword by Mike Pandey
Afterword by Ganesh H. Shankar

NIYOGI
BOOKS

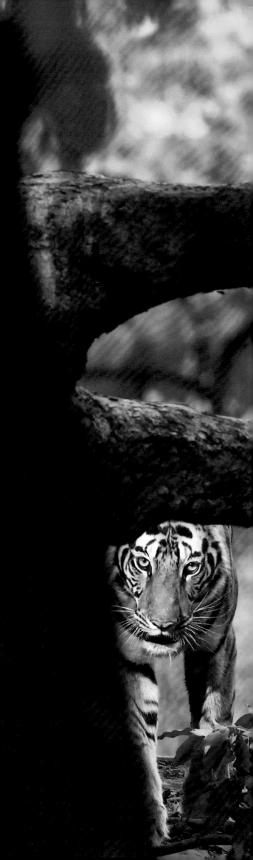

Published by

NIYOGI BOOKS

Block D, Building No. 77,
Okhla Industrial Area, Phase-I,
New Delhi-110 020, INDIA
Tel: 91-11-26816301, 26818960
Email: niyogibooks@gmail.com
Website: www.niyogibooksindia.com

Text © Shivang Mehta
Photographs © Shivang Mehta (except those credited)

Editors: Upama Biswas/Siddhartha Banerjee
Design: Nabanita Das

ISBN: 978-93-86906-03-8
Publication: 2017

Printed at: Niyogi Offset Pvt. Ltd., New Delhi, India

To the naturalists, guides, and drivers of the various national parks of India, who work tirelessly to serve tourists to the best of their abilities. These images are proof of your dedication and efforts on the field.

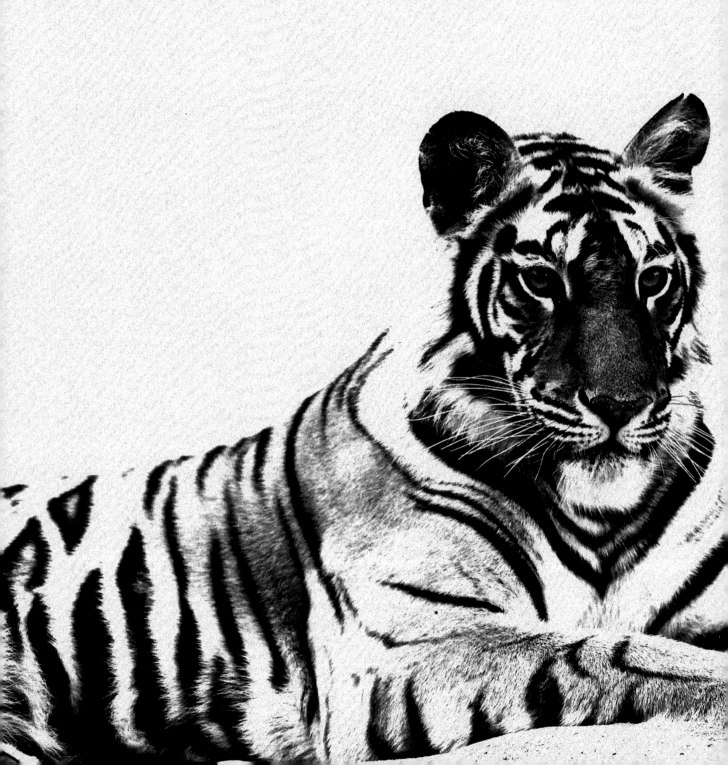

CONTENTS

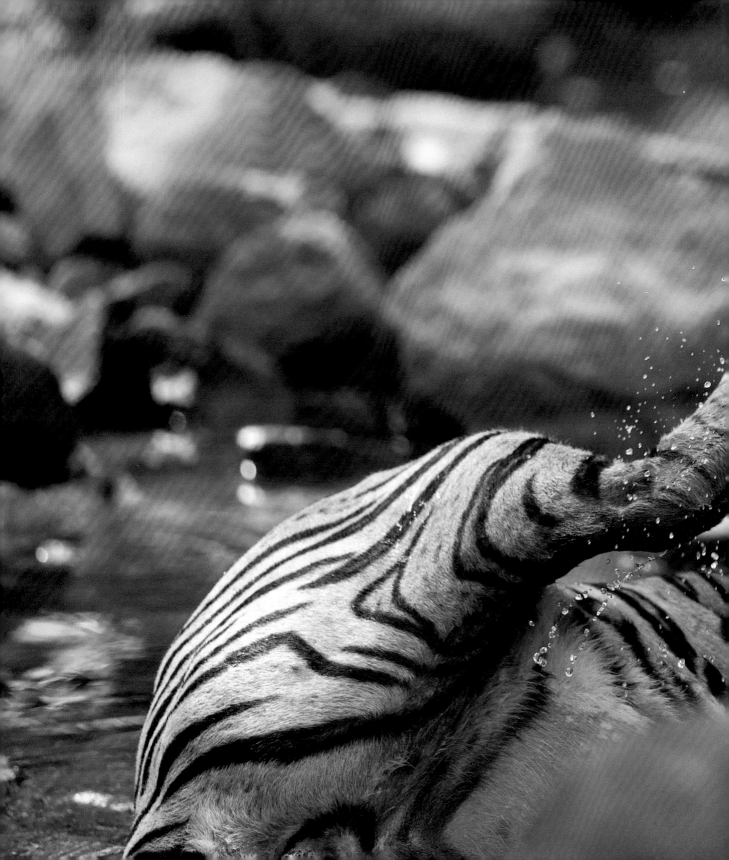

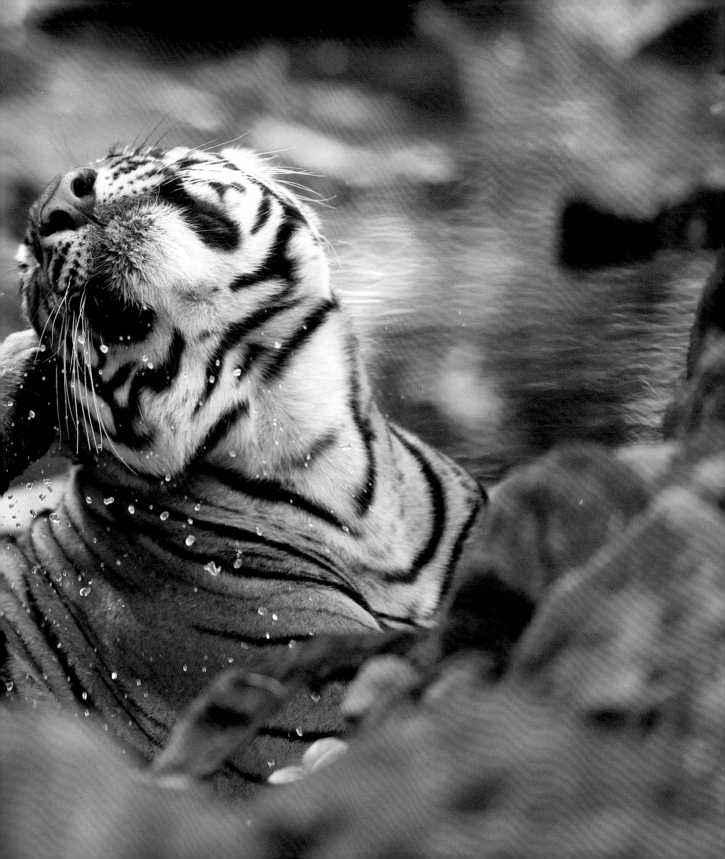

"Tigers have touched the hearts of their millions of followers. Individuals are anthropomorphised and this book narrates stories of some such iconic characters in the last 10 years

FOREWORD

Close Encounters in the Wild

Visual imagery is transforming our world. From capturing the myriad hues of nature to the incredible microscopic exploration into the origins of life. From the tiny human cell to the mindboggling complex structure of a pollen grain. Versatility of modern technology has enabled us to freeze and observe our magical world more closely than ever before. Technological evolution, though a double-edged sword, is not only expanding our knowledge and understanding of life on our planet

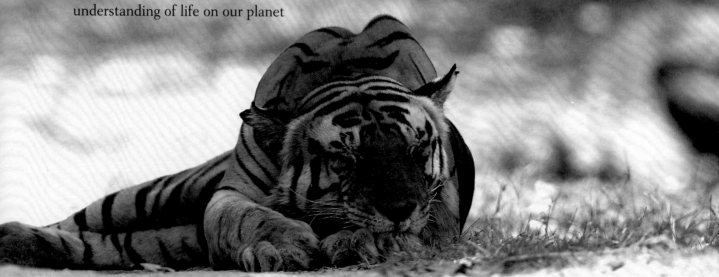

but is also opening new doors, helping us to document and understand better the planet we live on—our Home.

No encounters or special moments are really repeated and if you are lucky to have recorded it on your camera then you have actually managed to freeze time and capture history…the passage of time.

But however advanced and evolved technology may become, in the final analysis it is the man behind the camera that matters, in capturing that very special moment.

I first met Shivang Mehta nearly a decade ago, a battle-worn camera that had seen heavy use slung over the shoulder, a man of few words. It was that special glint in the eye and the firm gait that betrayed the stubborn streak—one that is so crucial if you are choosing to walk the path he had decided to take. This quality eventually helped him persevere, taking up all challenges in his stride and trudging along creating a new path in visual communications—photographing under extreme conditions and special moments, capturing and registering special encounters in the wild along with his partner and adventurous companion Kahini…and his camera. It was

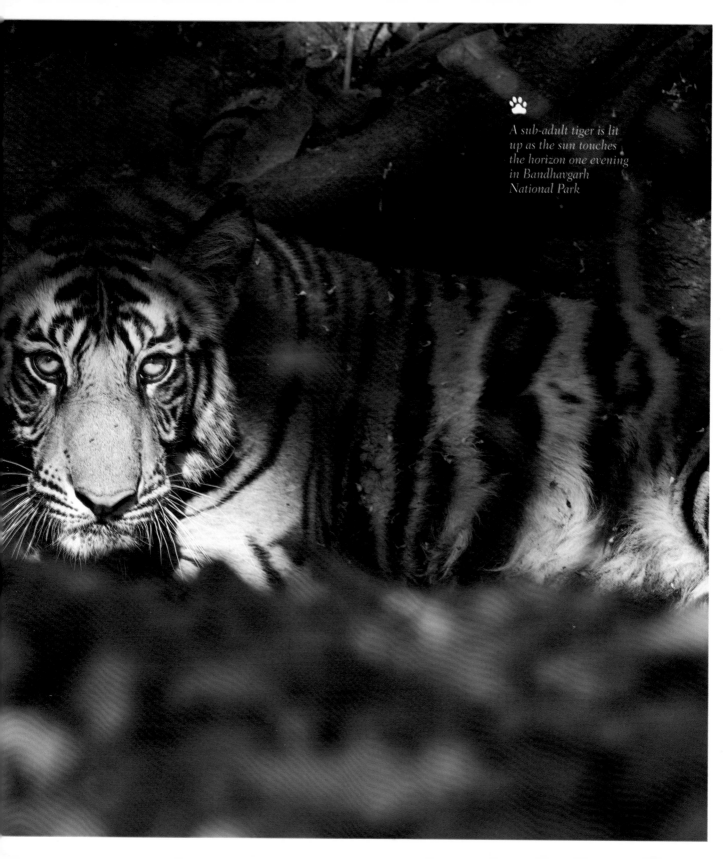

A sub-adult tiger is lit up as the sun touches the horizon one evening in Bandhavgarh National Park

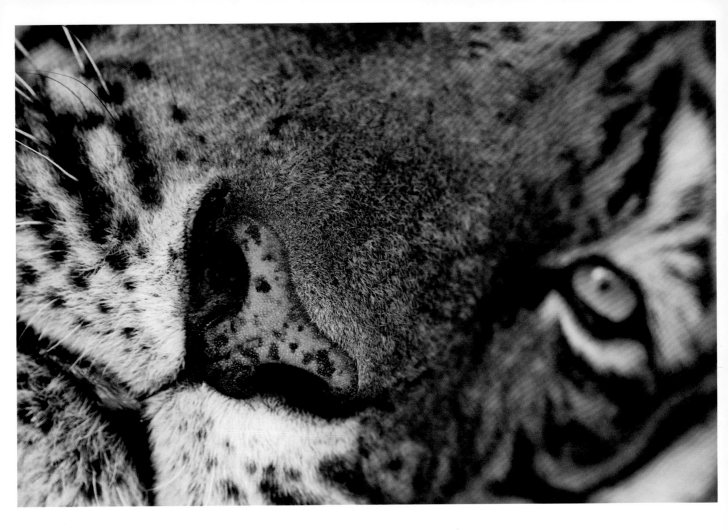

such a pleasure to go through the engaging moments and images of one of the most powerful predators—the tiger. The book has captured some special moments and dramatic tiger behaviour.

Climate change and mankind's activities are rapidly changing our natural world. Hundreds of species are being lost everyday, never to return. The fragmentation of the planet is visible across the world.

It's books like these that offer hope and will inspire new generations to reach out and make all the effort to keep our diversity and heritage intact. This book will be an excellent resource of inspiration and revelation of nature's intricate designs. I firmly believe that

A tight portrait of a male tiger resting in Ranthambhore National Park

education is the key, the catalyst. It is only when people understand that they begin to respect and what they respect, they love and protect. Hopefully this book will create an understanding and respect for tigers in the hearts and minds of the readers. The planet is in crisis. There is a need for us to understand that we must live in harmony and with compassion for all the life forms who share this planet with us. I take this opportunity to congratulate Shivang Mehta for his single-minded commitment and dedication towards the documentation and representation of our natural world.

Mike Pandey

Mike Pandey is the winner of three Green Oscar Awards for his pioneering work in wildlife films in India. Featured on the cover of *Time* magazine, Mike's powerful films have facilitated the conservation of rare species of wildlife such as whale sharks, horseshoe crabs, and vultures in India.

"Propelled by a surge in photographers and social media, the last 10 years have been revolutionary in the photographic documentation of tigers in India

PREFACE

They are the pride of India, the apex predators of Indian forests. They have been a victim of population, shrinking forest cover, and human greed, but tigers have survived for centuries, carving their way out against all odds. An iconic species, the Royal Bengal Tiger may look the same across the length and breadth of India, however, much like humans, each tiger is unique and so is the terrain and habitat it dwells in.

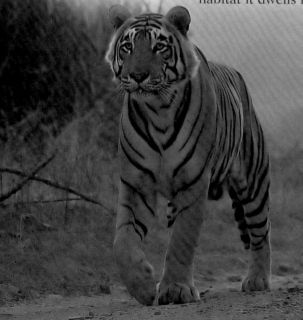

The last 10 years have been revolutionary for tigers in India owing to a surge in photographers thronging tiger reserves, and, aided by social media, the daily lives of tigers are monitored and photographically documented. Individual families have been given names and codes, and people across generations have been able to relate to some of these characters. Tigers are no longer confined to books based on the observations of a handful of tiger experts who analysed their behaviour and documented it in their writings. The individual, geographical, and demographical characteristics and behaviours of tigers across India are now supplemented with powerful photographic evidences that have given greater insight into the private lives of otherwise secretive cats.

The decade has also seen the trend of changing focus, shifting from the eminent and popular tiger reserves of Ranthambhore, Bandhavgarh, Kanha, and Corbett to lesser-known forests of central India like Tadoba, Pench, and many other wildlife sanctuaries and tiger reserves that are slowly making their mark on the global tiger map.

There are tigers who have constantly been in the limelight and have become legends in their own right, especially in the past few years; some because of their sheer might and their innate capability to survive amidst shrinking forests and growing pressure from mankind, others because of their contribution in ensuring that the striped baton is passed on to future generations of tigers, who would rule the food chain in the years to come.

My approach as a photographer has undergone a sea change in the last decade. What started with mere documentation of subjects using basic cameras graduated to technically perfect images using high-end equipment. While the first phase of evolution took just a few years,

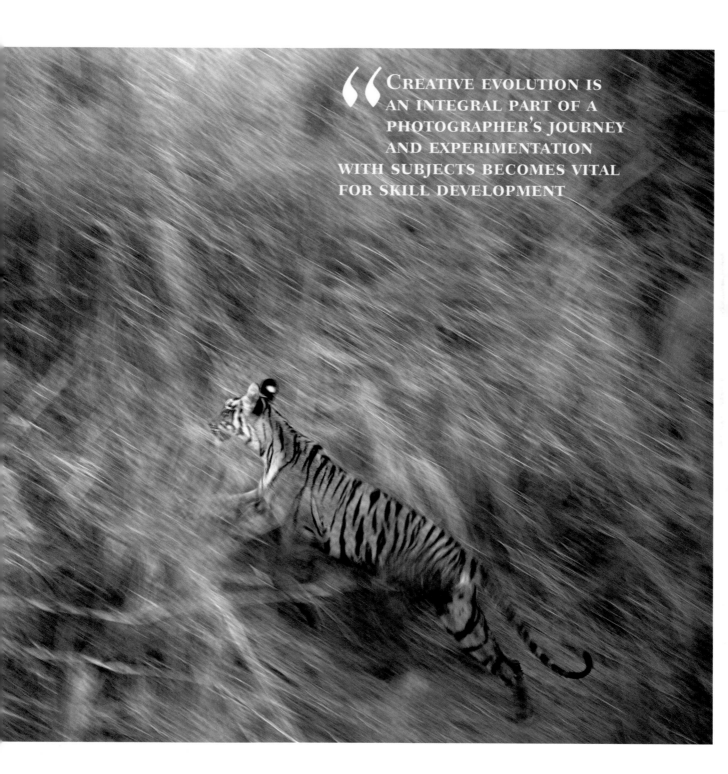

"Creative evolution is an integral part of a photographer's journey and experimentation with subjects becomes vital for skill development

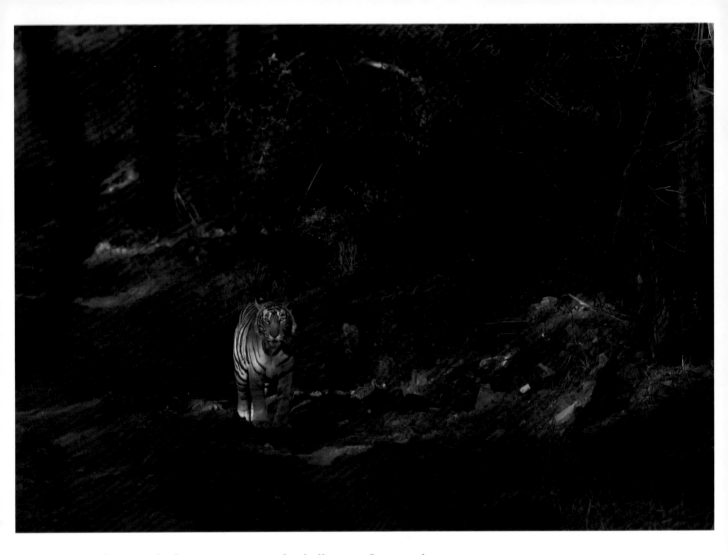

photography became increasingly challenging for me when capturing sharp portraits using top-of-the-line gear were no longer exciting for me. During this phase of creative evolution, I began experimenting with my subjects a lot and tigers were a key part of this progression.

Having spent 200 odd days on the field every year and constantly observing tigers during such long and routine journeys, I gradually started considering a body of artistic images that could be created by only treating this subject differently. The contrasting stripes on their bodies made tigers aptly suited for a black-and-white treatment. From the creative use of blurs, using harsh and spotlighting scenarios,

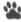

Light filters through the dhonk forest illuminating a forest track chosen by a tiger in Ranthambhore

to ultra-tight portraits composed by dissecting the body parts as individual frames—the opportunities were many. At times, just a faint depiction of the stripes was sufficient to convey the message.

Wildlife photography is a mix of 3 key elements—the science of photography, creativity, and aspects of natural history. While the last bit is beyond our control, achieving the desired mix of the first two elements is a never-ending learning process, which ensures that there is never any shortage of novel approaches or ideas for a photographer to have a productive field day.

The other aspect of my photography in the tiger world was looking for interesting stories and understanding the family dynamics of tigers in some varied tiger habitats of India. Standalone tiger images used to look good, but, supplemented with a series of images taken over months and years, depicting the stories of a tiger family, the images receive a whole new meaning. The challenges of photographing this species in varied habitats and across seasons are many. Right from braving extreme weather conditions and rough terrains to long hours of waiting, tiger photography does cultivate patience and perseverance in a person.

There are a myriad genres of tiger images yet to be conceptualised; we are blessed to be born in a country where we have access to this wonderful creation of nature. The onus is on us, as photographers, to develop the creative desire to innovate and think about making the best use of the subject while looking through the viewfinder.

This book talks about some of the prominent stories that unfolded in the lives of some celebrated tiger characters of India supplemented by photographs and experiential notes gathered

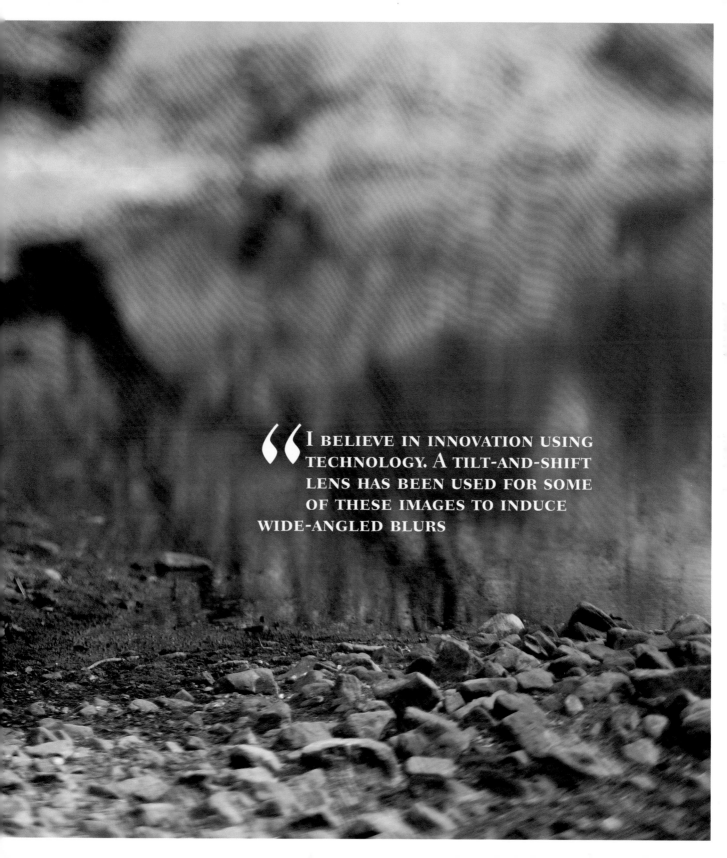

"I BELIEVE IN INNOVATION USING TECHNOLOGY. A TILT-AND-SHIFT LENS HAS BEEN USED FOR SOME OF THESE IMAGES TO INDUCE WIDE-ANGLED BLURS

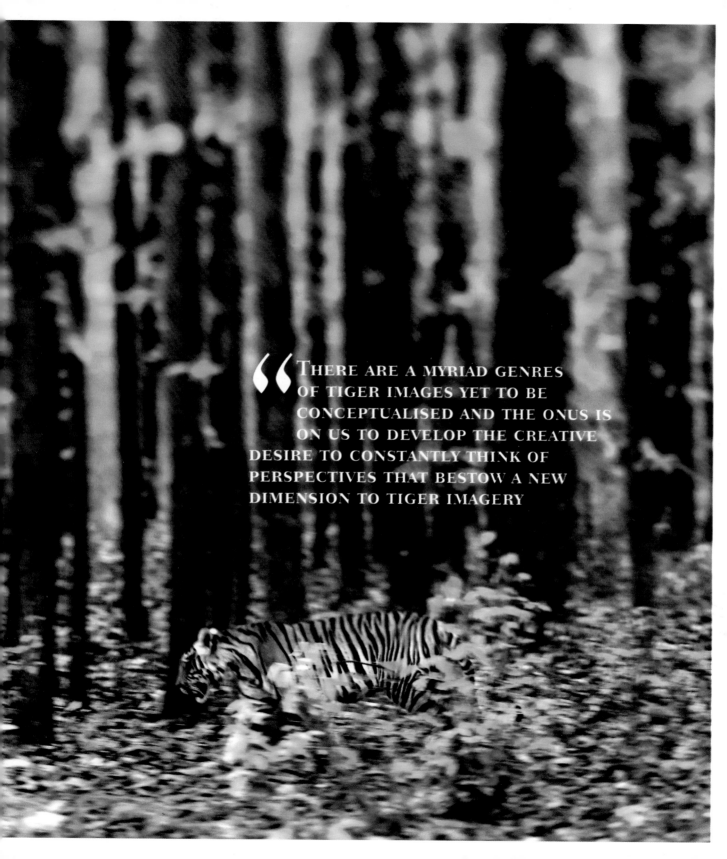

" THERE ARE A MYRIAD GENRES OF TIGER IMAGES YET TO BE CONCEPTUALISED AND THE ONUS IS ON US TO DEVELOP THE CREATIVE DESIRE TO CONSTANTLY THINK OF PERSPECTIVES THAT BESTOW A NEW DIMENSION TO TIGER IMAGERY

during the few thousand hours of my life spent in the various tiger habitats of India. Also discussed, though very briefly, are certain key aspects pertaining to tiger photography in India in the form of some compelling images that treat tigers as a creative subject with an immense potential yet to be explored. Lastly, it is worth a mention that this book is essentially a personal account of the travels of a wildlife photographer, whose zealous interest in and pursuit of the mighty predators of the forests has awarded him with the best of photographs that one can take of this much-coveted member of the cat family. However, these photographs are not to be forgotten or stored in dusty boxes in the attic; they are an experience in itself for those who may never have the chance to see these beautiful and intelligent beasts at such close quarters.

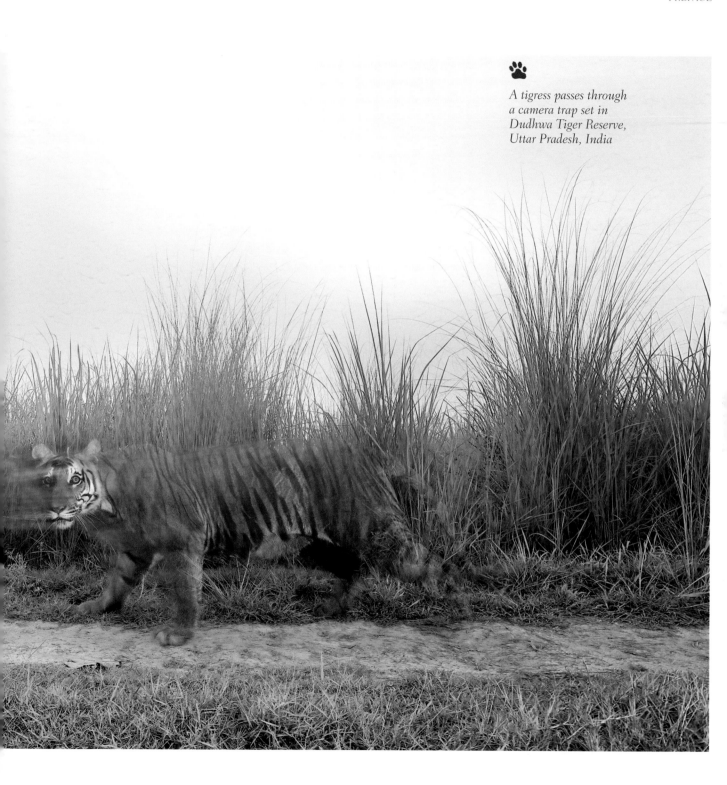

A tigress passes through a camera trap set in Dudhwa Tiger Reserve, Uttar Pradesh, India

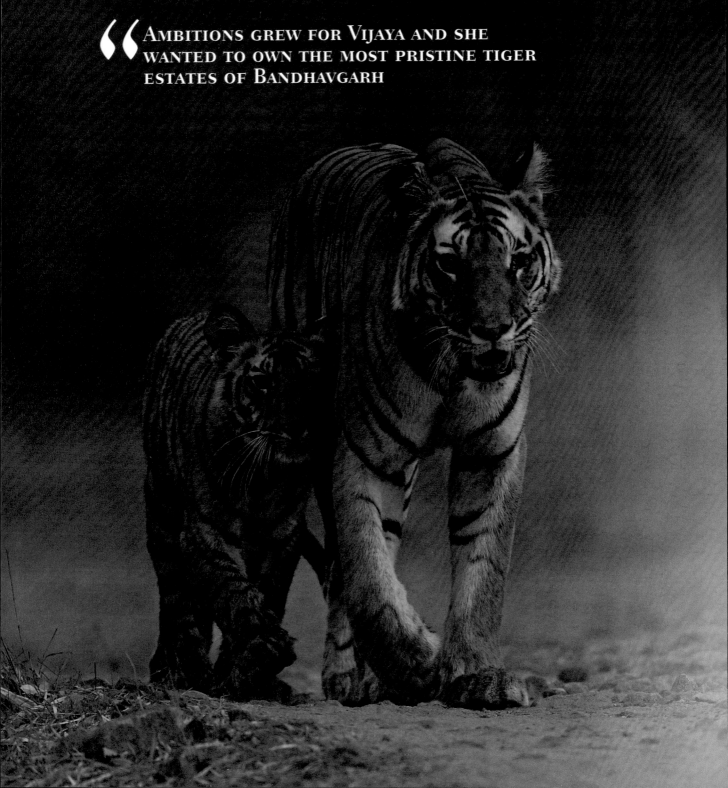

"AMBITIONS GREW FOR VIJAYA AND SHE WANTED TO OWN THE MOST PRISTINE TIGER ESTATES OF BANDHAVGARH

TIGER MOTHERS

BANDHAVGARH

VIJAYA
The Warrior Queen of Bandhavgarh

Four-year-old Vijaya was a bold, buoyant, and beautiful tigress. Like all striped kings and queens of Bandhavgarh, she was a favourite with lensmen, who yearned for an opportunity to photograph her. All seemed rosy till the summer of 2010 but as monsoons approached, Vijaya grew ambitious. She wanted to rule one of the most pristine tiger estate of Bandhavgarh—the stretch ranging from Chorbehra, Chakradhara, right up to Bandhavgarh Fort. She wanted to be crowned the new queen of the Tala Range of the forest.

Such ambition was good from a tiger's perspective for this has been the dream territory of any tiger at Bandhavgarh. Legends like Charger, Seeta, and B2 occupied this stretch of land because of its abundant prey base, year-round presence of water, superb hunting grounds, and the availability of adequate shady areas for comfort.

Competition, was quite tight tough for the young Vijaya as 10-year-old Lakshmi (Langadi, as she was locally called), who, despite her physical limitations, was managing to rule Vijaya's desired lands. Lakshmi's weakness, apart from her sore leg, were her young, 10-month-old cubs, and since she relied on livestock kills, her movement was restricted to the peripheral areas of the forest.

During the rains of 2010 the meadows of Bandhavgarh turned into a battleground. Vijaya knew the weaknesses of Lakshmi and advanced towards her in what seemed to be a lost battle for Lakshmi. However, the physically disabled mother put up a brave fight, making things difficult for young Vijaya. An encounter that seemingly lasted for the whole night resulted in much bloodshed, and some extraordinary tiger behaviour was recorded on that fatal night—Vijaya, in her fury, had not only killed Lakshmi but had also consumed more than half of her body. It was quite unusual for me to come across tiger cannibalism, a tiger behaviour I had never encountered as a photographer. Multiple search parties of forest guards on elephant-back were formed, but all that was found were the mortal remains of Lakshmi and an agitated Vijaya bleeding profusely.

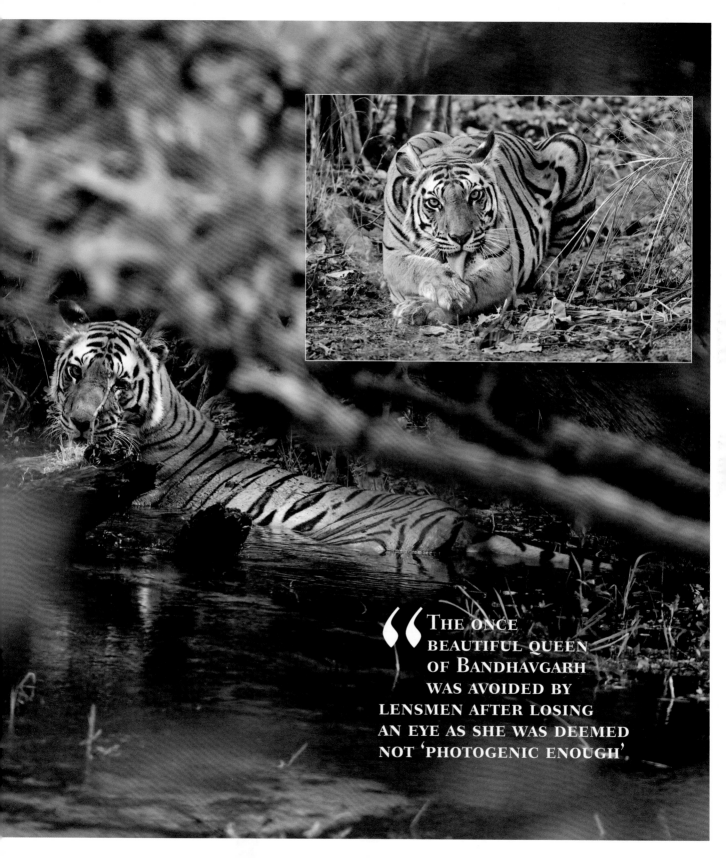

"THE ONCE BEAUTIFUL QUEEN OF BANDHAVGARH WAS AVOIDED BY LENSMEN AFTER LOSING AN EYE AS SHE WAS DEEMED NOT 'PHOTOGENIC ENOUGH'.

Left with just one eye and a huge territory to rule, survival for the ambitious Vijaya seemed tough. Tiger history across India features very few warriors who have been able to survive with such critical physical limitations. As in the case of any predator, the slightest of injuries that impacts the capability to hunt may prove to be fatal. The title of Bandhavgarh's queen, though hard-earned, would be difficult to keep for this young tigress. A lot of Bandhavgarh observers had given up on Vijaya as she lacked the mental and physical fortitude to rule a territory as prime as Bandhavgarh Fort.

The lensmen, too, had lost interest in her. The once beautiful female of Tala Range was now being avoided because she wasn't photogenic enough. It was at this juncture that I decided to dedicate my photographic journey and field efforts in Bandhavgarh to follow this fascinating turn of events. I was keen to observe what Vijaya's survival tactics would be, now that life would never be the same as she could now see just half her world. Even if she manages to survive, would she be thrown away by a dominating, physically fit tiger? These were some of the questions that only time could answer and made me keep coming back to Bandhavgarh, eventually spending more than 200 field days with Vijaya, the warrior queen of Bandhavgarh.

Post the injury she became shy and avoided vehicles and people. I remember seeing a lot of images of Vijaya during that period where she was seen snarling at vehicles, and made very brief public appearances. The winter of 2010 passed by and all I could see were glimpses of a tigress in distress. I wondered how much the eye had impacted her hunting activities. She took at least four months to settle down.

During the summer of 2011, Vijaya surprised me with her future strategy. She knew that in order to survive and retain this estate, she

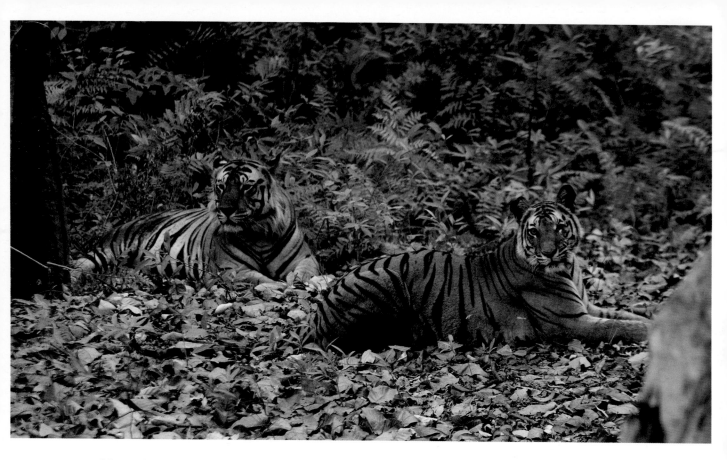

would need the company of a dominant male who could offer her adequate protection. She aspired to become a mother but even for that the shadow of a male was critical.

The dominant male of Bandhavgarh, Shashi (locally known as Bamera male), blessed with the genes of a legendary family, to which belonged Charger (his grandfather) and B2 (his father), was expanding his territory at an astronomical rate. He cornered his father in one area of the park and acquired his legacy, and added a significant part of the forest, which he acquired on his own by driving off intruding males, to roam about freely in an area spanning more than 100 square kilometres. He was already the reigning king of Bandhavgarh National Park and his rule was undisputed. His frequent ventures into the forest areas surrounding Bandhavgarh Fort brought him close to Vijaya, and, in the summer of April

The week-long, unsuccessful romance during Vijaya's first encounter with Shashi (Bamera) in April 2011

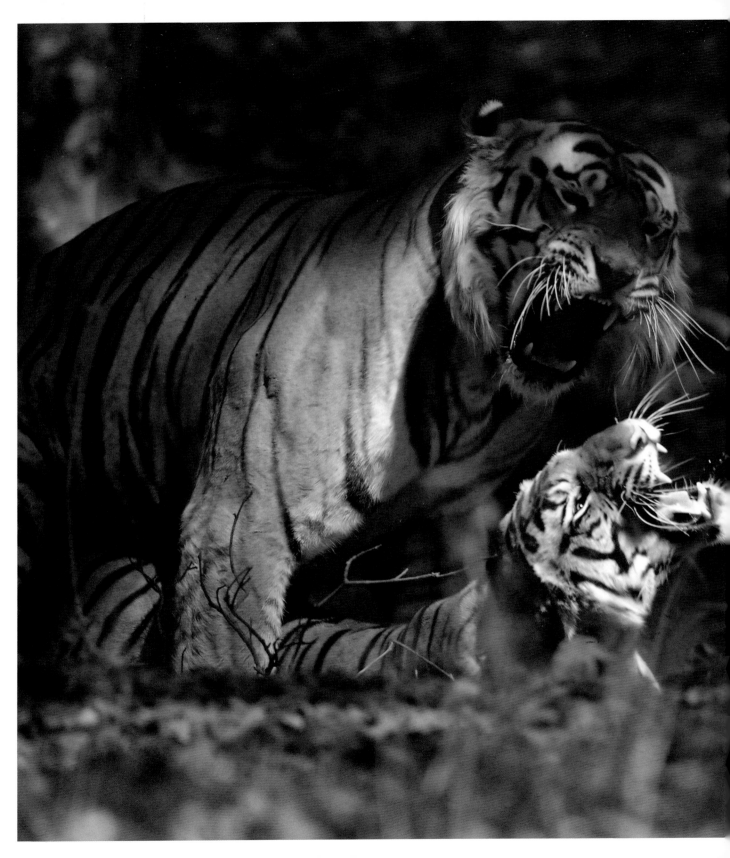

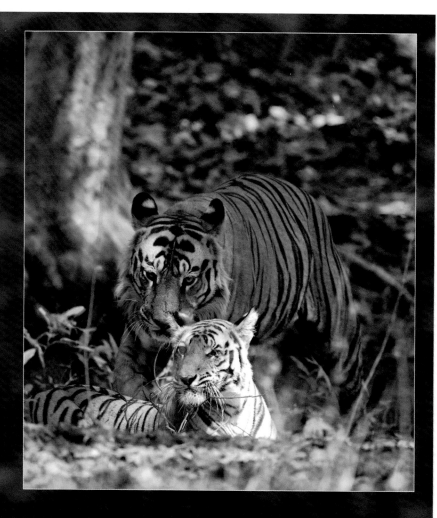

" THE ROYAL HONEYMOON
CONTINUED IN JUNE 2011
IN THE LUSH GREEN
FERNS AND BACKDROP OF
BANDHAVGARH FORT. VIJAYA'S
BOND WITH SHASHI (BAMERA)
STRENGTHENED JUST BEFORE
THE MONSOONS

2011, they were seen together for almost a week, romancing in lush green ferns and rocky terrains in the backdrop of the fort. Their week-long royal honeymoon raised hopes for Vijaya's legacy and the news of her pregnancy was eagerly awaited; the timing of mating was perfect and it seemed that Vijaya would deliver before the forest closed for the monsoons. Surprisingly, the couple was seen together again within a couple of months, in the first week of June 2011. Was the previous act of mating just a stratagem by Vijaya to bide her time with Shashi or did the April honeymoon end in failure? There are some mysteries in the world of tigers that are hard to decipher.

Post the mating in June the forest had closed for the monsoon and the forest season post the rains started with a lot of anticipation. As the days of October 2011 passed, the search for Vijaya was on. Did the pre-monsoon mating succeed? Were the cubs able to survive the monsoons? The search was bound to be tough; Vijaya, being a first-time mother, would be very careful in ensuring the safety of her cubs. In November 2011, it was sheer delight to hear the news of Vijaya nursing her small, two-month-old cubs in the rocky area of Chorbehra.

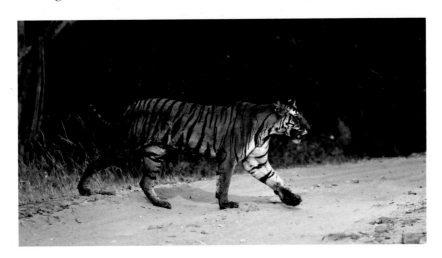

Bold and beautiful Vijaya patrolling her territory in the summer of 2011

FACING PAGE
A pregnant Vijaya post the monsoon of 2011 in a lush green sal forest of Bandhavgarh

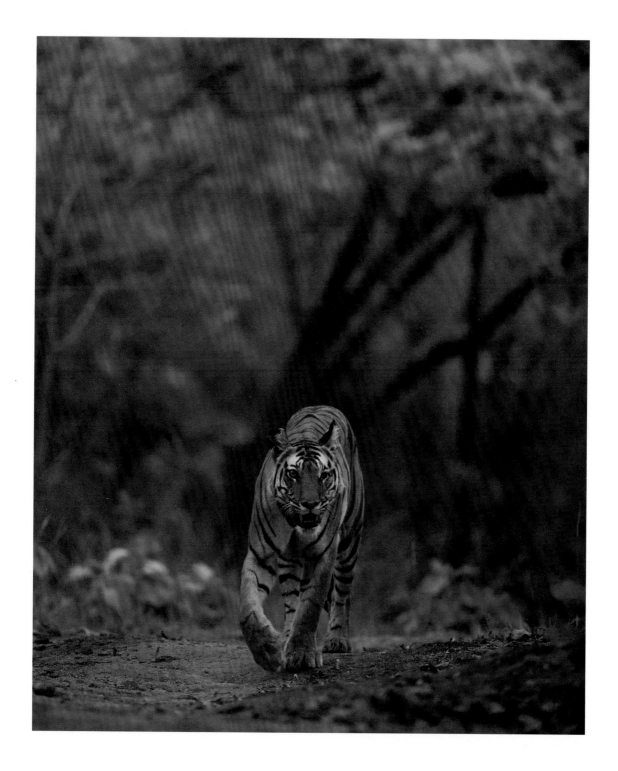

Rigorous elephant patrolling revealed that she was raising a family of three.

With a father like Shashi shielding them, the cubs were at minimal risk of being harmed by another male of the region. However, intruding tigers were not the only threat to the young siblings. Vijaya's area had a good density of leopards and it was a real challenge for her to protect the cubs during the crucial first few months, when tiger cubs start exploring the world outside their dens and become a part of the ruthless jungle life.

In the early days, for these newly born cubs, their home was confined to some patches of bamboo thickets and rocky hillocks, and their sighting was infrequent. As the news of fresh blood in Bandhavgarh spread, Vijaya again started rising up the popularity charts amongst photographers, who knew that she was another legend in the making. Filming teams started camping in Bandhavgarh; her story was fascinating and deserved to be told.

The cubs were growing up well by March 2012 and the summer season was highly anticipated. The devoted mother Vijaya was now the unquestioned ruler of the fort territory. She pushed herself hard to all corners of her territory to hunt food for her

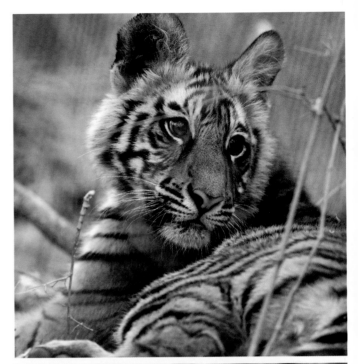

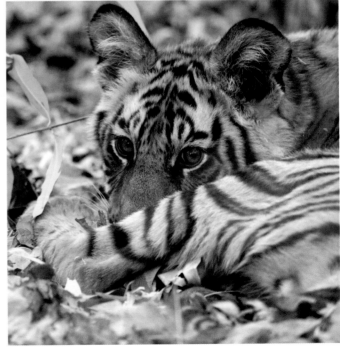

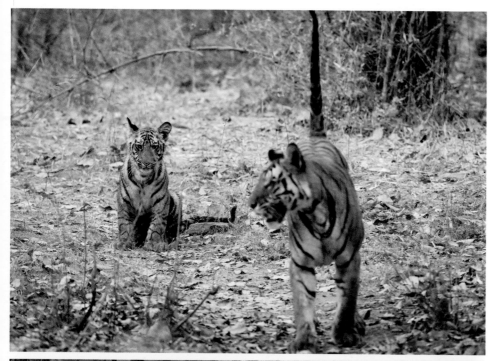

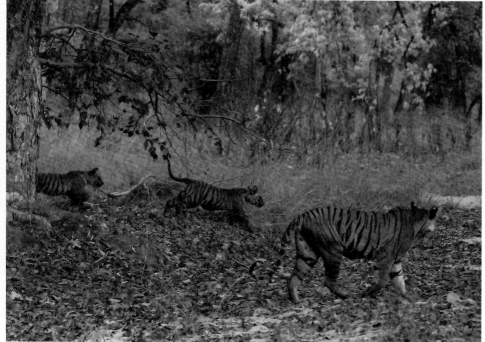

(above) Vijaya using her tail to direct her naughty male cub to follow her, in March 2012; (below) Vijaya leading two of her cubs to a hard-earned kill in the Chakradhara meadows

FACING PAGE
Portraits of Vijaya's cubs taken as the family enjoyed a morning meal in March 2012

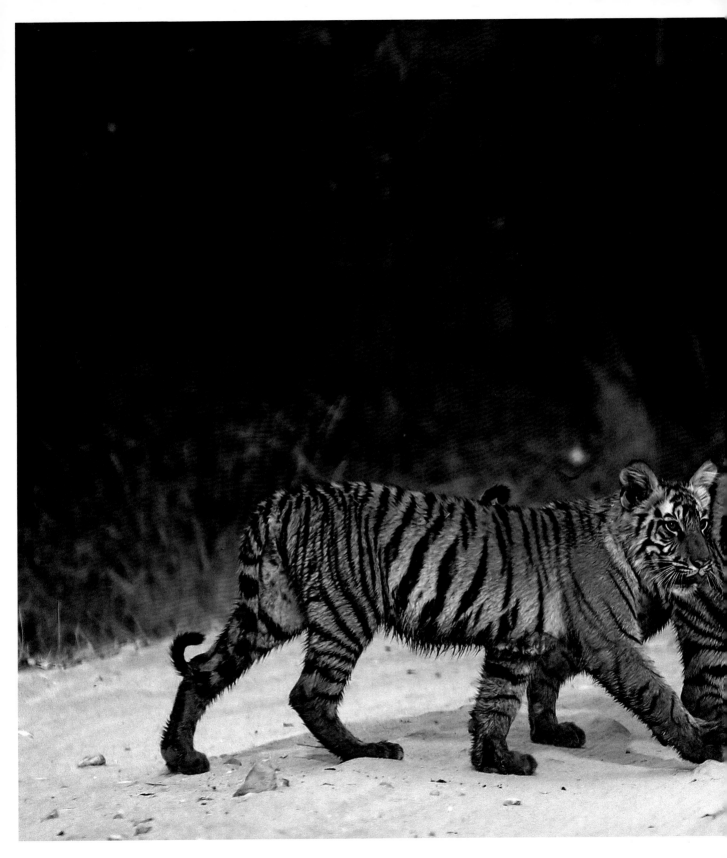

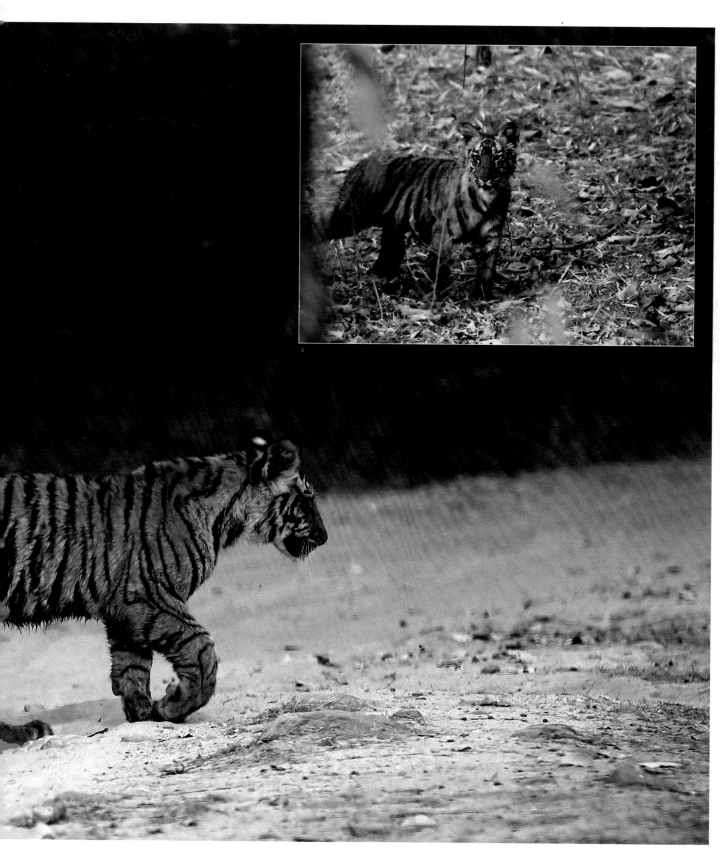

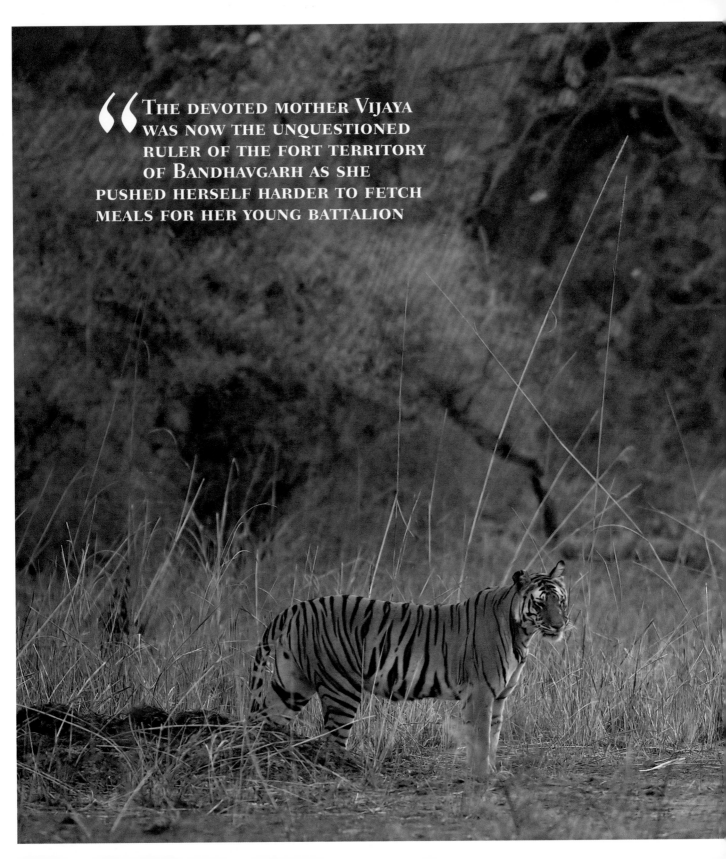

THE DEVOTED MOTHER VIJAYA WAS NOW THE UNQUESTIONED RULER OF THE FORT TERRITORY OF BANDHAVGARH AS SHE PUSHED HERSELF HARDER TO FETCH MEALS FOR HER YOUNG BATTALION

young battalion. From large sambar stags to wild boars, she was hunting every beast of prey, albeit with some amount of difficulty; her perseverance was unmatched.

As the sal shed its spring colours and the bamboos turned yellow, water around the fort territory started to diminish. Vijaya wasn't bothered about water, though, because of natural springs that kept certain patches alive even when the mercury soared. The tiny ones were growing up fast, and Shashi made periodic visits to share a meal with his family and be a tolerant father to his naughty offsprings. One of the cubs was already showing signs of lessened dependency and always wandered off on his own. At times all three were seen together, while Vijaya was out for her hunting expeditions.

Finally, in the first week of May 2012, Vijaya did something that is not a regular sight in Bandhavgarh. Early in the morning, as the cubs were playing in the grasslands overlooking the fort, Vijaya emitted a deep growl and her entire family followed her. For the first time since they were born, Vijaya boldly displayed all her cubs together as she marched alongside them. They marched like an army right up to Shesh-Saiya, a large statue of Lord Vishnu reclining on the seven-

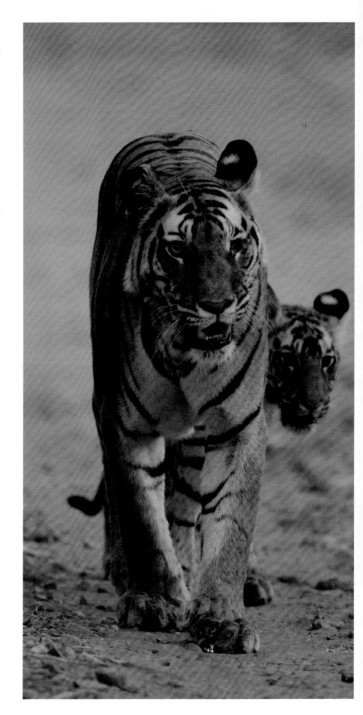

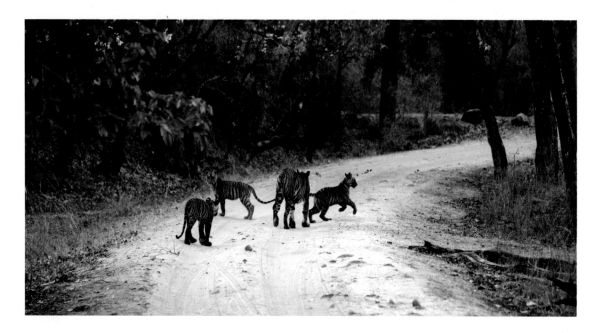

headed serpent Sheshnag, and, after seeking divine intervention, climbed the hills of Bandhavgarh Fort.

The cubs survived and were shaping up well through the monsoon and winter of 2012. However, with the onset of spring in 2013, some new challenges unfolded for Vijaya—her partner Shashi, the king of Bandhavgarh, started losing ground to the males violating his territory and was gradually pushed out of the prime areas around the fort. This meant the cubs were in danger as a new male tiger had started entering the fort territory. In order to command his supremacy, the male would either drive the family away or kill the cubs for mating with Vijaya. During the months of March-April 2013, Vijaya boldly stood her ground, hiding her three beautiful cubs and keeping them out of harm's way. The forest department even recorded an interesting incident where she tried to deceive this mysterious new male by mating with him in order to draw him out of the reach of the cubs.

Vijaya marches towards the Bandhavgarh Fort with all her three cubs one early morning in May 2012

FACING PAGE
Vijaya's cub peeps from behind while trying to keep pace with mom during May 2012

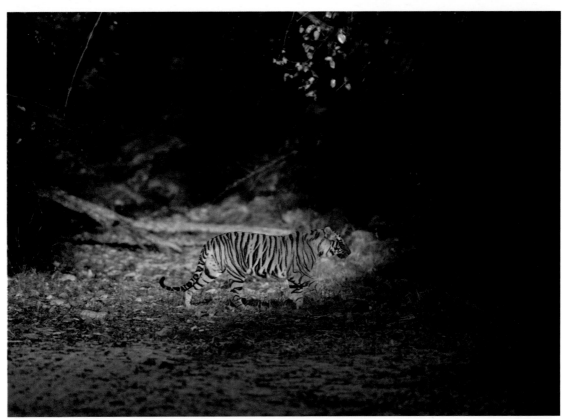

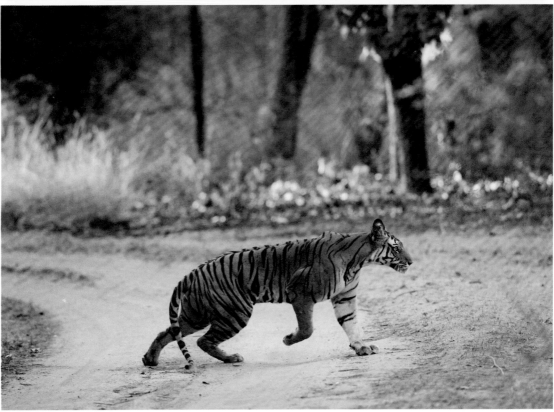

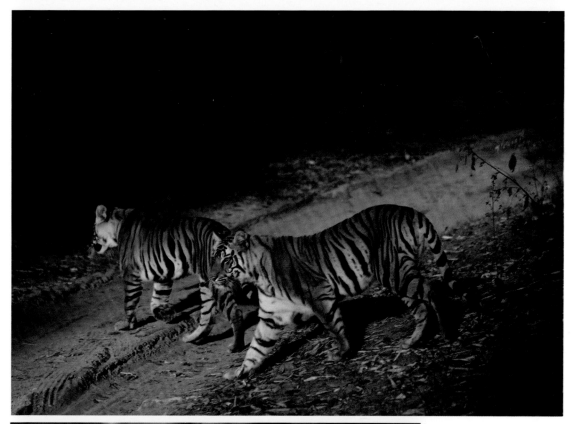

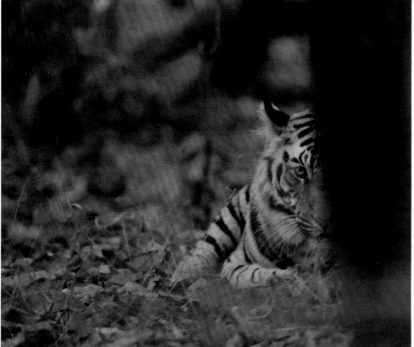

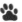

(above) The female
cubs were captured
one early spring
morning in 2013 as
they rushed past a forest
track; (below) One of
Vijaya's cubs curiously
observing her through
bamboo thickets

FACING PAGE
(above) Vijaya's
male cub grows bigger
and stronger over the
spring of 2013; (below)
Vijaya on a hunting
expedition as she stalks
a sambar deer in the
summer of 2013

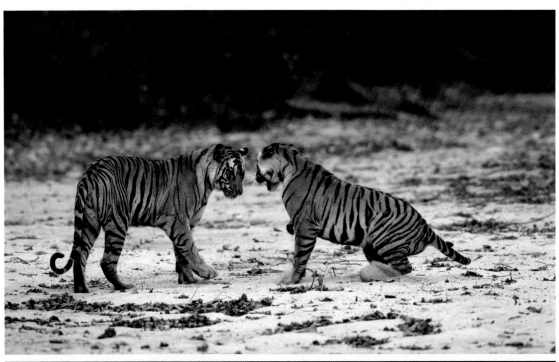
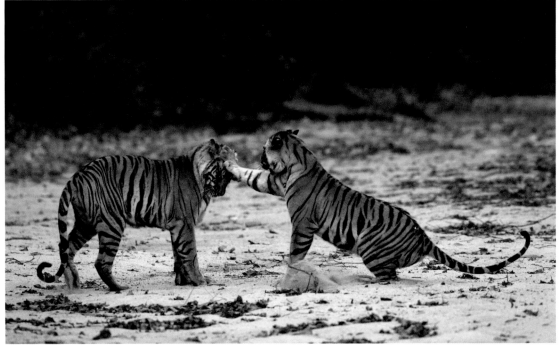

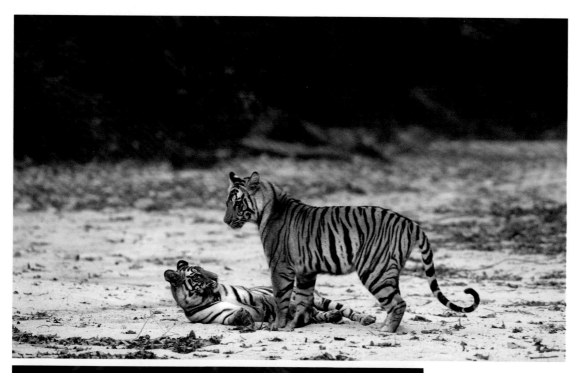

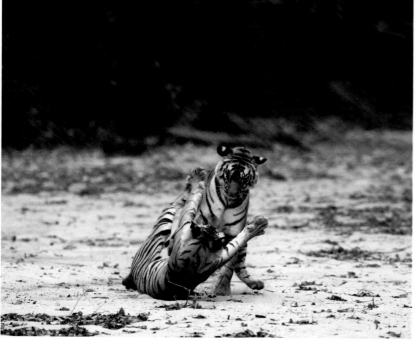

THIS AND FACING
PAGE
*It was a quiet evening
on 23 March 2013
when Vijaya was
confined to some deep
bamboo thickets for
almost two days on end
after a heavy meal. In
the last five minutes
before sundown, the
female cubs decided to
use the soft white sand
of the stream bed for a
brief bout of wrestling*

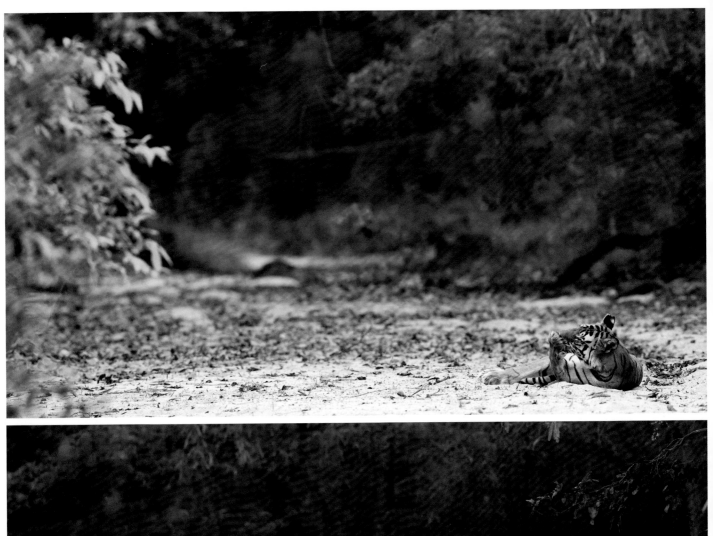
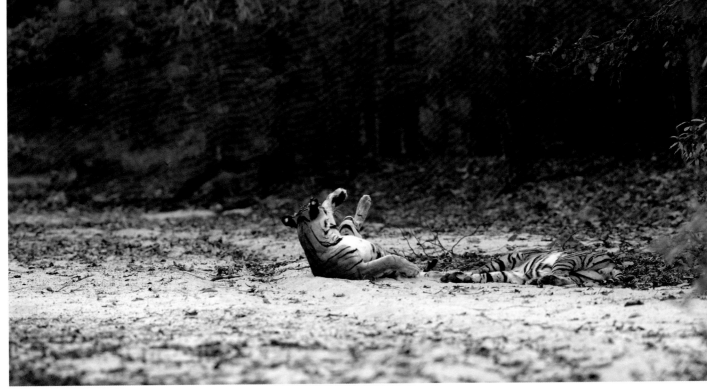

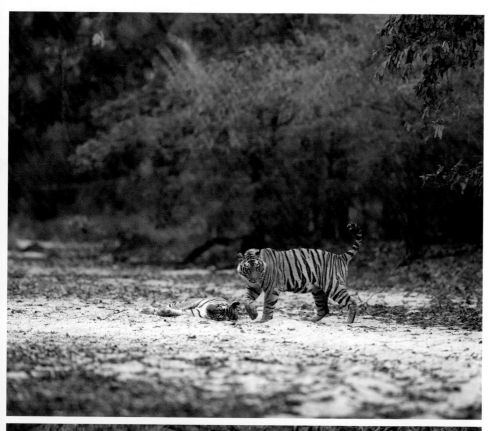

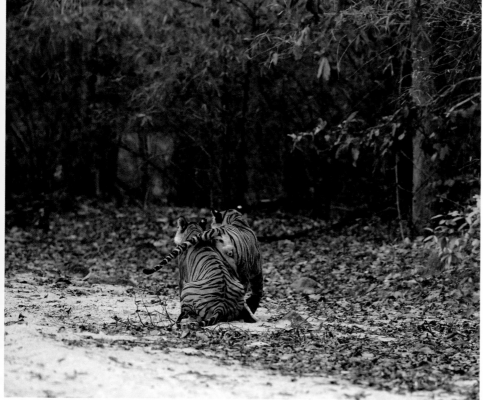

THIS AND FACING PAGE
While her female cubs enjoyed themselves, Vijaya and her timid male cub rested further along the dry stream bed. The family had consumed a full-grown sambar and usually spent long hours resting post such heavy meals

Pressure on Vijaya's family continued to mount, and, with Shashi gone, Vijaya was fighting a losing battle. She was too weak to put up a fight against a male tiger in his prime. Having spent so much time with this family, I could feel Vijaya's helplessness and was praying for the safety of her cubs. Several emotional moments were spent with them during their upbringing, but we could do nothing but follow the course Nature would take in the coming months.

The inevitable news broke out in May 2013 as one of Vijaya's cubs was found dead in the fort area. This was followed by the death of another cub in the subsequent days. A number of theories were advanced post the death of the cubs. While forest officials claimed that the cause of their death was the mystery male, a section of local naturalists believed that since the bodies of the cubs were partially consumed, similar to that of Lakshmi a few years back, Vijaya, the brave mother, had herself decided to sacrifice her family in order to retain her territory. She knew that survival would be tough outside this prime territory, especially with her physical disability. But can a mother kill her own cubs at that age? Was territory more important for Vijaya than her own blood? Did she feel threatened by the bolder females of the litter? A lot of questions went unanswered and the mystery around the world of tigers thickened. The male cub from this litter, who had also been declared dead, had, however, separated from his mother and set out on an independent journey in the adjoining areas of his mother's territory.

The hysteria around Vijaya died down for a prolonged period post the monsoon of 2013. Her sighting statistics dropped drastically and focus shifted towards other areas of the park; across the hill in particular, where another female was raising a litter of four cubs.

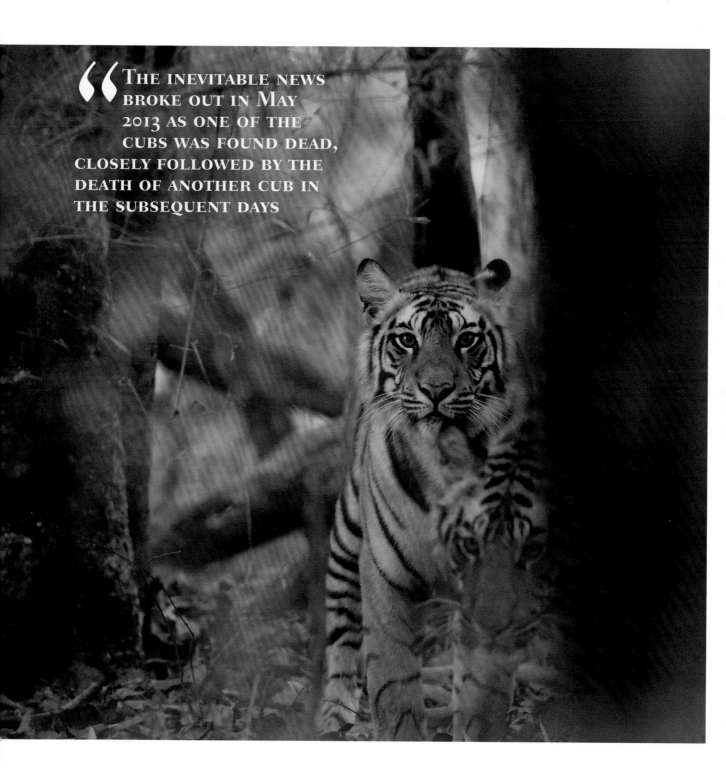

"THE INEVITABLE NEWS BROKE OUT IN MAY 2013 AS ONE OF THE CUBS WAS FOUND DEAD, CLOSELY FOLLOWED BY THE DEATH OF ANOTHER CUB IN THE SUBSEQUENT DAYS

a
decade
with
tigers

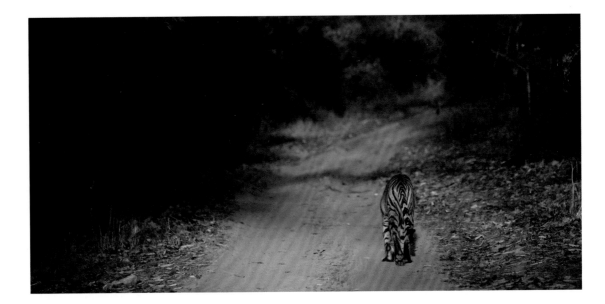

During the spring of 2014, the forest department analysed the few photographic records of Vijaya and started speculating on the possibility of a pregnancy. With temperatures rising during the summer of 2014, Vijaya made a dramatic comeback by walking down the fort hills accompanied by tiny little cubs. The scarcity of water in the upper reaches of the fort had forced her to descend to the low-lying areas, replete with natural water bodies, in order to beat the scorching heat of May 2014. The queen of Bandhavgarh had, once again, triumphed against all odds to come up with fresh blood for the park. The meadows were looking forward to being the playground for yet another litter and Vijaya was on her way to be etched in history as one of the legendary tigers of India, at par with the iconic Machali (from Ranthambhore) because of her resilient spirit. In June 2014, she gave me a brief opportunity to photograph her fresh litter and I was excited to be on her trail again, exploring new aspects of her fascinating story. As the park closed for monsoon in June 2014, Vijaya had a challenge at hand—feed the three little striped souls for three tough rainy months.

Vijaya's sightings dropped considerably post the setback she had received. I saw only fleeting glimpses of her during this period as she became shy and elusive

FACING PAGE
Shashi (Bamera) failed to live up to the reputation of his celebrated bloodline and succumbed to the pressures of the young and dynamic males of Bandhavgarh

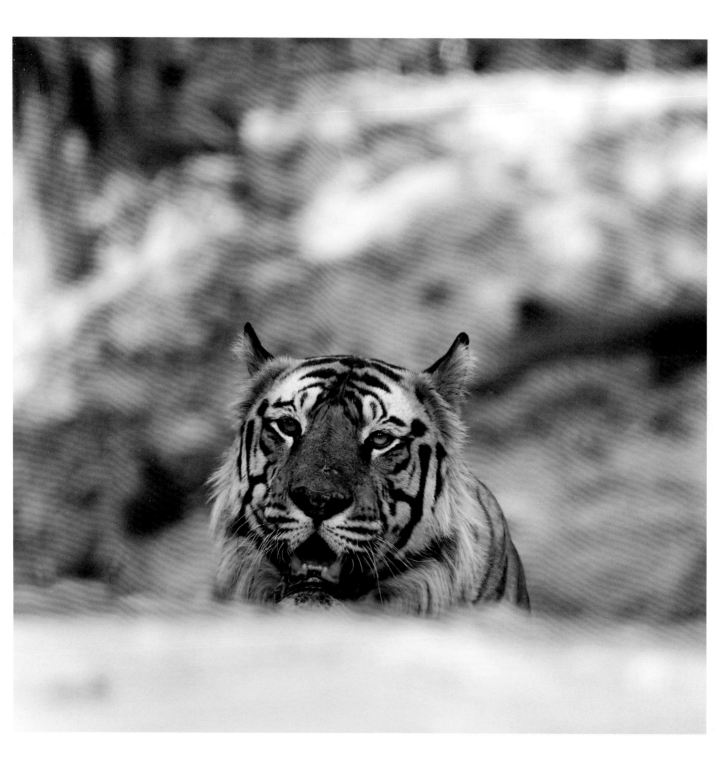

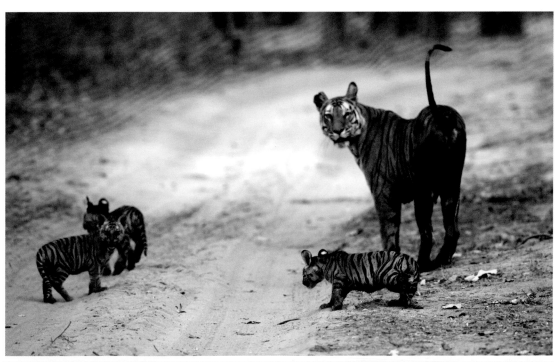
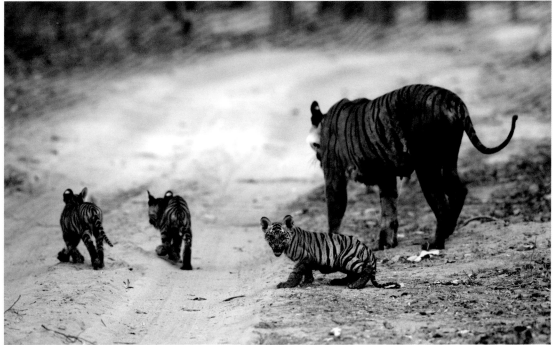

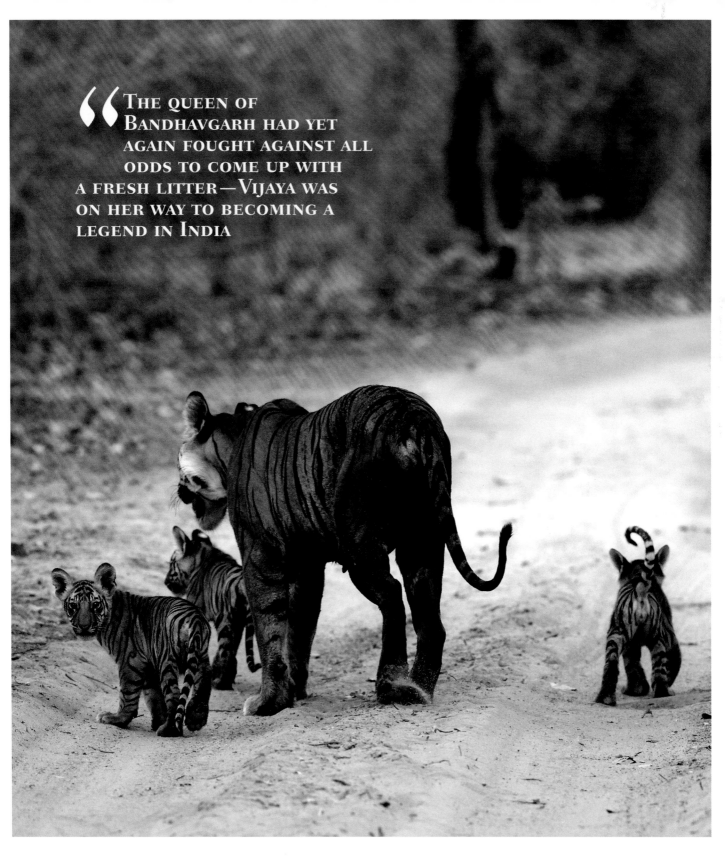

"THE QUEEN OF BANDHAVGARH HAD YET AGAIN FOUGHT AGAINST ALL ODDS TO COME UP WITH A FRESH LITTER—VIJAYA WAS ON HER WAY TO BECOMING A LEGEND IN INDIA

Sometime during the monsoon month of August I was enroute to a flamingo shoot at Lake Bogoria in Kenya when a message flashed on my mobile that made my heart sink and my eyes become moist. I hoped against all hope for the news to be mere speculation. The forest department had reported the discovery of a decomposed body of a tigress, with the post-mortem report revealing the tigress to be Vijaya. An intensive investigation revealed territorial fighting as the cause of death, and, after search operations by the forest department, two of her cubs were declared dead as well. While the entire wildlife fraternity of India mourned the death of Vijaya, I felt that her journey and her life showcases some of the true characteristics of this majestic species called the tiger. A species that has braved all odds and continues to strive and survive amidst dwindling forest covers and ever-increasing human habitation. A species that can adapt brilliantly to changing environmental scenarios and has the grit and willingness to survive. Vijaya, through her lifetime, showcased the true essence of a tiger.

Vijaya will remain alive in the hearts of Bandhavgarh and tiger lovers for the longest time. The stories and memories of this one-eyed queen still echo in my heart whenever I traverse through the woods of this tiger heartland in central India.

A hungry Vijaya after multiple failed hunting attempts for five consecutive days in the summer of 2014

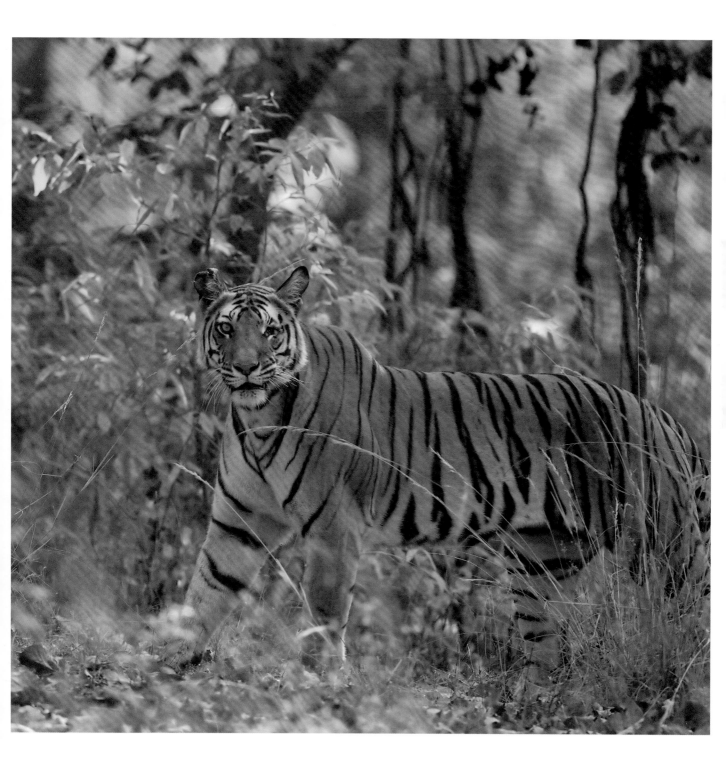

Anecdotes

The Morning Family Walk

It had been four months and despite making various attempts, I had failed to get the Vijaya family together in a single frame for a complete family portrait. Most of the times one of the female cubs would linger behind, and, at times, the foliage made photography difficult. Patience and long hours of waiting were giving way to frustration and I told my team, 'the day we get them together I am going to shave my head and offer my hair to Sidhbaba.' A small temple in the middle of the park dedicated to the Hindu god Shiva has been a perpetual driving force behind my work in this beautiful forest.

Despite numerous disappointments, each morning in the life of a nature photographer starts with the same spirit and hope. The morning of 5 May 2012 was nice and pleasant. The weather was clear, and, as the sun emerged from behind the Bandhavgarh Fort, Vijaya emerged from the Chakradhara grasslands. The cubs were playing in the dark bamboo thickets on the edges of the grassland. Before I could react, a simple instruction from the mother in the form of a low decibel growl stopped the play and the cubs ran towards Vijaya, walking on the forest track. With every second, the morning turned golden as the family marched towards Bandhavgarh Fort. As she led her cubs up the stairs of the mammoth Vishnu statue, emotions ran high, lasting for the next 45 minutes. I then stepped out of the park and headed straight to the local barber's to fulfil the promise I had made to the deities.

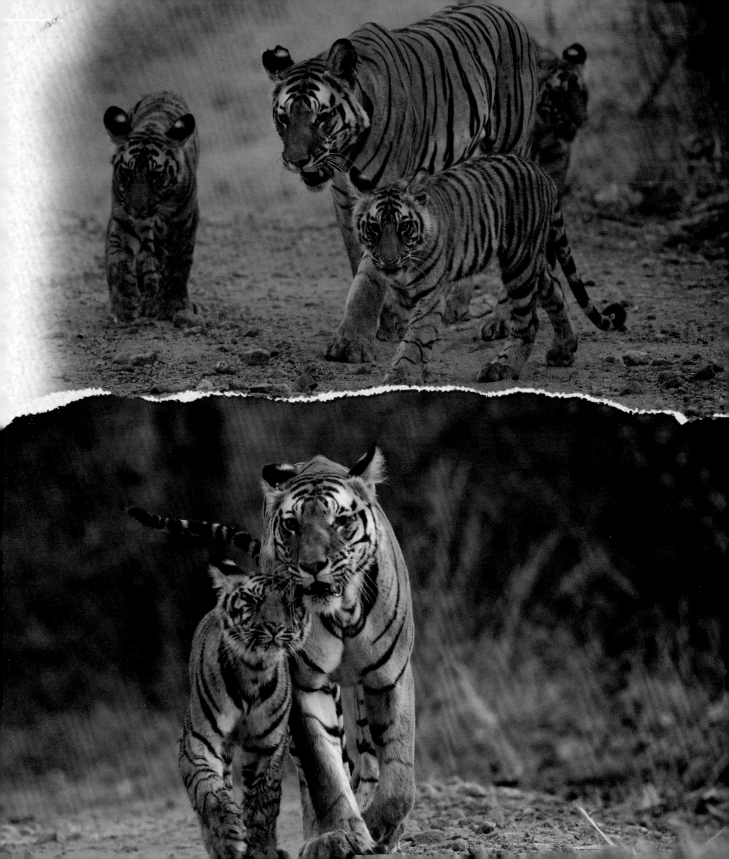

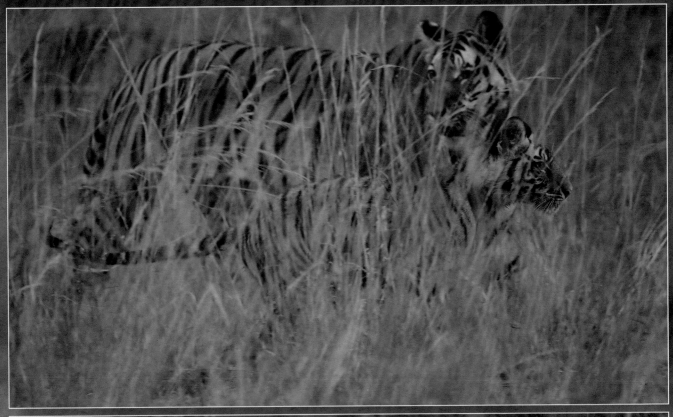
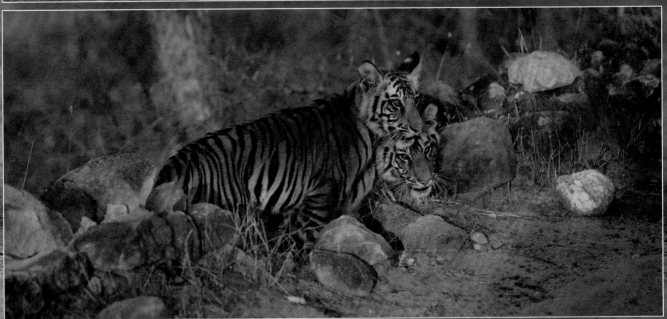

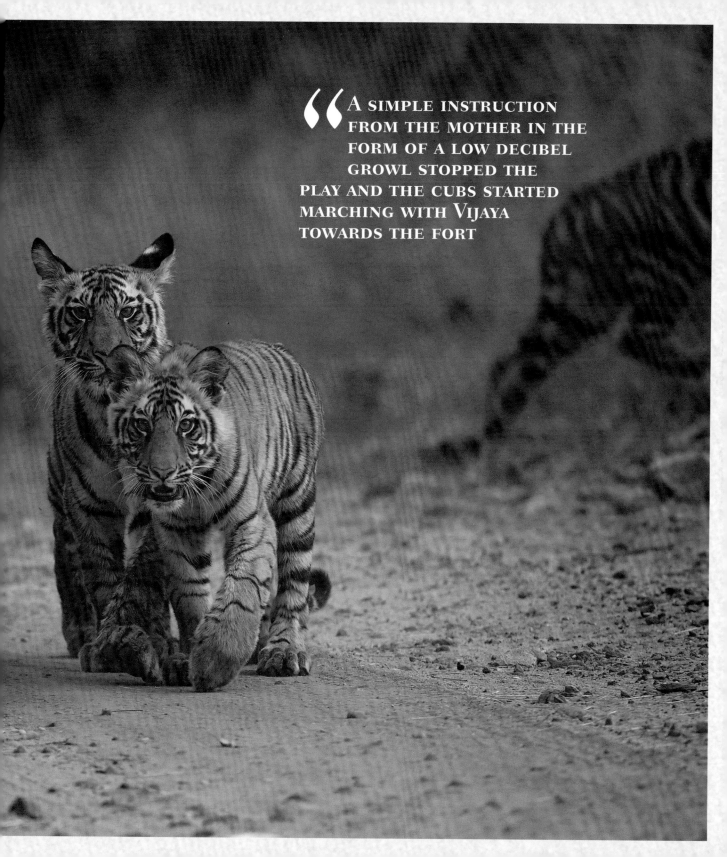

" A SIMPLE INSTRUCTION FROM THE MOTHER IN THE FORM OF A LOW DECIBEL GROWL STOPPED THE PLAY AND THE CUBS STARTED MARCHING WITH VIJAYA TOWARDS THE FORT

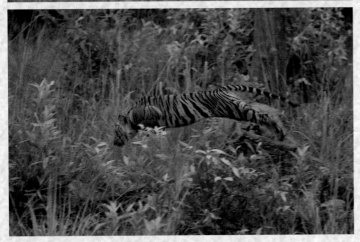

And they played as if there was no tomorrow…

Monsoon clouds were visible on the distant horizon in June 2012 and some early showers had turned Chakradhara into a carpet of green. Vijaya as usual was busy with her daily chores, looking for meals to feed her battalion. The cubs were growing fast and would at times ignore the mother's instructions; during those three days her orders were royally ignored. While Vijaya was out on a hunting expedition, one of the naughty female cubs induced some evening play with her siblings. What started with a gentle nudge gradually resulted in the three musketeers turning the grasslands of Sidhbaba into a playground for the next three days. They ran from one corner of the ground to the other, stalking and chasing each other. They sprung up in the air in action and pounced on one another.

Drenched in sweat, my eyes started burning while shooting these sequences as it was becoming strenuous to look through the viewfinder. It is at times like this when I regret being a photographer, not being able to see these high-voltage, electrifying yet cute moments with my naked eyes. During those three days, I had to leave the location each evening owing to time constraints, but the tiger cubs just refused to tire.

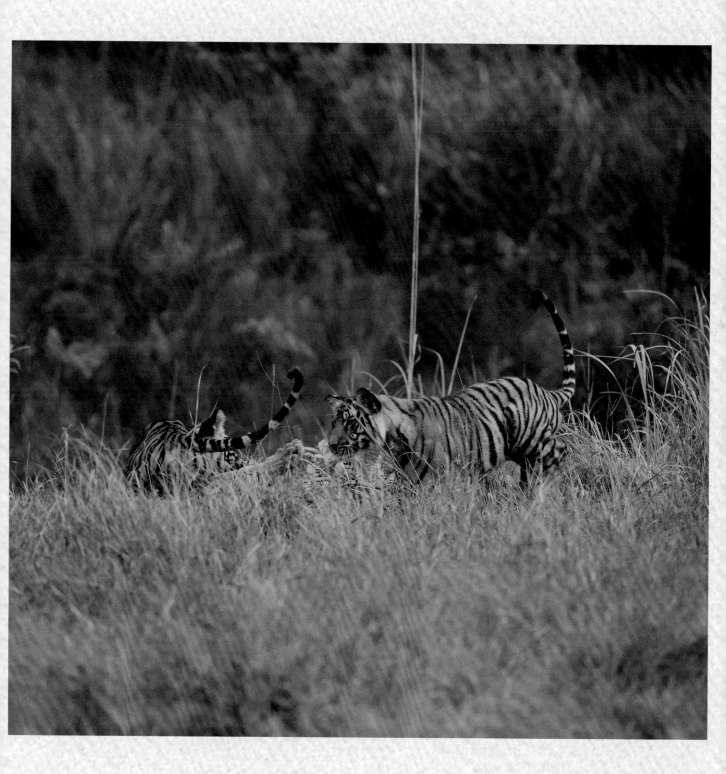

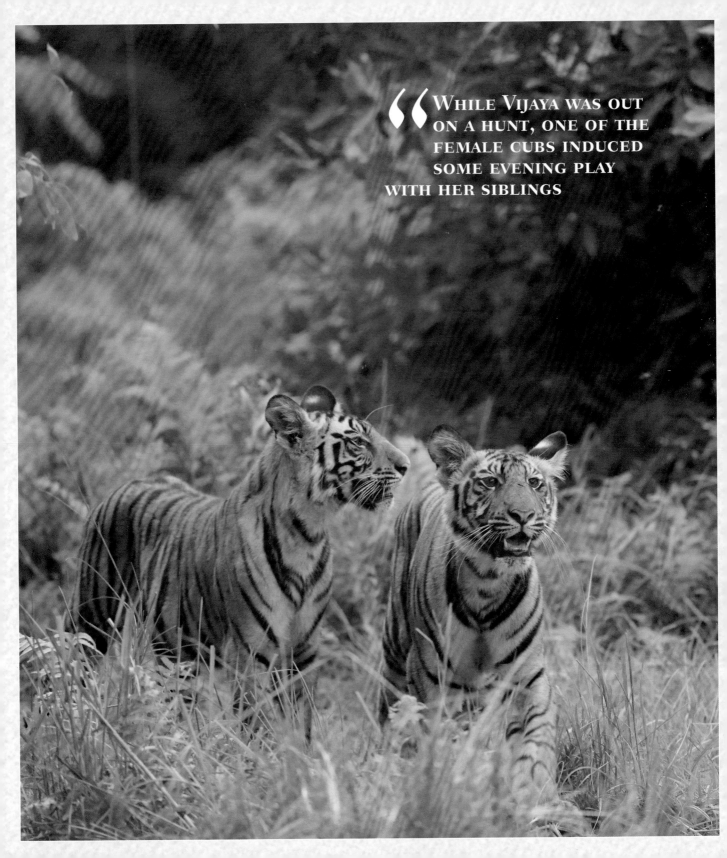

> **WHILE VIJAYA WAS OUT ON A HUNT, ONE OF THE FEMALE CUBS INDUCED SOME EVENING PLAY WITH HER SIBLINGS**

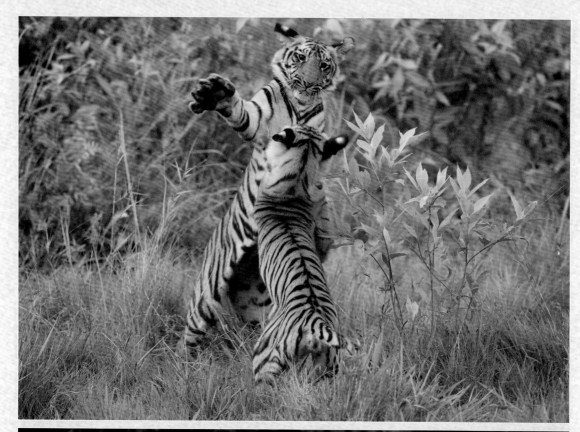
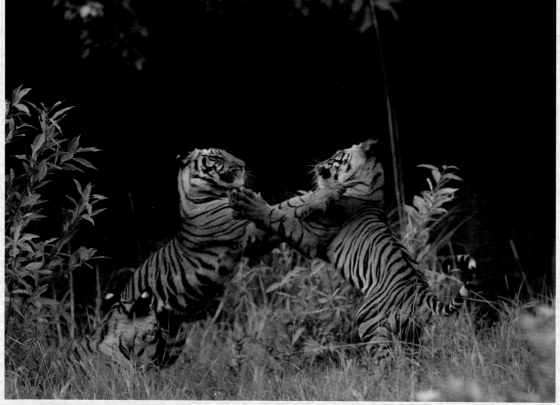

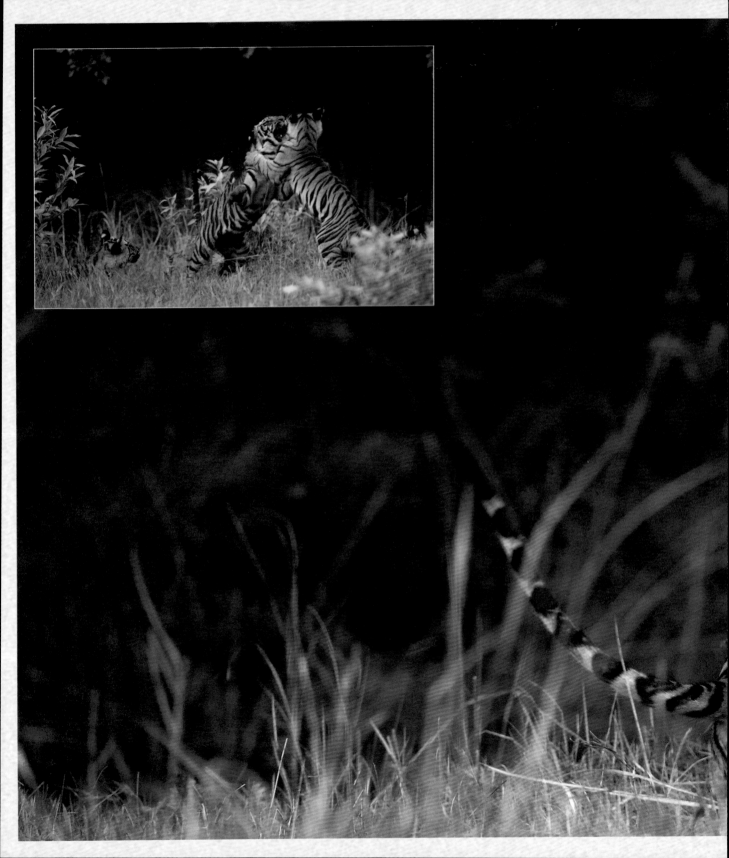

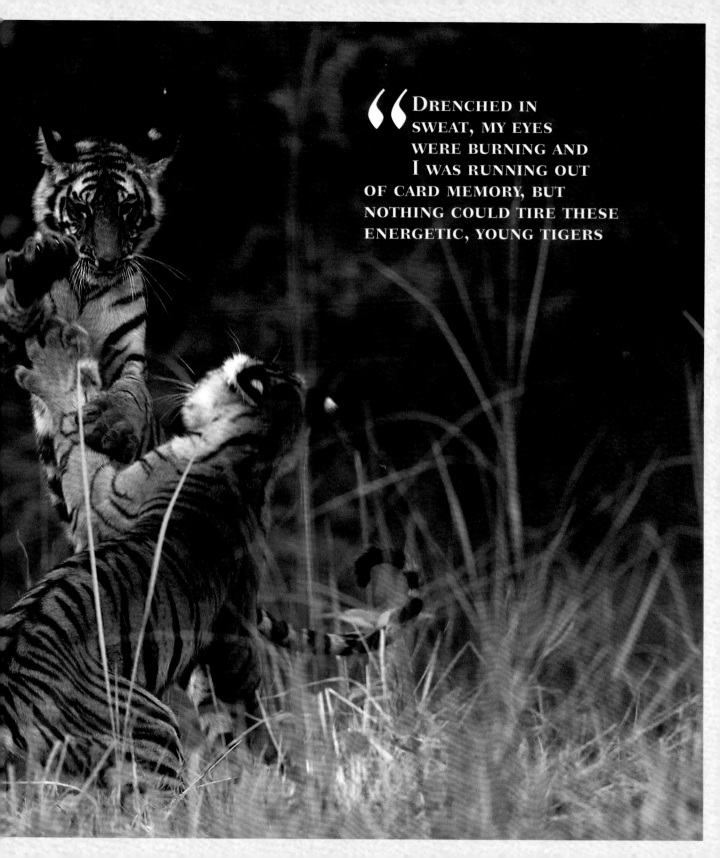

> **Drenched in sweat, my eyes were burning and I was running out of card memory, but nothing could tire these energetic, young tigers**

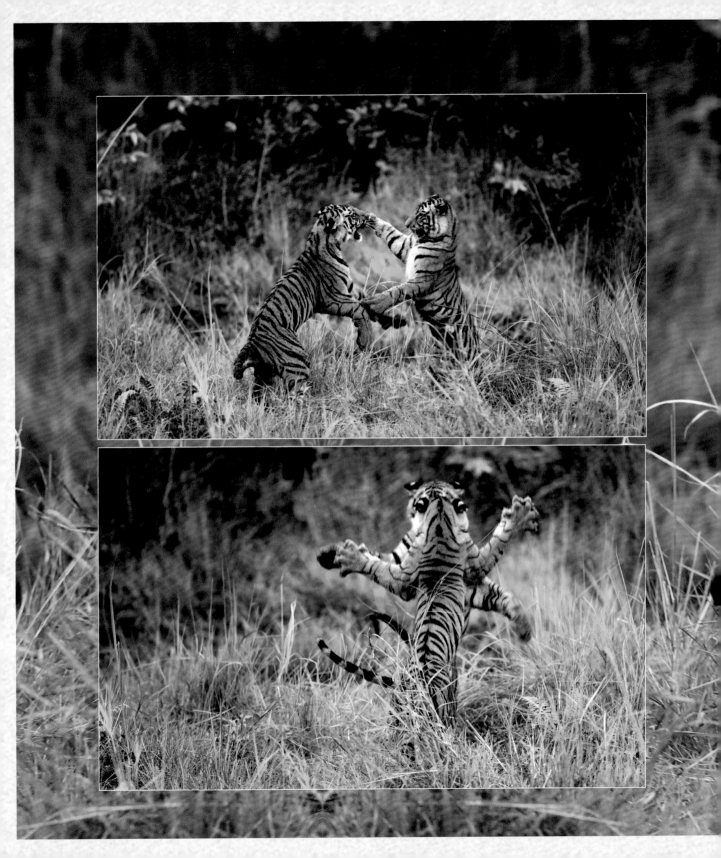

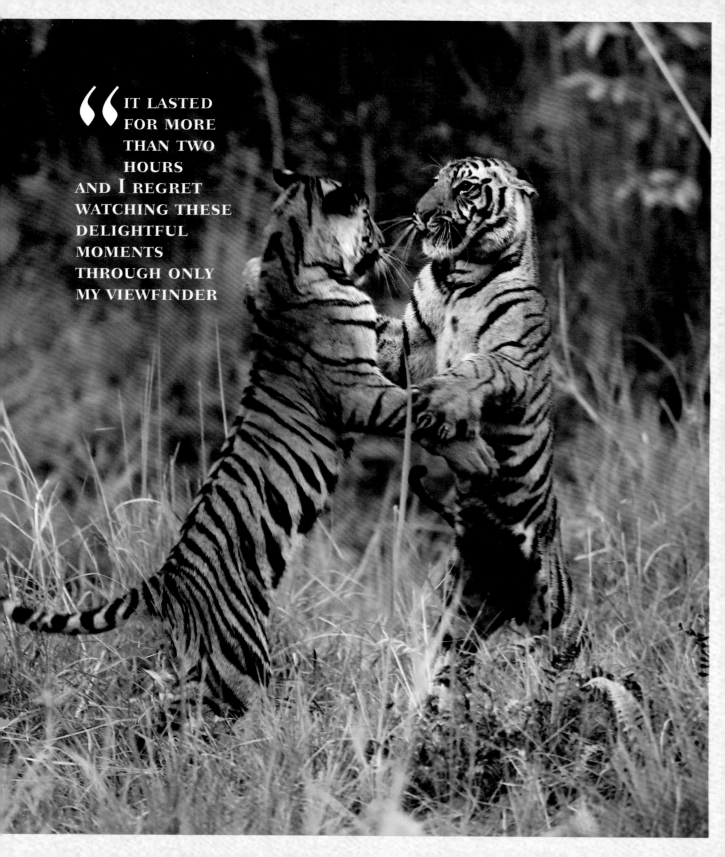

" IT LASTED FOR MORE THAN TWO HOURS AND I REGRET WATCHING THESE DELIGHTFUL MOMENTS THROUGH ONLY MY VIEWFINDER

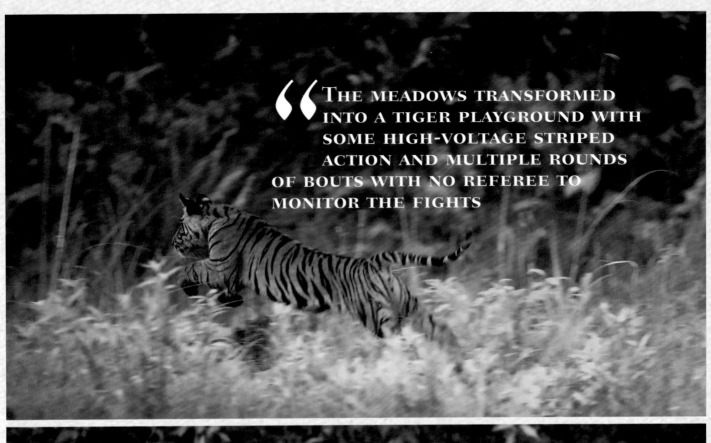

> THE MEADOWS TRANSFORMED INTO A TIGER PLAYGROUND WITH SOME HIGH-VOLTAGE STRIPED ACTION AND MULTIPLE ROUNDS OF BOUTS WITH NO REFEREE TO MONITOR THE FIGHTS

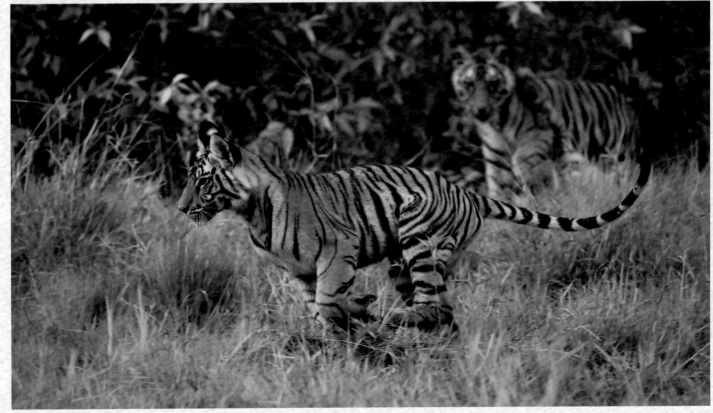

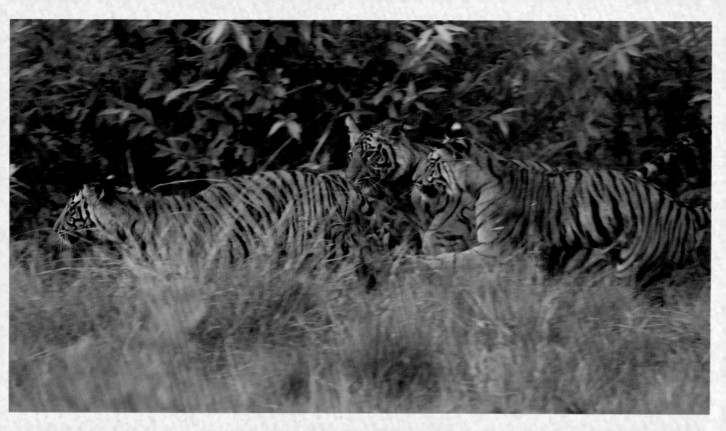
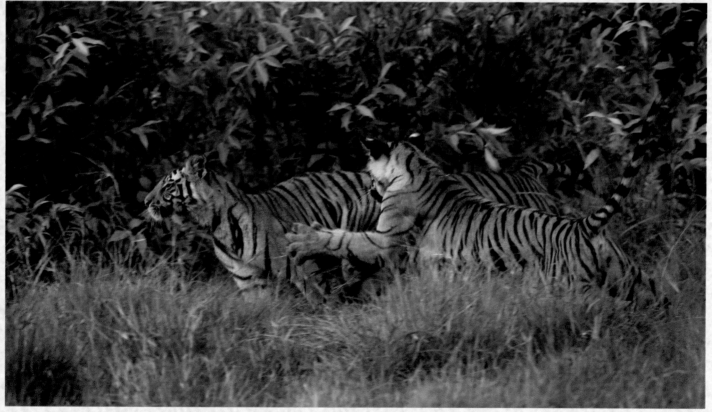

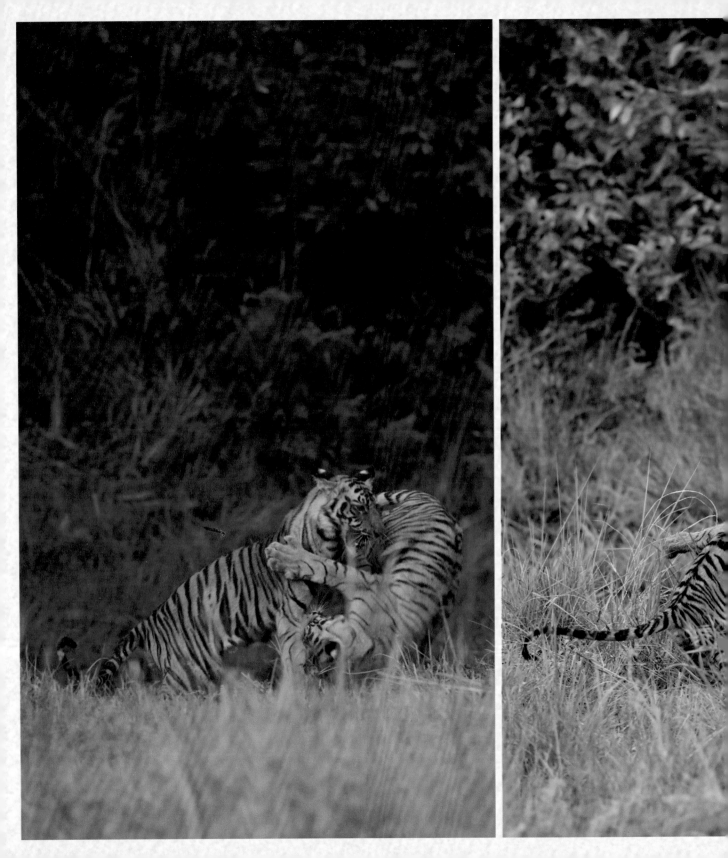

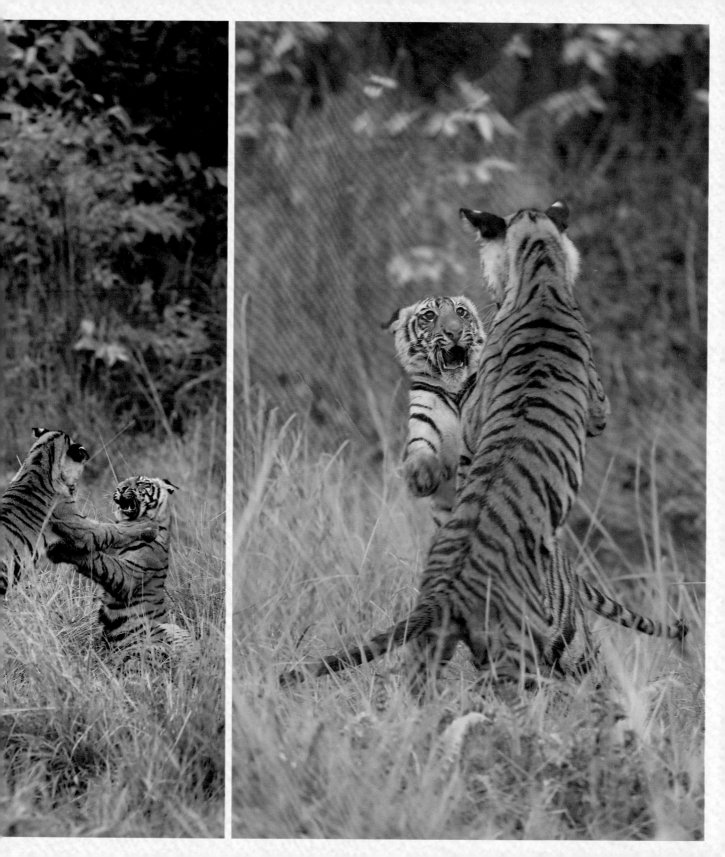

NEIGHBOURING FAMILIES OF BANDHAVGARH

In my pursuit of Vijaya, there were these long periods when she disappeared, and I made use of that time for tracking a few neighbouring families in Bandhavgarh. During the period of 2012–2014, the Banbahi female controlled the high-lying, rocky ridges of Tala and the bamboo forest adjoining the edge of the park along with her litter of three (two males and one female). The father, interestingly enough, was Shashi (Bamera) again and it was interesting to see the male spending time with both families. The two ladies (Vijaya and Banbahi) spent a hard time feeding the growing appetites of their cubs and Shashi frequently demanded his share.

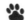

The Banbahi mother emerges in the magical morning light during the spring of 2012

BANBAHI FAMILY

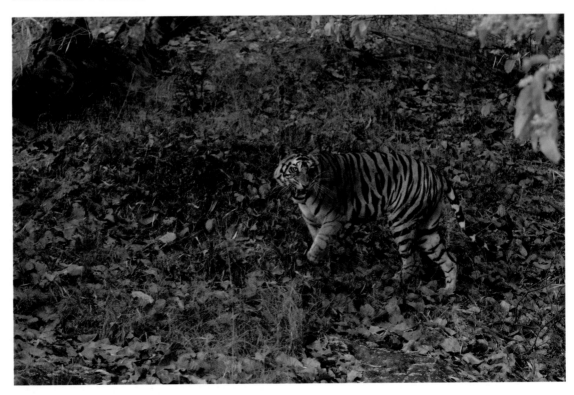

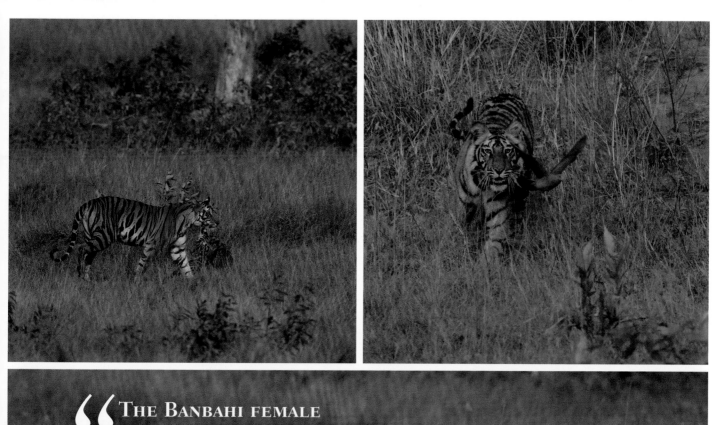

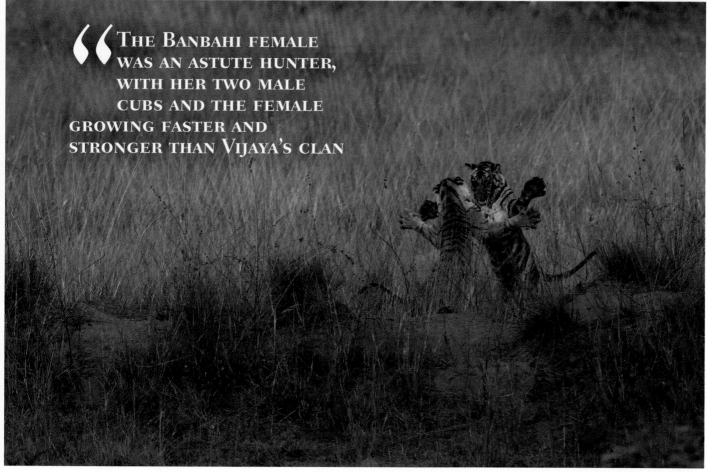

> " THE BANBAHI FEMALE
> WAS AN ASTUTE HUNTER,
> WITH HER TWO MALE
> CUBS AND THE FEMALE
> GROWING FASTER AND
> STRONGER THAN VIJAYA'S CLAN

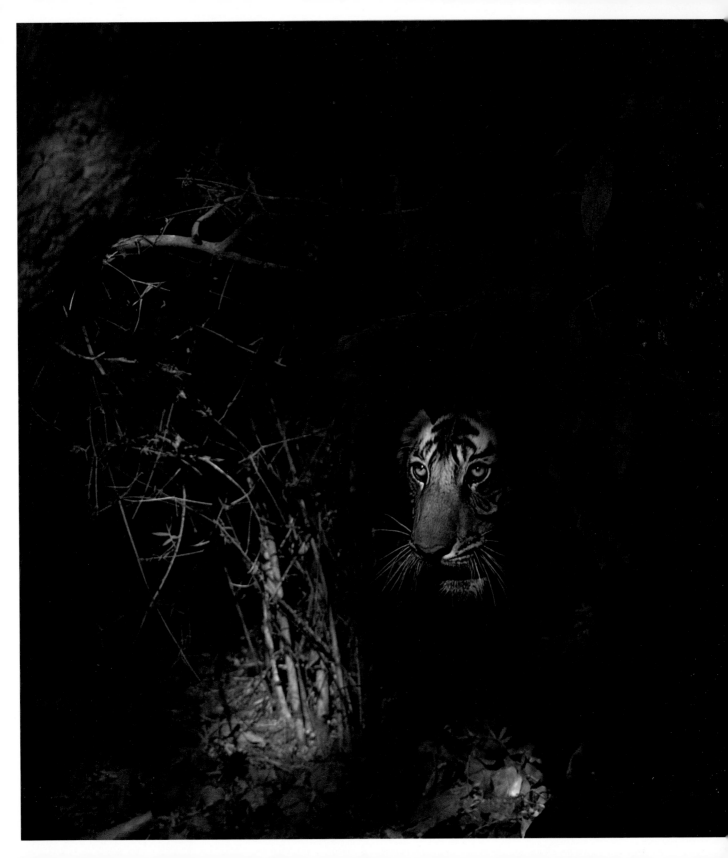

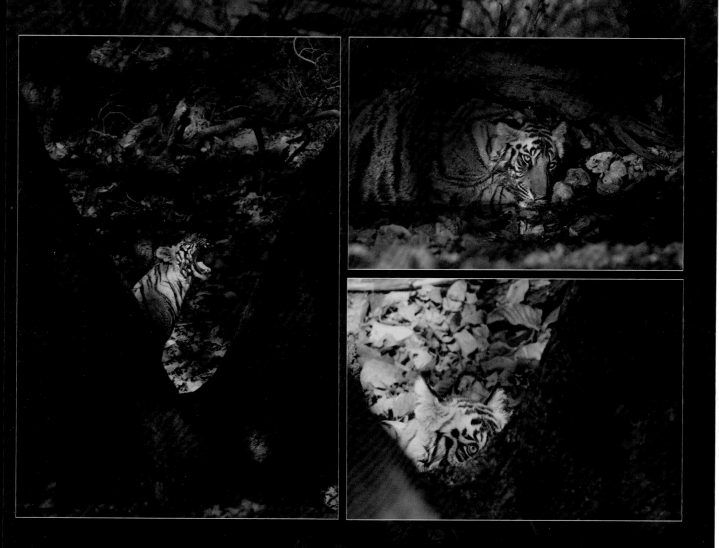

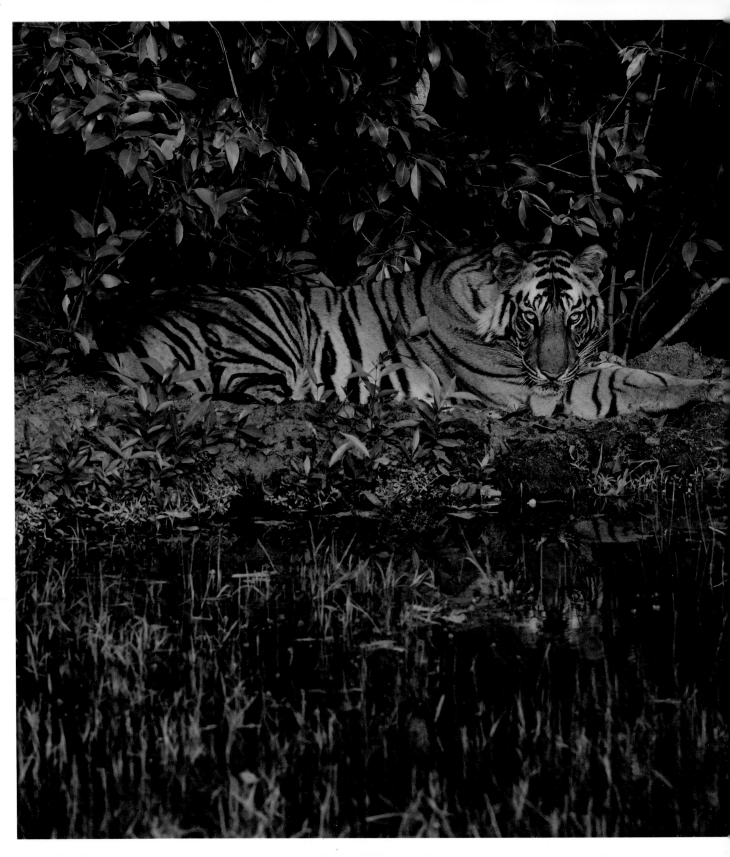

> " **The cubs became independent by the summer of 2013 and shared territory with their mother. I spotted the male cub one morning with a pangolin kill—a singular sight to behold**

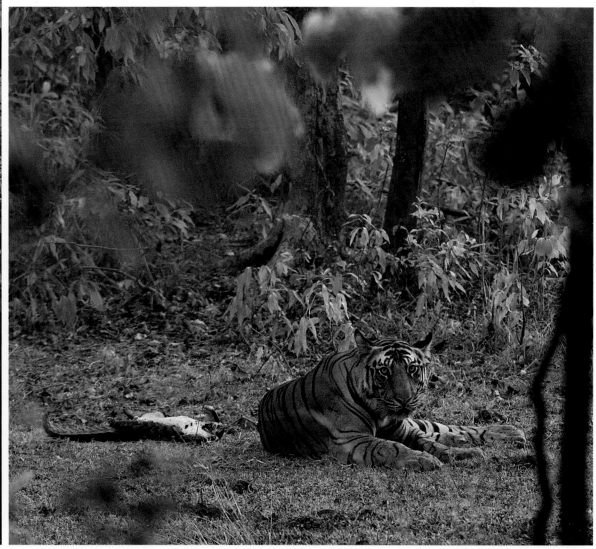

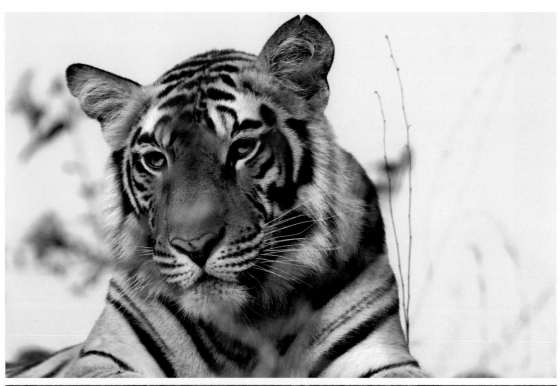
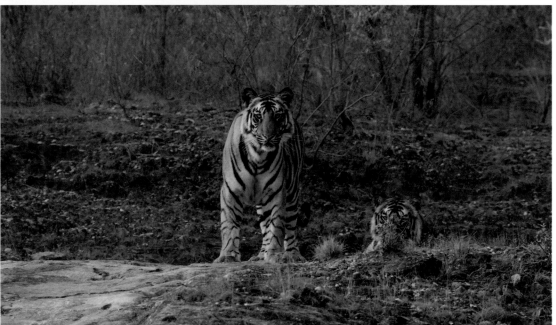

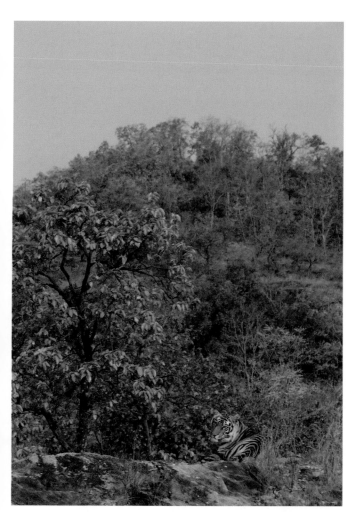

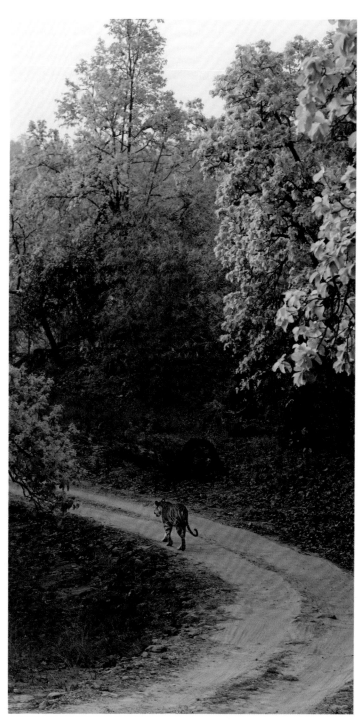

“ THE UPPER REACHES OF
TALA OFFER SOME OF THE
BEST LIGHTING IN INDIA
WHEN THE HILLS ARE
LIT UP BY THE FIRST RAYS OF
MORNING LIGHT. IN MARCH
2013, THE ENTIRE FAMILY WAS
FOUND IN BRILLIANT LIGHTING
AT SUNRISE

Further ahead, in the Rajbehra meadows, the Rajbehra female gave birth to a new litter of four in the warm summer months of May 2012. The family was relatively shy and the thick Rajbehra sal forests made tracking tough. I was lucky to have bumped into this clan on a few occasions while on the lookout for Vijaya.

RAJBEHRA FAMILY

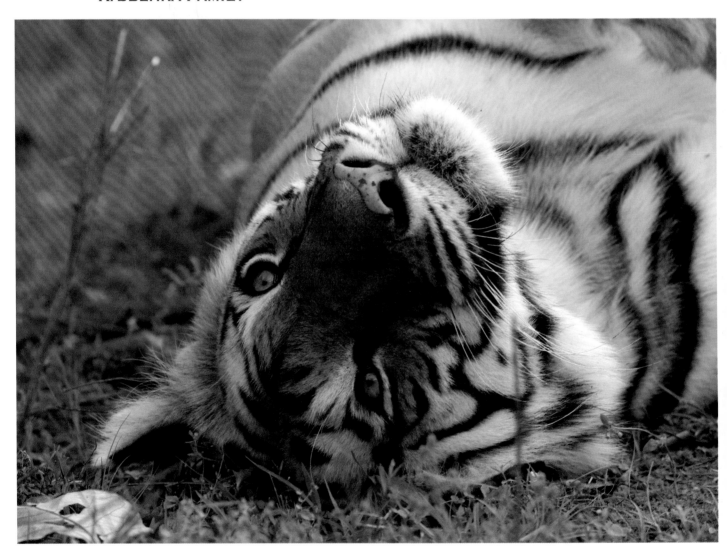

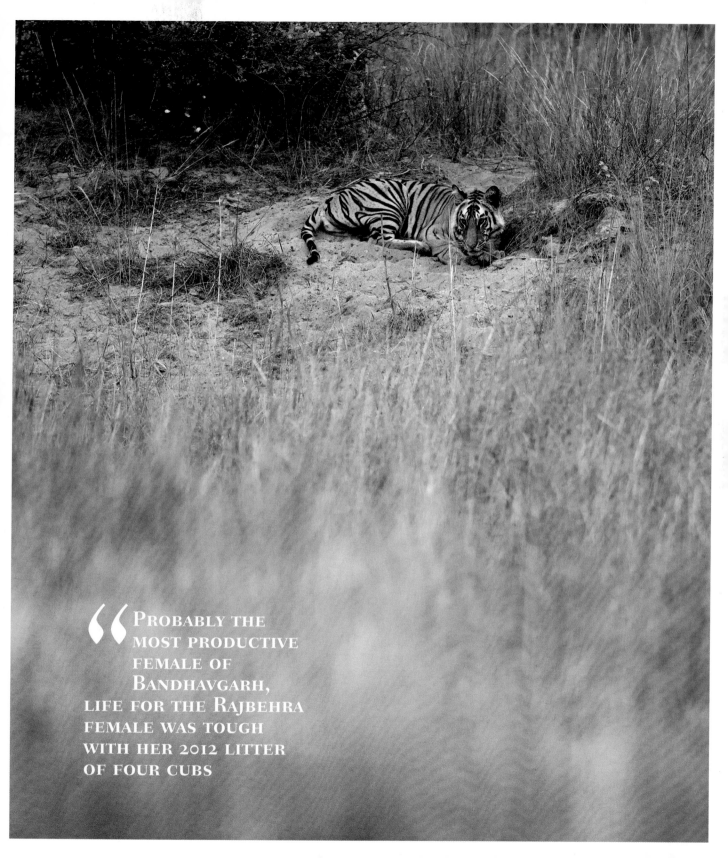

" PROBABLY THE MOST PRODUCTIVE FEMALE OF BANDHAVGARH, LIFE FOR THE RAJBEHRA FEMALE WAS TOUGH WITH HER 2012 LITTER OF FOUR CUBS

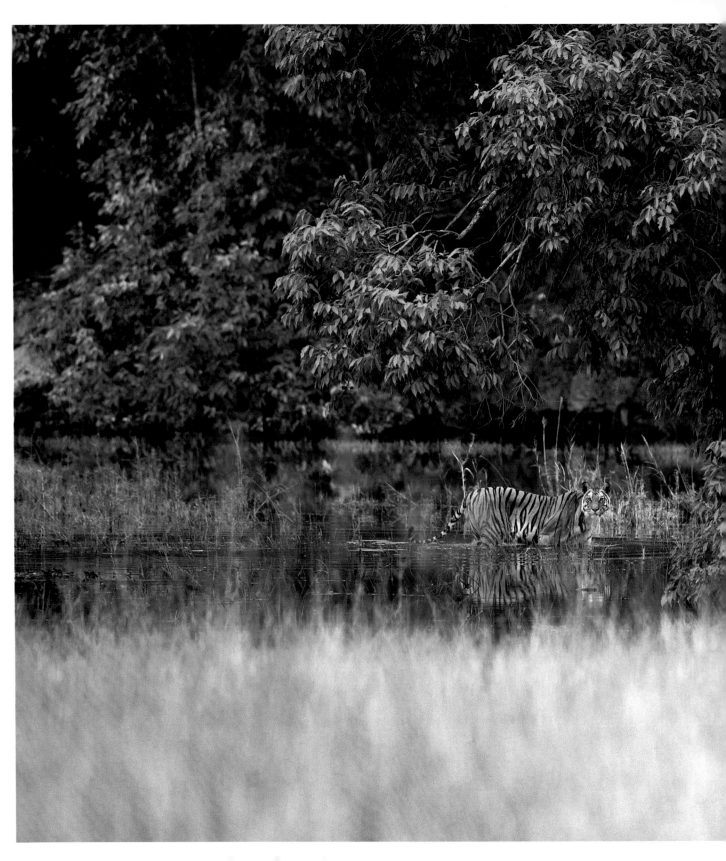

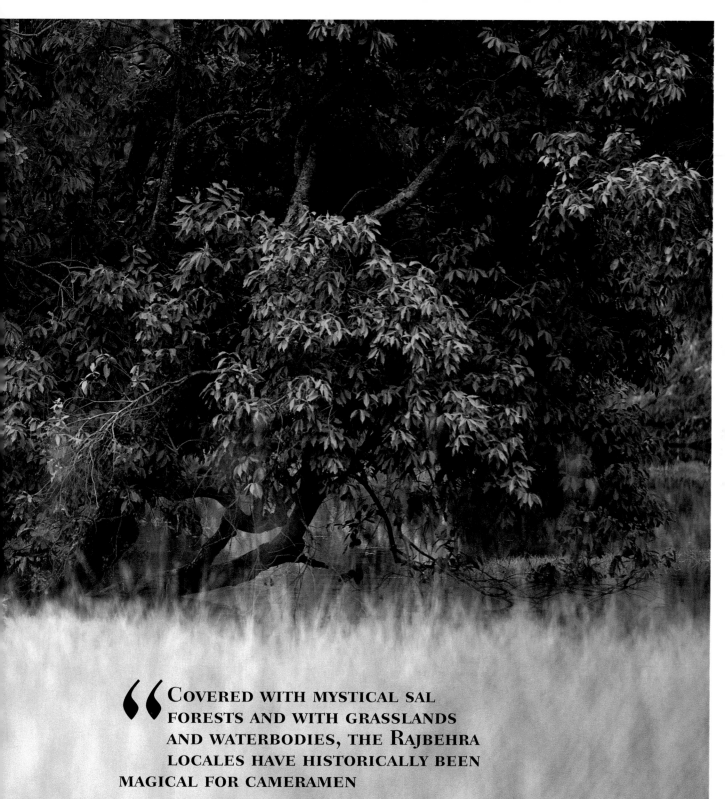

"COVERED WITH MYSTICAL SAL
FORESTS AND WITH GRASSLANDS
AND WATERBODIES, THE RAJBEHRA
LOCALES HAVE HISTORICALLY BEEN
MAGICAL FOR CAMERAMEN

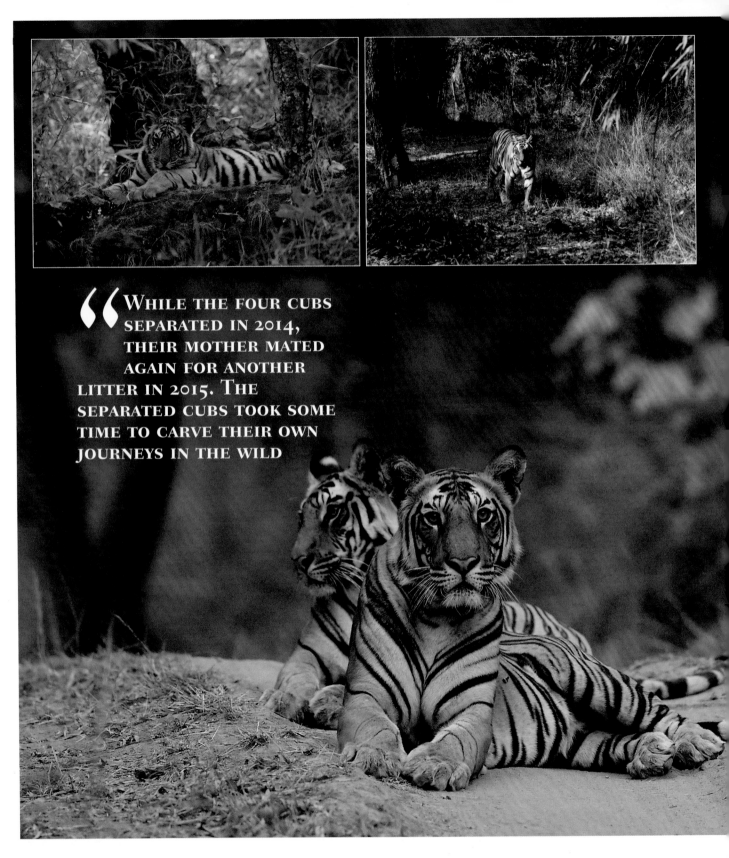

> **WHILE THE FOUR CUBS SEPARATED IN 2014, THEIR MOTHER MATED AGAIN FOR ANOTHER LITTER IN 2015. THE SEPARATED CUBS TOOK SOME TIME TO CARVE THEIR OWN JOURNEYS IN THE WILD**

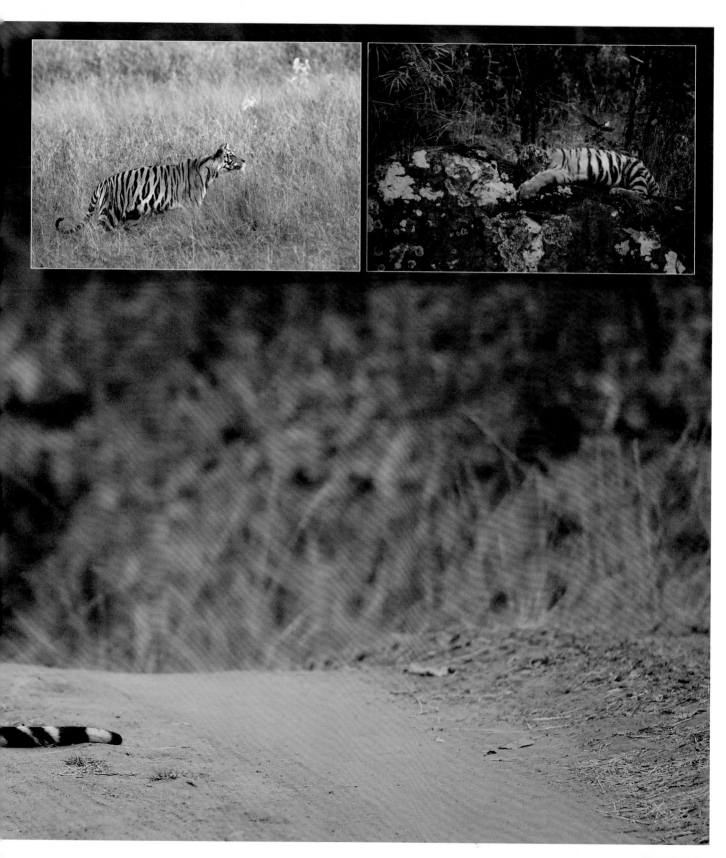

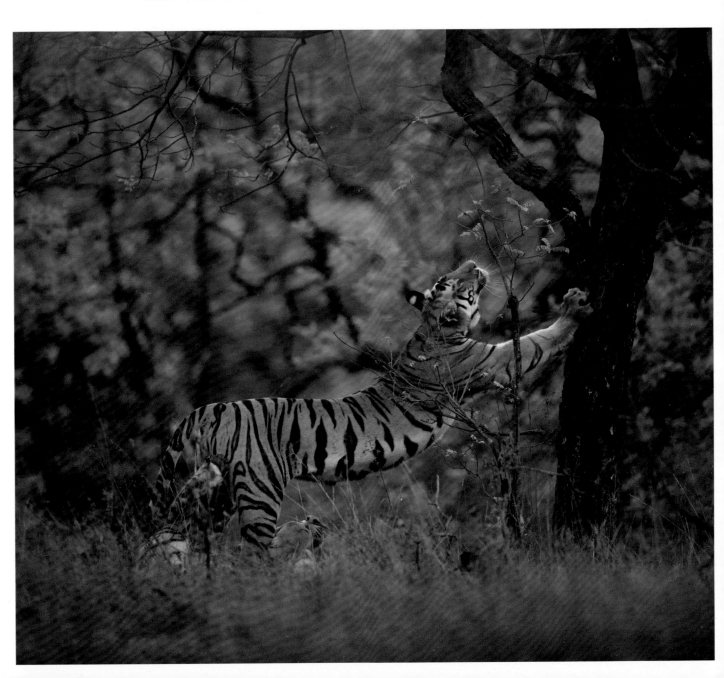

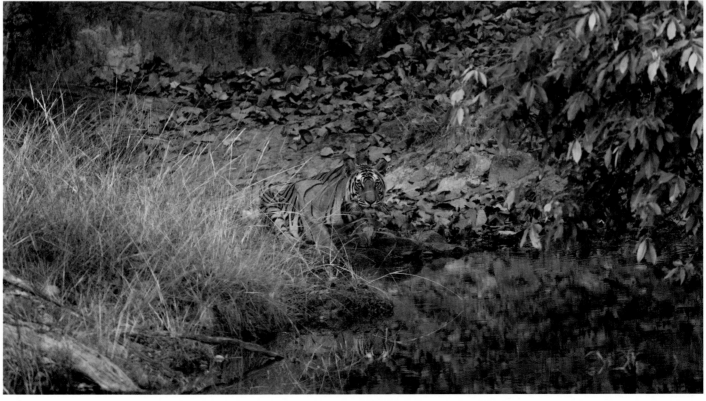

Tiger sightings in the picturesque Tala area of Bandhavgarh witnessed a big slump post the death of Vijaya, and, while there was speculation of it being a dry tiger season in Bandhavgarh, a tigress in the adjoining region came to the limelight with a new litter of three cubs. I got a chance to photograph this family, known as the Patiha clan, in the summer of 2015. During this schedule, I came across some of the most dramatic tiger habitats of Bandhavgarh. The rocks and caves chosen by the Patiha cubs as shelter from the scorching summer heat featured stunning contours, patterns, and formations, which made some of these images very special in my journey with tigers.

The Patiha female crosses a forest track with one of her cubs during the summer of 2015

FACING PAGE
When the mother goes out on a hunting expedition, the cub waits patiently for a meal

PATIHA FAMILY

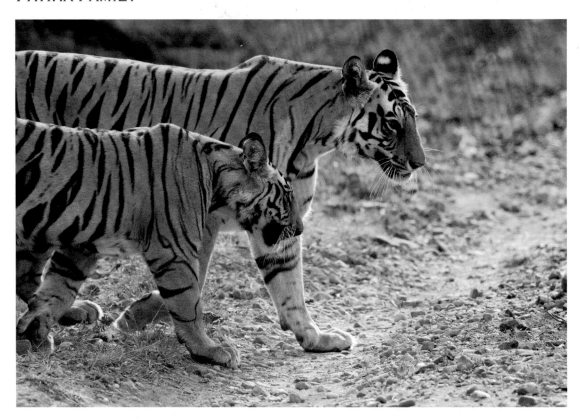

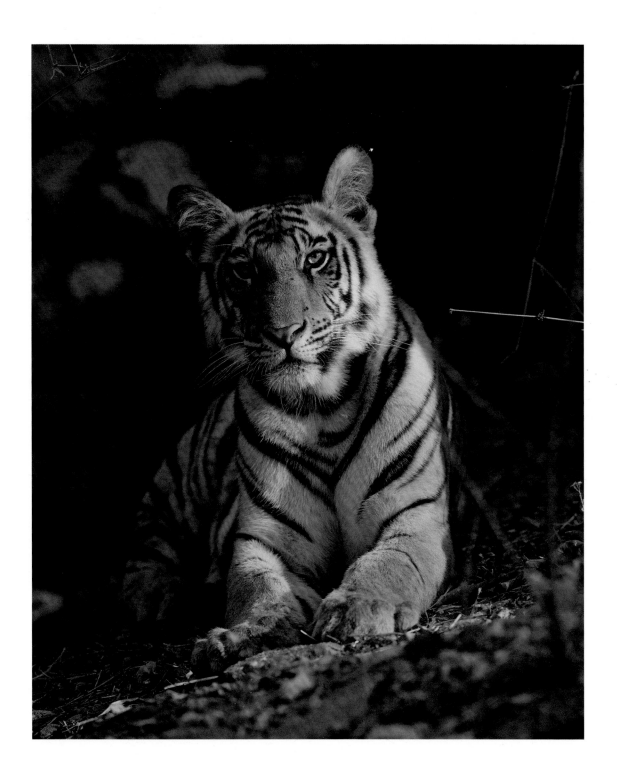

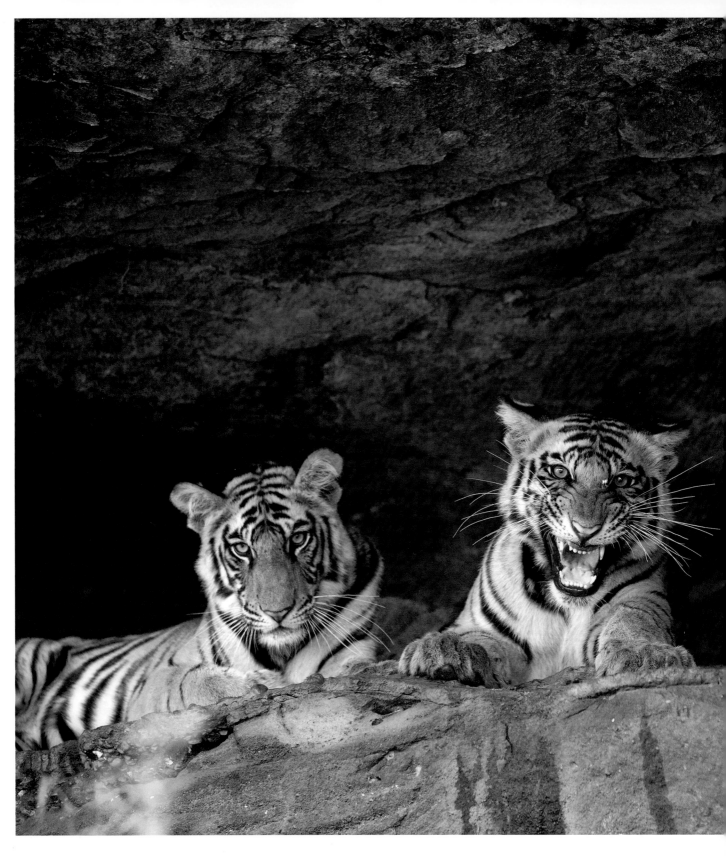

> " THE CAVES CHOSEN
> BY THE PATIHA
> FAMILY TO BEAT THE
> 2015 SUMMER HEAT
> FEATURED STUNNING ROCK
> CONTOURS AND THESE
> NATURAL THRONES MADE
> THEM LOOK REGAL

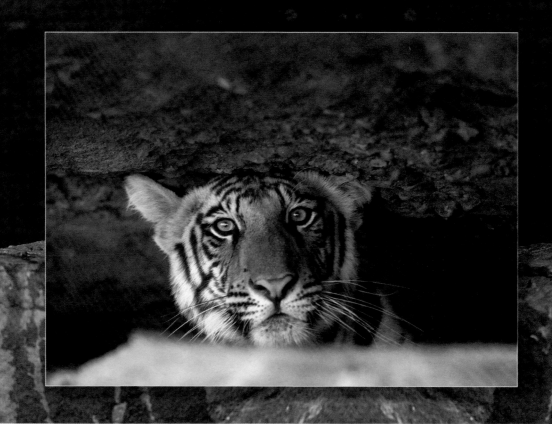

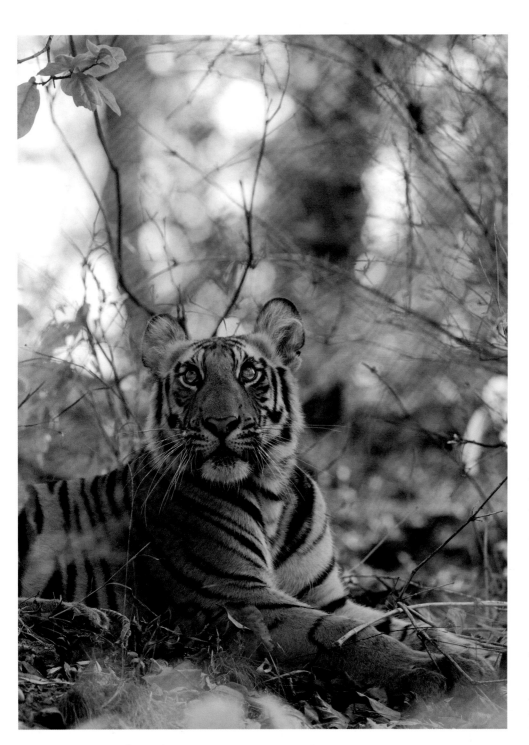

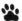

A curious Patiha cub
observes a langur atop
a nearby tree while the
mother is out on a hunt

FACING PAGE
*The Patiha mother in
her favourite waterbody
before her pregnancy
in 2014, observing
a peacock trying to
impress his mate. Most
of her summer was
spent in these waters
even after she became
a mother*

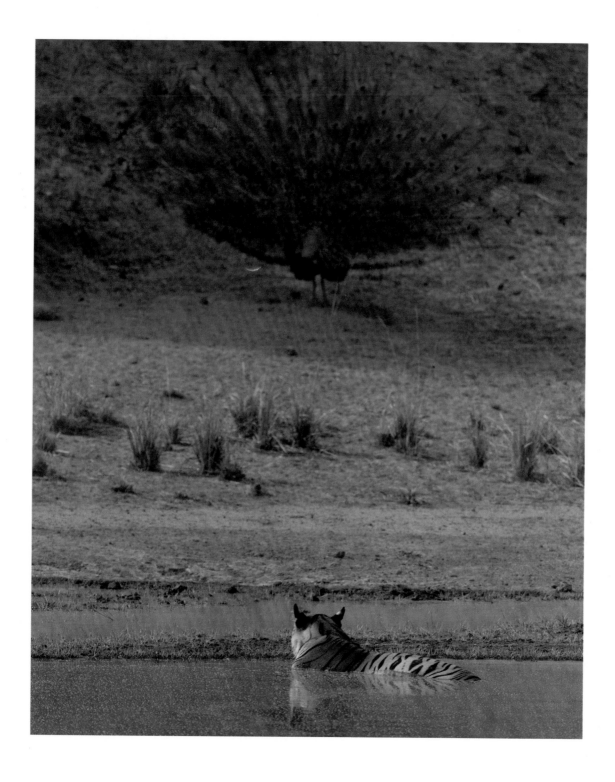

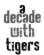

The park reopened post the monsoon of 2015 and, by winter, Tala was showing signs of recovery—the Rajbehra female was ready with a fresh litter of four cubs. One separated cub from Patiha's first litter tried to gain entry into the sal canopies around Rajbehra and her boldness became the talk of the town. Known locally as Spotty (because of an 'S' mark on her face), she steadily moved up the popularity charts. I saw her mating right after monsoon, in October 2015. With the arrival of the summer of 2016, Spotty became a bit shy and avoided vehicles as childbirth was just round the corner. It was in the last week of May that she emerged with three young cubs; I immediately rushed to Bandhavgarh and was fortunate enough to document this new family just before the monsoon of 2016.

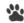

Spotty rests in a natural spring during the summer of 2016. The first-time mother deceived me on multiple occasions by drawing me away from the cubs

FACING PAGE
Spotty eventually disregarded my presence one morning and moved her cubs, giving me my first glimpse of the newborns

SPOTTY AND CUBS

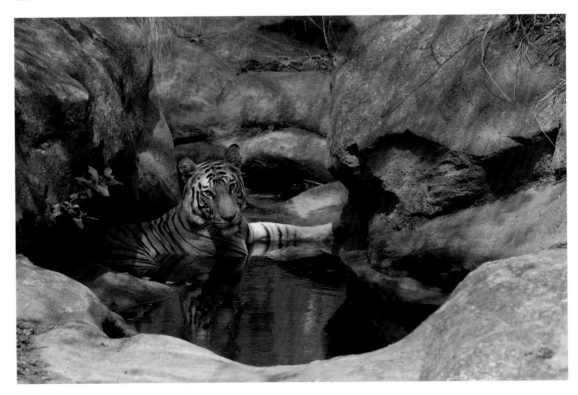

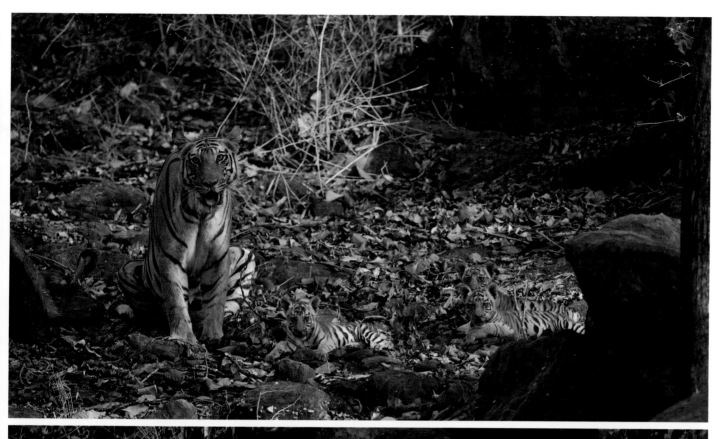

“SPOTTY'S CUBS MANIFEST SIGNS OF THEIR MOTHER'S BOLDNESS AND INTERESTING TIMES LIE AHEAD FOR BANDHAVGARH

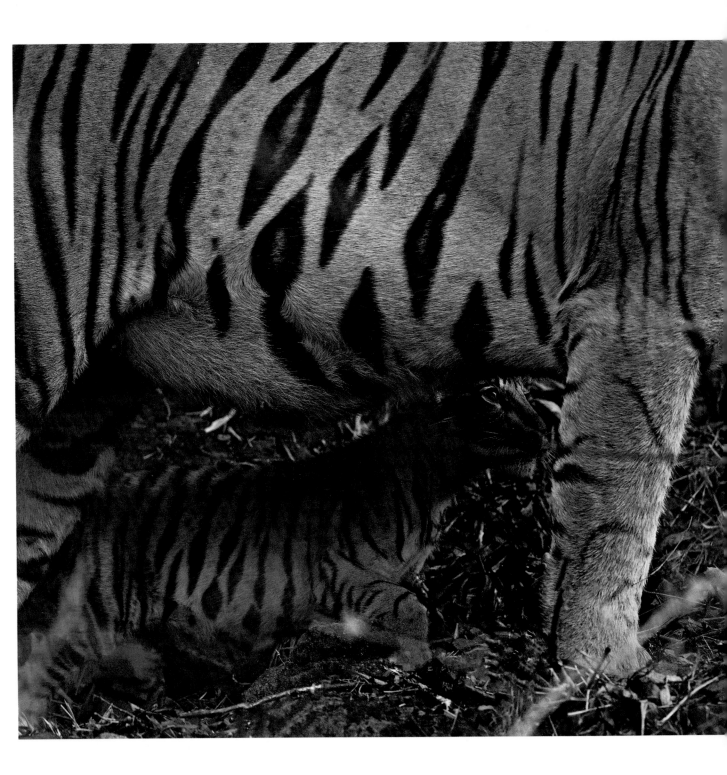

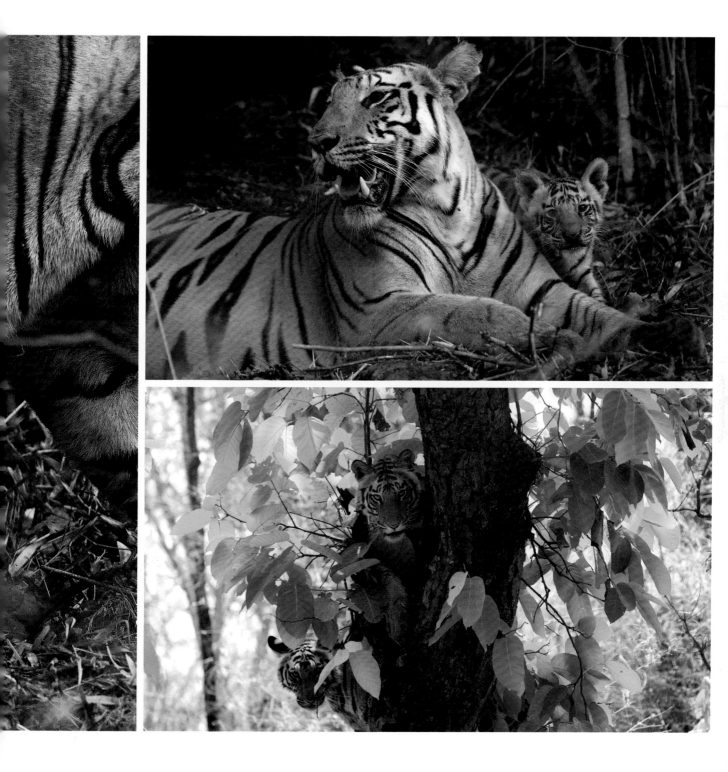

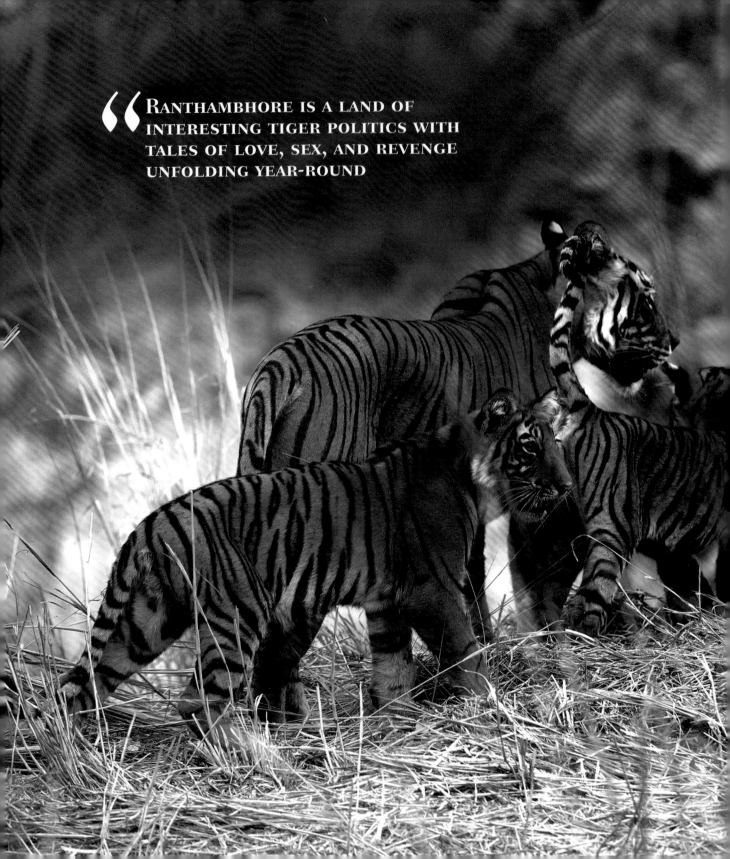

" RANTHAMBHORE IS A LAND OF
INTERESTING TIGER POLITICS WITH
TALES OF LOVE, SEX, AND REVENGE
UNFOLDING YEAR-ROUND

RANTHAMBHORE

Royal Mothers of Ranthambhore

I was a late entrant in Ranthambhore and missed the prime of the legendary Machali and her antics around the lakes. However, over the years, it has been a privilege and a unique experience to witness the contrasting behaviours and follow the maternal lives of the various Ranthambhore mothers. I picked up the threads of Ranthambhore from the last litter of Machali—Sundari and Krishna. While these two females stepped predominantly into their mother's shoes to rule the lakes, the charismatic Noor from the adjoining area was a devoted mother to some bold and boisterous cubs.

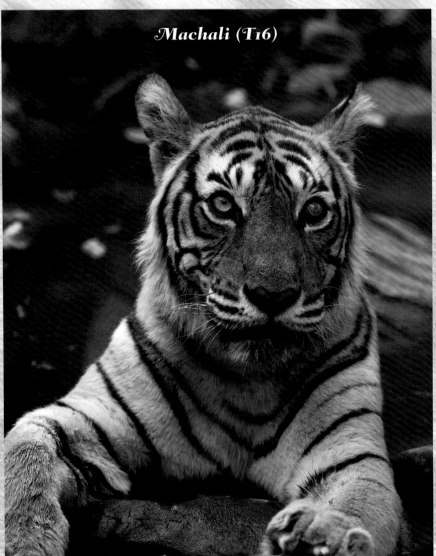

Machali (T16)

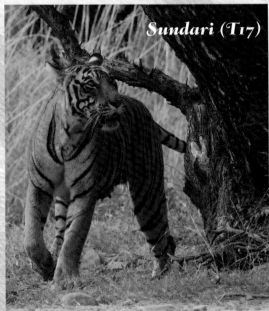

Sundari (T17)

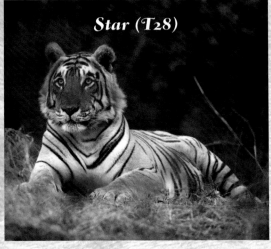

Star (T28)

Ranthambhore has a long history and a rich legacy of tigers, who have ruled various parts of this royal forest over the years. The kingdom remains the same but the characters keep changing. The last decade saw the decline of the grand old mother Machali (T16) (the oldest surviving tiger in the wild), who died at the age of 19 in August 2016. She vacated the throne to give way to her daughters Sundari (T17) and Krishna (T19), who, along with Star (T28), a dynamic male, wrote new chapters in the books of Ranthambhore. In the neighbouring forests, Noor (T39)(a charismatic young tigress) took the baton from her mother to rise up the popularity charts along with her flamboyant son Sultan, who grew up to be as handsome as his father Ustad (T24). Her second and third litters made her a busy mother over the years; her name is now etched in the history books of Ranthambhore as a successful mother who has seen her own set of ups and down in this ever-changing world of tigers.

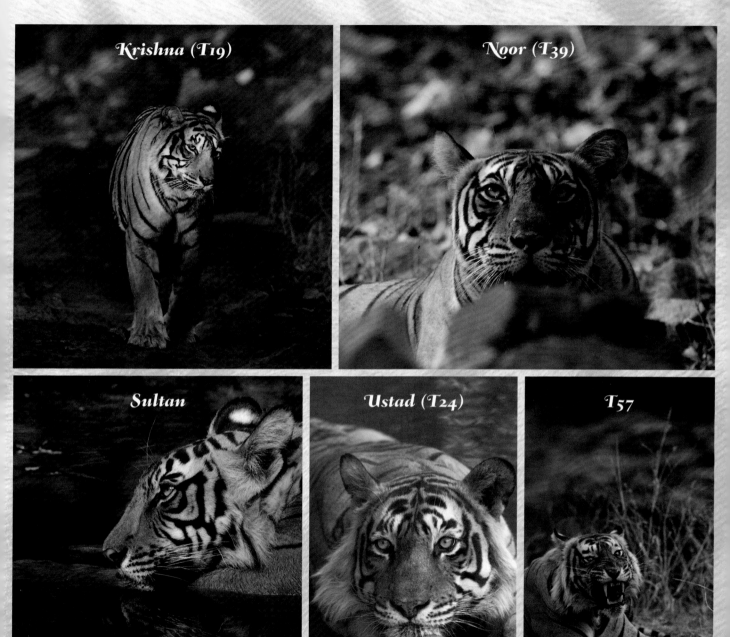

Krishna (T19)

Noor (T39)

Sultan

Ustad (T24)

T57

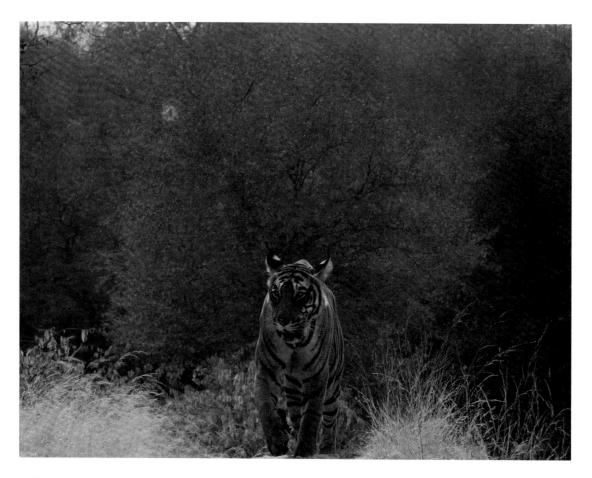

Lakes, ruins, and the presence of tigers in such unique backdrops is what makes Ranthambhore special. Sundari inherited this estate from her mother; the stage was set and all eyes were on her to see whether she could live up to the legacy of her mother, the legendary Machali. The newly crowned queen of Ranthambhore mated with every dominant male of the park but none of the attempts bore fruit. The reasons were unknown. There was a belief that the radio collar put on her by the forest department may be the reason behind the series of failed mating attempts. However, theoretically, tigresses in the other national parks of India were similarly collared and were successfully breeding.

Sundari (T17) patrols her newly acquired royal estate

FACING PAGE
Sundari with a sambar kill one early winter morning in December 2013

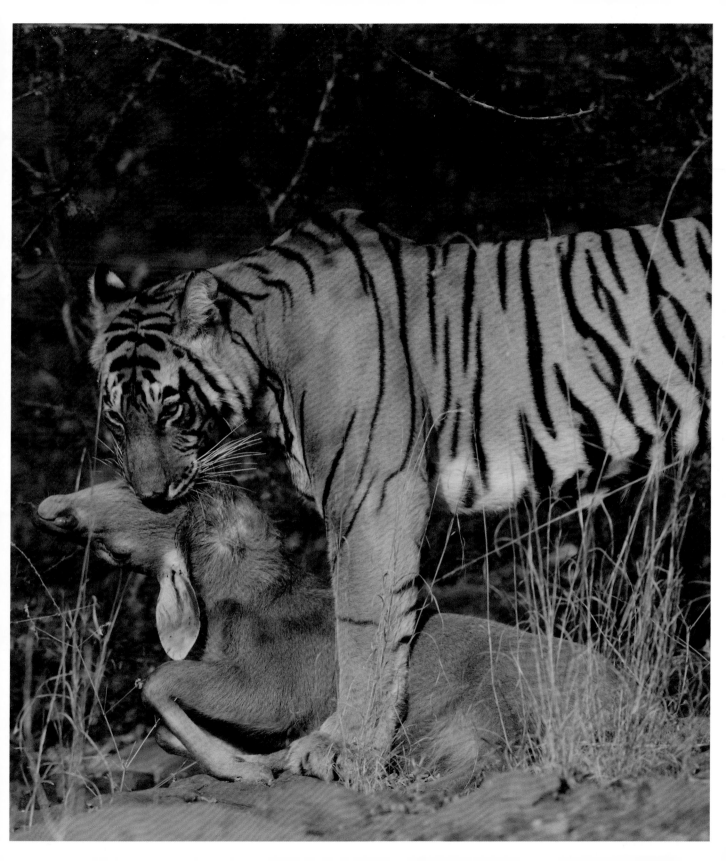

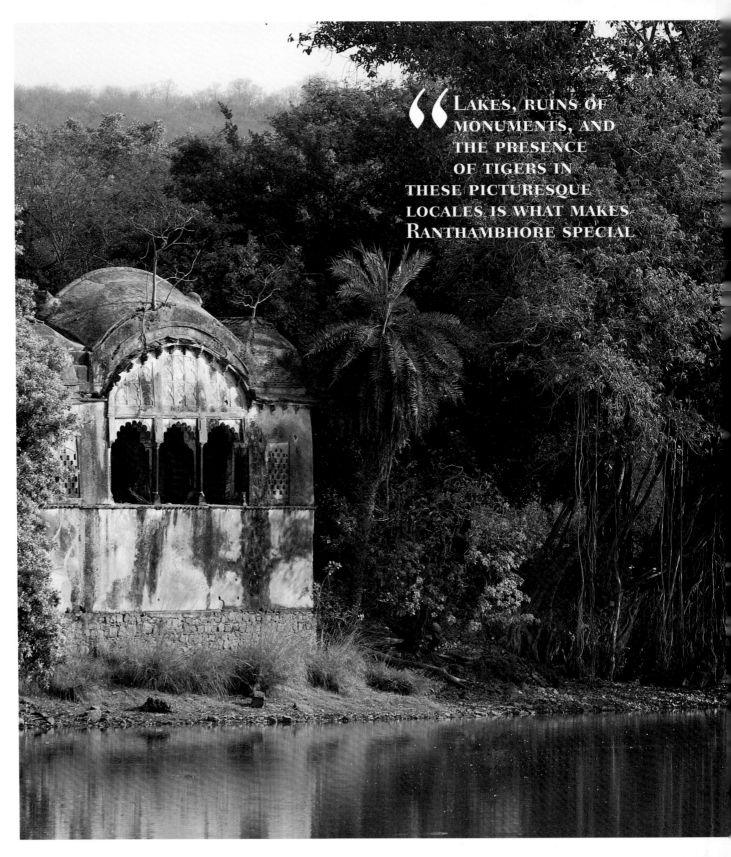

"LAKES, RUINS OF MONUMENTS, AND THE PRESENCE OF TIGERS IN THESE PICTURESQUE LOCALES IS WHAT MAKES RANTHAMBHORE SPECIAL

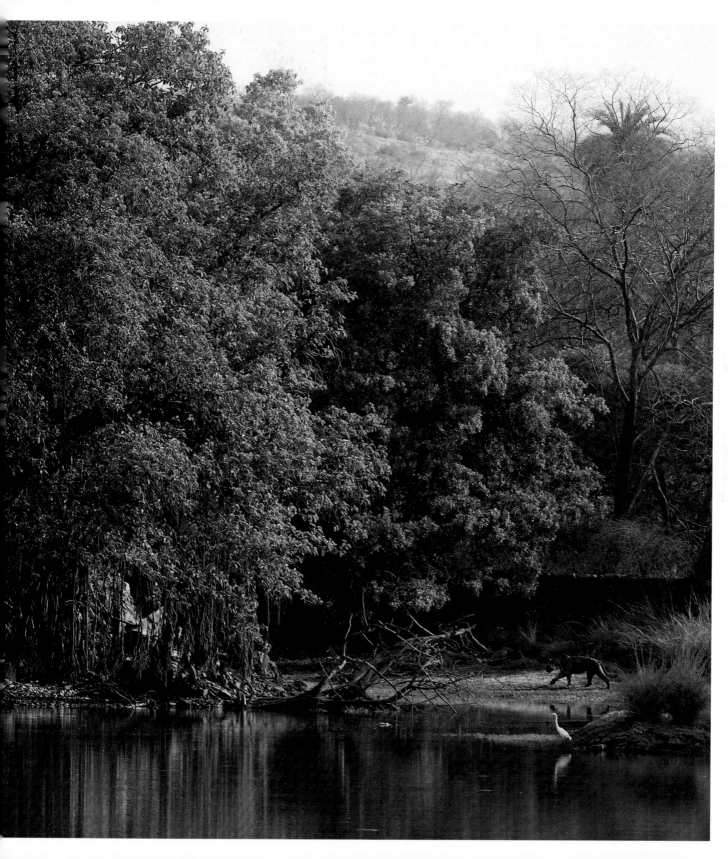

One fine winter morning in 2012, after the radio collar was removed, I captured Sundari as she emerged from the rocky thickets on the fort road in Ranthambhore. As she went around marking her territory and calling for a mate, I saw her climb inside a small mosque. She stopped and licked the shrine before exiting the premises, and proceeded to hop inside a small temple opposite to the mosque. 'Is she seeking some divine blessings to conceive?' my naturalist quipped on a lighter note.

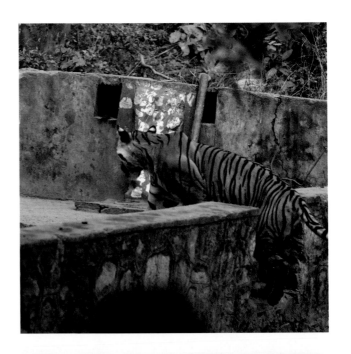

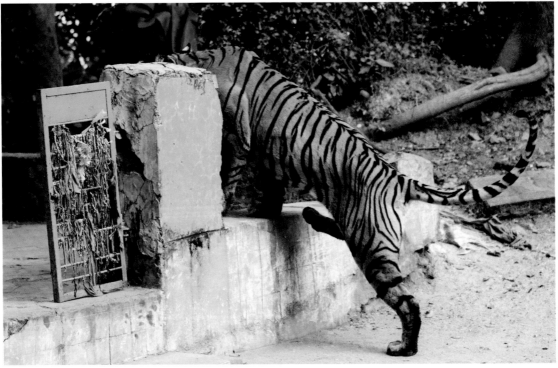

That same winter, in early 2013, Sundari mated again and gave birth to three cubs in the summer, right before the park closed for the monsoon. Expectations rose as the world wondered if Ranthambhore's lakes would be alive with action again after a long gap. Anticipation reigned supreme through the monsoons, reaching a fervent pitch as the parks opened again. Sundari took us by surprise by vacating the lake area to find a new home in the fringe area of the park, bordering some villages. The reason for this sudden change in behaviour was unknown, but tracking the young cubs was becoming increasingly difficult as the bold queen of Ranthambhore suddenly became shy and elusive. Summers were seemingly critical for the future of this new litter and there was speculation that shrinking water sources may bring Sundari back to her home ground. Her frequent disappearances in areas inhabited by humans was also a cause of much concern for the forest department.

A collared Sundari (T17) rests in Rajbagh lake during the summer of 2011

FACING PAGE
Sundari (T17) enters a roadside mosque and then a temple in December 2012, post which she mated with almost all the leading males of Ranthambhore

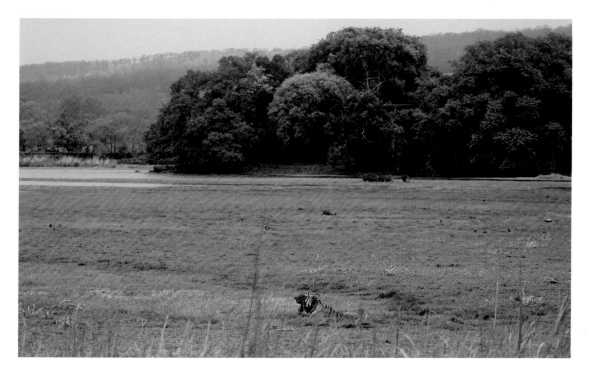

Tragedy struck Ranthambhore when, in the summer of 2013, Sundari went missing, leaving behind three nine-month-old cubs. Extensive search operations were conducted but in vain, signalising the end of one of the most popular tigers of India. While the forest department raised the orphaned cubs in the wild, a lot of speculation went into the mystery behind the disappearance of Sundari—territorial pressure from her sister Krishna, her inability to dodge intruding males in order to protect the cubs, injuries suffered in fights with males. The world of tigers is truly an enigma and a lot of questions remain unanswered in this case.

Sundari out on a hunting expedition post giving birth to her first litter in October 2012

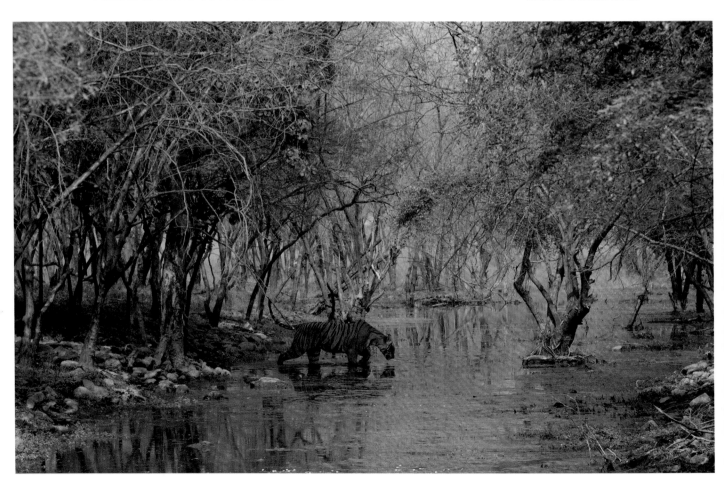

With the tiger real estate around the lakes up for grabs, sister Krishna lost no time in assuming command and started frequenting the area. A master hunter, Krishna had already raised a litter of three cubs in one of the adjoining territories, and, with her recent experience of motherhood, was set to be crowned the new queen of Ranthambhore. Seeing her regally peeping through the windows of the Rajbagh palace during the summer of 2013 brought back memories of her mother Machali for a lot of Ranthambhore old-timers. An experienced mother, Krishna needed a mate in order to stamp her authority on the lakes. The

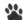

Krishna (T19) returned from her exile to be crowned the new queen of Ranthambhore. She is seen here resting royally on the palace window during the summer of 2013

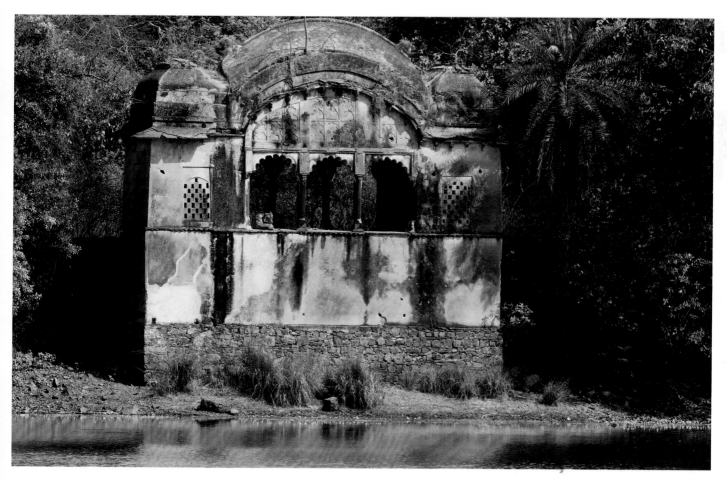

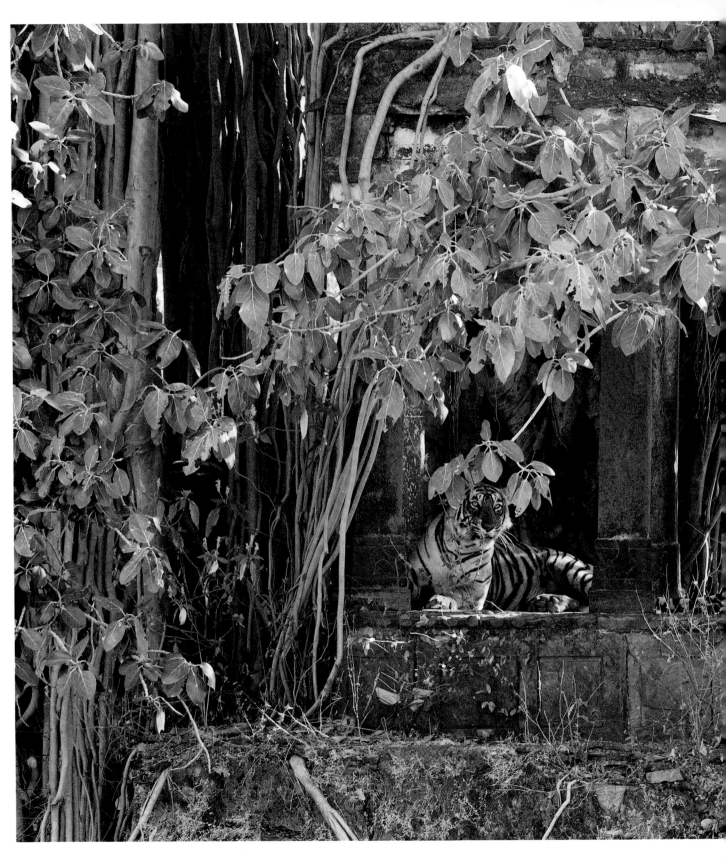

Krishna (T19) takes refuge from the intense summer heat in one of the old, ruined structures located around the lakes. Known locally as 'chatari', these structures are centuries old

choice was between Zalim (T25) and Star (T28). Both were impressive and could provide protection to her cubs as also feed her ambitions. She inched closer to Zalim during the summer of 2013 but seemed distant during her romance. Perhaps her heart was set on Star (T28), who had fathered her first litter during her time in exile. In a surprising turn of jungle romance, Krishna left Zalim in the middle of mating in April 2013 and rushed to the lakes to meet Star. They were caught royally romancing at the Rajbagh palace. The couple stayed together just before the close of the park for monsoon.

The start of 2014 was special for Ranthambhore as Krishna was seen for the first time with her battalion of four new cubs. Tough times lay ahead for her as the protection of four young cubs from the flurry of dangers lurking around—intruding tigers, leopards, and crocodiles—was no easy task.

A perplexed Zalim (T25) looking at his uninterested mate Krishna (T19) during their romance in April 2013

FACING PAGE
Star (T28) seen resting through a window of the Rajbagh palace. He romanced with Krishna at this royal location during the summer of 2013

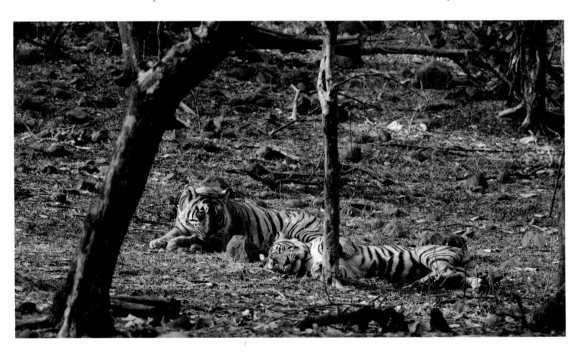

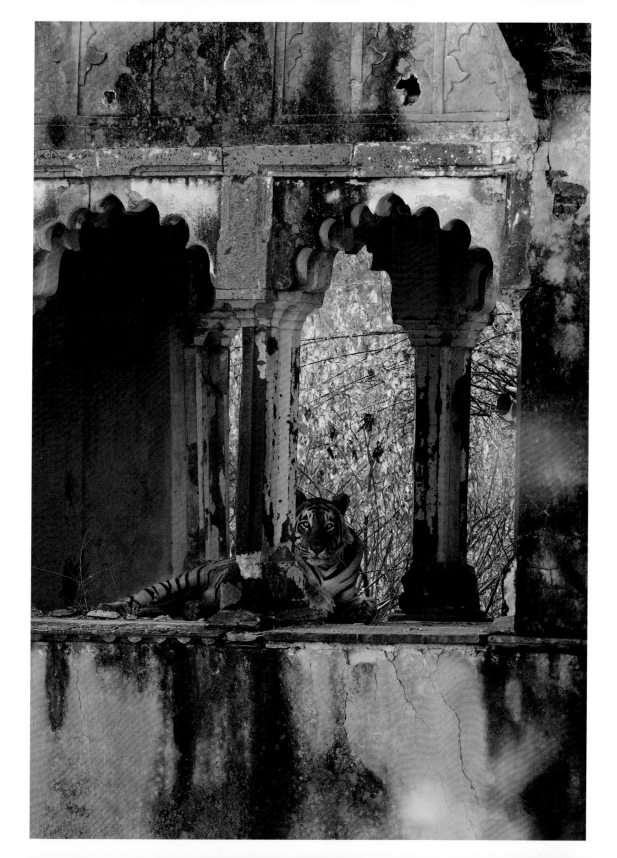

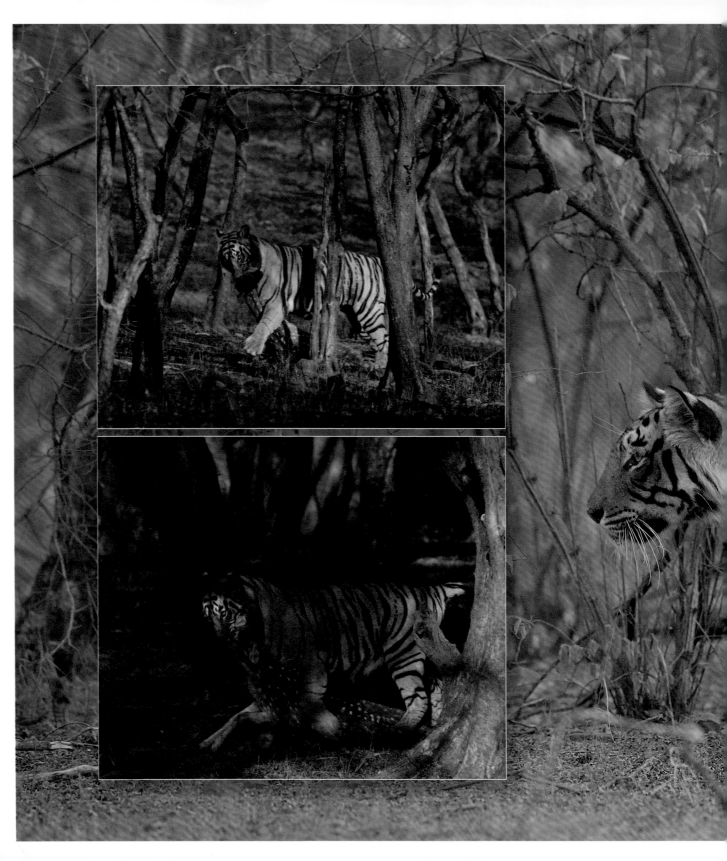

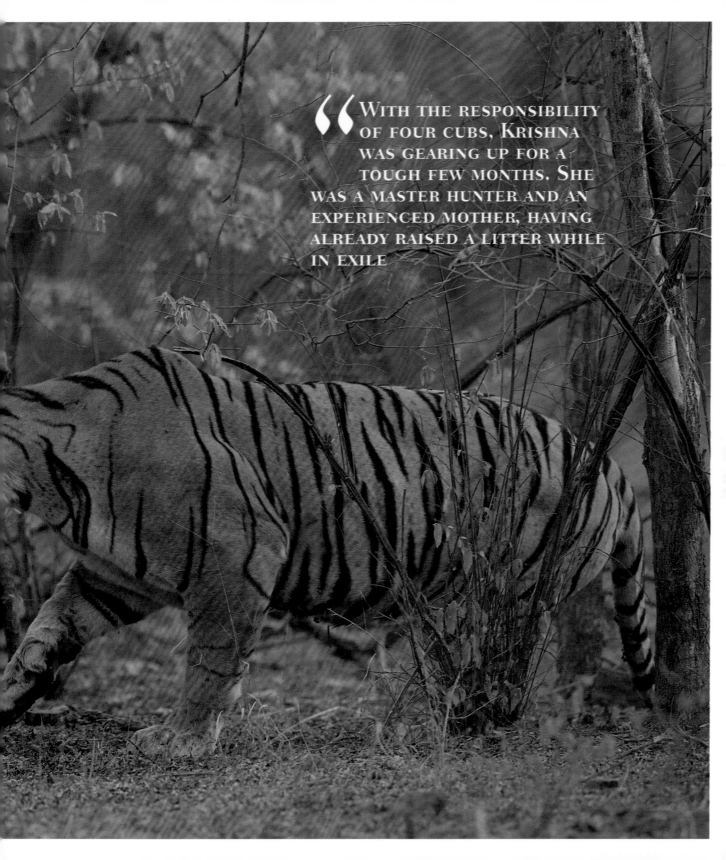

> With the responsibility of four cubs, Krishna was gearing up for a tough few months. She was a master hunter and an experienced mother, having already raised a litter while in exile

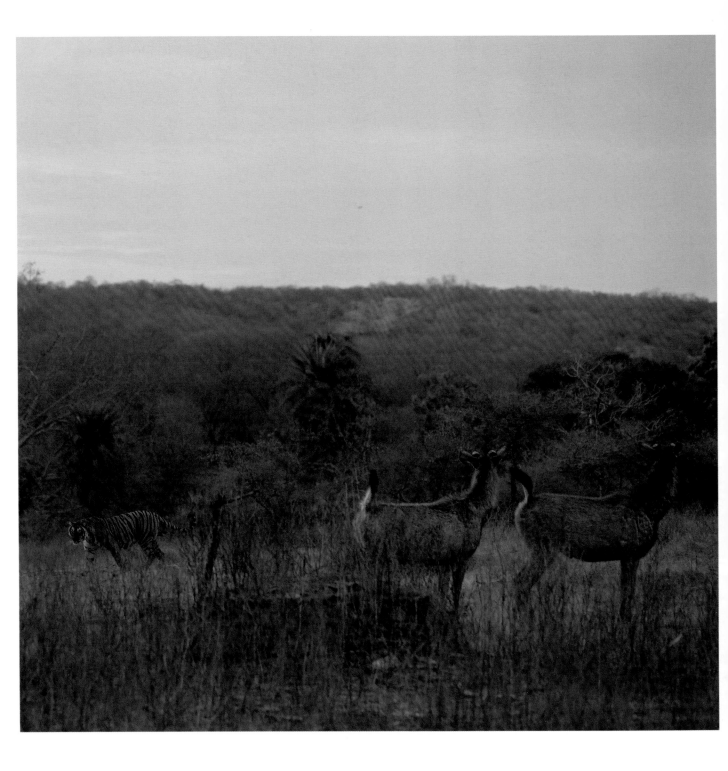

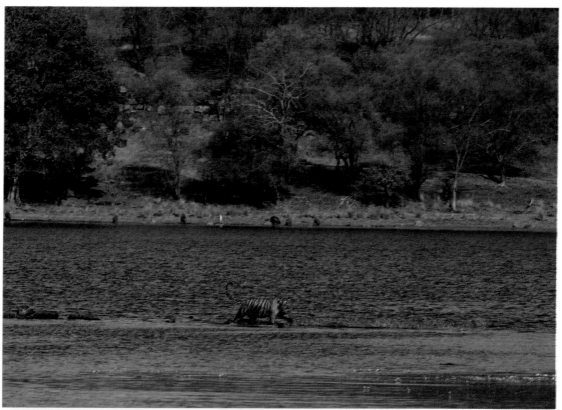

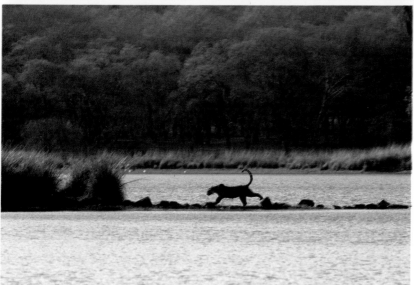

Her majestic presence around the lakes made Krishna a star attraction of Ranthambhore

FACING PAGE
Ruling the lakes meant an abundance of prey. Krishna walks past alert sambar deer during the summer of 2013

Barely a month after her cubs were seen for the first time, Krishna's fourth cub went missing. It was assumed that the young cub went down to a crocodile as the family was once seen crossing the Rajbagh lake. Krishna was an astute hunter and possessed the capability to bring down large prey. Unlike her sister Sundari, her success rate when it came to large prey like sambar, spotted deer stags, and wild boars was much better. Her experience as a mother was an added advantage. Krishna had all the makings of a great tiger mother, capable of providing the required protection, nourishment, and training to the young cubs.

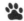

Krishna cautiously observes her young, two-month-old cub during the summer of 2014

FACING PAGE
The tiny battalion of Krishna's was set to script a new chapter in the history books of Ranthambhore

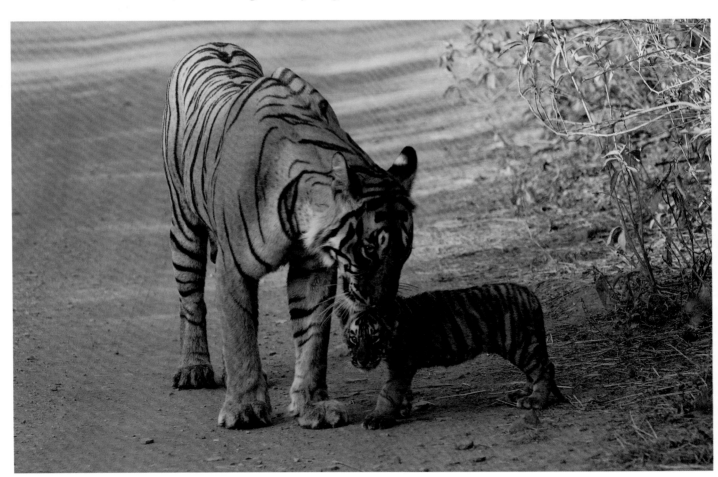

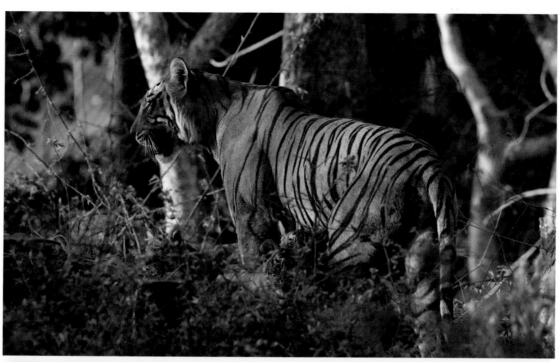

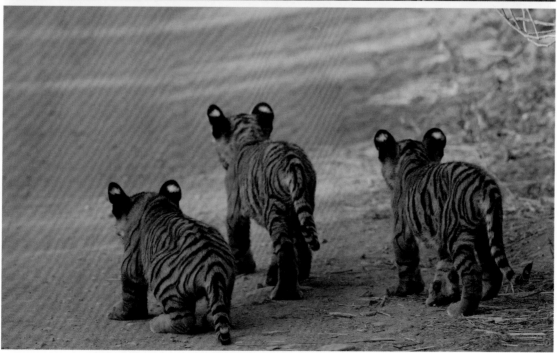

"THE LAKES BECAME THEIR
PLAYGROUND AND THE ROYAL
PRINCESSES AND PRINCE
WERE BOLD AND NAUGHTY
RIGHT FROM CHILDHOOD

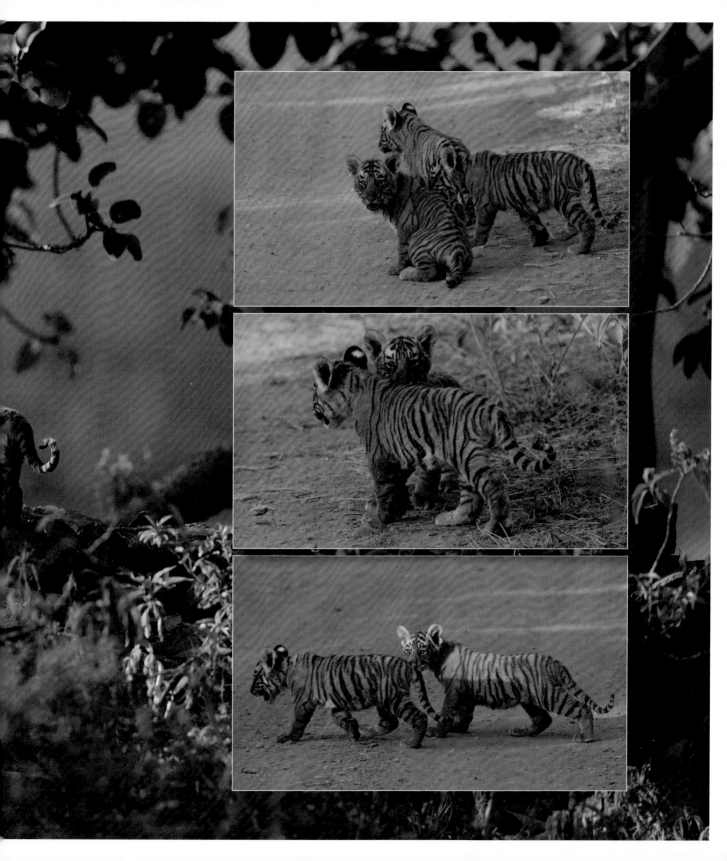

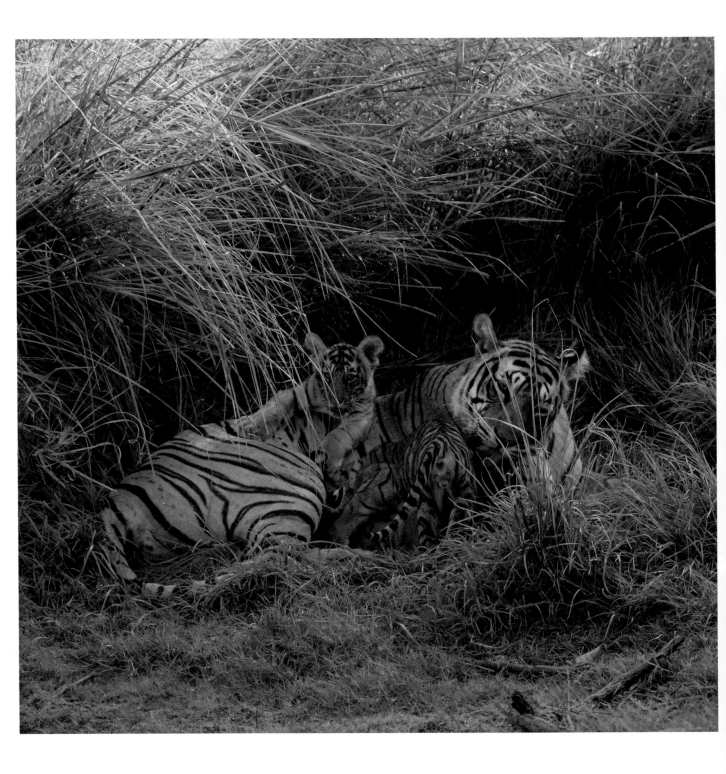

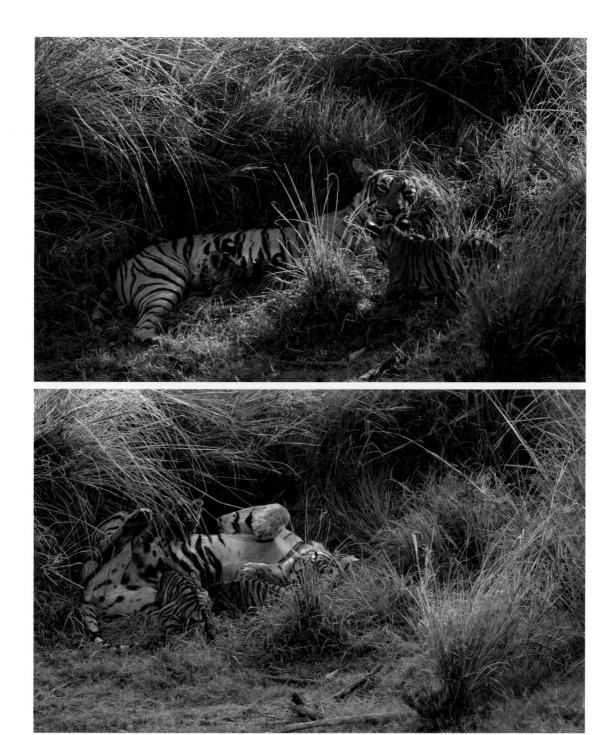

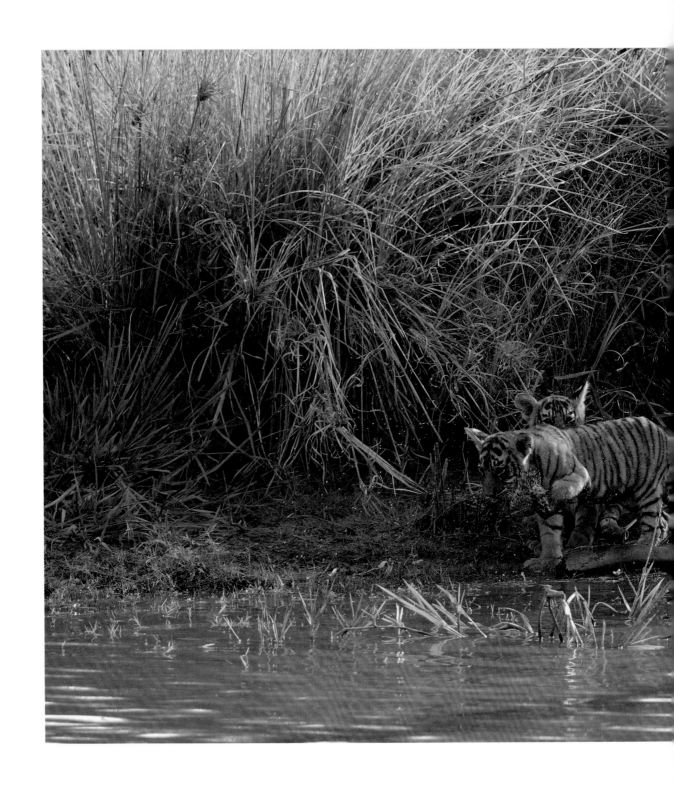

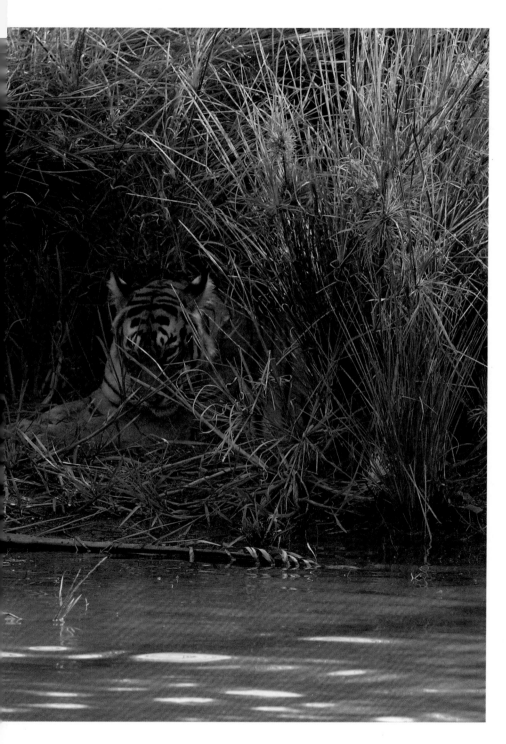

Krishna observes her cubs as they test some shallow waters around the lakes during the summer of 2014

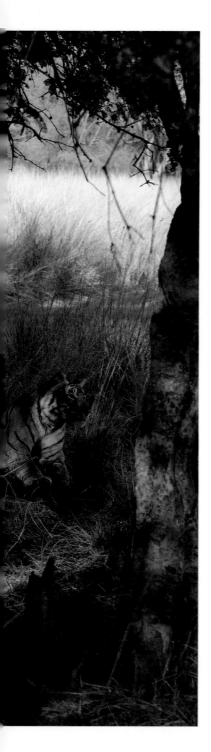

Through the next 18 months, Krishna and her cubs were the star attraction at Ranthambhore. The litter comprised two females—one of them was called Arrowhead or Machali Jr owing to a fork mark on her cheek that closely resembled grandmom Machali's. The second female was called Lightning and the male cub was called Pacman. The lakes were alive with action as the three siblings splashed around in the waters and chased everything they could, including porcupines and crocodiles, under the watchful eyes of the mother.

During the 150 odd days I spent photographing the family, I witnessed some extraordinary phenomena in natural history—a 13-month-old tiger cub trying to bring down his first kill, and, in his inability to kill it, starting to eat it alive. I was also amazed to see 14-month-old tiger cubs suckling; the mother, too, was reluctant. The strong emotional bond between mother and cubs weakens as the months pass by and competition for food increases. As dependency on the mother decreases, tensions in the family come to the fore. Maternal instincts give way to territorial considerations. Krishna's family was no different, with the change in family dynamics being gradual but apparent.

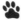

Krishna charges at a herd looking for an evening meal. This was an unsuccessful attempt and the deer managed to exape

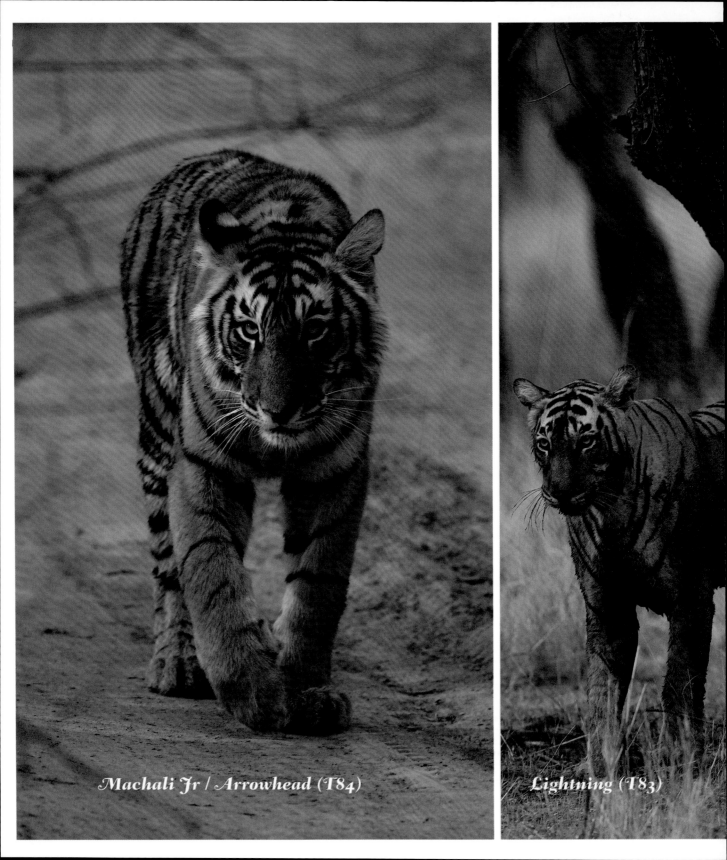

Machali Jr / Arrowhead (T84)

Lightning (T83)

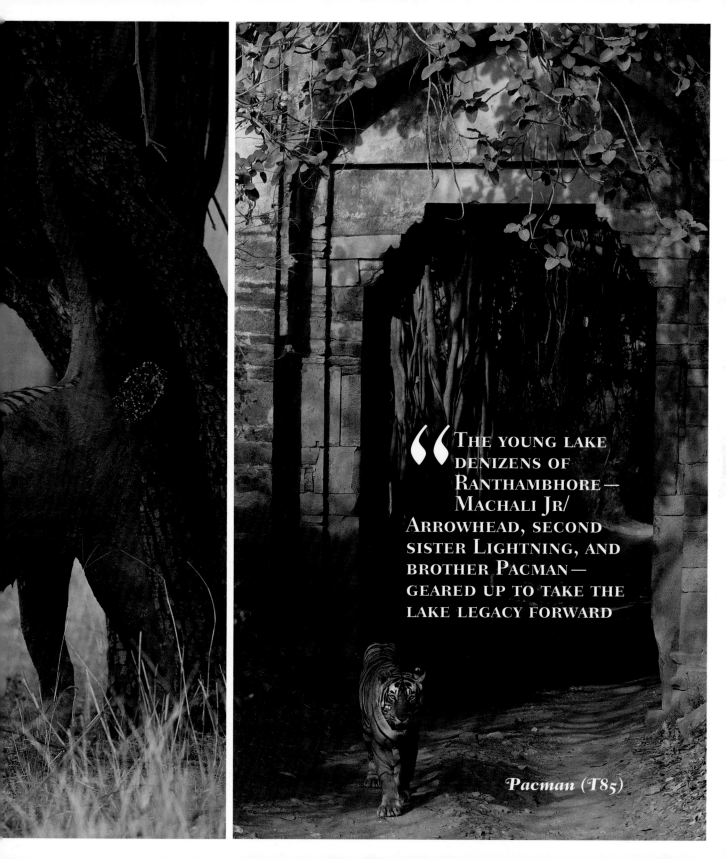

" THE YOUNG LAKE DENIZENS OF RANTHAMBHORE — MACHALI JR/ ARROWHEAD, SECOND SISTER LIGHTNING, AND BROTHER PACMAN — GEARED UP TO TAKE THE LAKE LEGACY FORWARD

Pacman (T85)

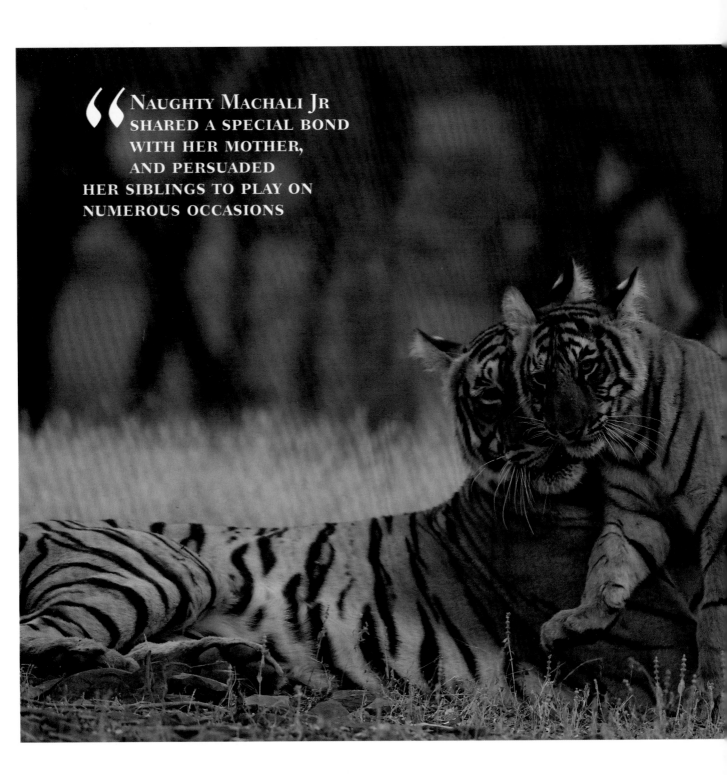

" NAUGHTY MACHALI JR
SHARED A SPECIAL BOND
WITH HER MOTHER,
AND PERSUADED
HER SIBLINGS TO PLAY ON
NUMEROUS OCCASIONS

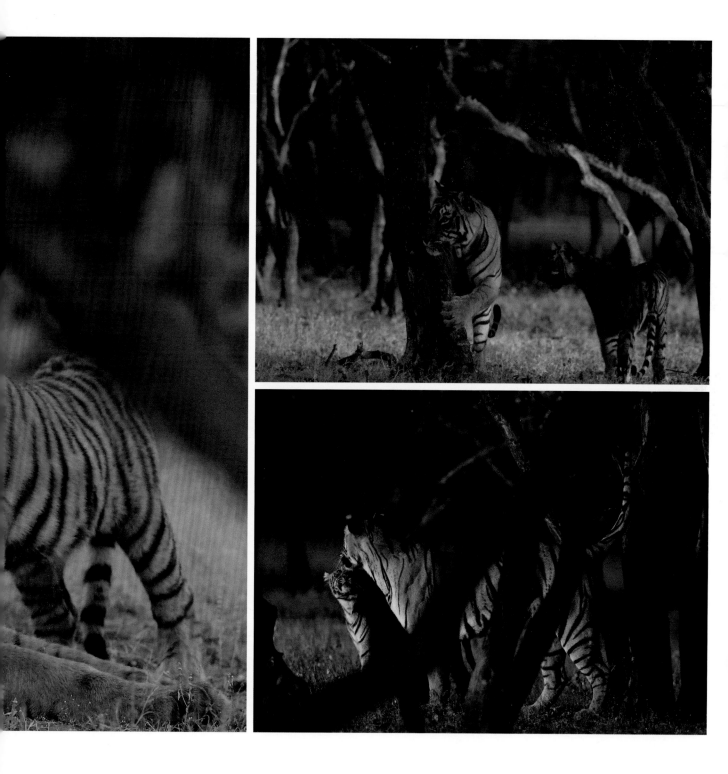

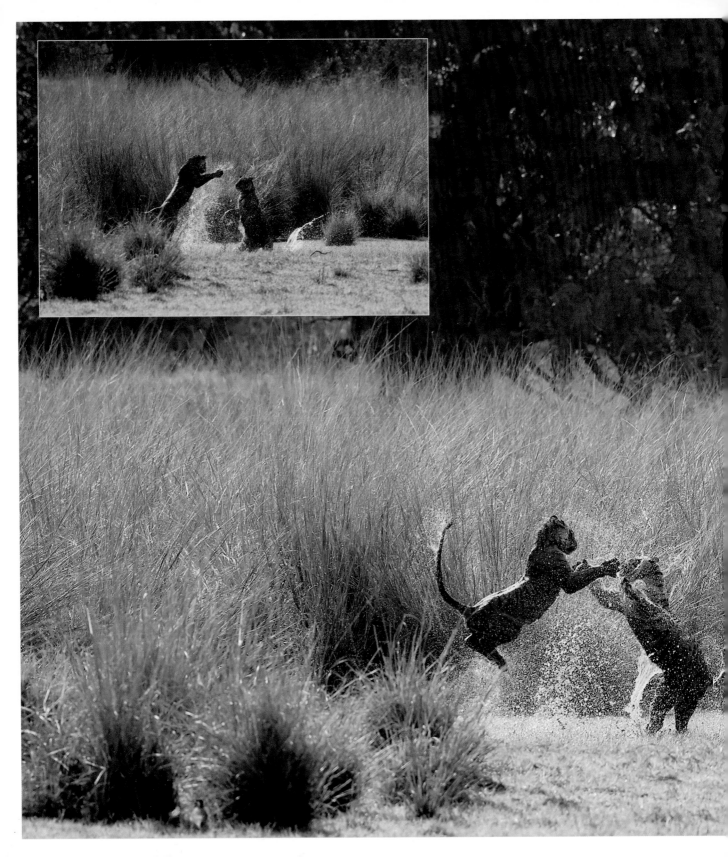

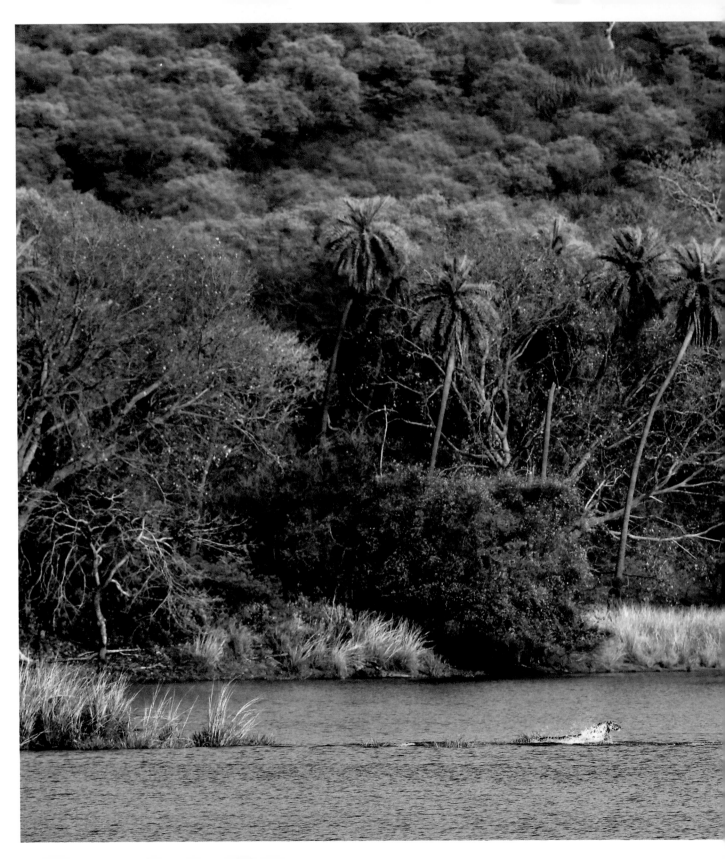

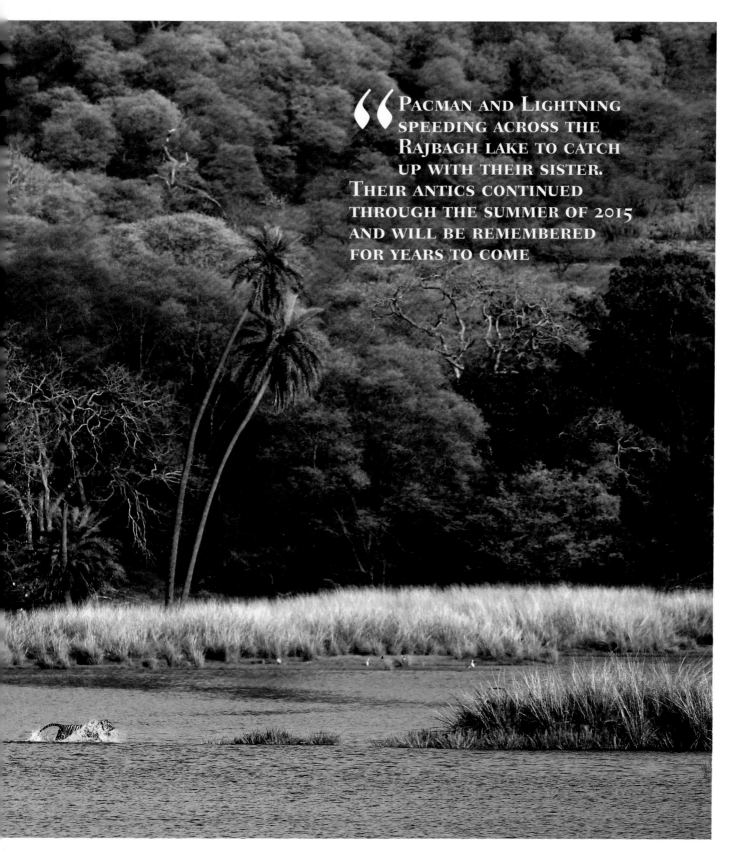

> **PACMAN AND LIGHTNING SPEEDING ACROSS THE RAJBAGH LAKE TO CATCH UP WITH THEIR SISTER. THEIR ANTICS CONTINUED THROUGH THE SUMMER OF 2015 AND WILL BE REMEMBERED FOR YEARS TO COME**

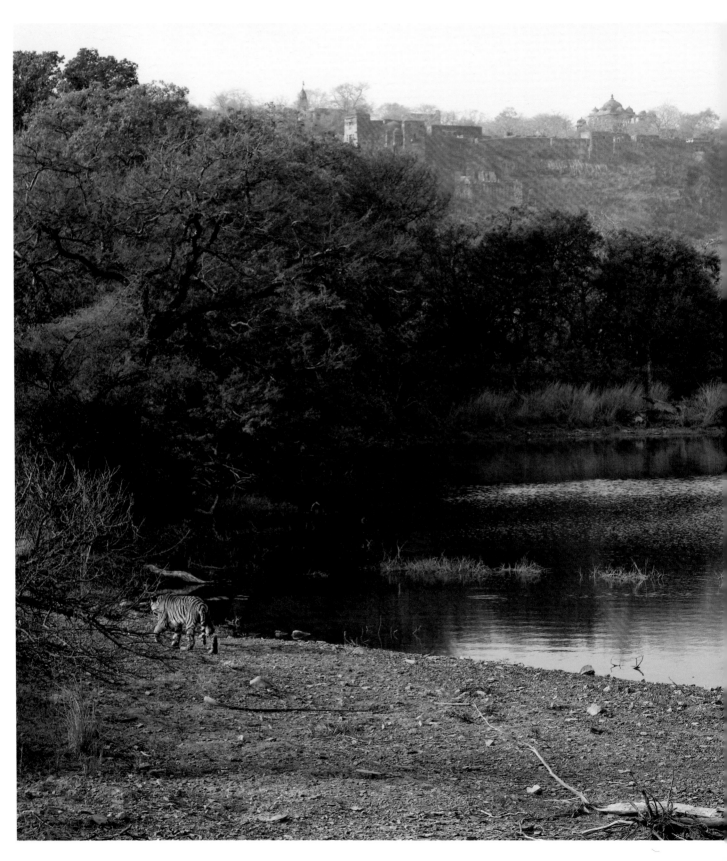

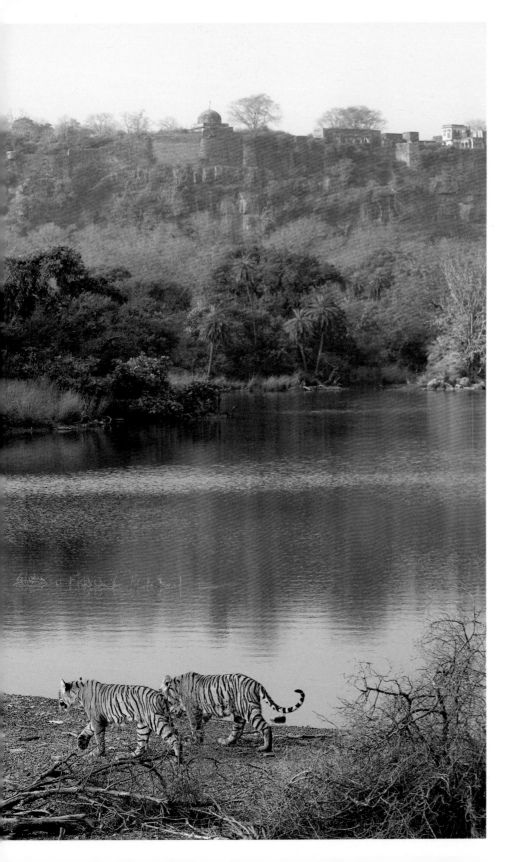

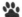

Krishna leads her cubs to a kill against the scenic backdrop of Ranthambhore Fort in February 2015

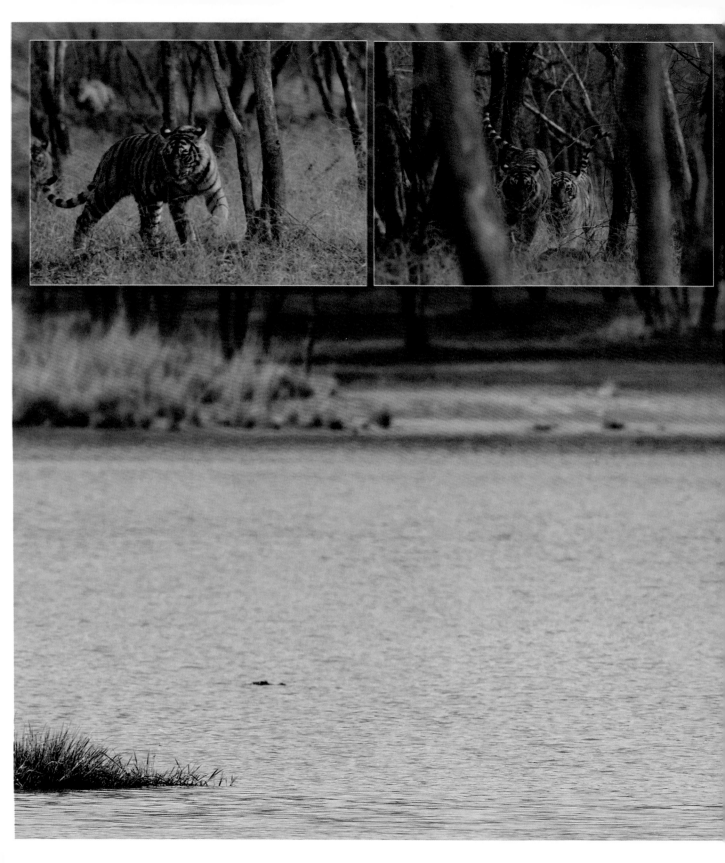

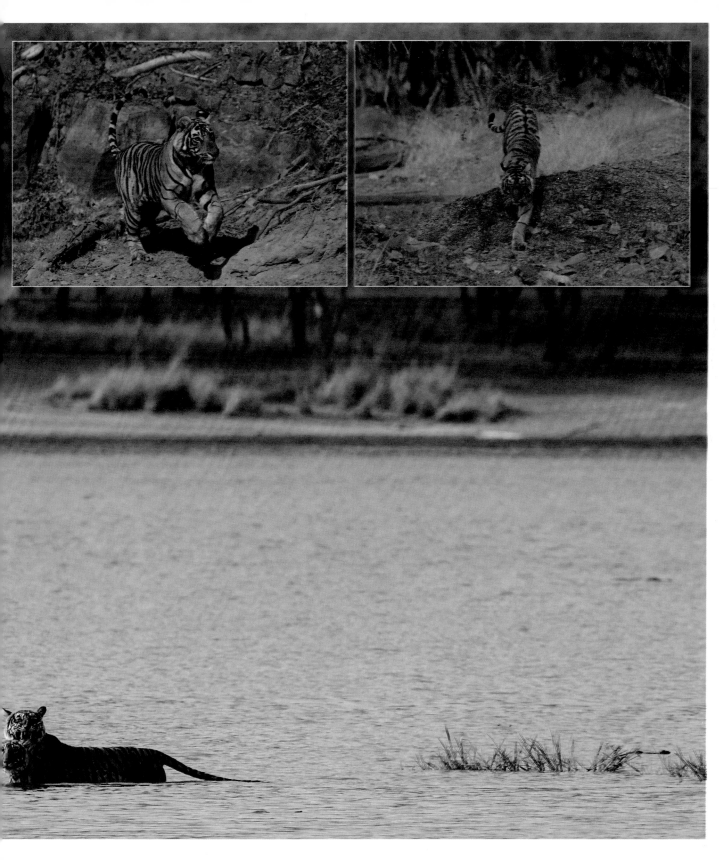

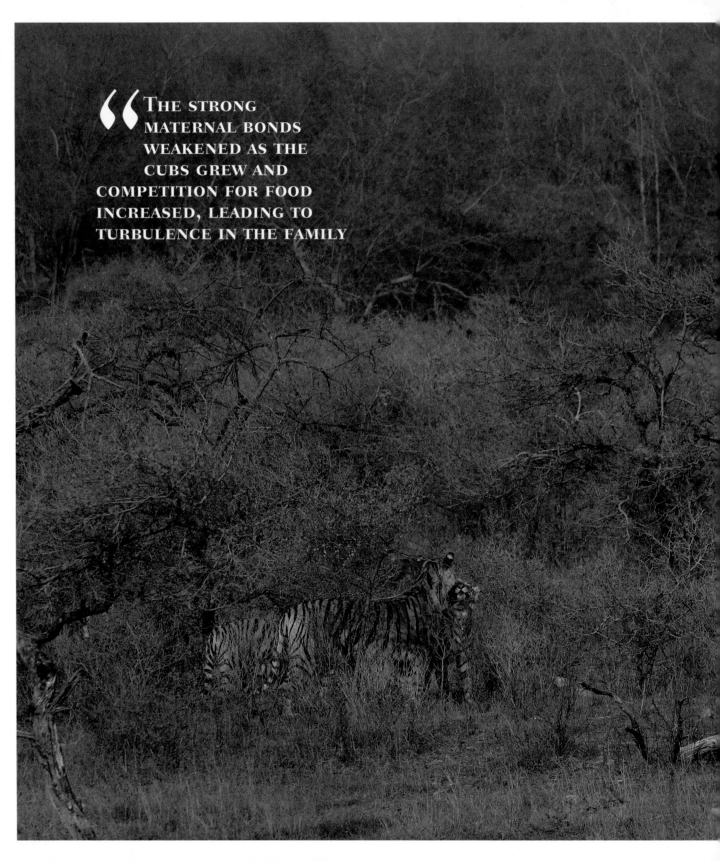

"THE STRONG
MATERNAL BONDS
WEAKENED AS THE
CUBS GREW AND
COMPETITION FOR FOOD
INCREASED, LEADING TO
TURBULENCE IN THE FAMILY

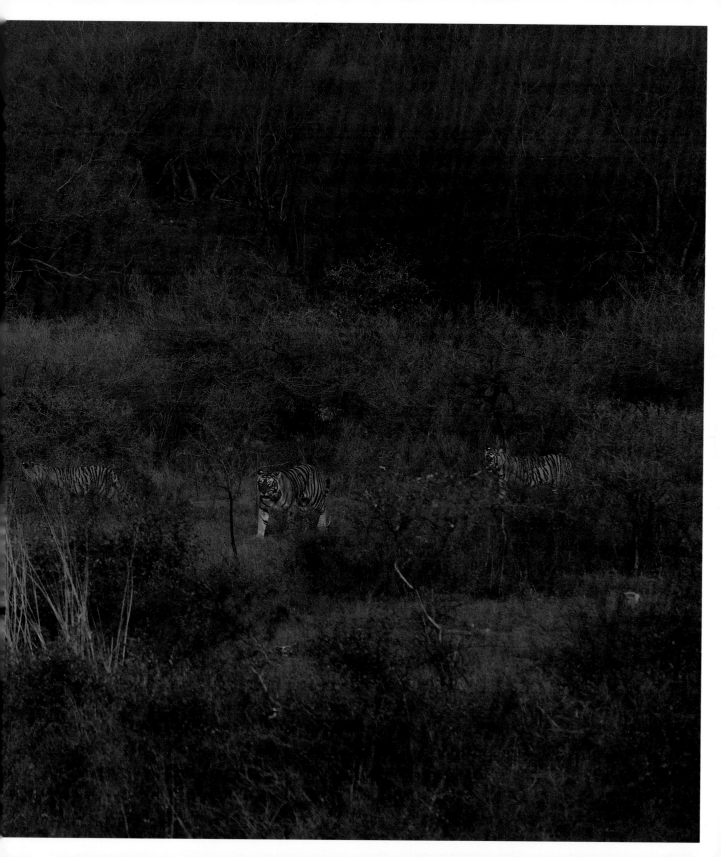

As of today, Krishna's cubs have separated from the mother, and a new story is set to unfold in Ranthambhore with Machali Jr (Arrowhead) assuming command of the lake territory. Krishna's visits to the lakes have been infrequent. The coming years should provide answers to a lot of questions: Krishna is still in her prime and her daughters are well-groomed to take over the reins. What would be the dynamics around the lakes?

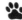

BELOW AND FACING PAGE
An inexperienced Pacman grabs a spotted deer, May 2015. It took him 30 minutes to bring it down—he had a long way to go to match his mother's hunting skills

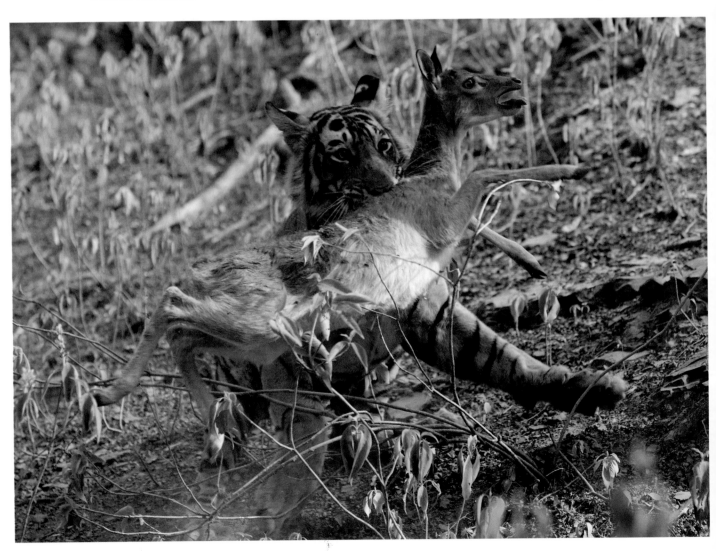

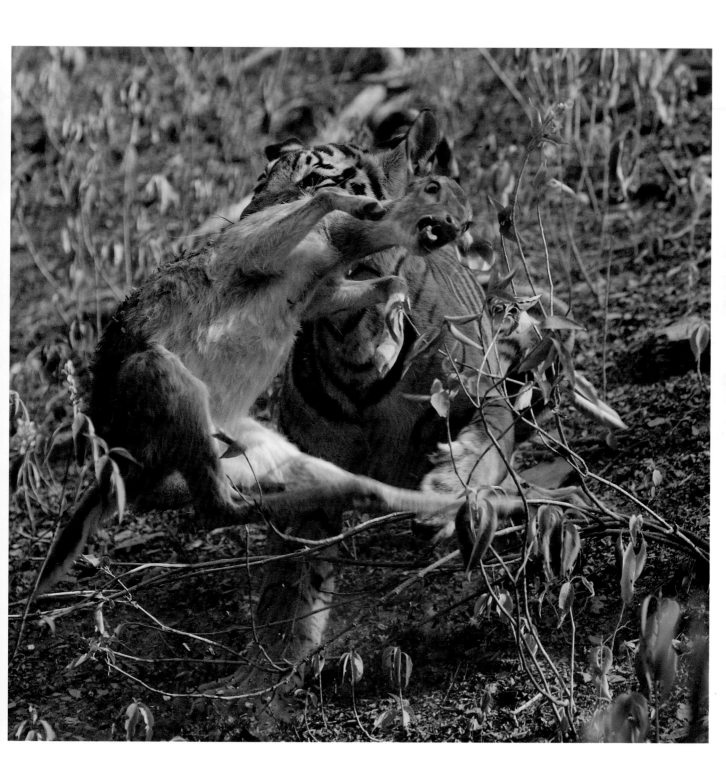

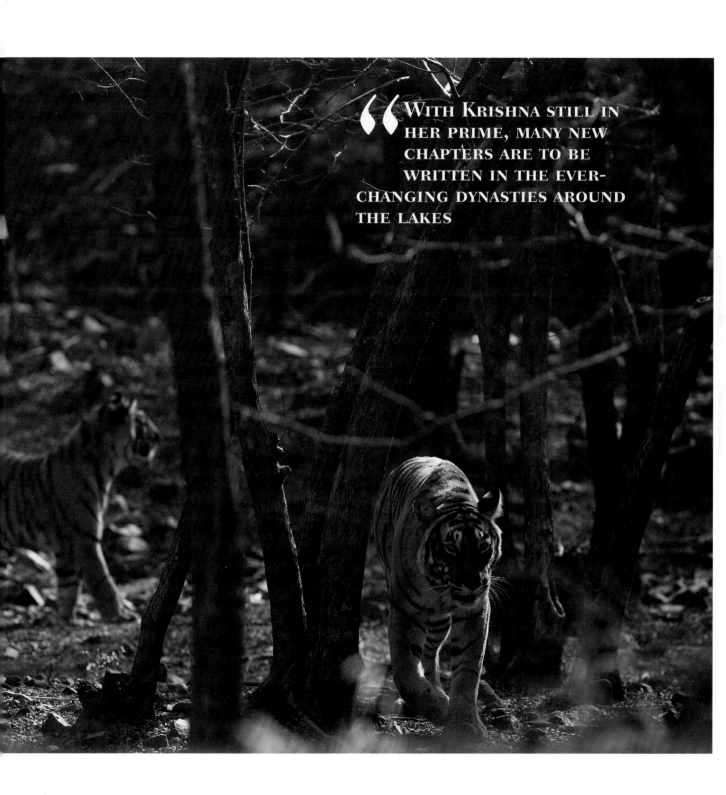

"WITH KRISHNA STILL IN HER PRIME, MANY NEW CHAPTERS ARE TO BE WRITTEN IN THE EVER-CHANGING DYNASTIES AROUND THE LAKES

Machali Jr inherited a fighting spirit from her mother and has successfully managed to keep her mother and siblings away from the lakes post separation. One of the male cubs of Sundari was seen advancing towards the lakes in January 2017. Will the estate have some new rulers from the royal blood?

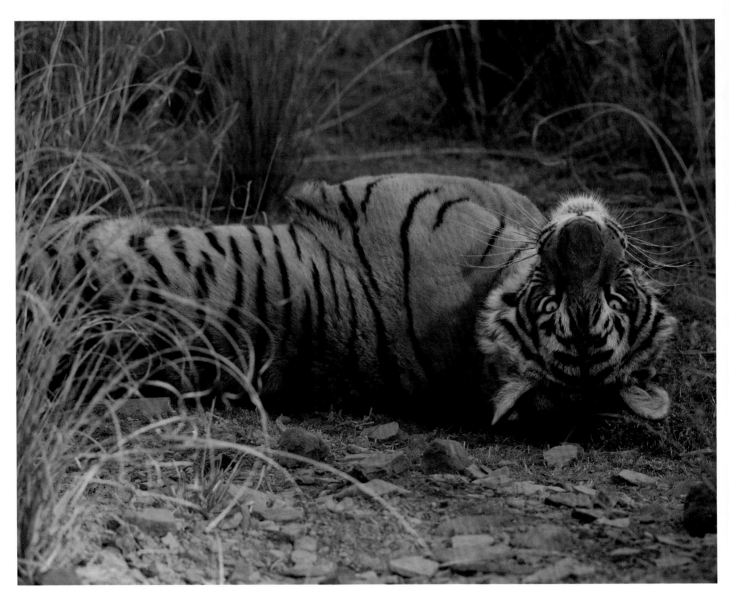

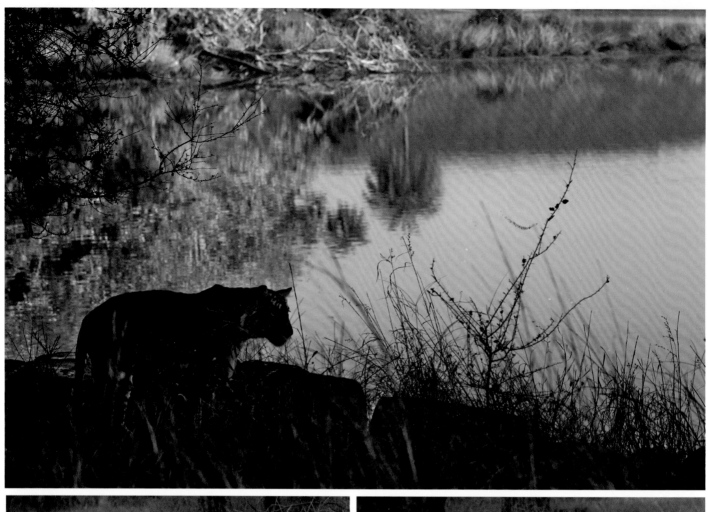

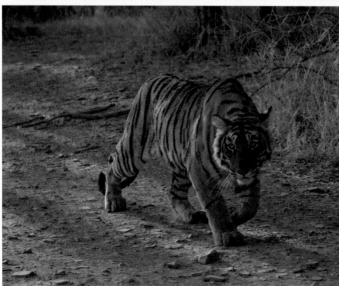

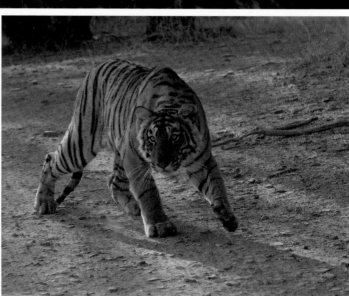

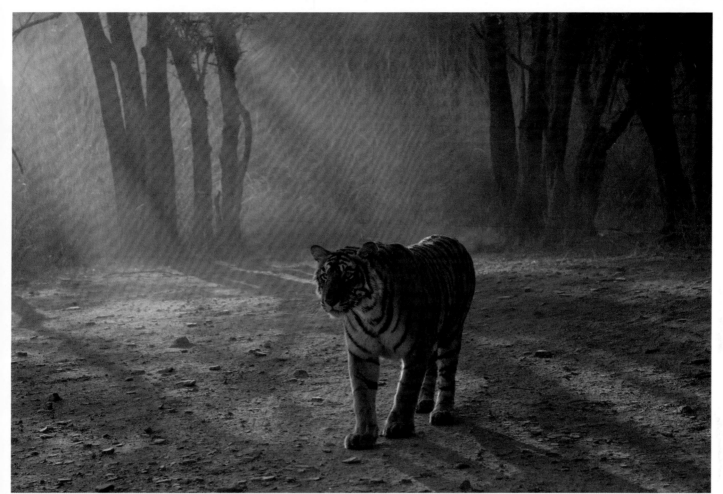

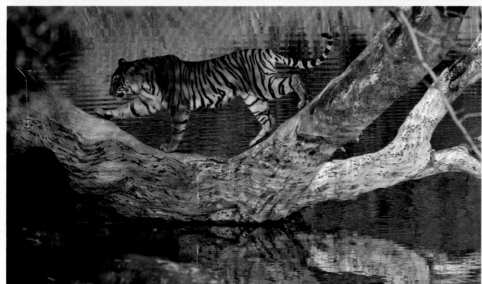

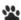

ALL
First sister Machali Jr
has taken over control
of the lakes from
Krishna. The mother
has been driven off
but the tables may turn
in the future

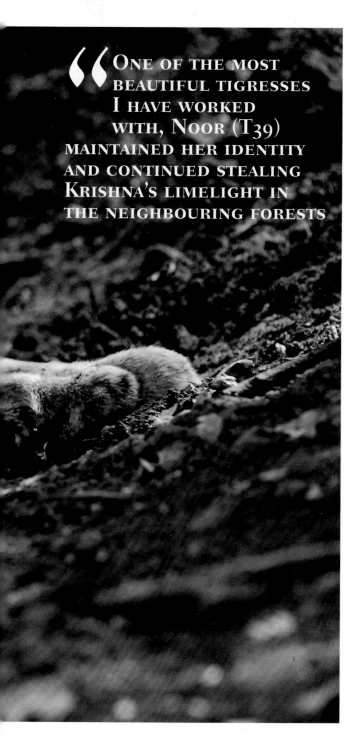

" ONE OF THE MOST BEAUTIFUL TIGRESSES I HAVE WORKED WITH, NOOR (T39) MAINTAINED HER IDENTITY AND CONTINUED STEALING KRISHNA'S LIMELIGHT IN THE NEIGHBOURING FORESTS

While the dynamics around the lakes was taking its own turn, a tiger mother from the adjoining area silently bore a naughty young male. Noor was a devoted mother, a great hunter, and a shrewd thinker when it came to outwitting human minds, in case she wanted to. I have always found her to be one of the more beautiful feminine faces in the world of tigers. Unlike Krishna, who was a lake denizen, Noor had a tougher habitat to negotiate with hardly any open grounds to hunt. Time and again she has surprised me with her grit and character.

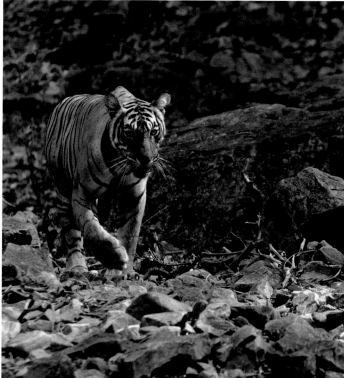

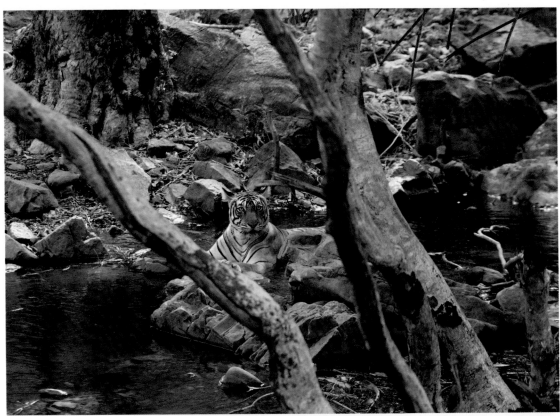
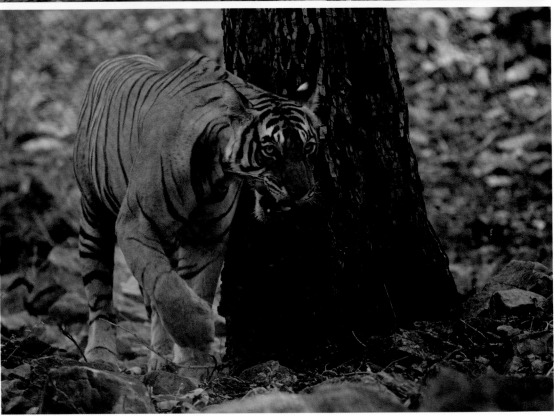

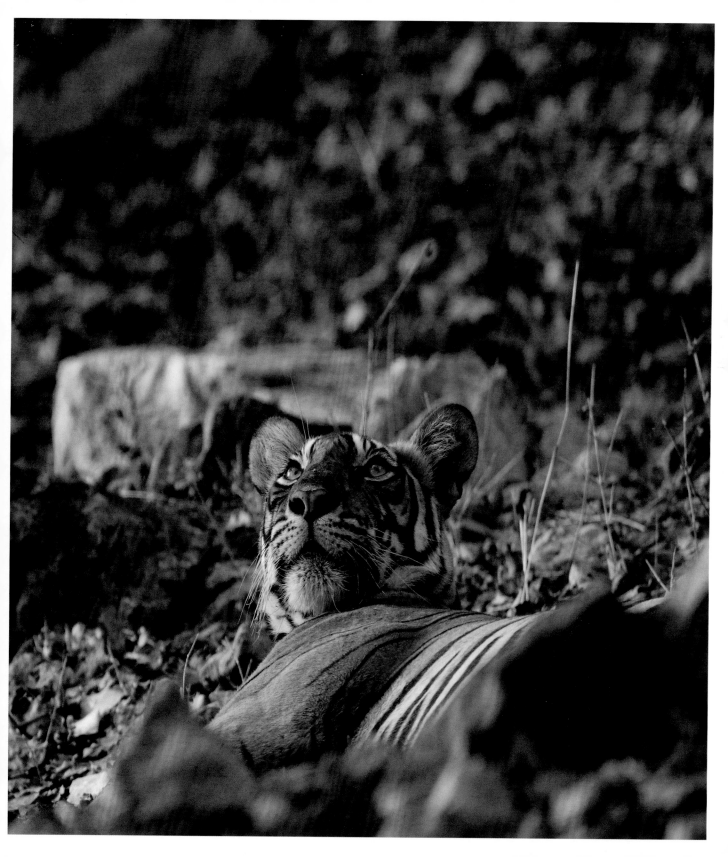

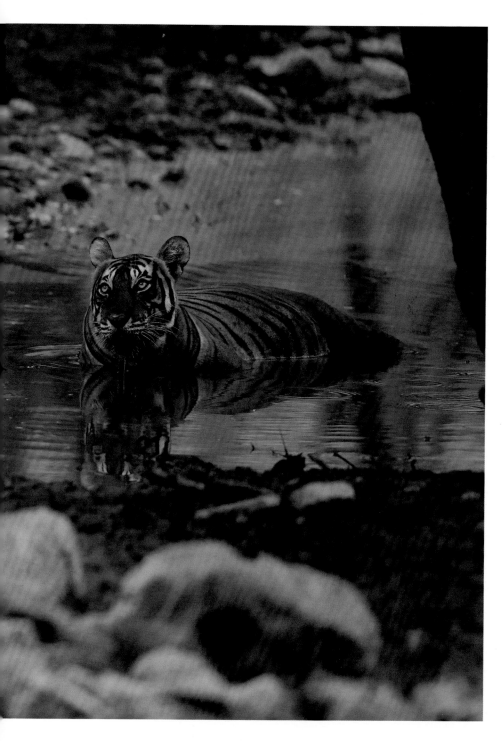

Noor rests in a pool of rainwater right after the park opened in October 2014

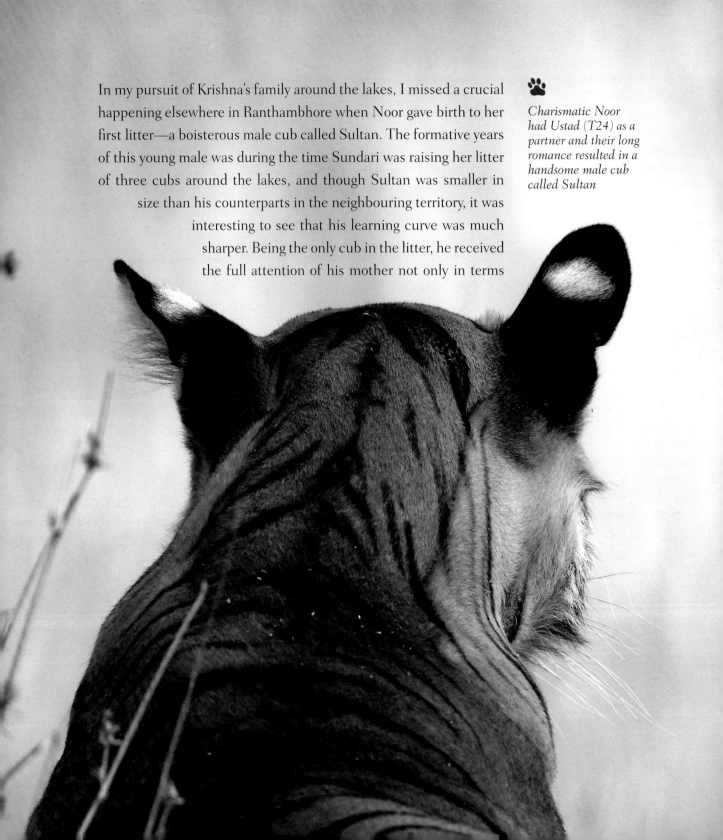

In my pursuit of Krishna's family around the lakes, I missed a crucial happening elsewhere in Ranthambhore when Noor gave birth to her first litter—a boisterous male cub called Sultan. The formative years of this young male was during the time Sundari was raising her litter of three cubs around the lakes, and though Sultan was smaller in size than his counterparts in the neighbouring territory, it was interesting to see that his learning curve was much sharper. Being the only cub in the litter, he received the full attention of his mother not only in terms

Charismatic Noor had Ustad (T24) as a partner and their long romance resulted in a handsome male cub called Sultan

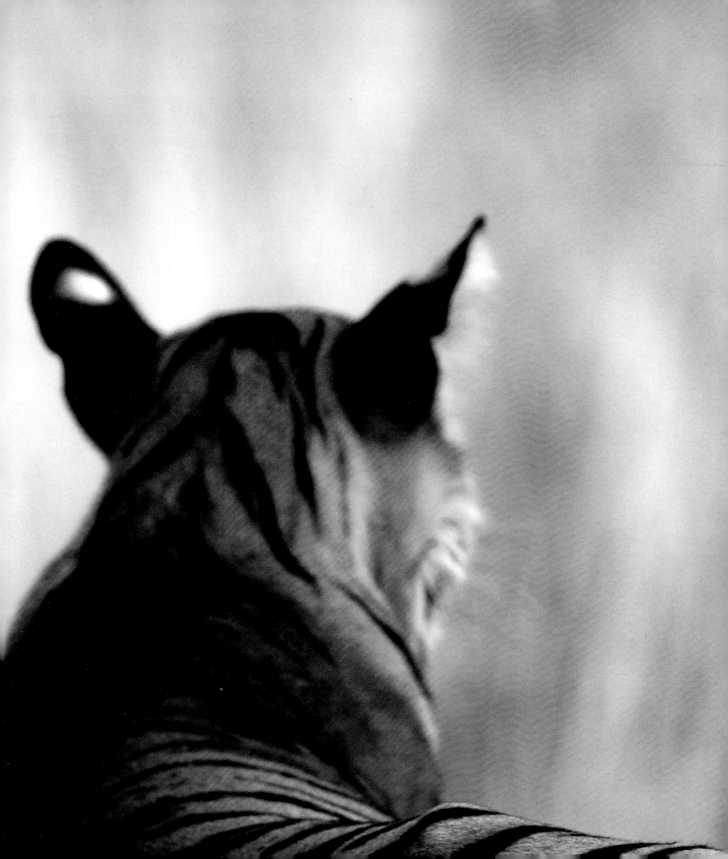

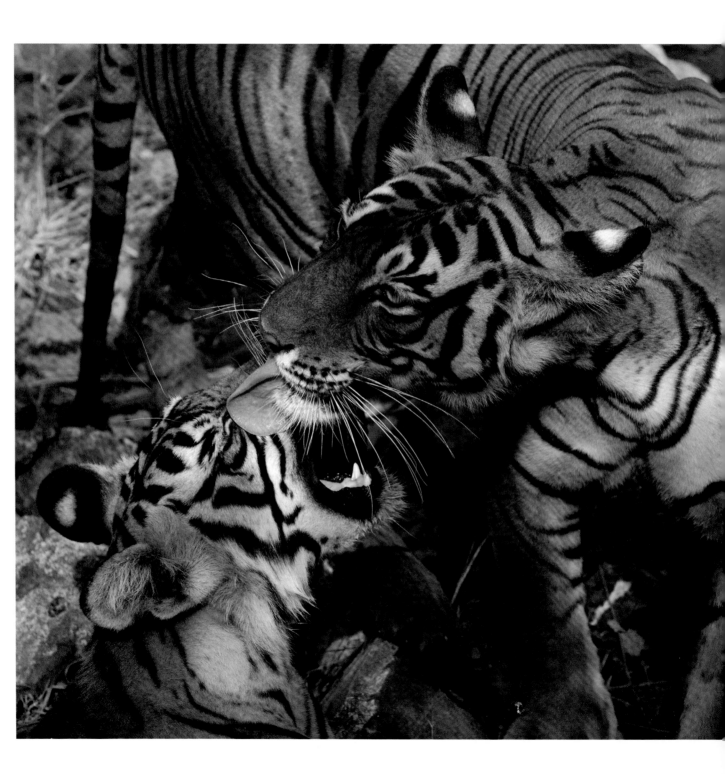

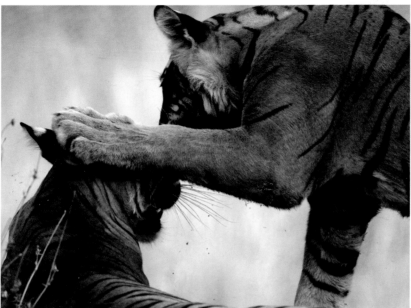

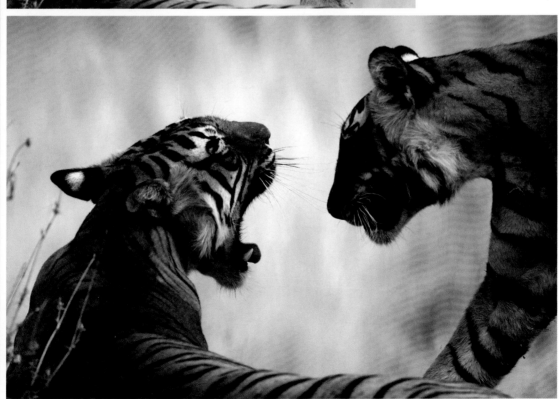

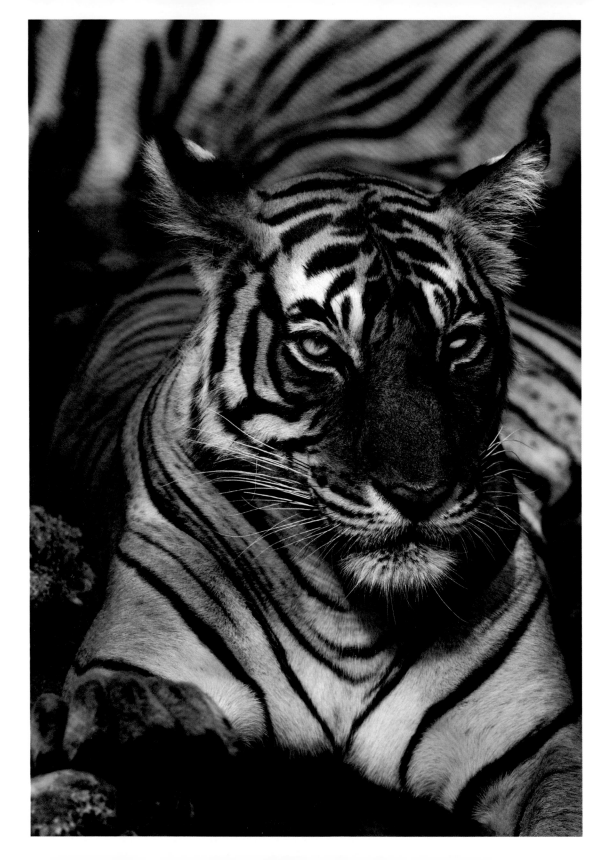

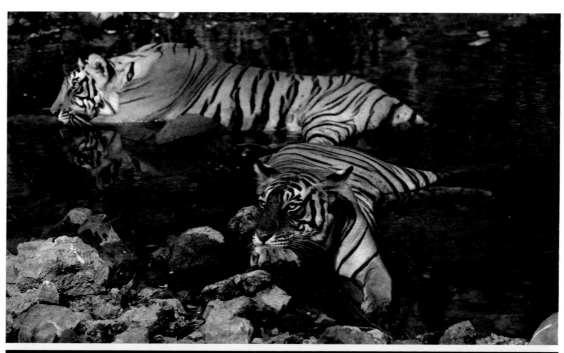

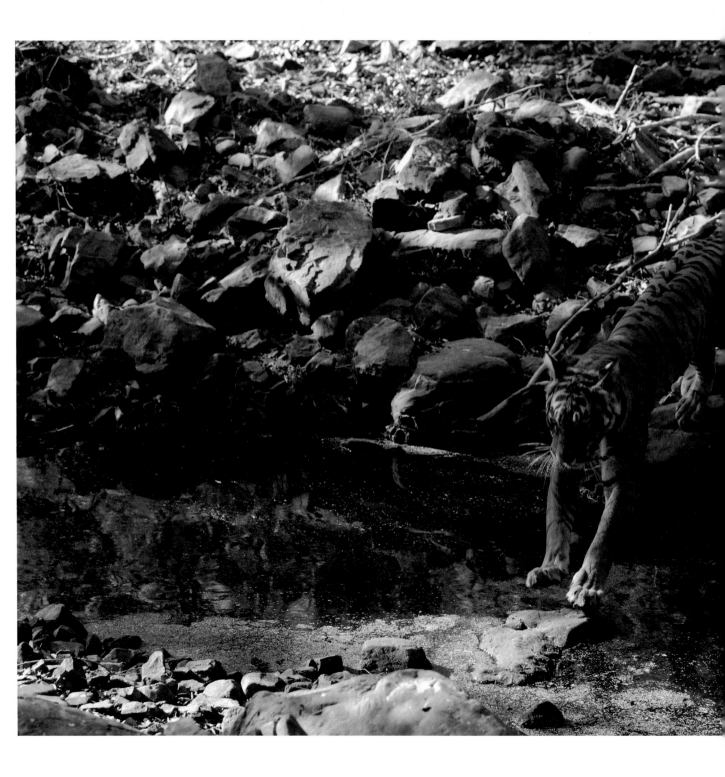

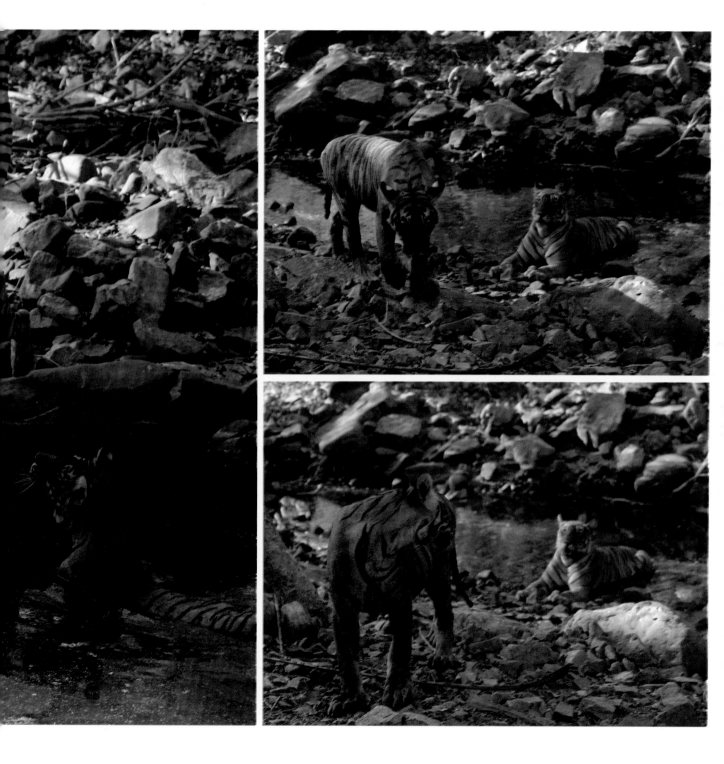

> " THE BOLDNESS OF YOUNG
> SULTAN BECAME NEWS IN
> RANTHAMBHORE AS HE
> QUICKLY LEARNED THE
> TRICKS OF BEING AN INDEPENDENT
> WILD TIGER

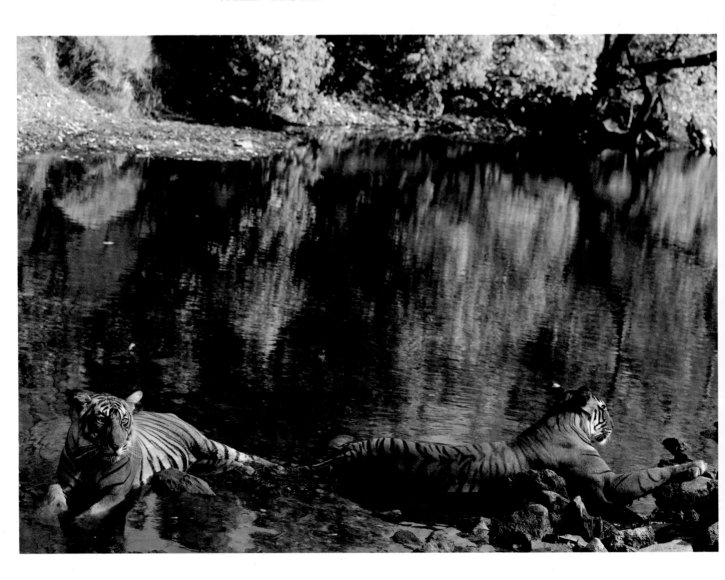

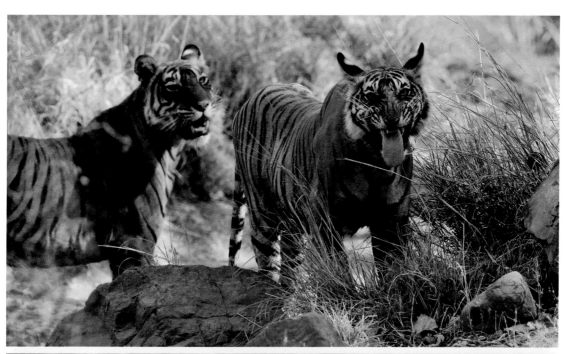
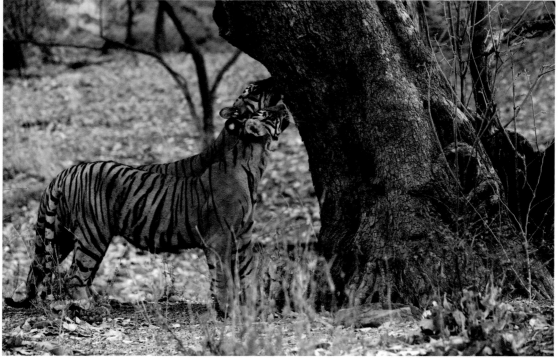

of motherly affection and training but also in terms of food. These factors contributed to his rapid growth as a tiger, both in size and maturity. Noor filled the void of siblings by being a great companion to Sultan—she was not only a mother but his teacher and playmate, and kept the brat under control. At times, I felt more engaged and intrigued working with this mother–boy family than the celebrity tigers around the lakes.

Having successfully raised Sultan to maturity, Noor mated again with her long-time companion Ustad (T24) to give birth to her second litter; this time it was two male cubs. It was smooth sailing for this family till May 2015. Ustad had a history of mauling people to death over the past few years, and, in May 2015, was found guilty of taking the fourth

The dynamic Ustad rests during the summer of 2013

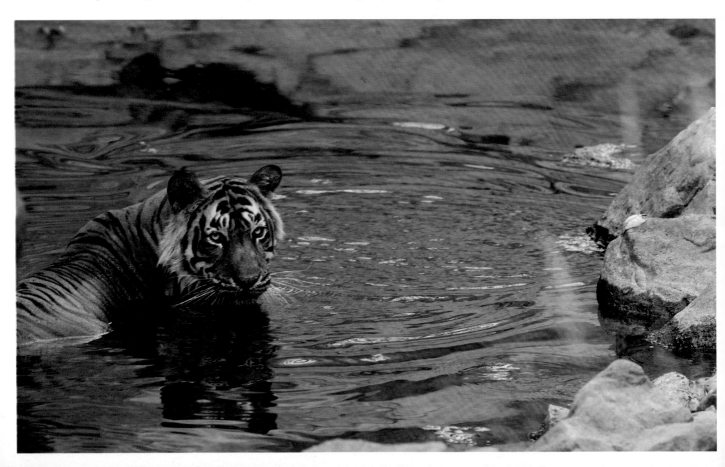

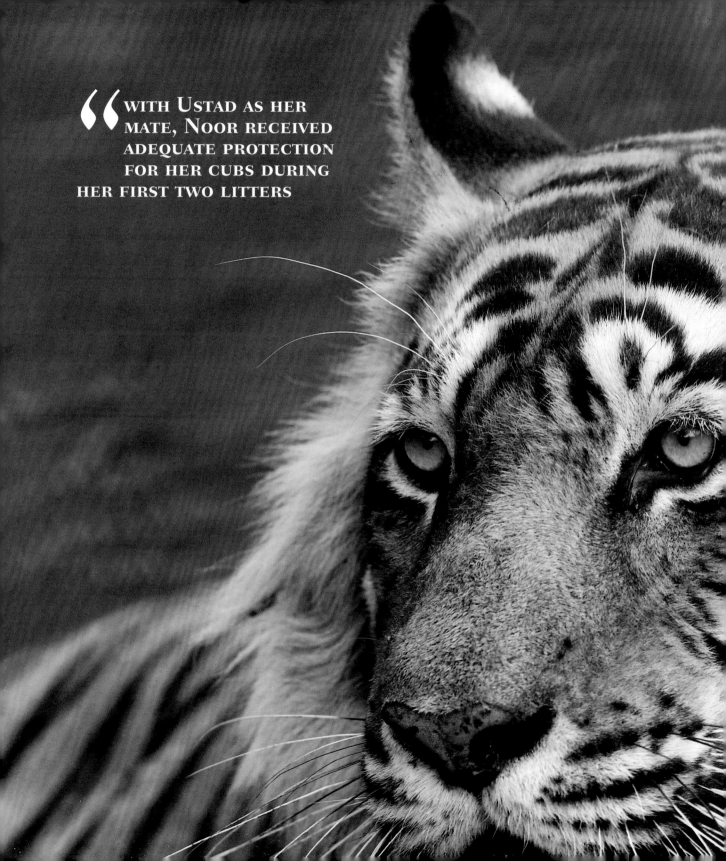

“WITH USTAD AS HER MATE, NOOR RECEIVED ADEQUATE PROTECTION FOR HER CUBS DURING HER FIRST TWO LITTERS

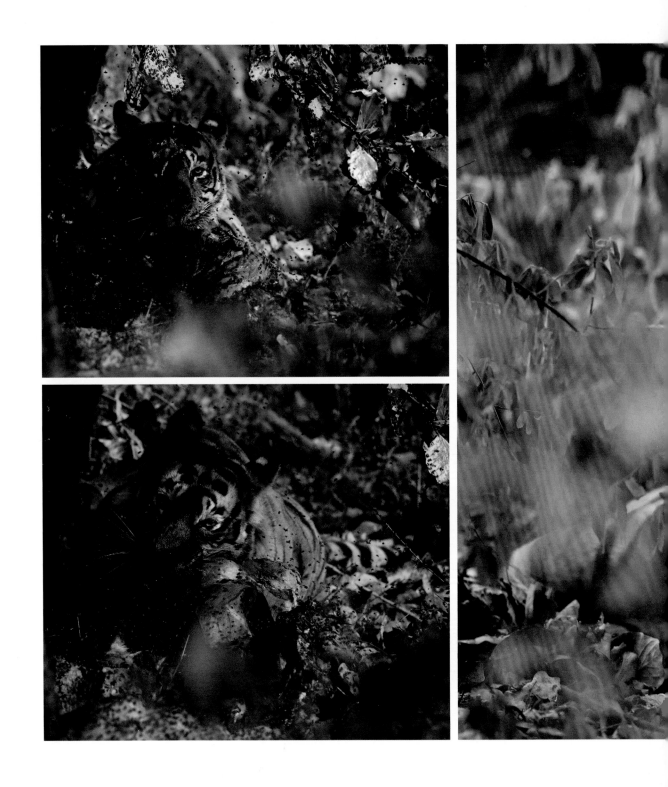

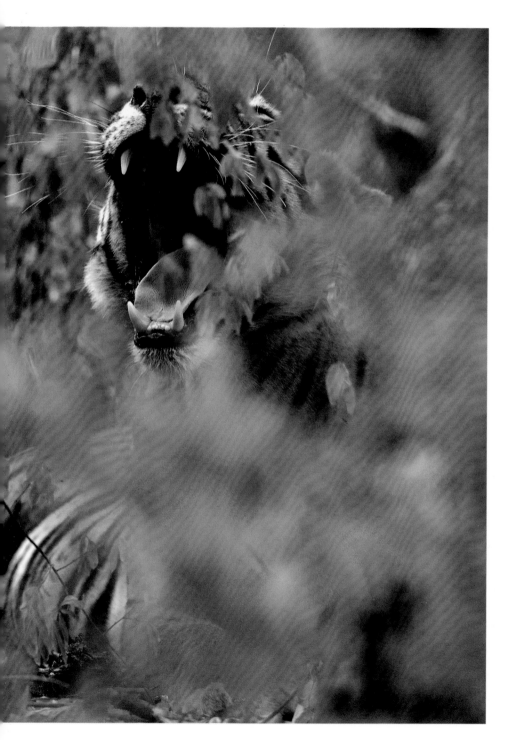

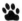

*Ustad a day before the
fateful incident of
8 May 2015. He killed
a forest guard barely
24 hours after this
image was taken*

EXTREME LEFT
*(both) Ustad enjoys
a meal he stole from
Noor in April 2015*

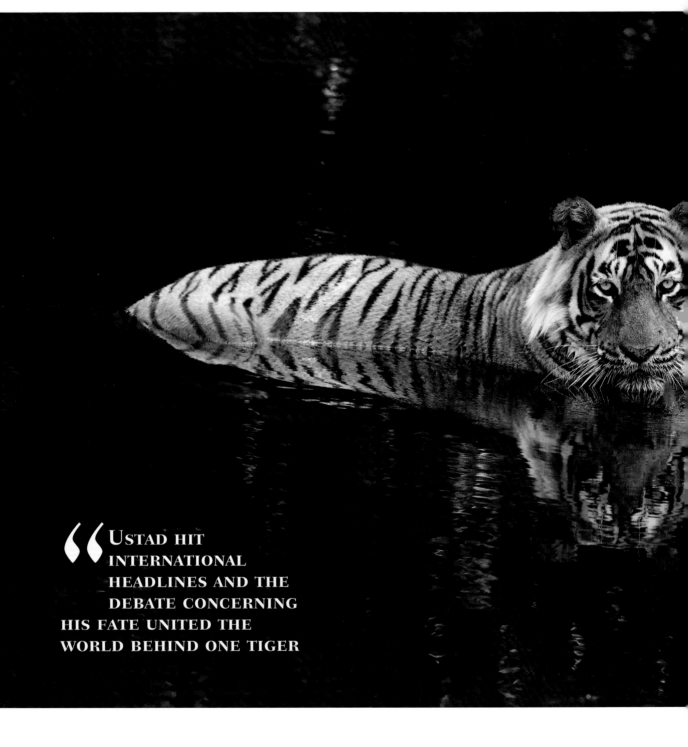

> **Ustad hit international headlines and the debate concerning his fate united the world behind one tiger**

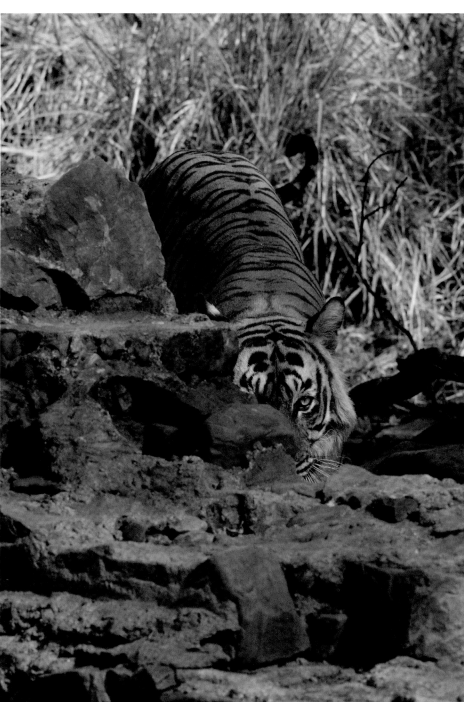

NOOR SECOND LITTER

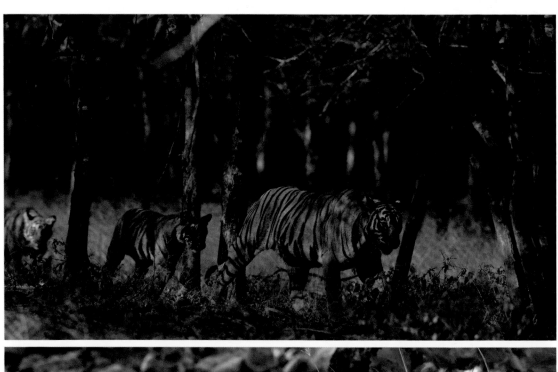

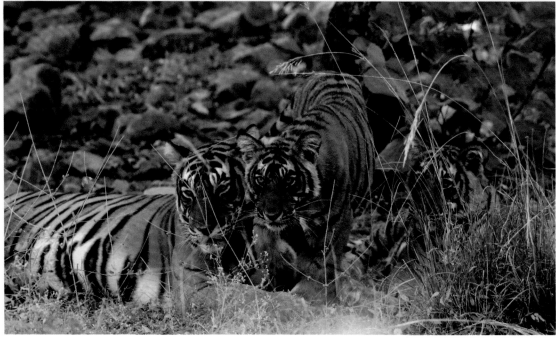

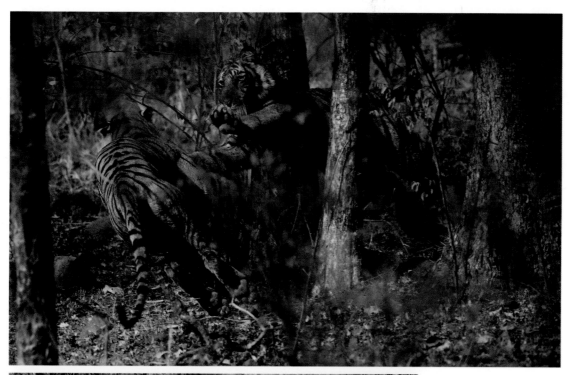

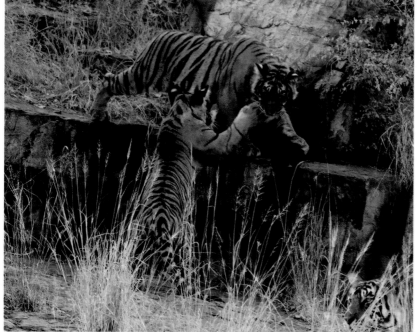

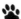

THIS AND FACING PAGE
Noor with her second litter of two males, who were later named Kalua and Dholua, in the winter of 2014

179

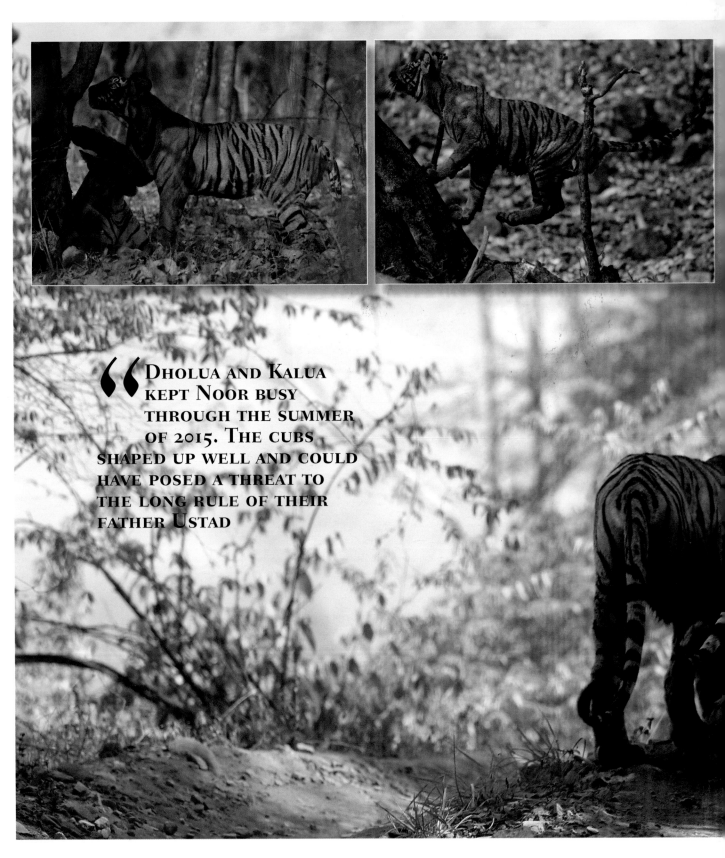

> **Dholua and Kalua kept Noor busy through the summer of 2015. The cubs shaped up well and could have posed a threat to the long rule of their father Ustad**

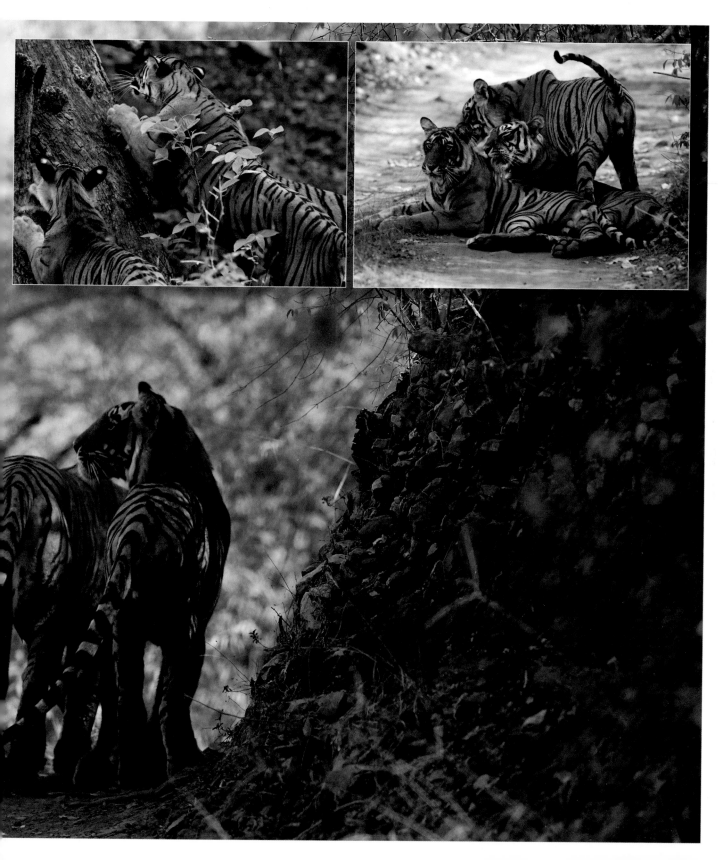

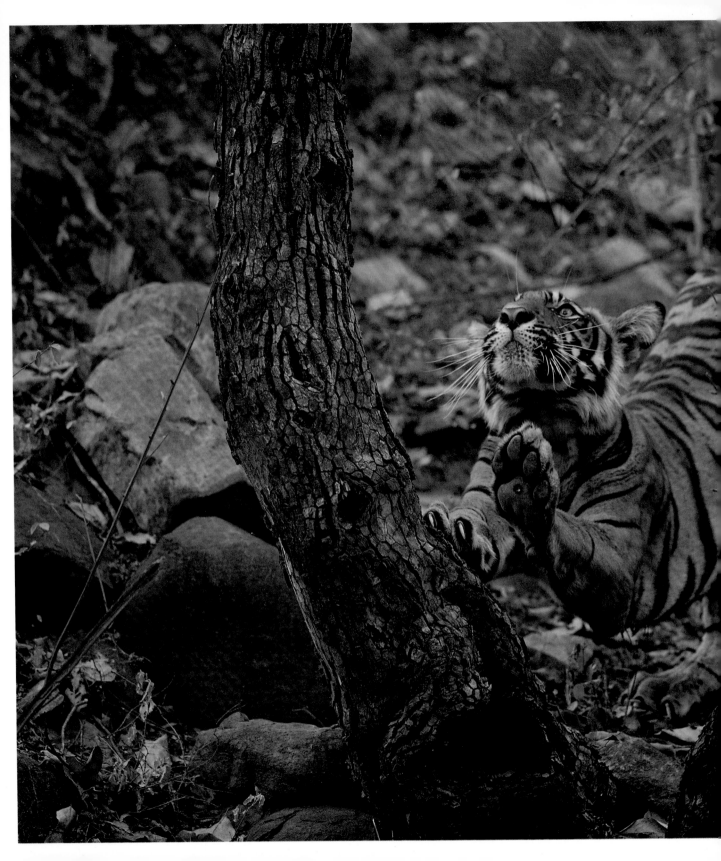

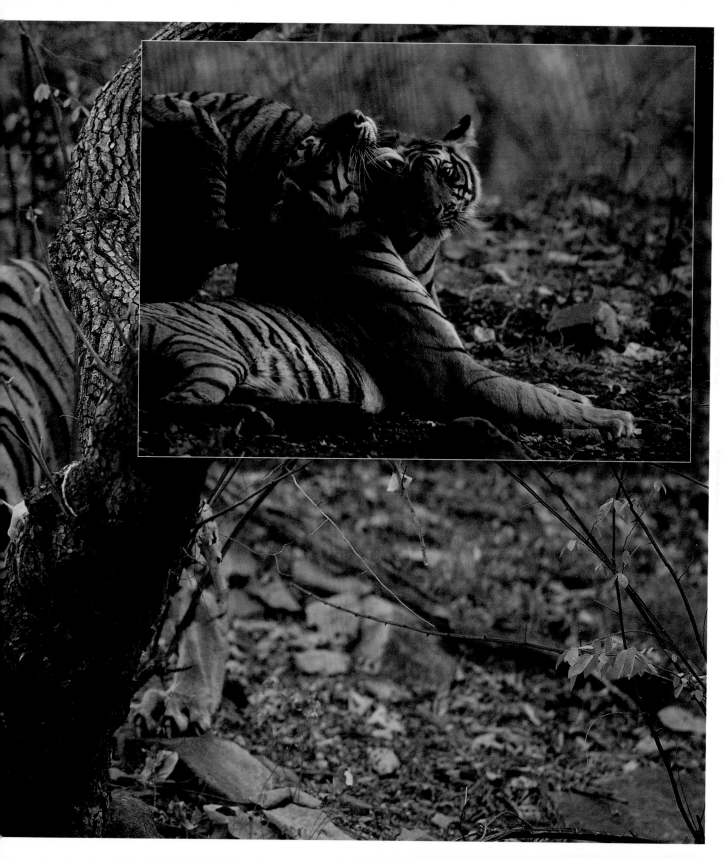

T57

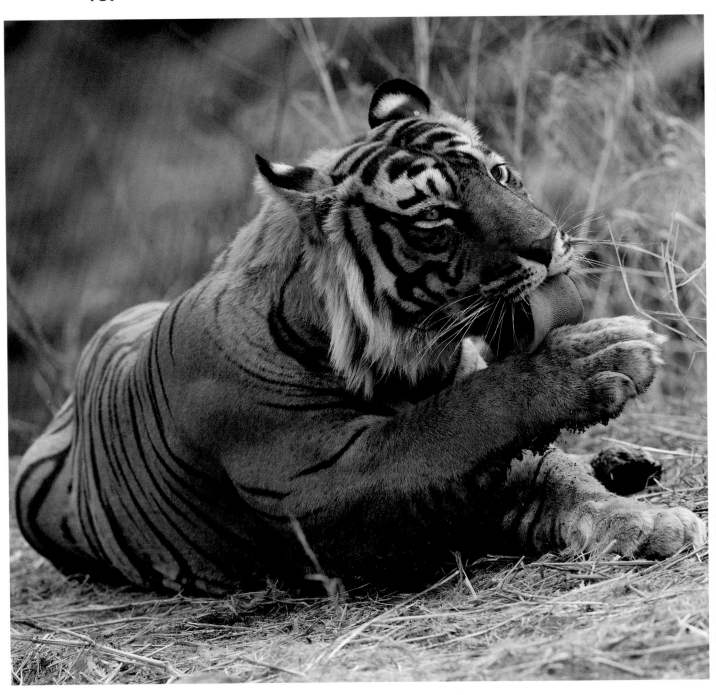

human life in three years when he killed a forest guard on the Ranthambhore Fort road. Ustad was then lifted from Ranthambhore and transferred to an enclosure in Udaipur, putting a big question mark on the safety of his young cubs. Life for Noor was predictably tougher, but she fought through all adversities and raised the cubs to maturity by the summer of 2015.

Soon after separation, Noor mated with T57, a young, dynamic male who has stepped into Ustad's shoes. Although Noor's success rate as a mother and life as a tigress have been relatively less complicated than the females around the lakes, the absence of females in her litters and her proactive contribution to the park's male population proved to be a worrying factor. Unlike some of the popular forests of central India, Ranthambhore has had an abundance of male tigers in recent years with the male–female ratio hovering around 1:1. A change of mate resulted in a change in gene pool; Noor's first litter with T57 was spotted in early 2016, but the cubs were not seen again after the initial sighting. Her romance with T57 continues—she delivered a fresh litter in the winter of 2016 and is currently raising three cubs, this time all females—an opportune development for the future of Ranthambhore.

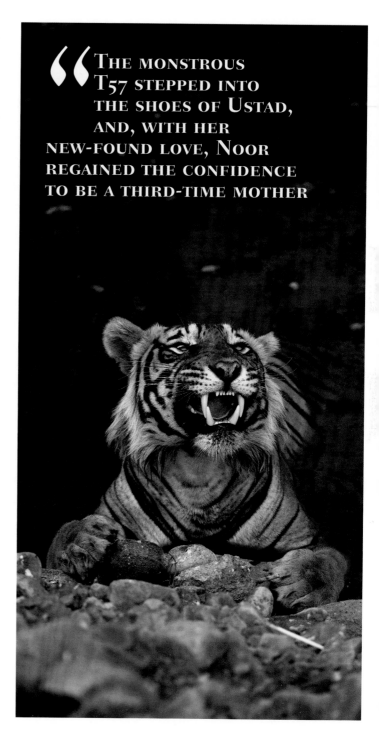

> THE MONSTROUS T57 STEPPED INTO THE SHOES OF USTAD, AND, WITH HER NEW-FOUND LOVE, NOOR REGAINED THE CONFIDENCE TO BE A THIRD-TIME MOTHER

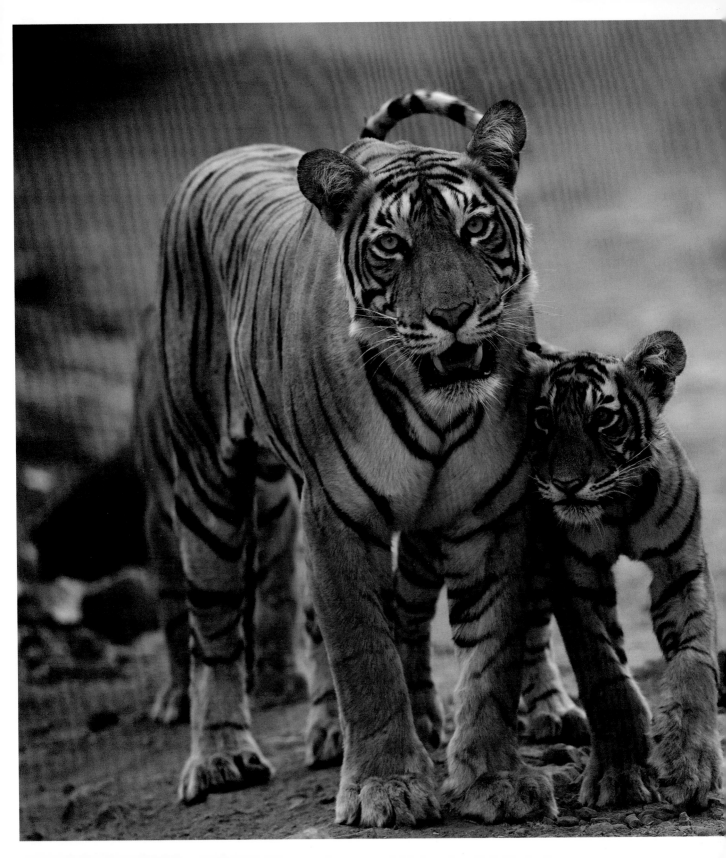

In the adjoining territory, some new cubs were spotted during the spring of 2016. A beautiful young female called T60 had dislodged the ageing Gayatri (T22; the mother of Ustad) and established her territory with her three young cubs. It is always a good feeling to observe new tiger mothers and compare their behaviour and interactions with their young to the families I have followed for longer periods. I spent around two months in the pursuit of T60 and bid farewell to the family as the park closed for monsoon in June 2016.

"T60, A BEAUTIFUL YOUNG FEMALE, DISPLACED AN AGEING GAYATRI (T22) TO RAISE HER OWN FAMILY OF THREE CUBS IN 2016

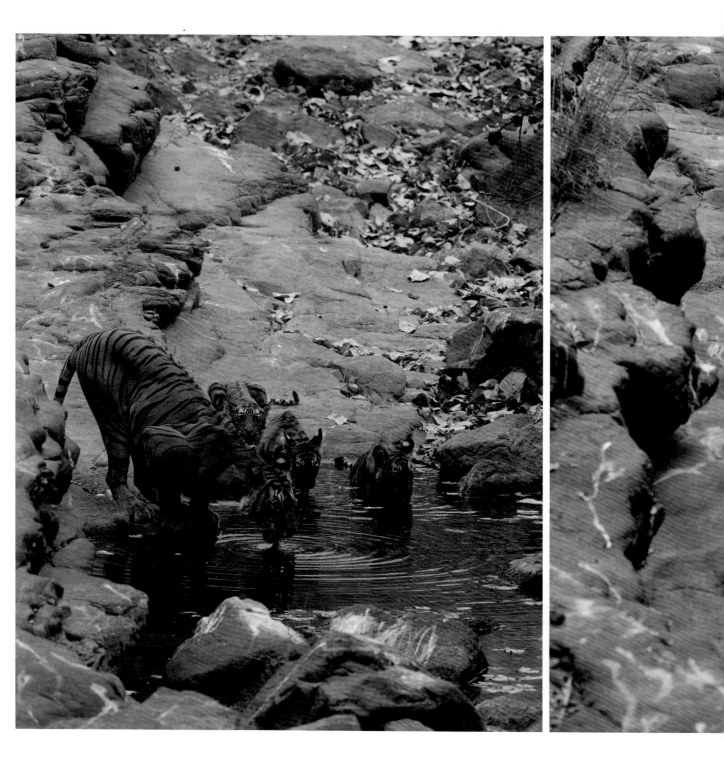

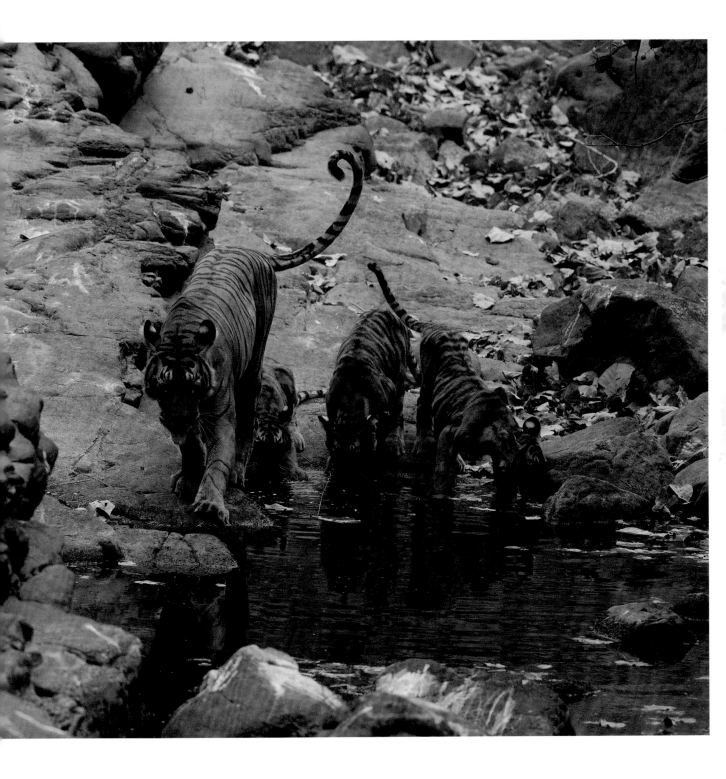

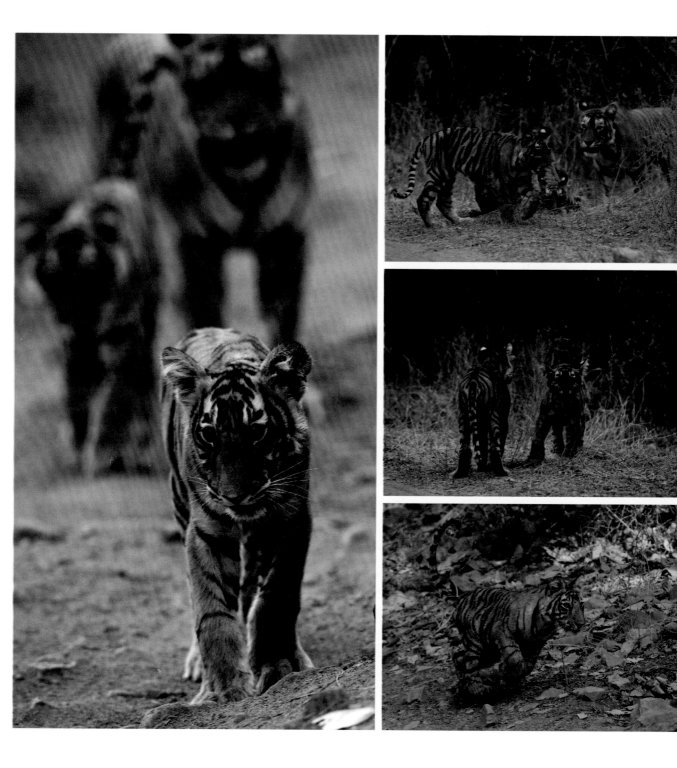

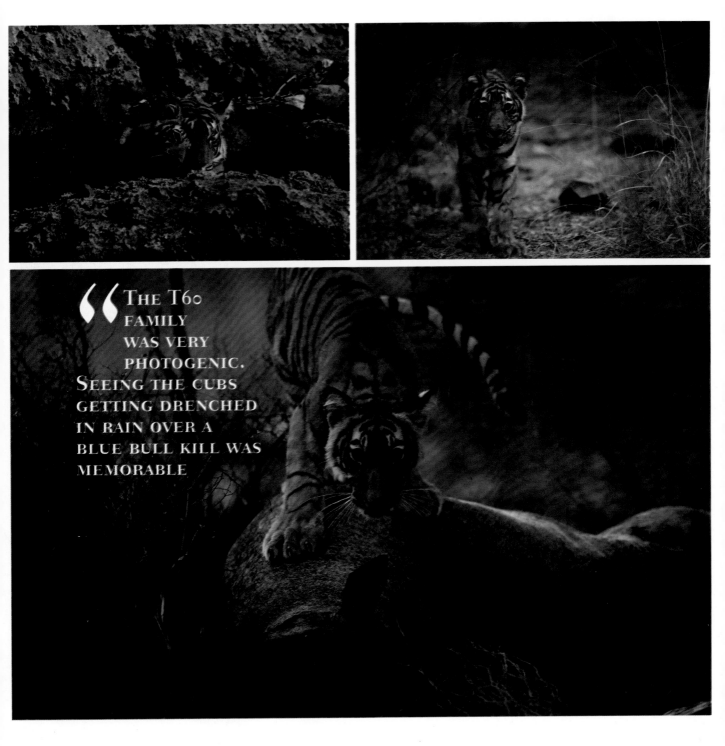

"THE T60 FAMILY WAS VERY PHOTOGENIC. SEEING THE CUBS GETTING DRENCHED IN RAIN OVER A BLUE BULL KILL WAS MEMORABLE

Anecdotes

My First Catch

27 April 2015

It was a dull morning around the lakes and there was no sign of Krishna or her cubs. Through the morning we scanned each and every area but clever Krishna succeeded in dodging us with no traces left behind. The sun was shining brightly on the lake waters and I gave up the search and headed towards the Jogi Mahal gate for a break. I was having a discussion with Shakir (my guide and companion throughout my Krishna pursuit), who suggested that we should give it a try in the evening. I looked at my watch and, because of my habit of trying till the last minute, I told him, 'Let's do one last round of the lake as we still have 20 minutes left.' As soon as we boarded the vehicle, a message flashed on the wireless handset at the forest checkpoint at the park gate. The forest guard rushed towards our vehicle informing, 'Krishna was seen heading towards the lakes.'

We drove towards Rajbagh; I could see a horde of vehicles and lenses pointed in the same direction. There was no way I could get even a glimpse of what was happening, so we decided to stay away from the crowd and wait. 'Tiger!' screamed Shakir. The young Pacman (Krishna's male cub) was stalking prey right behind our vehicle, and, before I could realise, pounced at a cheetal fawn inches away from the vehicle.

He was hardly 12 months old at the time and his hunting technique was essentially flawed as he grabbed the cheetal from the back rather than by the neck. Tigers normally choke their prey by grabbing the neck (refer to images on p. 148–149); here was one inexperienced cub who made a mess of his first kill. Nonetheless,

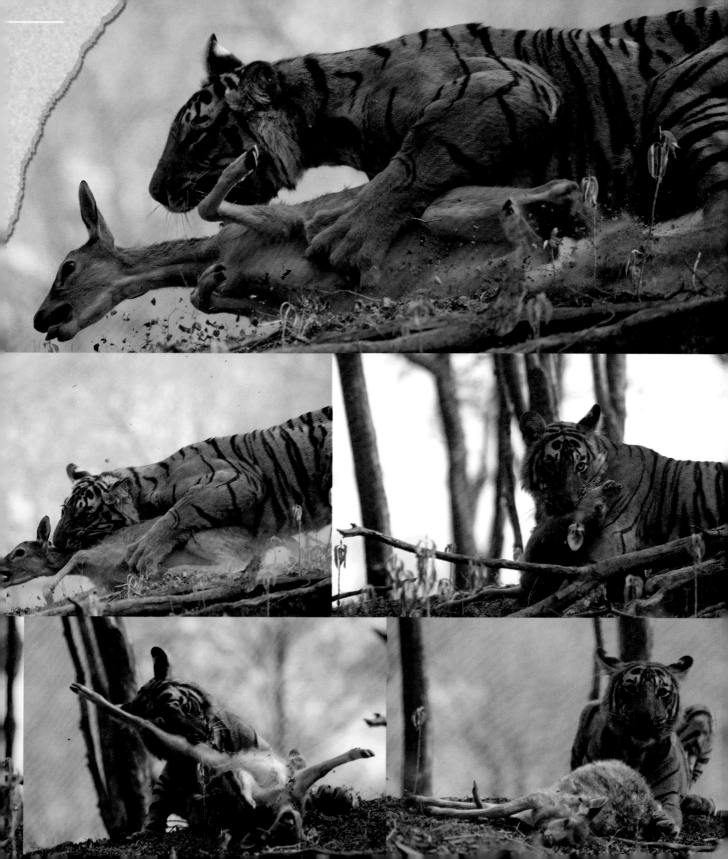

Pacman refused to give up and dragged the cheetal to the edge of the dhonk clearing, making an attempt at its neck this time. The forest resounded with the desperate squeals of the young cheetal.

Inexperienced as he was, Pacman just couldn't keep the cheetal down; the helpless prey kept trying to escape from the claws of a tiger who was not able to give it a peaceful death! His sister Machali Jr (Arrowhead) emerged from the horizon and sat looking at her brother's attempts. Pressure on Pacman intensified and he decided to give it a final try, crouching down to tear apart the hindquarters of the cheetal and eating it alive.

The cheetal wagged its tail and blinked its eyes while it was being eaten, and slowly breathed its last. Pacman emerged from the carcass with a bloodied face as his sister walked towards him to share the meal.

" SISTER MACHALI JR SAT STARING AT HER STRUGGLING BROTHER AS PACMAN TRIED ALL HE COULD TO KEEP THE CHEETAL DOWN

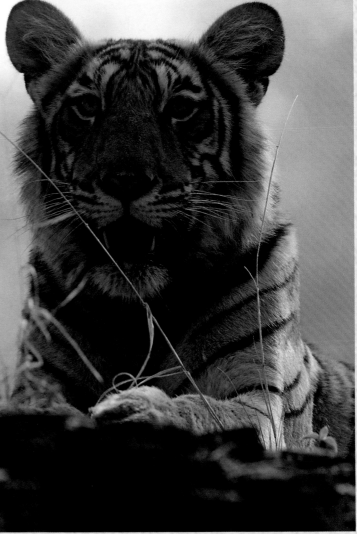

A Morning in Rajbagh

24 January 2015

I reached Savai Madhopur on a rainy day and wasn't sure whether to go to the park that evening as it was pouring heavily. When my vehicle arrived, I made up my mind to go with the rain covers on. It was winter and the rains further lowered temperatures as I headed towards Rajbagh on an overcast evening in fading light.

As we were driving towards the palace grounds, Shakir spotted some movement in the tall winter grass, and, within a few seconds, Machali Jr walked out. She was completely drenched in the rain and looked magnificent in her vibrant winter coat. While looking through the viewfinder, I could make out that the entire family was out on a kill as her face and whiskers had blood all over. The next day we headed off to the same area and this time Machali Junior was joined by Pacman as they

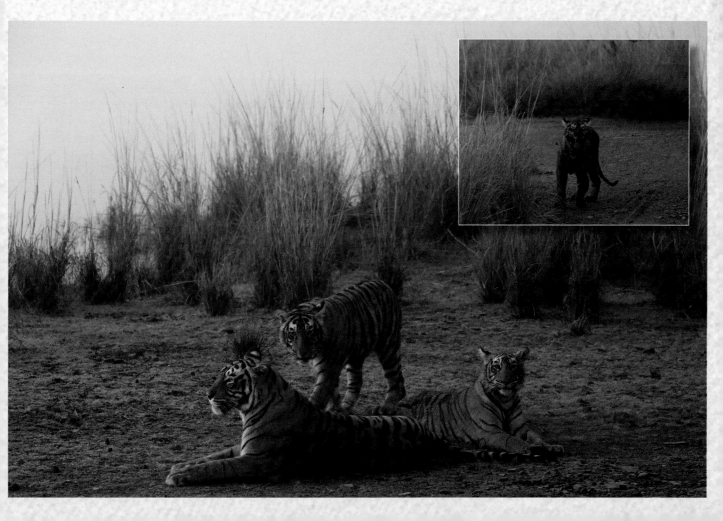

both came out to spend some time in the open areas of the lakes. It was clear that Krishna was feeding on a big kill—may be a sambar or a full-grown cheetal—and the family of four was taking their time to finish off the kill.

That night I stepped out of my room to see a cloudless sky with sparkling stars all round. The weather had cleared up and the following morning promised to be eventful; I was hoping the tigers would have wrapped up their meal. At the strike of dawn, I rushed towards Rajbagh to find the three cubs already out in the open.

Unlike her siblings, Machali Jr was in a playful mood. When she failed to enthuse her companions, she rushed towards Krishna looking for entertainment. In her excitement she even climbed a tree and was coaxing her sister to join her up there. While the morning antics of Machali Jr continued, the sun peeped above the Rajbagh palace lighting up the grassland with a soft golden glow. The winter mist mingled with this light to create a dramatic impact in the backdrop of the Ranthambhore Fort in the distant horizon.

The next hour was full of action in this theatrical set up as Machali Jr successfully ensured that the entire family gave in to her demand to simply play. While the cubs were at play, Krishna kept a close eye on them and eventually led them back deep into the forest.

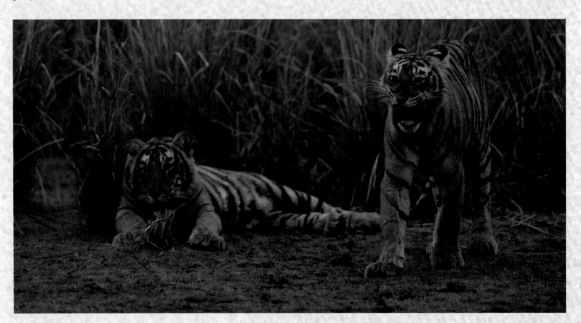

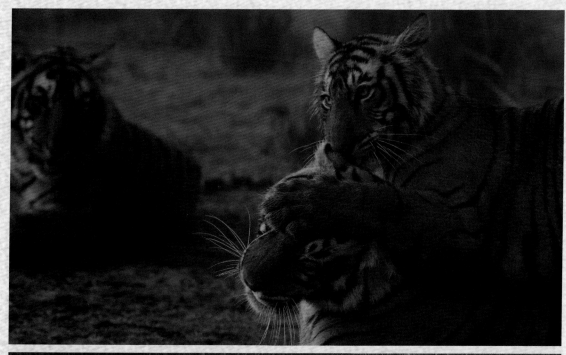

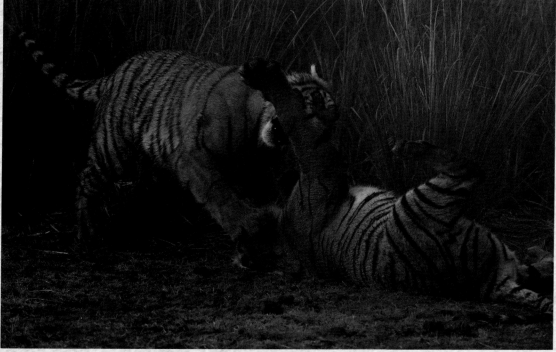

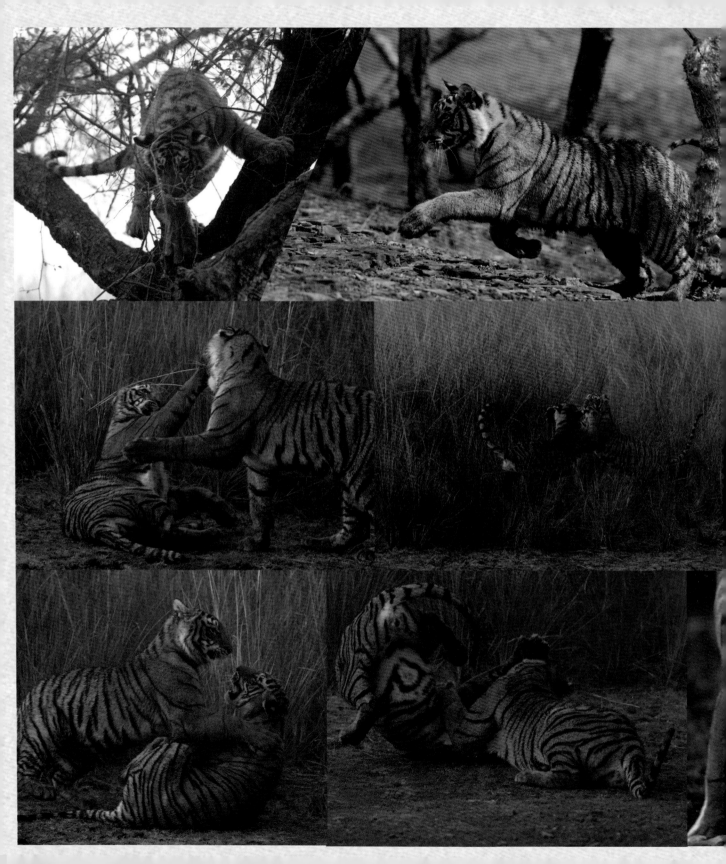

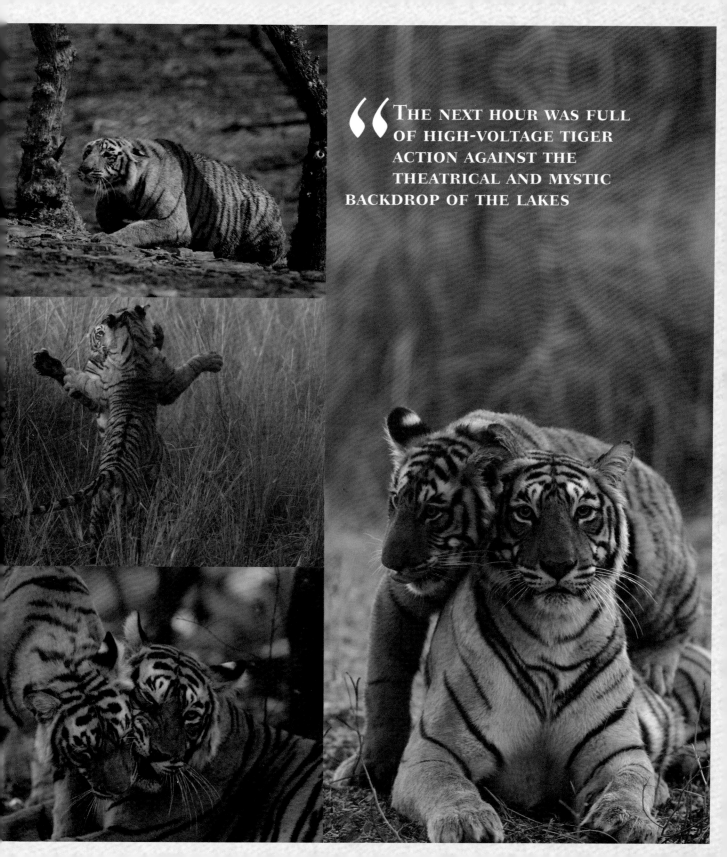

> THE NEXT HOUR WAS FULL OF HIGH-VOLTAGE TIGER ACTION AGAINST THE THEATRICAL AND MYSTIC BACKDROP OF THE LAKES

Summer Splashes at Malik Talao

11 May 2015

It was nice and sunny morning as we cruised towards the picturesque Malik Talao. When we turned towards the lake, from a distance Krishna could be seen resting at the edge of the water. By the time we approached her, all the cubs ran towards the mother, splashing water all round, for a group nuzzle. Krishna was reluctant to entertain the cubs but they

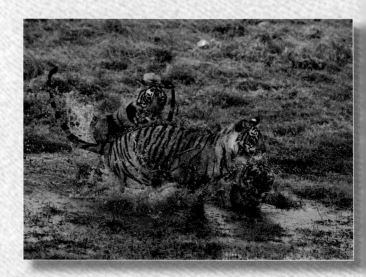

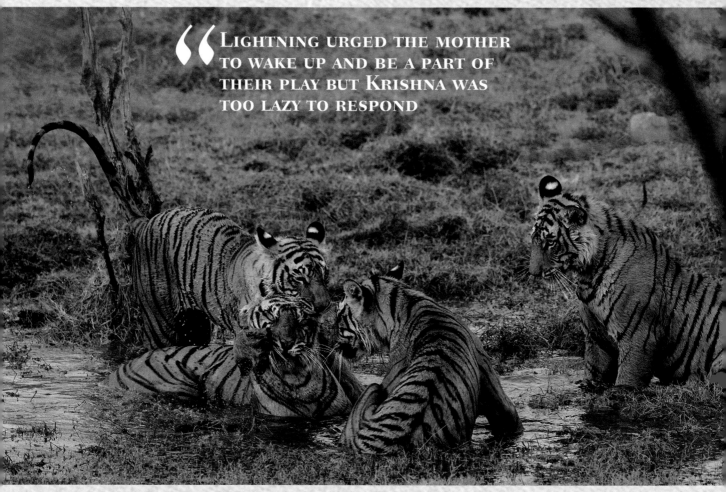

" LIGHTNING URGED THE MOTHER TO WAKE UP AND BE A PART OF THEIR PLAY BUT KRISHNA WAS TOO LAZY TO RESPOND

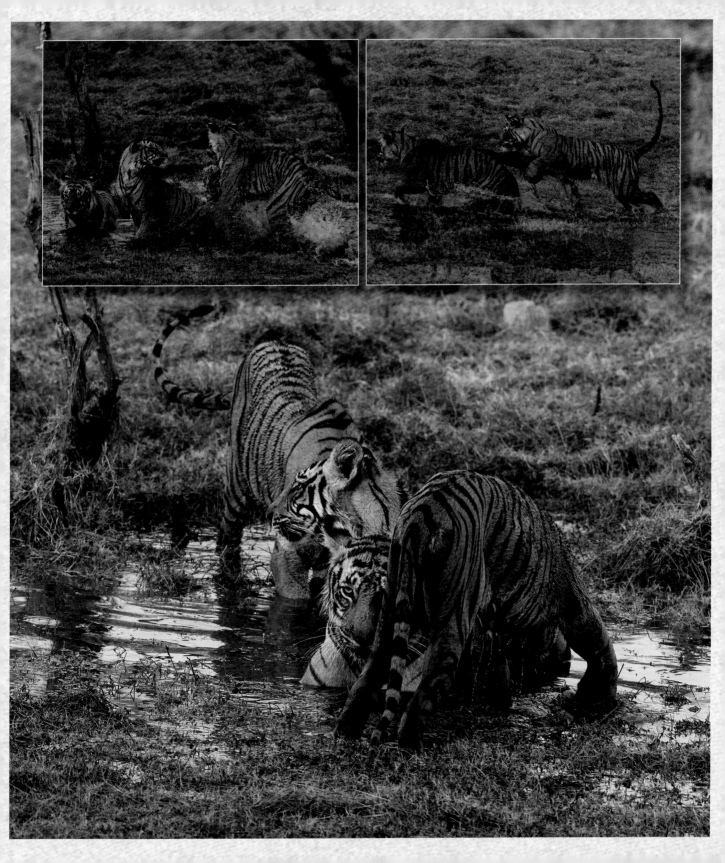

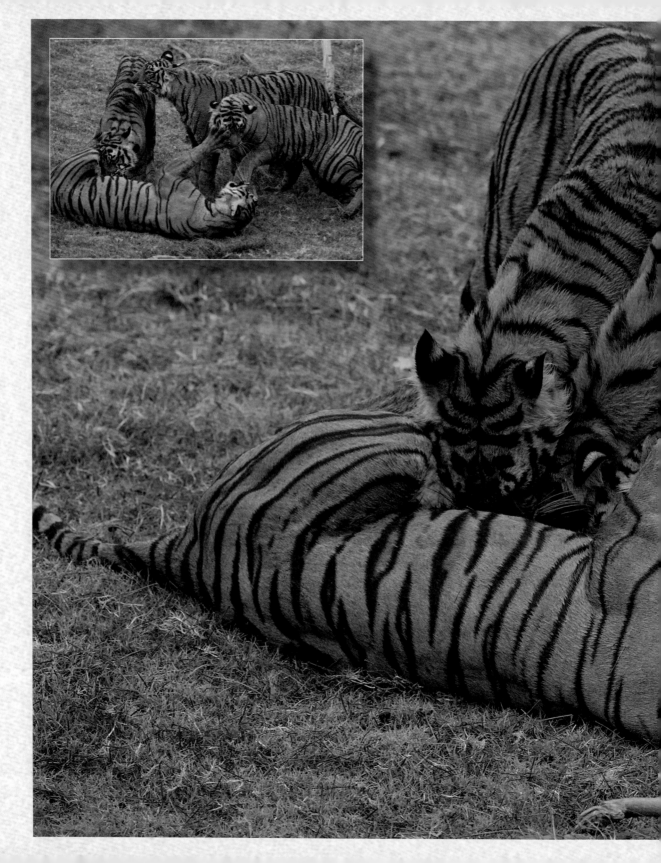

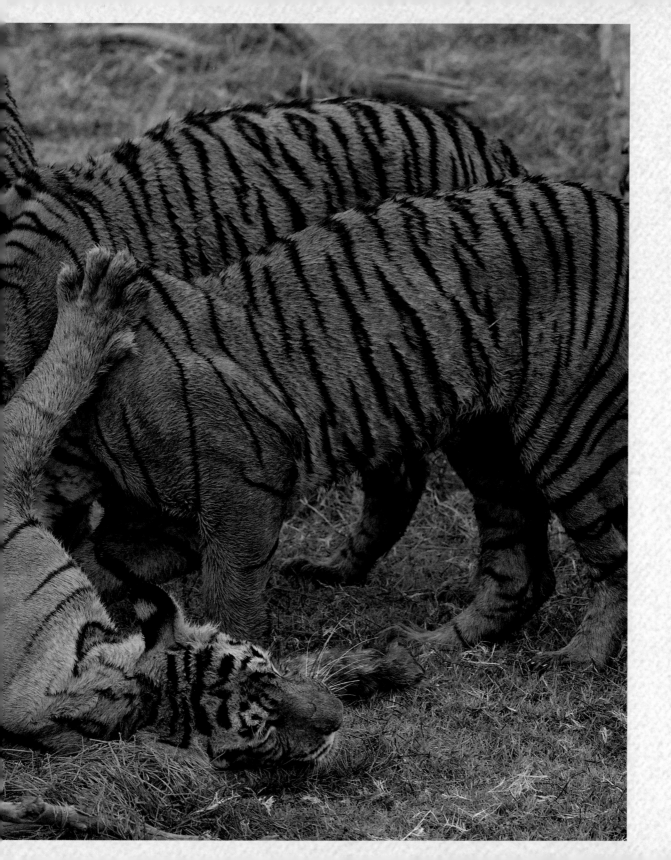

continued to vie her attention. After multiple attempts, Krishna finally decided to move towards the forest cover but the cubs didn't want the play to end so soon.

The three musketeers surrounded Krishna in an attempt to milk-feed and Krishna was not amused at all. She pushed them away but decided to play around with the cubs for a bit to control their excitement. She matched the sprints of the cubs and made them play till the time they finally settled at the edge. Finally after an hour, she led them into the thick dhonk forests where the family rested for the rest of the day.

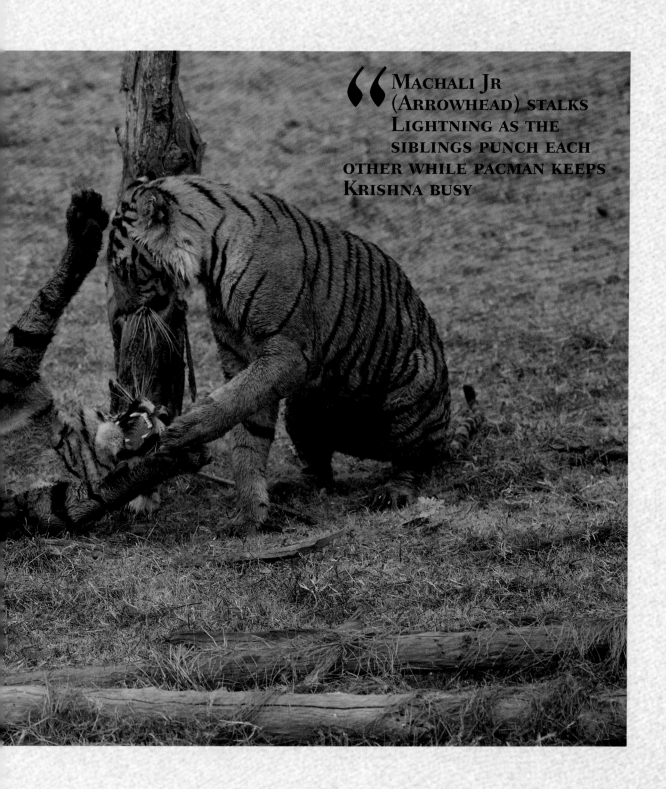

"Machali Jr (Arrowhead) stalks Lightning as the siblings punch each other while Pacman keeps Krishna busy

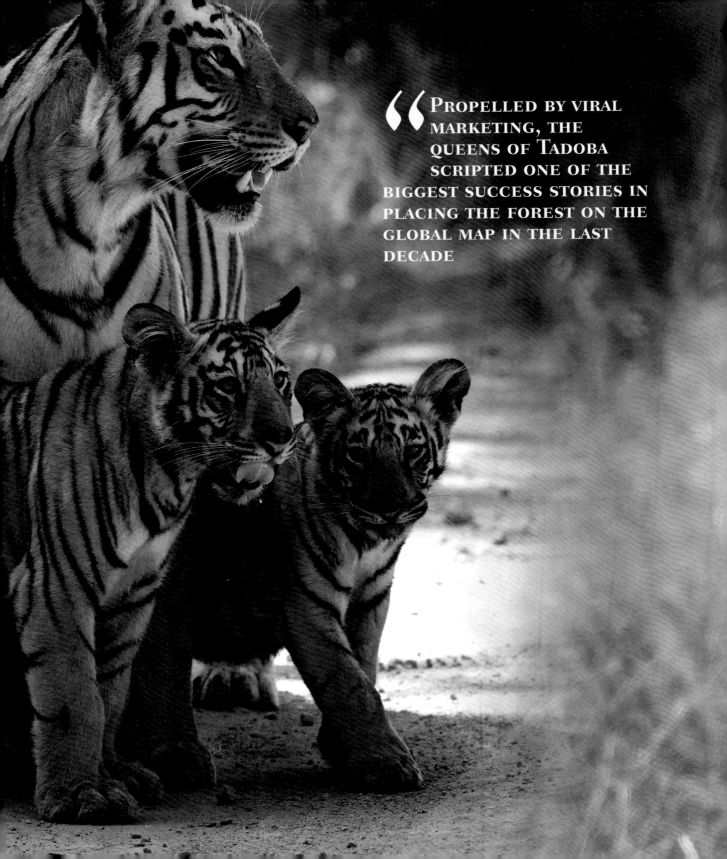

"PROPELLED BY VIRAL MARKETING, THE QUEENS OF TADOBA SCRIPTED ONE OF THE BIGGEST SUCCESS STORIES IN PLACING THE FOREST ON THE GLOBAL MAP IN THE LAST DECADE

TADOBA

QUEENS OF VIDARBHA
The Emergence of Tadoba

The standard of tiger photography in India has improved dramatically in the last five years. The volume of tiger photography enthusiasts has also grown exponentially during this period. One key turning point in this regard was the period between 2010 and 2013, when an earlier unheard of forest in central India came into the limelight and made tiger sighting and photography look like child's play.

Propelled by viral marketing through social media, the Tadoba-Andhari Tiger Reserve scripted the biggest success story during that three-year time frame, turning it into the hottest destination for tiger enthusiasts. Tadoba owed this rise in popularity to a few tigresses along with the most playful and boisterous cubs the country had seen in a long time. I was fortunate enough to photograph these families during this opportune period—the late Panderpauni female

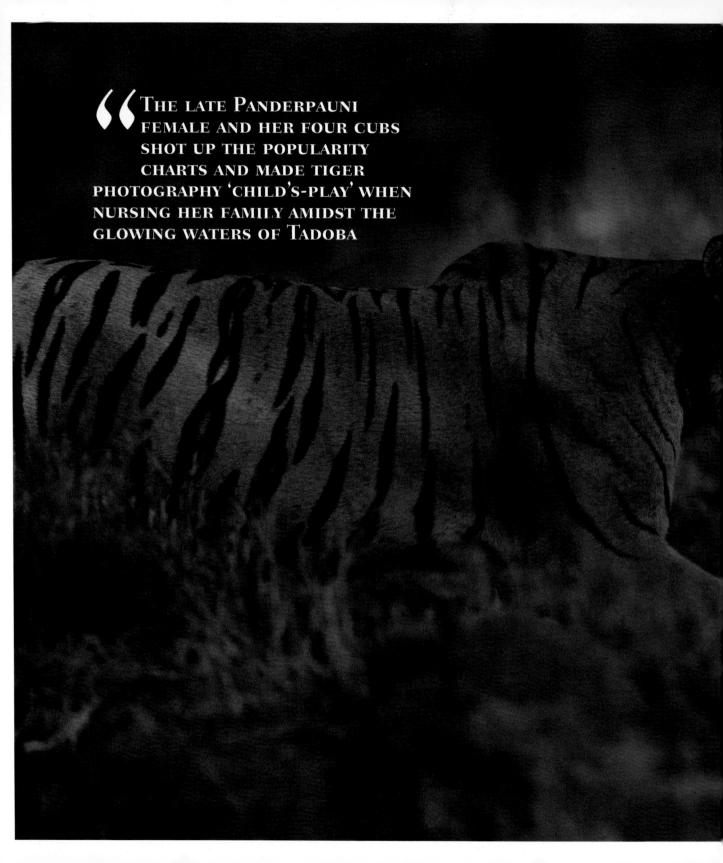

"THE LATE PANDERPAUNI
FEMALE AND HER FOUR CUBS
SHOT UP THE POPULARITY
CHARTS AND MADE TIGER
PHOTOGRAPHY 'CHILD'S-PLAY' WHEN
NURSING HER FAMILY AMIDST THE
GLOWING WATERS OF TADOBA

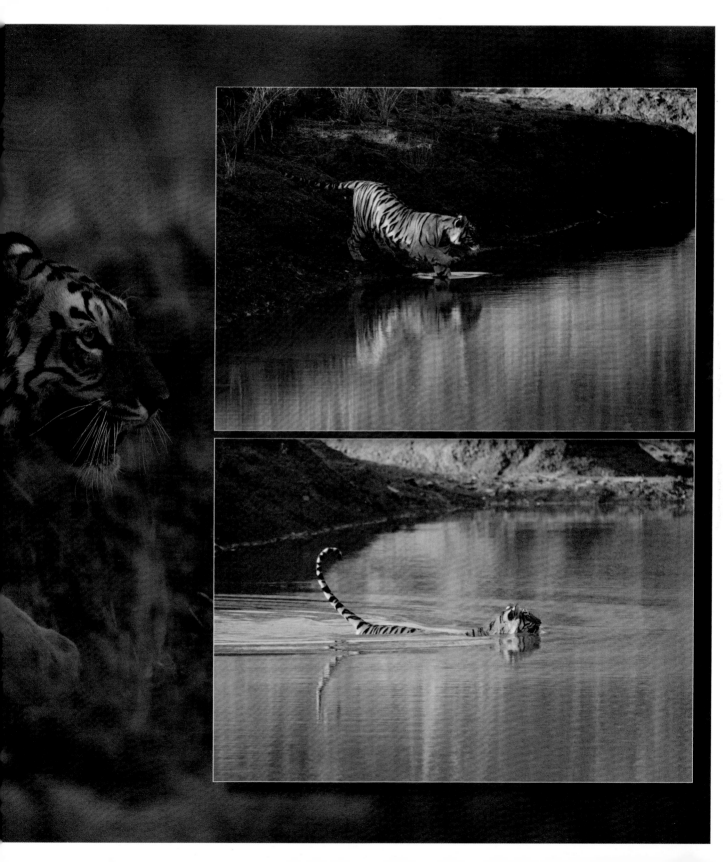

" The revival and success of Tadoba is due largely to effective forest management practices, where tigers were given adequate space to breed, and the cats took no time to respond. Today, Tadoba lives up to its reputation of easy tiger sightings with an abundance of water and prey

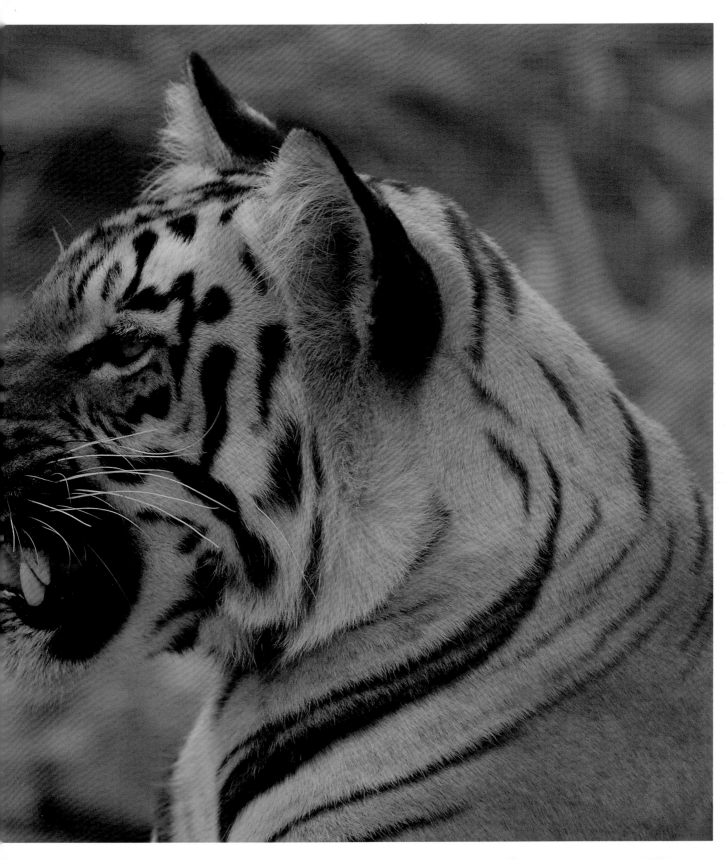

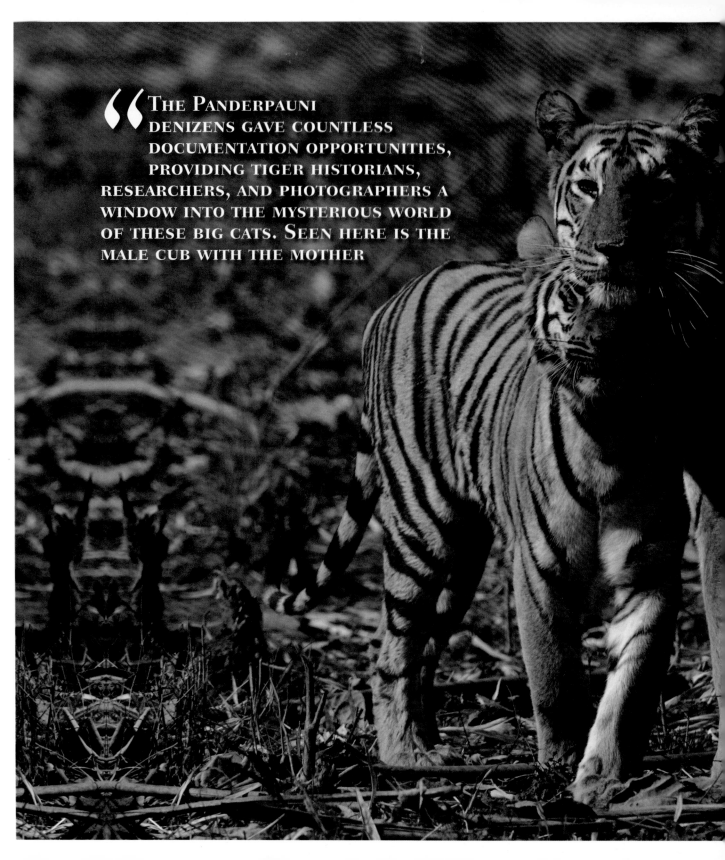

"THE PANDERPAUNI DENIZENS GAVE COUNTLESS DOCUMENTATION OPPORTUNITIES, PROVIDING TIGER HISTORIANS, RESEARCHERS, AND PHOTOGRAPHERS A WINDOW INTO THE MYSTERIOUS WORLD OF THESE BIG CATS. SEEN HERE IS THE MALE CUB WITH THE MOTHER

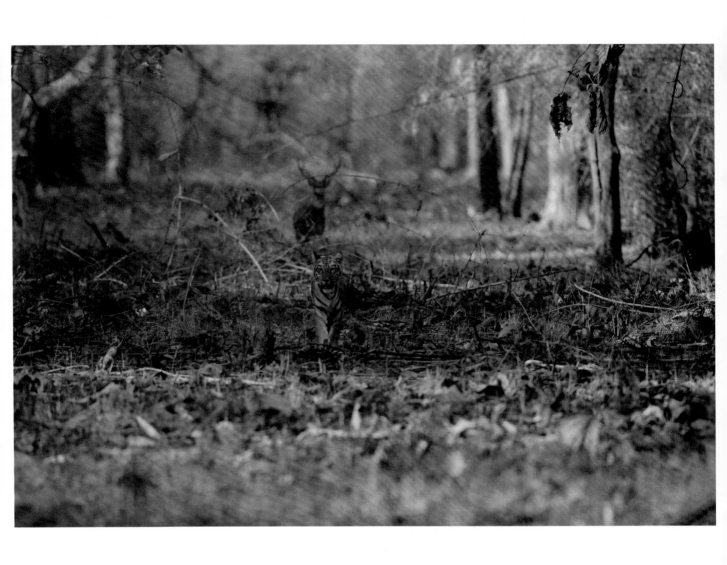

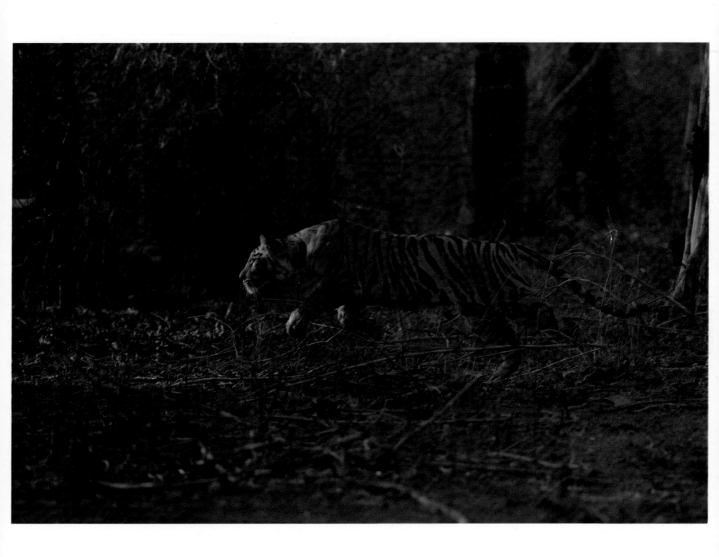

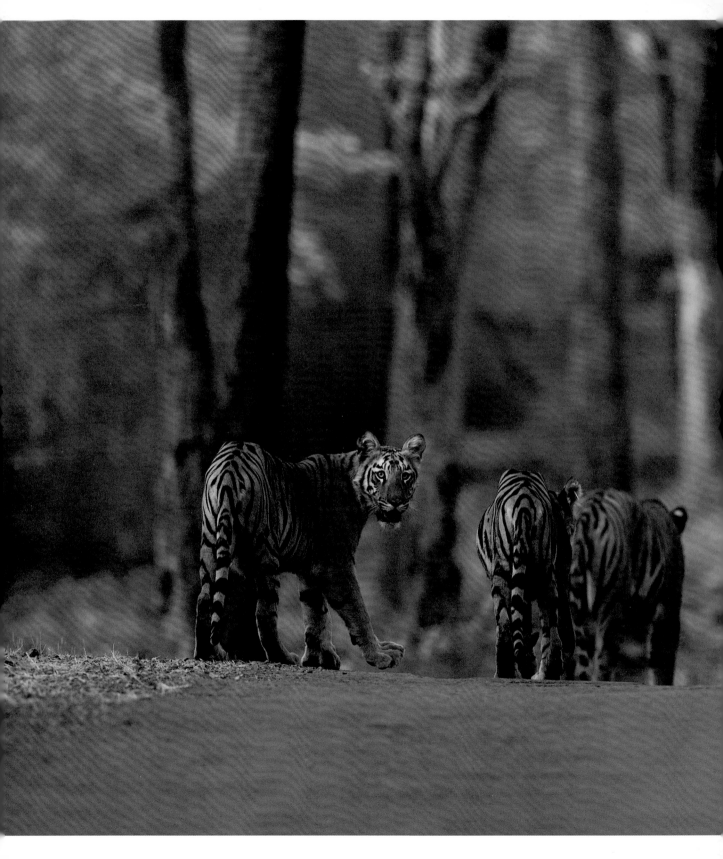

and her litter of four cubs ruled the Tadoba lake area; the Telia female Madhuri and her cubs controlled the Telia lake in Moharli; the Wagdoh female had established rights over the bamboo forest areas in Wagdoh, right up to the river; and not to lag behind was the Katezari female and her little cubs, often joined by the adults from her previous litter. From hunting to play and other interactions, the tiger mothers along with their young battalions provided ample opportunities for in-depth photographic documentation in the world of tigers. Tadoba, in a way, changed

" MADHURI, THE MATRIARCH OF TELIA, AND HER GANG OF GIRLS EMERGED AS THE STAR ATTRACTION DURING THE 2011—2013 PERIOD AS THEY MADE THE LAKES THEIR PLAYGROUND

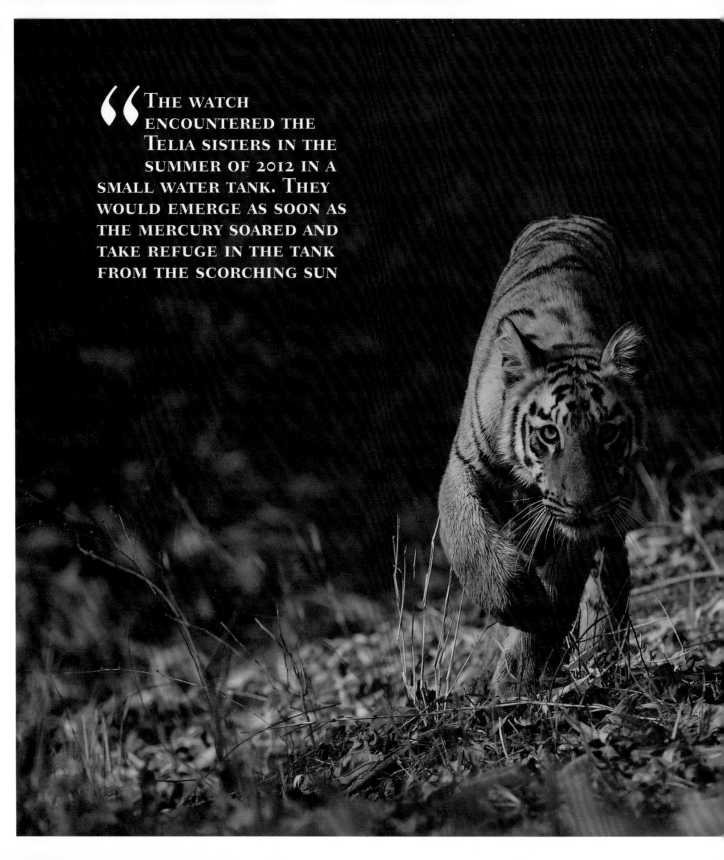

"THE WATCH ENCOUNTERED THE TELIA SISTERS IN THE SUMMER OF 2012 IN A SMALL WATER TANK. THEY WOULD EMERGE AS SOON AS THE MERCURY SOARED AND TAKE REFUGE IN THE TANK FROM THE SCORCHING SUN

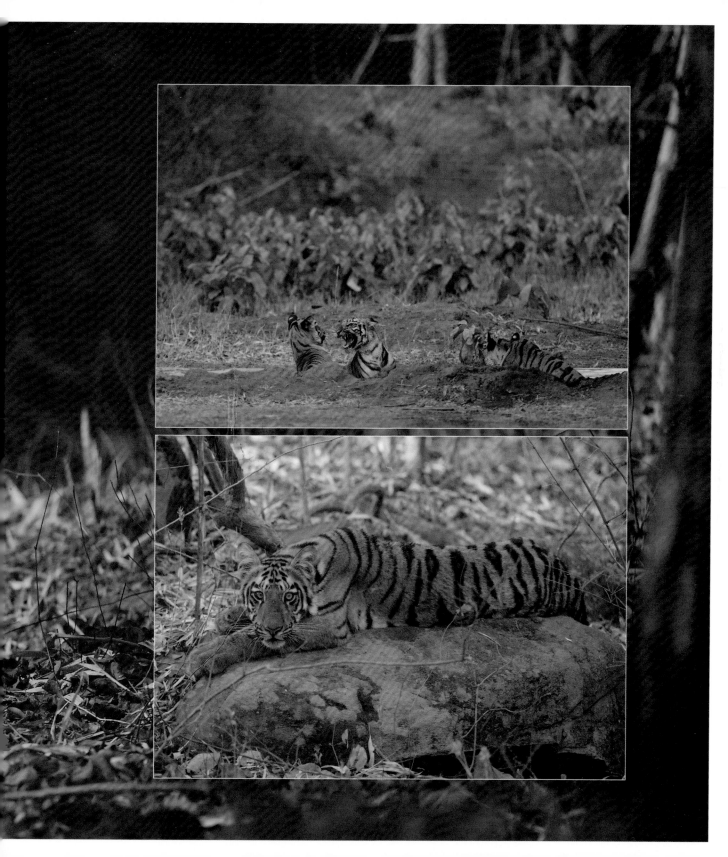

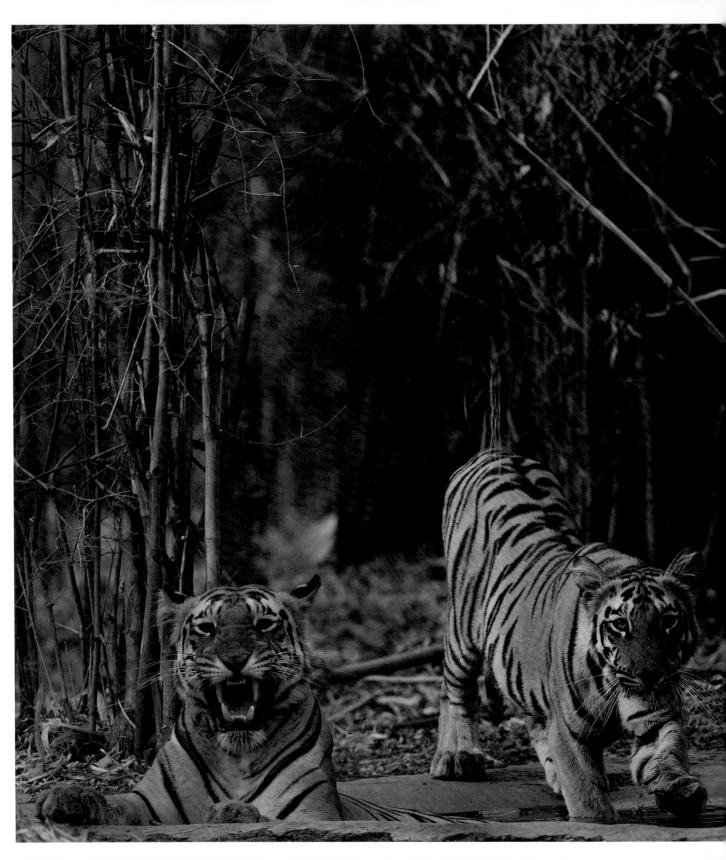

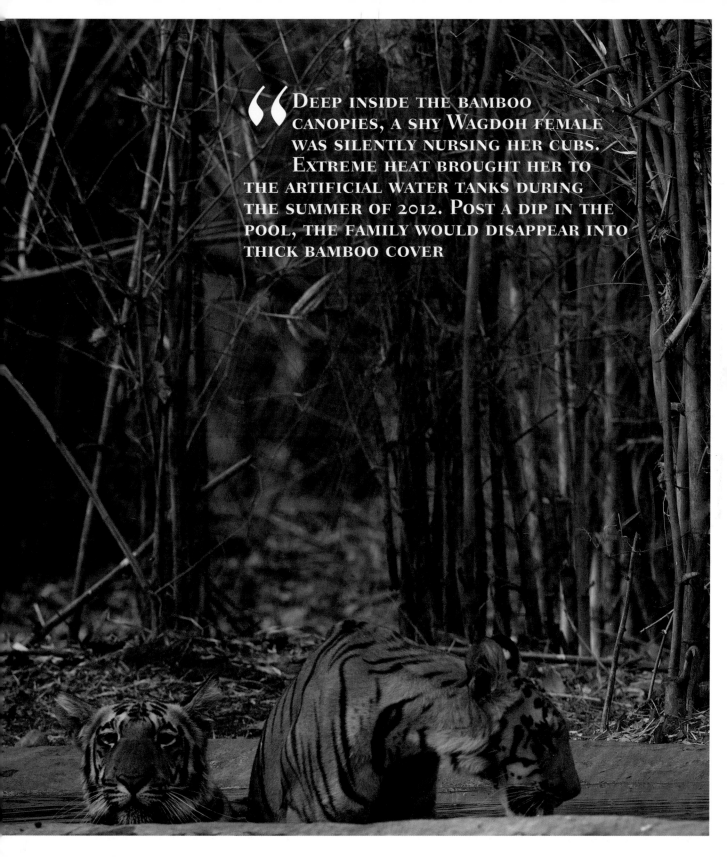

"DEEP INSIDE THE BAMBOO CANOPIES, A SHY WAGDOH FEMALE WAS SILENTLY NURSING HER CUBS. EXTREME HEAT BROUGHT HER TO THE ARTIFICIAL WATER TANKS DURING THE SUMMER OF 2012. POST A DIP IN THE POOL, THE FAMILY WOULD DISAPPEAR INTO THICK BAMBOO COVER

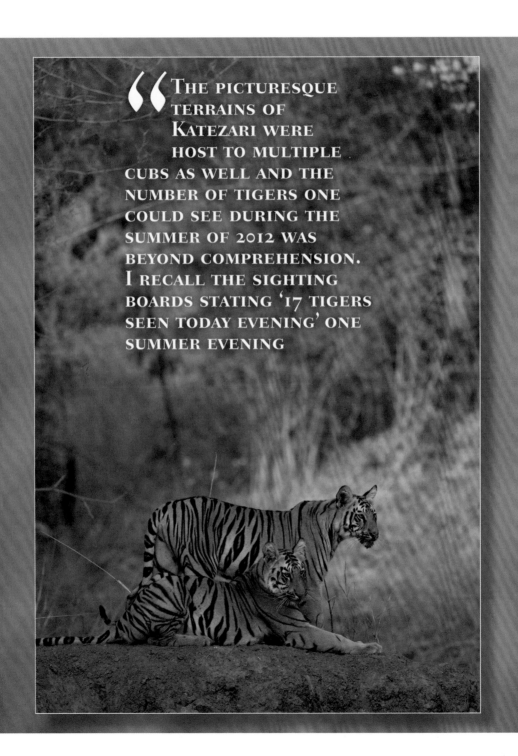

"THE PICTURESQUE
TERRAINS OF
KATEZARI WERE
HOST TO MULTIPLE
CUBS AS WELL AND THE
NUMBER OF TIGERS ONE
COULD SEE DURING THE
SUMMER OF 2012 WAS
BEYOND COMPREHENSION.
I RECALL THE SIGHTING
BOARDS STATING '17 TIGERS
SEEN TODAY EVENING' ONE
SUMMER EVENING

many long-held notions about tiger behaviour. For instance, it was earlier believed that the role of a male tiger was only to mate, never to be seen after that. It was during this phase that photographers recorded male tigers tending to cubs, sharing meals and waterholes with their offspring. The wildlife diaries of Jim Corbett mentioned tiger and sloth bear encounters. Such rare moments in natural history were witnessed in real time, that too quite frequently; Madhuri and her cubs were seen hunting down a sloth bear mother and cub as photographers clicked away.

A cub from the Katezari brigade on a hot summer morning

FACING PAGE
The Katezari cub curiously smelling a tree as the sibling walks away

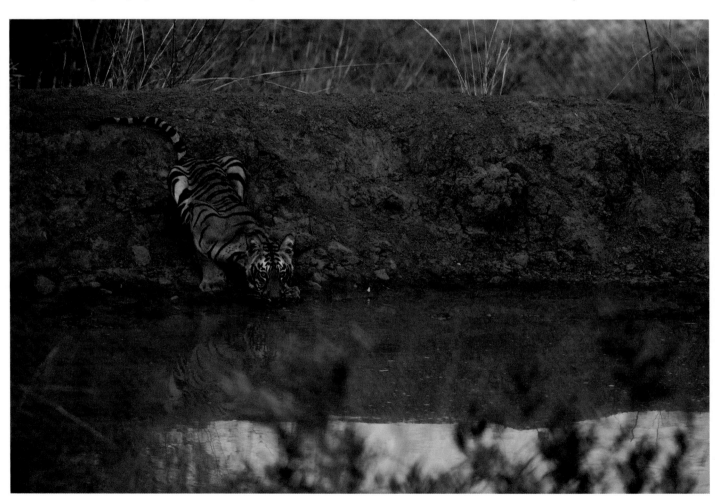

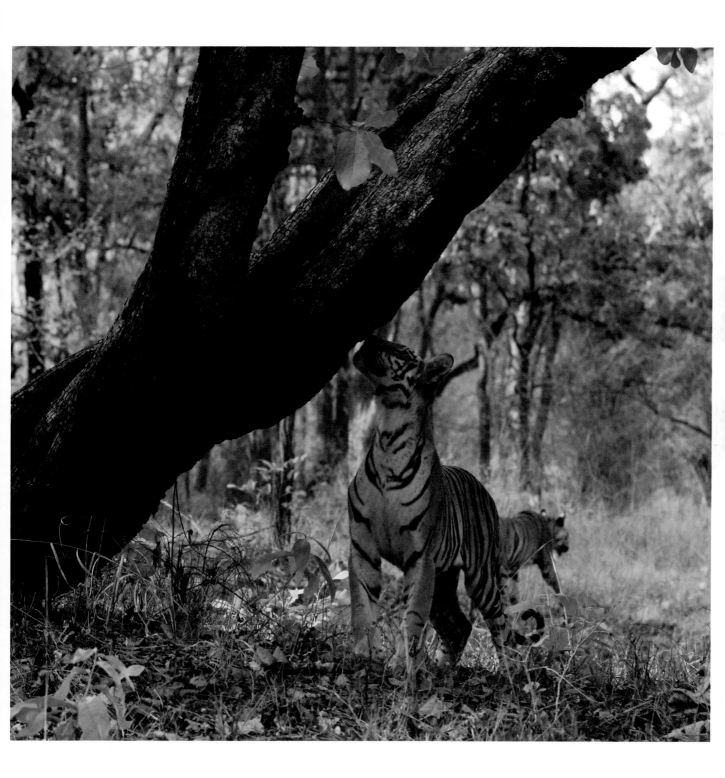

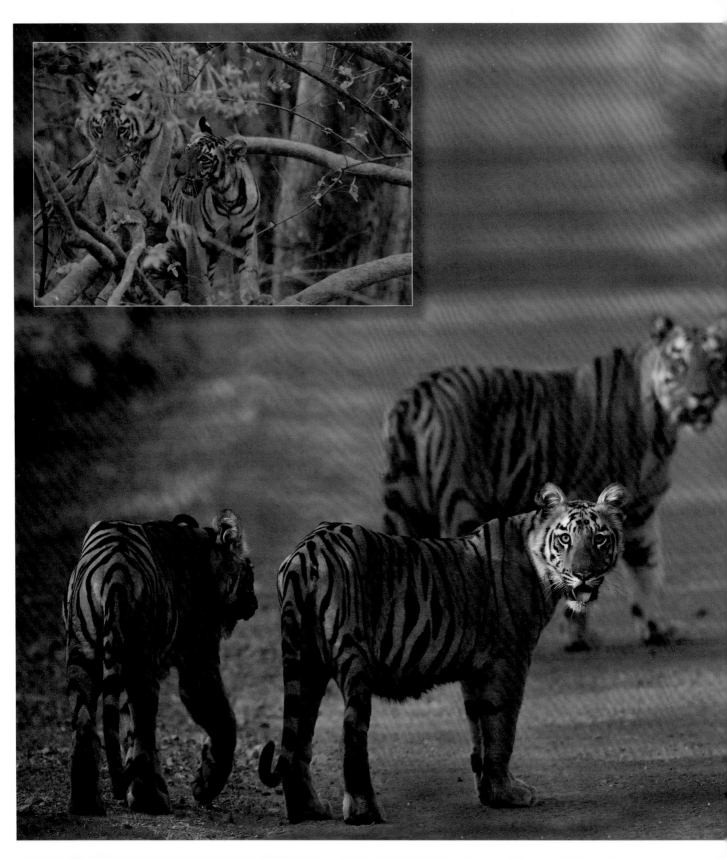

All this and more has made Tadoba and its families very special. The tigers of Tadoba were not shy or elusive, helping experts gain an insight into the lives of tigers and change popular perceptions.

The most popular of these families was Madhuri and her all-female litter, known affectionately as the 'Telia Girl Gang'. The lush green Telia lakeside flanked by bamboo forests was their playground. Visitors to the park were treated to some rare and exciting tiger behaviour, courtesy Madhuri and her girl gang. Madhuri trained and raised her cubs well: all the females were bold and had strong individual characters; having the huge Wagdoh male as father was an added advantage.

> **MADHURI WALKS WITH HER ALL-GIRL GANG ON THE MAIN ROAD LEADING TO MOHARLI IN MAY 2012. ONE FROM THIS LITTER WAS LATER NAMED SONAM, CURRENTLY THE QUEEN OF THE LAKES IN TELIA. THE CUBS PLAYED MERRILY AROUND THE BAMBOO FORESTS OF MOHARLI**

I went back to Tadoba in the 2015–2016 season after a three-year gap in search of Maya—one from the litter of the 2011–2013 Panderpauni female I had photographed—as she was then raising a litter of three cubs, and Sonam—one of Madhuri's cubs—who claimed her mother's territory with her own three cubs. It was special to see cubs becoming caring mothers themselves and taking over the reins of the tiger kingdom. Watching the two mothers walking the same path with their young ones made me nostalgic—the powerful visuals of the 2012 era kept running through my mind like a flashback.

FACING PAGE
Maya walks on the road leading to Panderpauni with her young brigade

The devoted mother Maya with two of her cubs in the grasslands during December 2015

MAYA AND CUBS

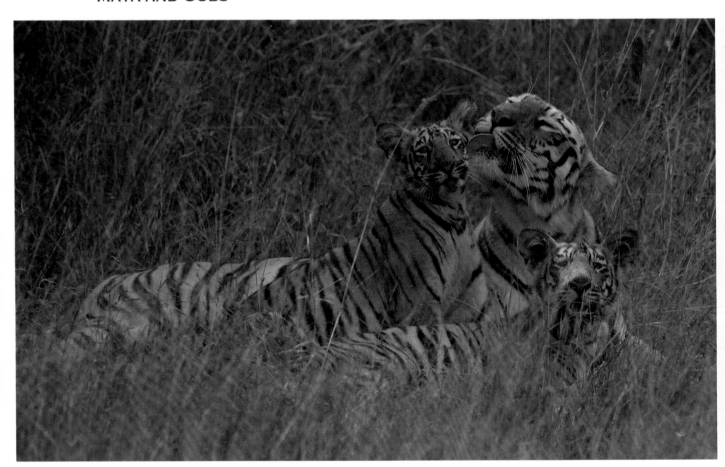

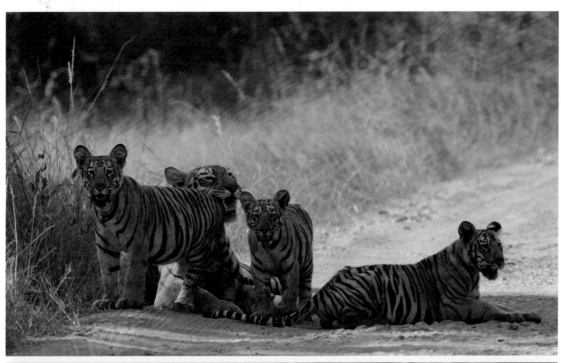

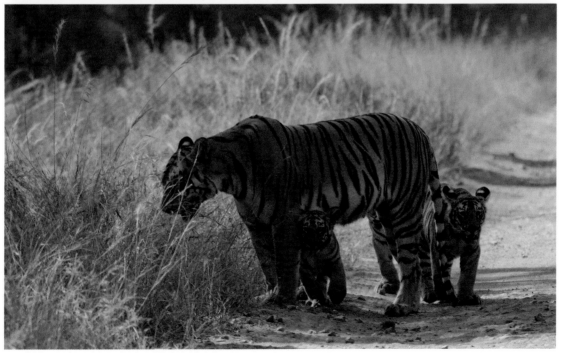

> MAYA LOST THE CUBS FROM HER FIRST LITTER EARLY. SHE, HOWEVER, TOOK OVER THE REINS OF PANDERPAUNI FROM HER MOTHER AND SUCCESSFULLY RAISED HER SECOND LITTER

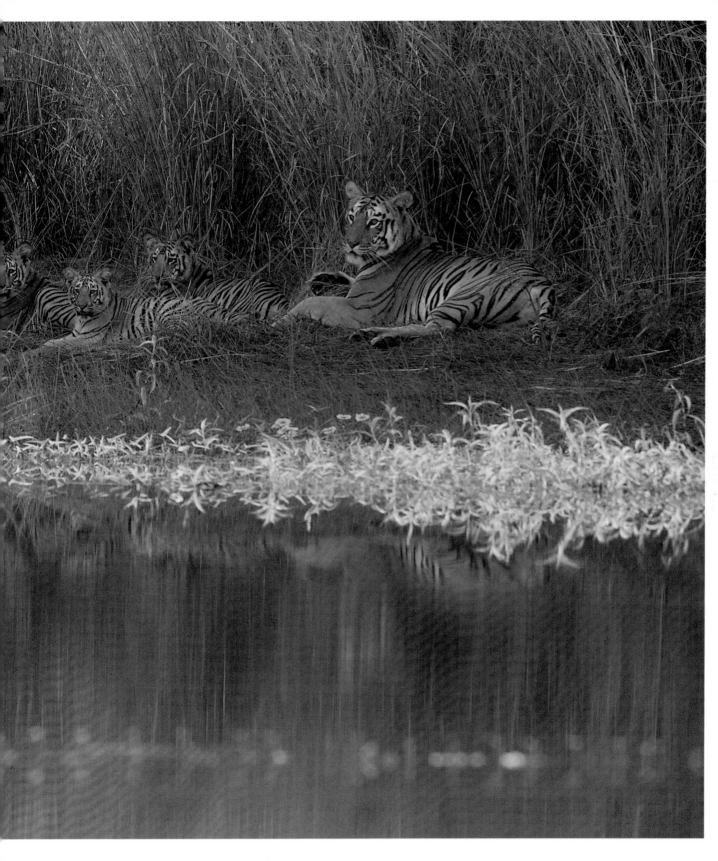

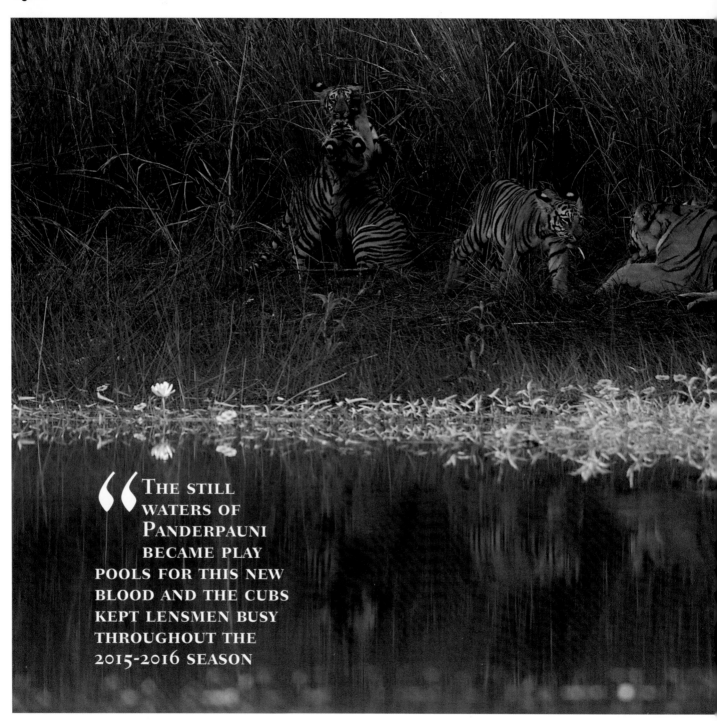

"THE STILL
WATERS OF
PANDERPAUNI
BECAME PLAY
POOLS FOR THIS NEW
BLOOD AND THE CUBS
KEPT LENSMEN BUSY
THROUGHOUT THE
2015-2016 SEASON

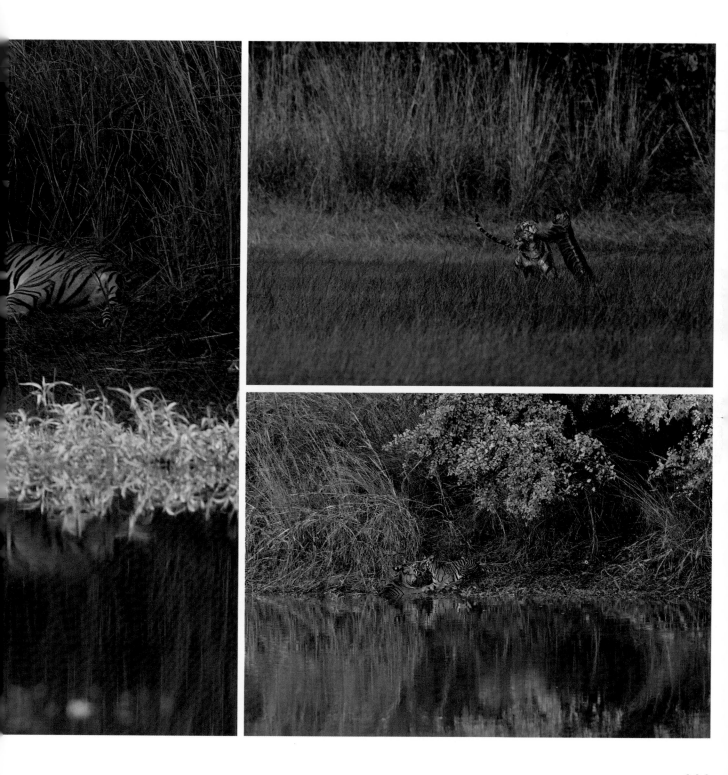

a decade with tigers

SONAM AND CUBS

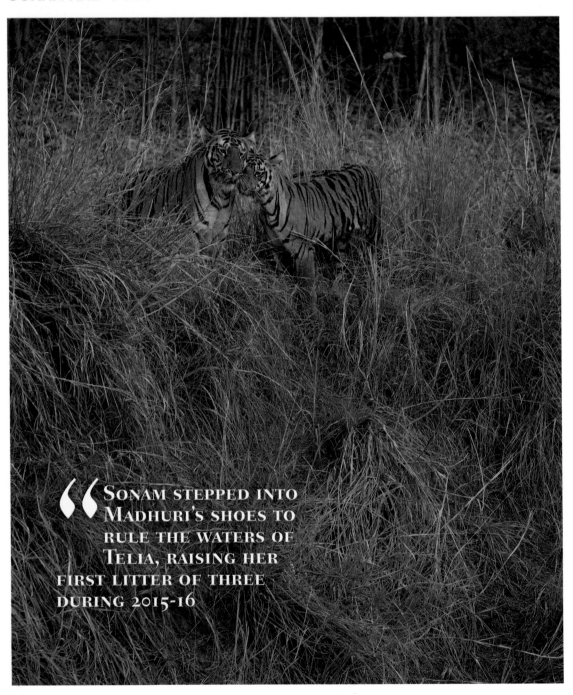

"SONAM STEPPED INTO
MADHURI'S SHOES TO
RULE THE WATERS OF
TELIA, RAISING HER
FIRST LITTER OF THREE
DURING 2015-16

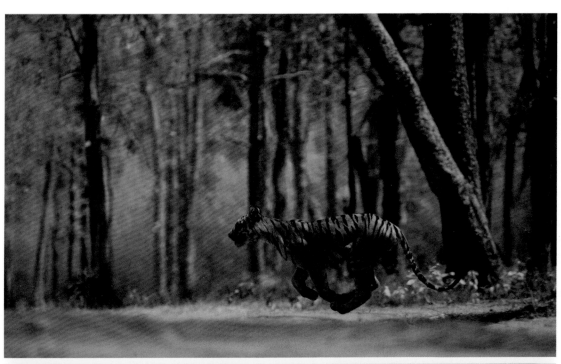
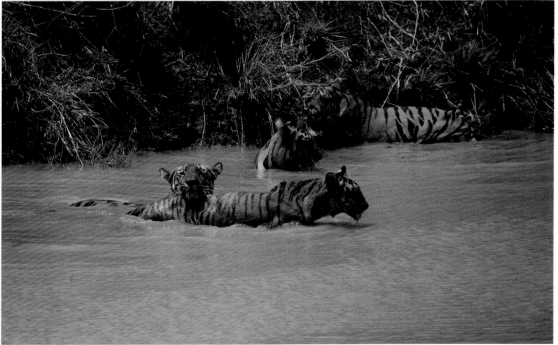

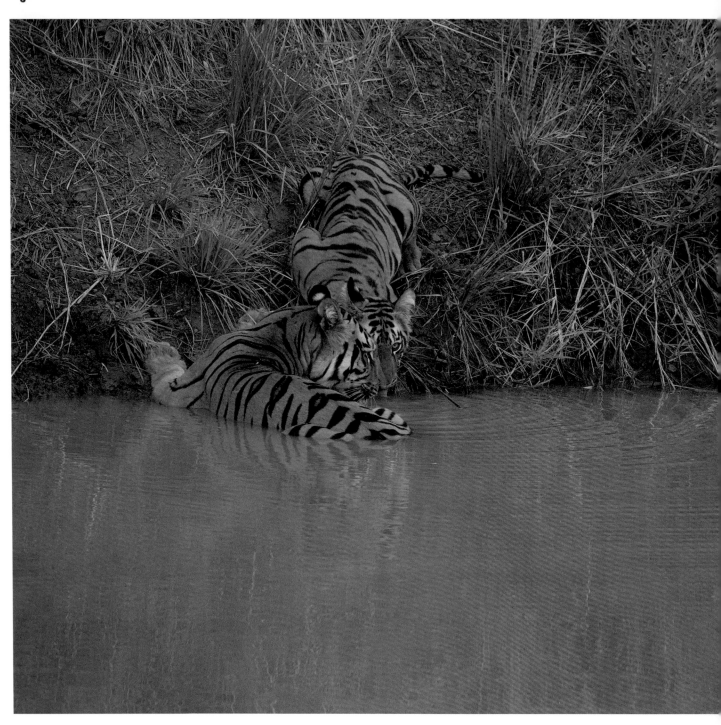

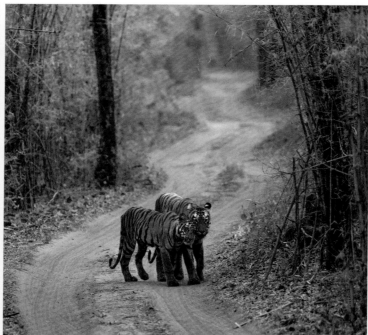

EXTREME LEFT
Sonam and her cub share a drink during the summer of 2016

(Above and below) Sonam and her cub wandering in the bamboo forests

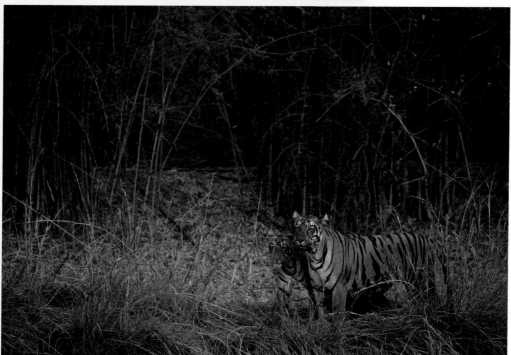

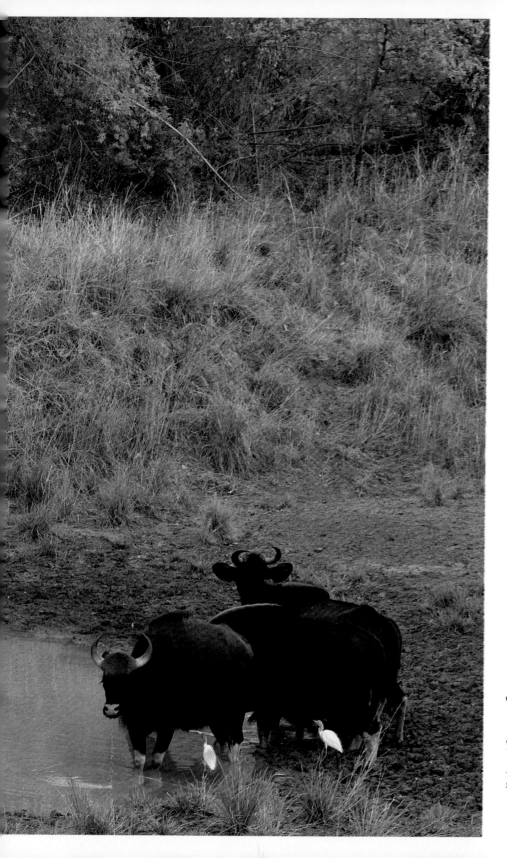

Sonam stalks a herd of Indian gaur at the Yenbodi waterbody in Moharli during the summer of 2016

"WITH 26 CUBS, COLLARWALI OF PENCH HAS ENTERED THE GUINNESS RECORD BOOK AS THE MOST PRODUCTIVE WILD TIGER MOTHER IN THE WORLD

PENCH

COLLARWALI
When mothers enter record books

She hit the headlines in her childhood when she became one of the cubs featured on BBC's *Tiger: Spy in the Jungle* documentary series, and has never been camera shy since. She grew up to acquire a vast territory from her mother in Mowgli land—Pench—and was collared by the forest department for research. She later set a record that will be hard to beat for any wild tiger in the world.

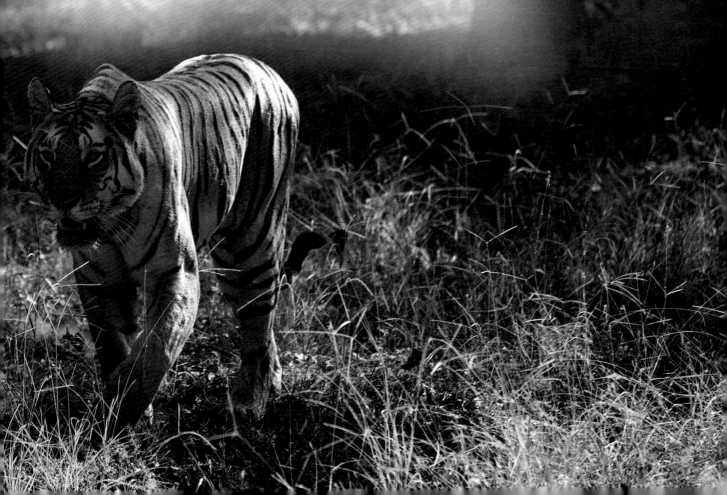

Collarwali took over the reins of Pench from her iconic mother Badi Maa (big mother), who was the main protagonist of the celebrated BBC documentary *Tiger: Spy in the Jungle*. The film was the first of its kind, where modern cameras and technologies were used to film wild tigers in India in the form of remote and trap cameras. Touted as one of the best tiger films from India, it was a tedious endeavour to document the newly born tiger cubs and to follow

THIS AND FACING PAGE
Collarwali walking through the forest and seen resting with a cub

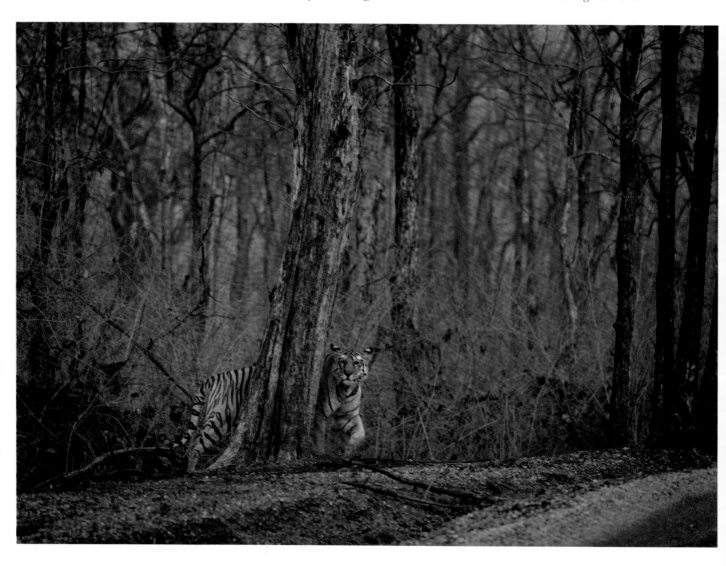

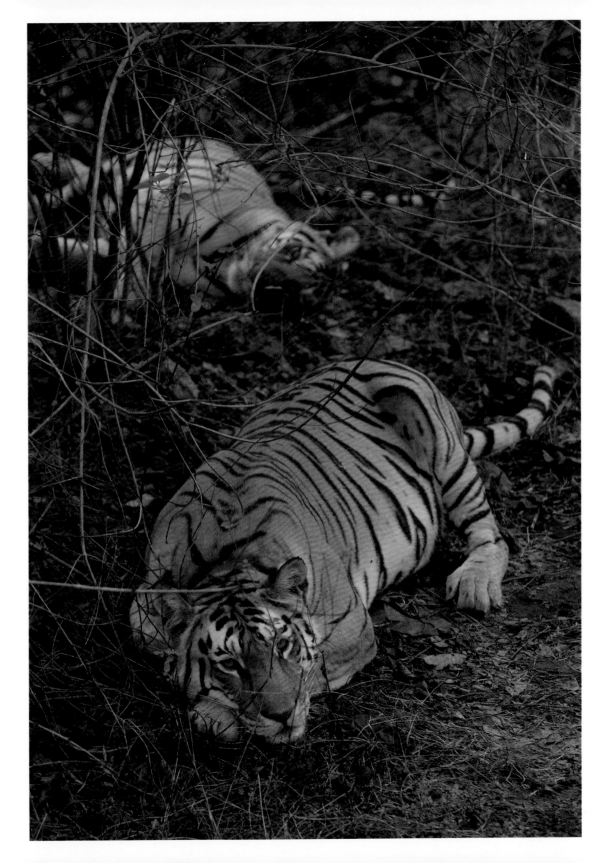

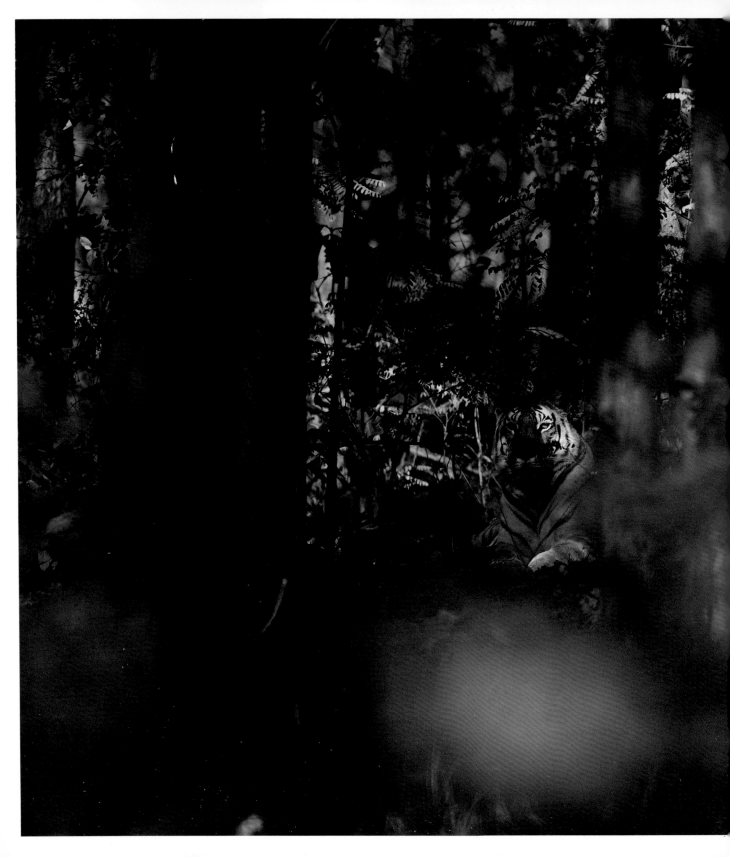

the entire family till separation. Sir David Attenborough lent his powerful baritone to this landmark film that afforded a glimpse into the secretive world of these cats. Young Collarwali featured as one of the cubs in the film. My Pench ventures started much later, but it was an honour to spend a few hours with the celebrated Badi Maa during the winter of February 2012 as she raised her last litter. She subsequently disappeared, never to be seen again.

With 26 cubs, Collarwali—the legendary queen of Pench—entered the record books as one of the most productive tigresses in the world. Collarwali gave birth to her first litter of three cubs in 2008 at the age of two and a half years. The cubs, however, did not

"BEING A CELEBRITY TIGER CAME NATURALLY TO COLLARWALI AS SHE TOOK OVER THE REINS FROM HER ICONIC MOTHER BADI MAA (BIG MOTHER), WHO FEATURED IN A BBC FILM

survive. In October 2008, some mahouts recorded her second litter of four cubs. She showed indications of being a remarkable mother by successfully raising this litter. Two years later, in 2010, she made history in Pench by being the first tigress to have a litter of five cubs. A master hunter, endowed with the capability of bringing down large prey, she ensured that she sufficiently fed her five cubs to raise them to maturity.

In today's era of social media, every tiger reserve needs a brand ambassador; Collarwali was sensational enough for Pench to get global recognition, boosting tourism revenues and employment for the local communities as well. In May 2012, Collarwali was again seen with a fresh litter of three cubs. While one of the cubs did not survive, she raised the remaining two to maturity. Her fifth litter was seen in October 2013, which she again raised successfully. It was astonishing when the tigress produced her sixth litter of four cubs in 2015, breaking records and changing a lot of textbook theories pertaining to tiger behaviour. Typically, tiger cubs stay with their mother for a period of two years, and separation is a slow and gradual process. Surprisingly, in the case of Collarwali, cubs of the fourth and fifth litters were born not even two years apart, and she was documented raising both litters together. Collarwali's amazing run as the top tiger mother of India continues with her seventh litter, spotted in April 2017 as this book goes for production.

Her contribution to the population of tigers in Pench has been phenomenal, though she may now be seeing the last of her reproductive ability. Despite her radio collar, she has been a photographer's delight owing to her charismatic features and her legendary reputation of being India's most successful tiger mother.

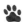

Collarwali emerges from the thick teak forests of Pench on separate occasions, once in 2012 and again in 2015

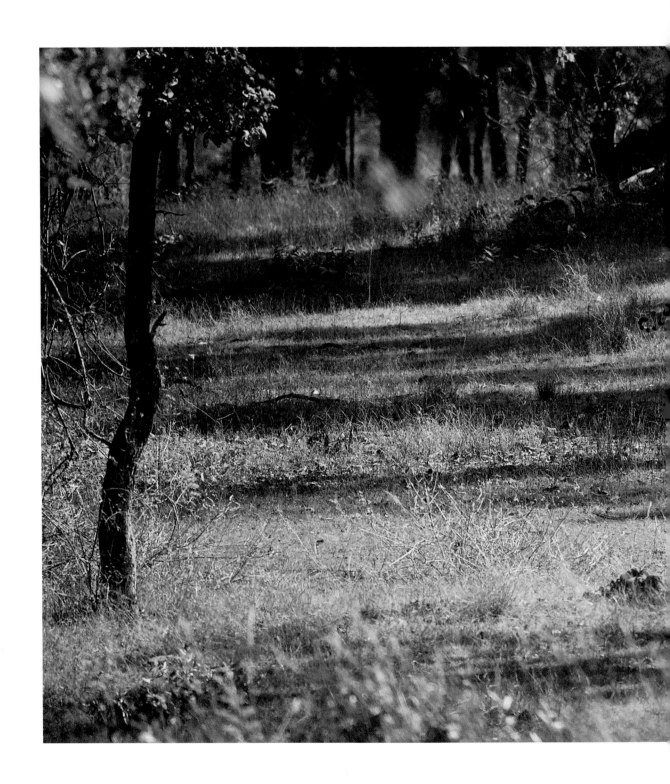

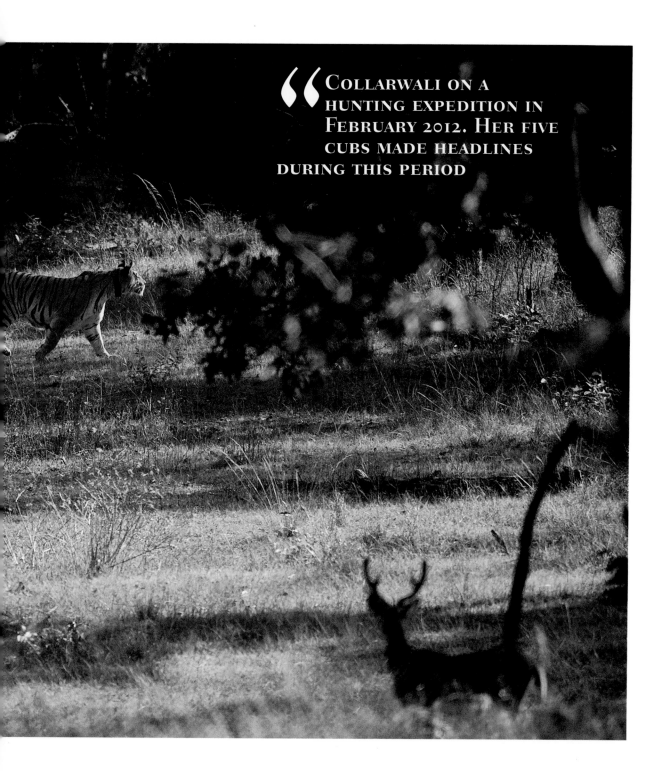

"Collarwali on a hunting expedition in February 2012. Her five cubs made headlines during this period

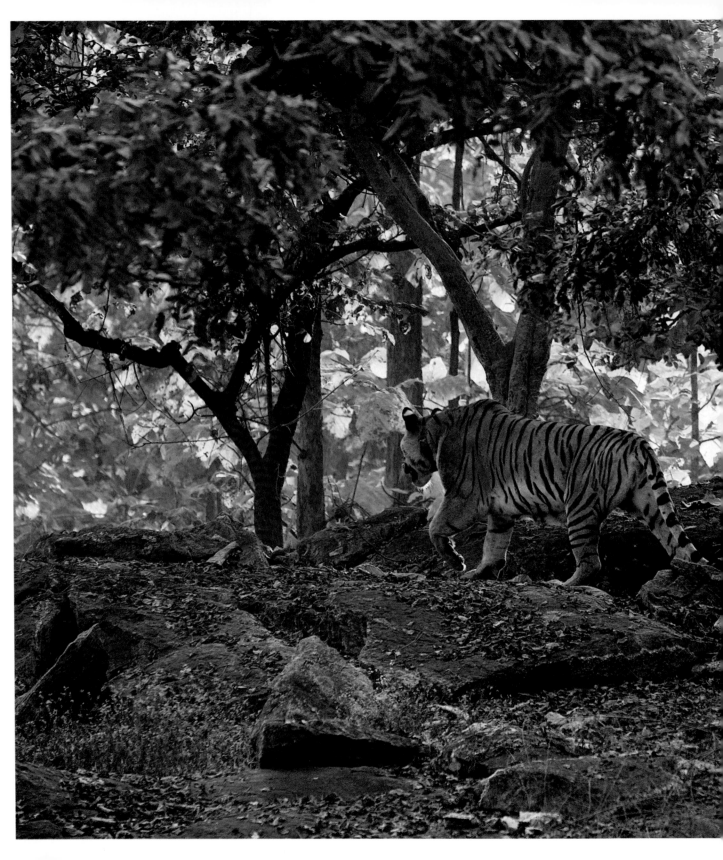

"A TRUE BRAND AMBASSADOR OF PENCH AND INDIAN TIGERS, COLLARWALI HAS PLAYED A VITAL ROLE IN PUTTING PENCH ON THE GLOBAL MAP AND AS A TOURISM MAGNET

Anecdotes

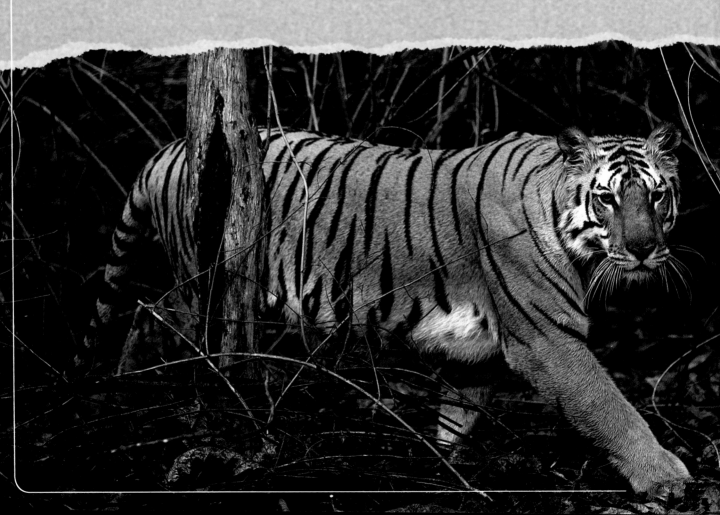

Collarwali during a downpour in Pench

My work with Collarwali has been memorable as she was one of the first tigers I photographed in Pench. It was the spring of 2015 and the land of Jungle Book was aglow in a riot of colours. On an overcast morning, I decided to head off to Collarwali's area and track her whereabouts. While we were trying to deduce her movements by analysing pugmarks from the previous night, my guide Anil suddenly spotted a tiger cub sitting outside the lantana in the open. The cub was bold but took cover in the lantana as soon as he heard the sound of other vehicles at a distance.

The local forest guards who were patrolling the area informed us that the entire family, comprising both the old and new litters, was hiding in the lantana, but the mother wasn't in the area. We decided to camp at the location for the day, waiting for the mother. As the day

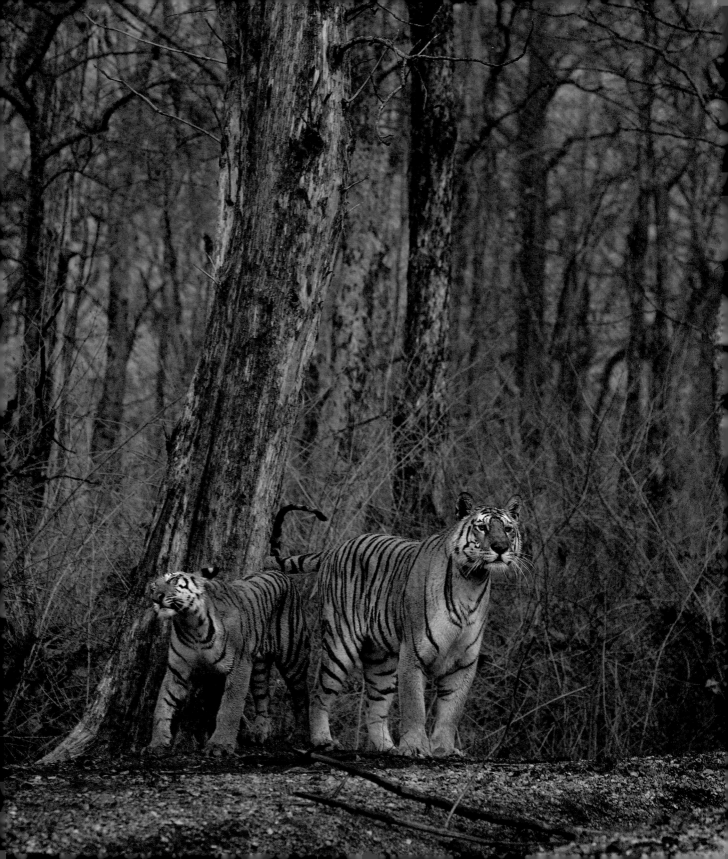

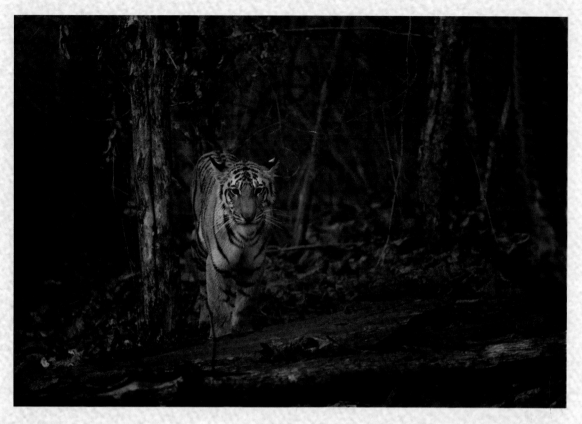

> **"WATER DRIPPED FROM ALL PARTS OF MY CAMERA AS WELL AS FROM THE TIGER'S BODY AS WE BOTH GOT DRENCHED IN THE DOWNPOUR**

progressed, I could see dark clouds on the horizon, closing in on our part of the forest. Rain was round the corner as humidity surged by noon. After a nine-hour wait, at around 4 pm, a light drizzle transformed into a heavy downpour. The colourful forest dazzled with freshness amidst the intoxicating petrichor. As the rain intensified, a cheetal alarm call announced the arrival of Collarwali, who walked majestically through the thick lantana foliage and called for her cubs. Within seconds, tiger cubs hiding in the undergrowth ran towards the mother and cuddled up to her.

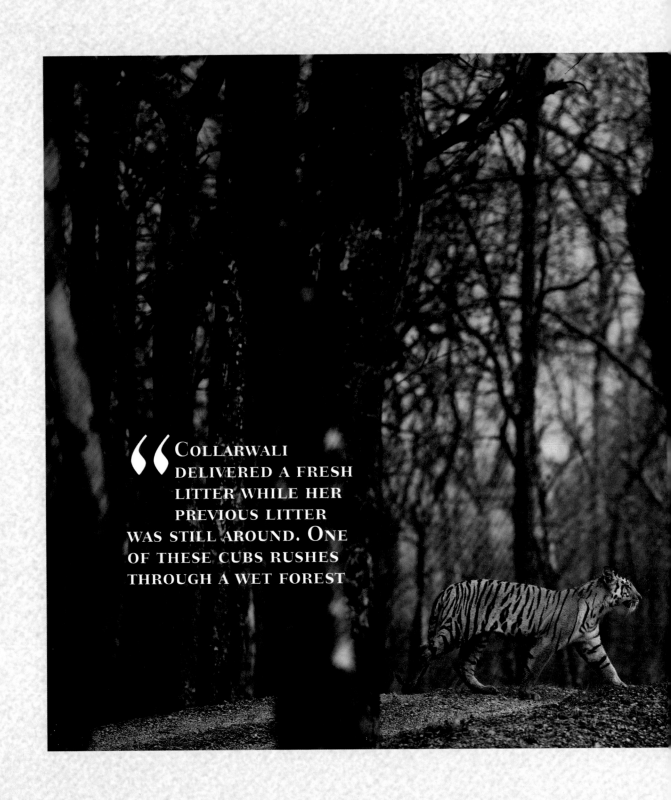

> **COLLARWALI DELIVERED A FRESH LITTER WHILE HER PREVIOUS LITTER WAS STILL AROUND. ONE OF THESE CUBS RUSHES THROUGH A WET FOREST**

It was a unique photographic moment that made me pull out my cameras even in the heavy rain, and, despite water dripping from all parts of my equipment, I continued shooting the scene before me. The mother walked out into the open with the cubs in tow and crossed the road to lead them deeper into the forest.

Personally, it is not the sight of a tiger that makes my day but the environment and circumstances in which the striped cat silently walks out—a memorable sight that one cherishes for a lifetime.

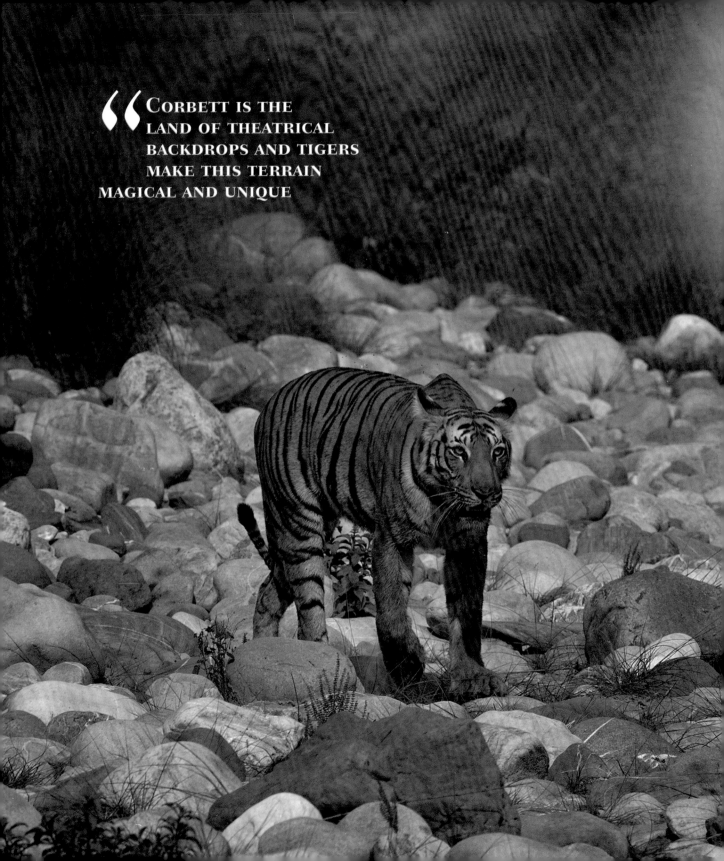

"CORBETT IS THE LAND OF THEATRICAL BACKDROPS AND TIGERS MAKE THIS TERRAIN MAGICAL AND UNIQUE

CORBETT

THE HIMALAYAN TIGER

To the layman, tigers across India look the same. One key aspect that differentiates the tigers in the country is the backdrop and habitat in which they thrive. India is blessed to have some distinctly dramatic forests, and tigers rule these uniquely different habitats across the length and breadth of the country. Talking of habitats, the Terai belt of India and the Himalayan foothills feature some theatrical and surreal forests comprising sal, grasslands, open riverbeds, and rivers.

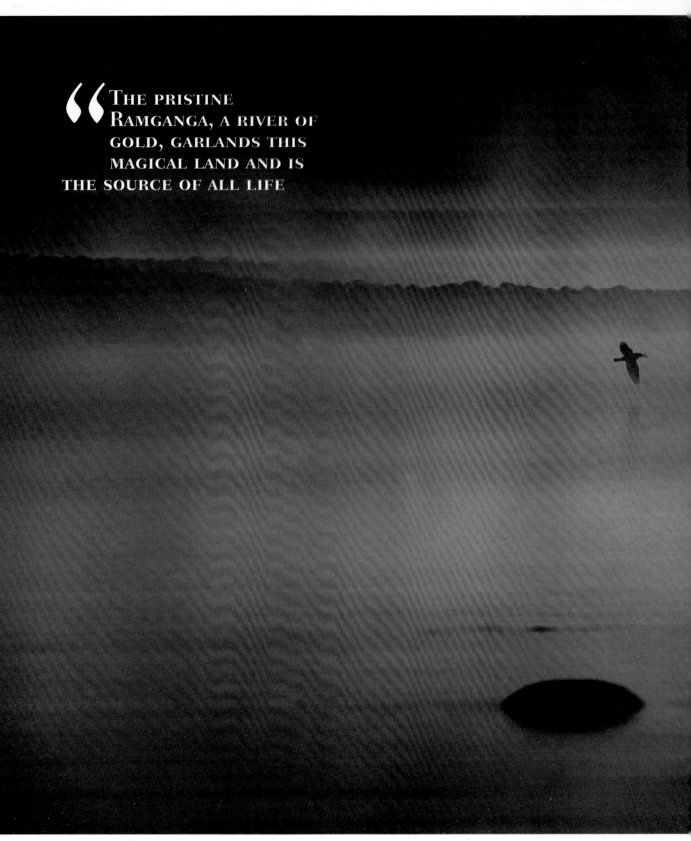

> **THE PRISTINE RAMGANGA, A RIVER OF GOLD, GARLANDS THIS MAGICAL LAND AND IS THE SOURCE OF ALL LIFE**

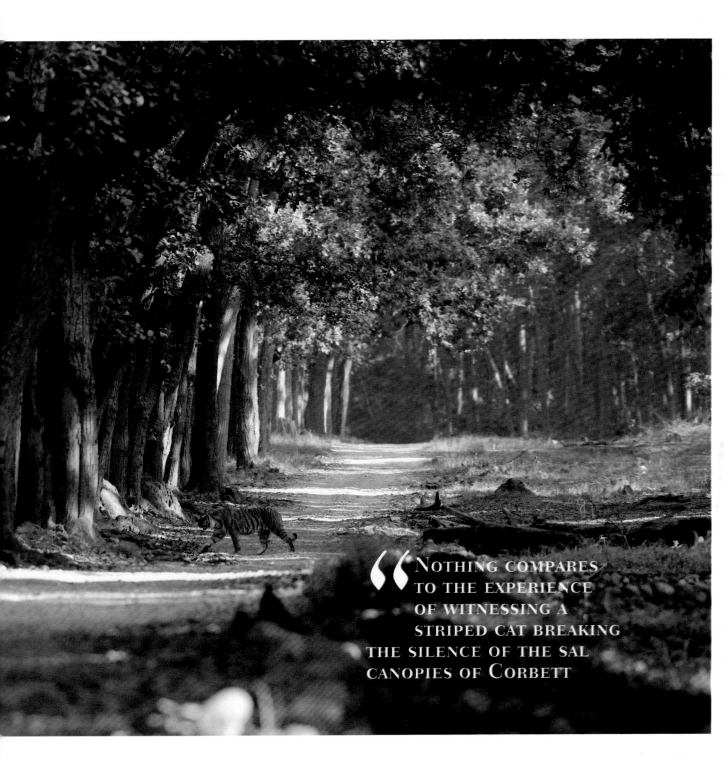

"NOTHING COMPARES TO THE EXPERIENCE OF WITNESSING A STRIPED CAT BREAKING THE SILENCE OF THE SAL CANOPIES OF CORBETT

My initial interest in wildlife was fostered by the books written by Jim Corbett, in which he has beautifully described these forests, as one can experience first-hand on visiting this part of India. Since starting my wildlife career amidst these pristine forests, I have photographed these majestic cats across the country, but feel that no other forest can offer better backdrops than the woods of Kumaon.

The belling of sambar and cheetal in the forest leads to the appearance of a shining, orange-coated cat, carefully balancing itself on the white stone riverbeds and swimming across the blue waters of a montane river with the mighty Shivaliks (outer Himalayas) towering across the horizon. The same, mighty cat then silently traverses the dense sal forests and looks dwarfed in the vast canvas of nature—these are visuals that no other forest in the world can likely offer.

❝ NOWHERE ELSE IN THE WORLD CAN A TIGER BE SEEN CROSSING A MONTANE RIVER WITH THE MIGHTY SHIVALIKS AS BACKDROP

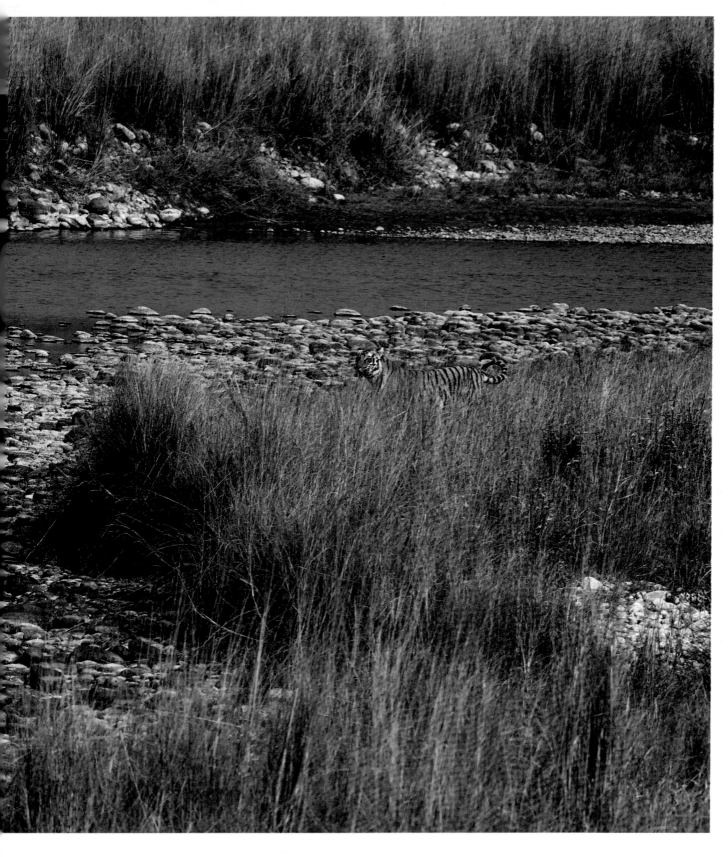

*A male tiger walks out
of the forest on to an
open riverbed on a cold
winter morning
in 2014*

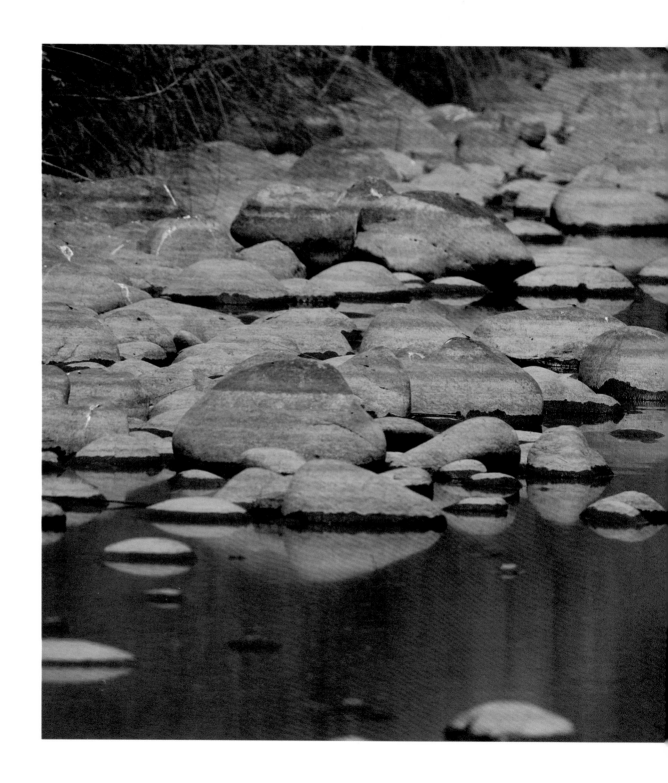

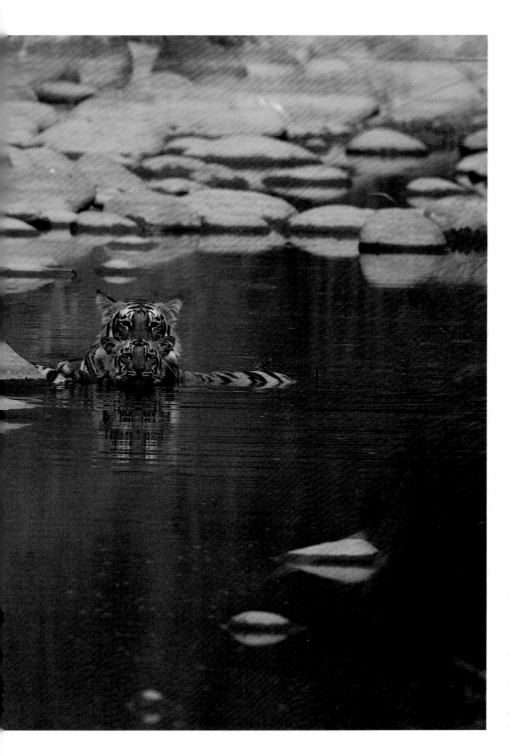

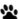

A tigress and her cub rest during the summer of 2016 in a stream in Corbett. Photographing tiger cubs in a typical Corbett setting has been a cherished moment in my tiger journey

Having observed some tiger mothers amidst these mysterious forests, I feel life for them is more arduous than tigers in central and western India. The terrain these cats encounter on a daily basis makes them tough, shy, and elusive, and they easily grow uncomfortable in the presence of humans.

I feel Corbett National Park is a location made for photographers because of the open landscapes and dramatic lighting conditions. Though Corbett tigers have always fascinated me and I respect the challenges of photographing this cat in this terrain, during the early stages of my career, I decided to stop chasing after the tigers of this forest and rather pursue light and subjects that can be photographed

(right) A tigress speeding across the Ramganga waters in the summer; (below) A male tiger walks out of the dense lantana during the winter of 2012

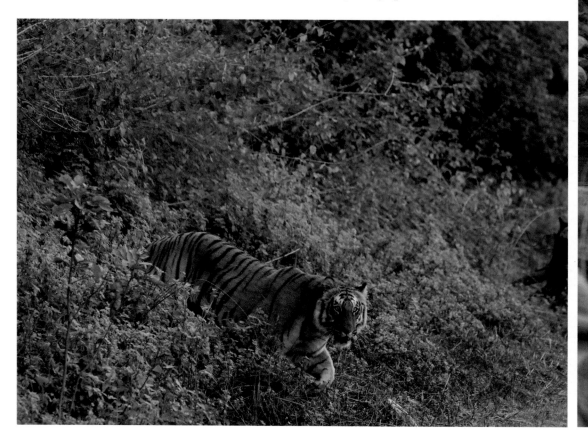

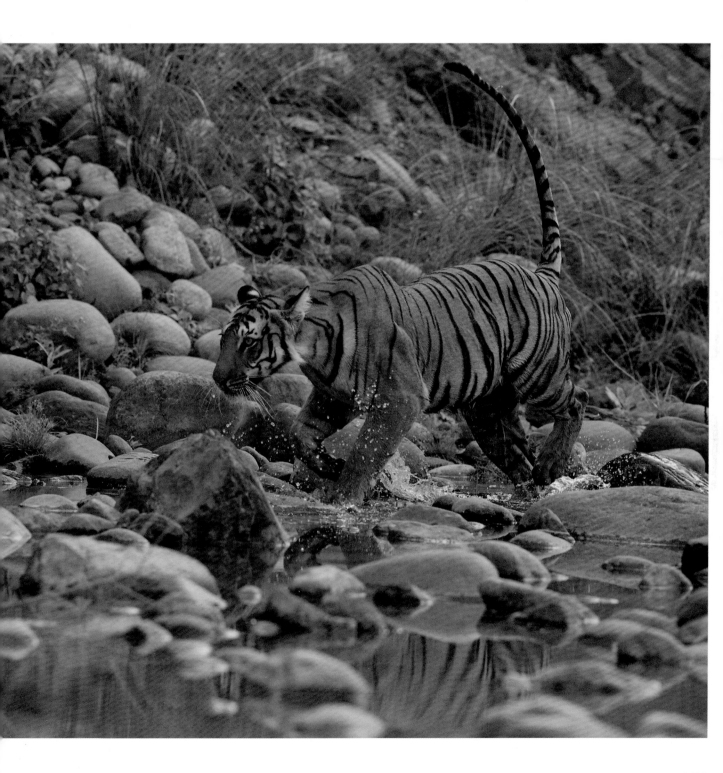

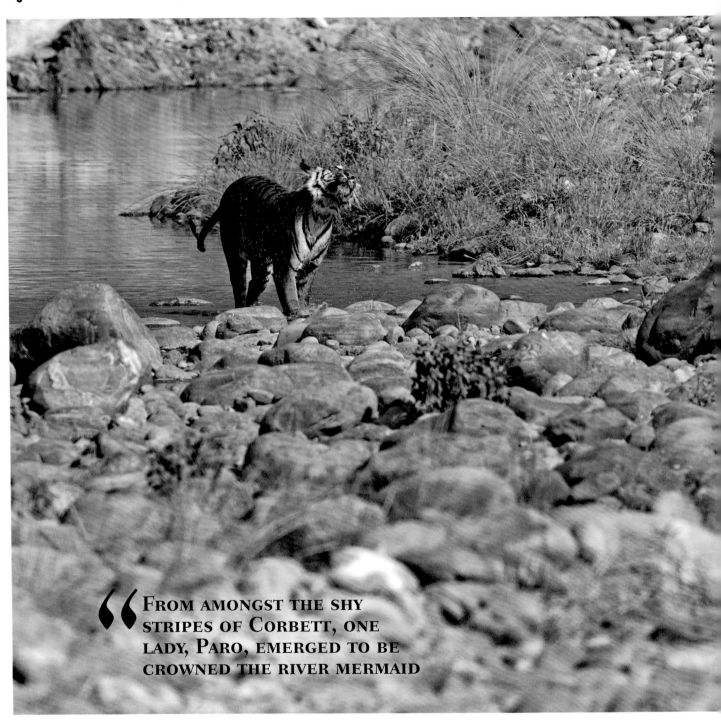

"FROM AMONGST THE SHY
STRIPES OF CORBETT, ONE
LADY, PARO, EMERGED TO BE
CROWNED THE RIVER MERMAID

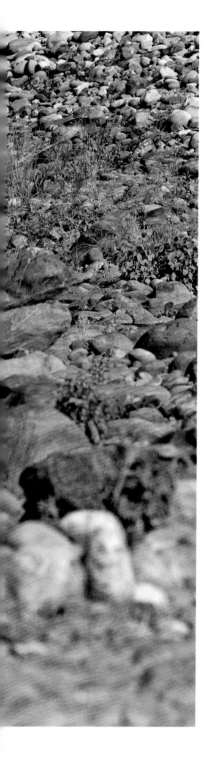

effectively utilising these cinematic backdrops. In my pursuit of subjects like the Asiatic elephant, I bumped into tigers on a lot of occasions; the experience of suddenly running into a tiger in this Himalayan forest is far more thrilling than tracking down the cat.

Having said that, in recent years, one Corbett cat has rapidly climbed the popularity charts. She was bold and covered a massive area spanning both sides of the Ramganga river. This made her frequently cross the river and her visibility around the same made her the perfect subject for a dream Corbett image. The river mermaid, locally called Paro, made a mark in the summer of 2015, and raised hopes when news of her pregnancy came in during the monsoon. It was over the following winter that Paro showed signs of raising a litter; while speculations were abound, she was photographed with two tiny cubs following in her footsteps on the riverbed. Ramganga was set to be a pool playground for the summer, but the increasing pressures of multiple males in Paro's area was visible as she was caught romancing intruding males on multiple occasions. Months passed by and attempts to track her cubs were in full swing when the moment of truth arrived, in the summer of 2016. If the cubs were alive,

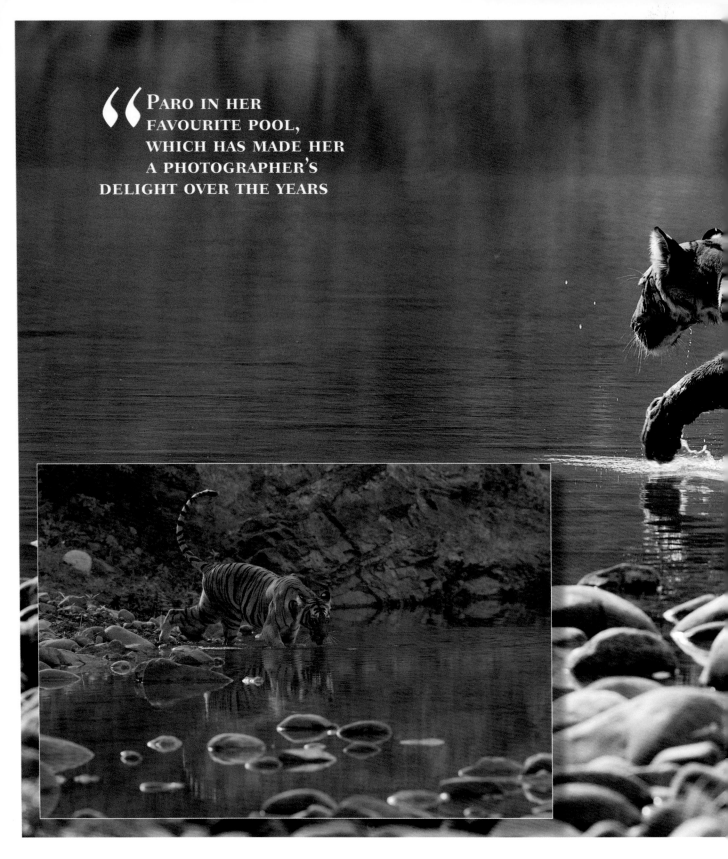

> **PARO IN HER FAVOURITE POOL, WHICH HAS MADE HER A PHOTOGRAPHER'S DELIGHT OVER THE YEARS**

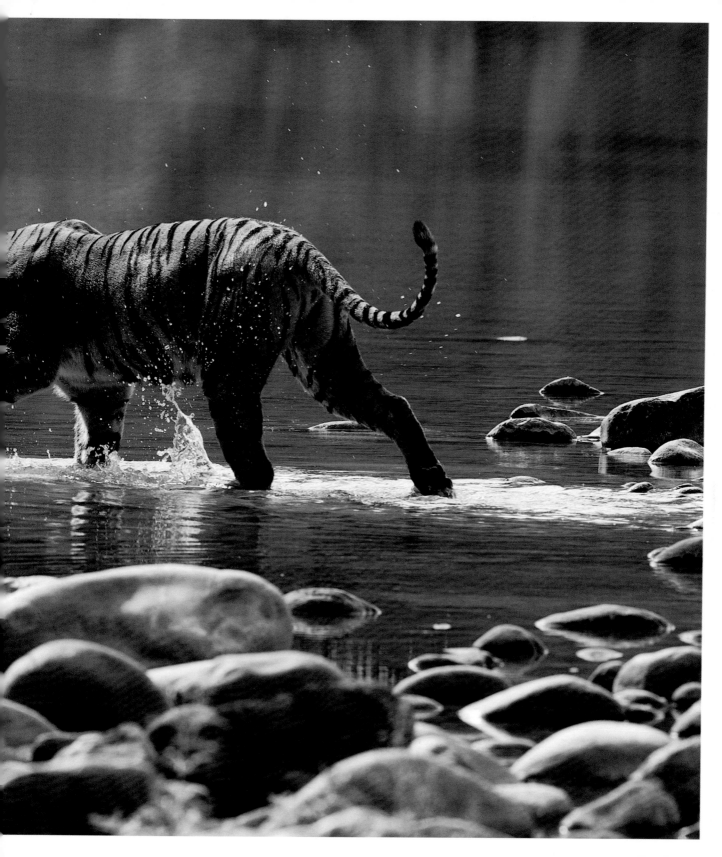

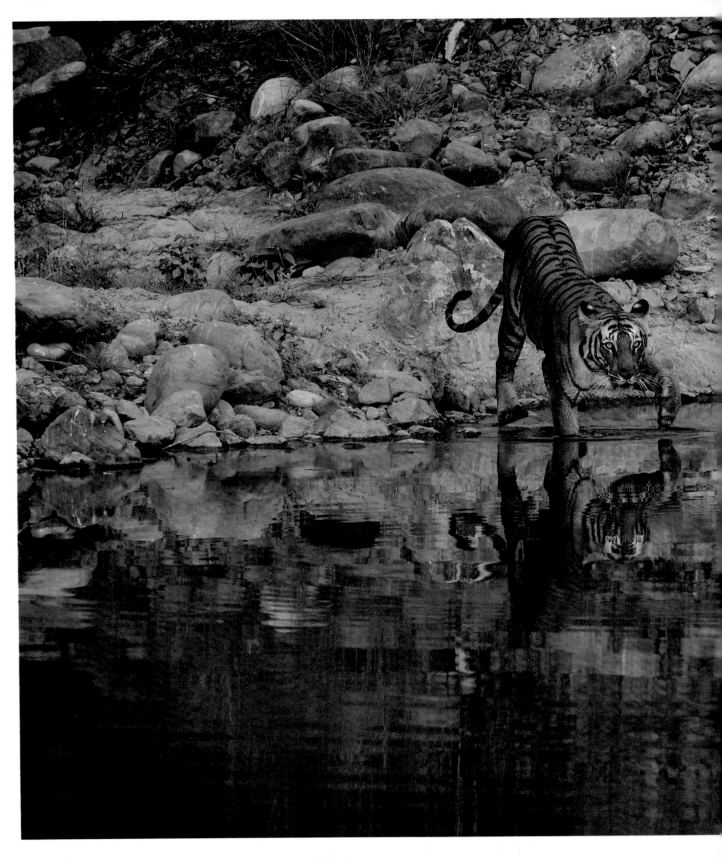

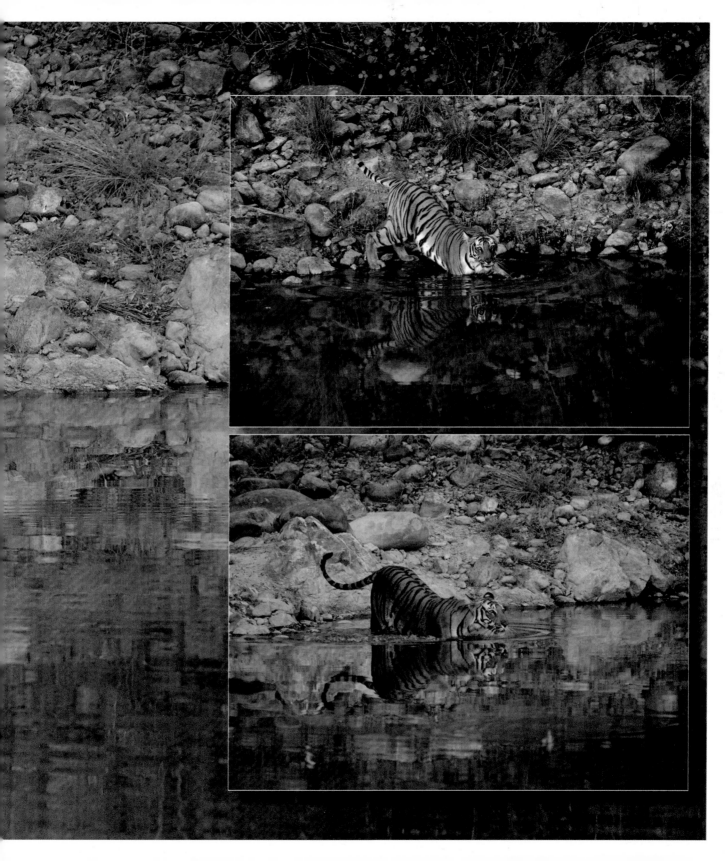

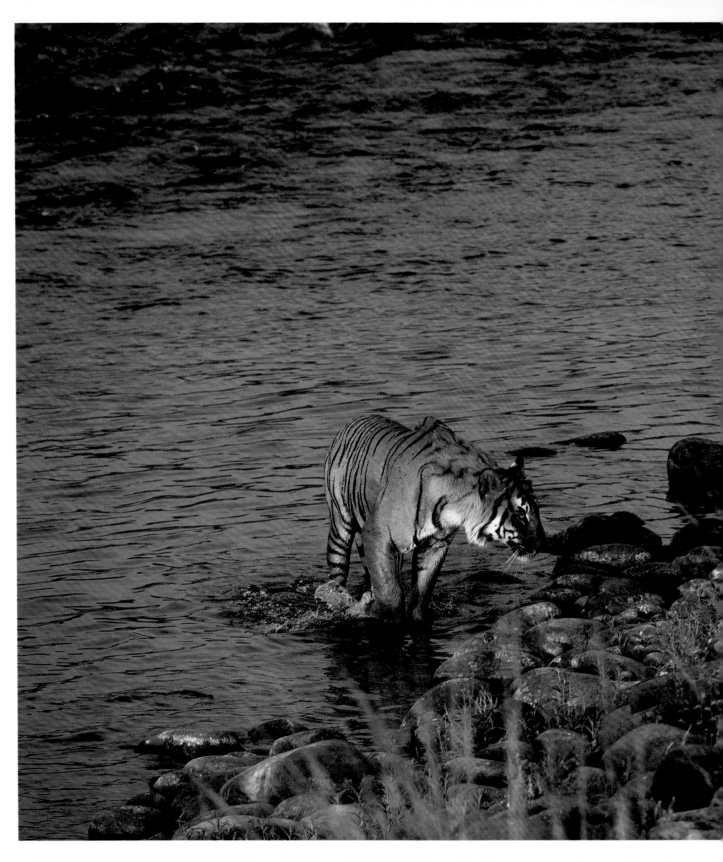

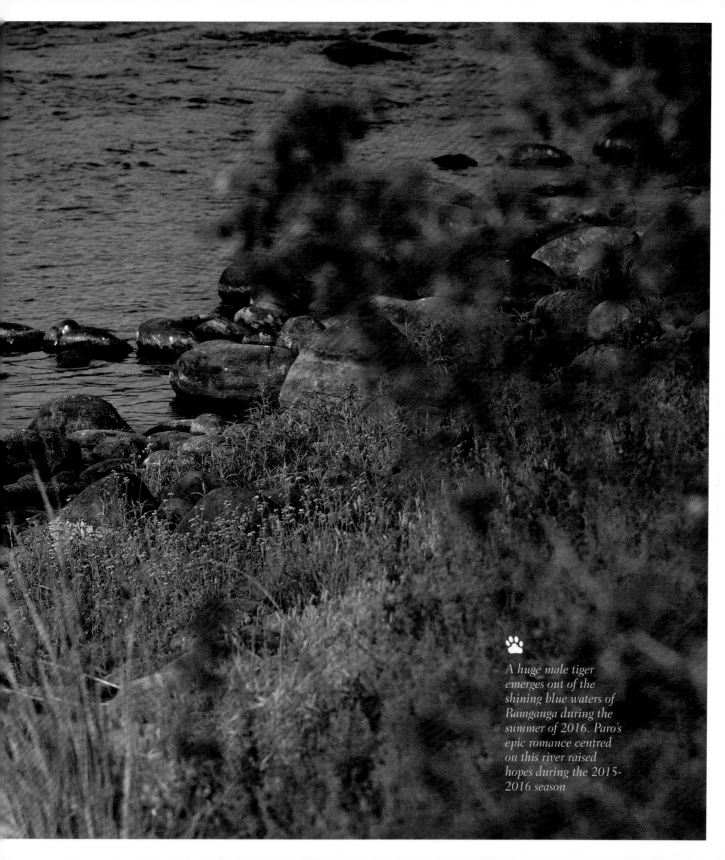

A huge male tiger emerges out of the shining blue waters of Ramganga during the summer of 2016. Paro's epic romance centred on this river raised hopes during the 2015-2016 season

a decade with tigers

Paro would have moved with them towards the river and catchment pools. While it's tough to solve the mystery around the missing cubs, Paro continues to be the most stunning striped mermaid the natural world has seen, and has been the center of attraction in Corbett for the past few years. The future looks bright for Paro as she was spotted with three cubs in the June of 2017.

These are forests that I had patrolled on foot as I tried to get a grasp of this vast canvas of nature in my early days, and, in these woodlands,

BELOW AND FACING PAGE
Moods of Ramganga over the years. A male tiger photographed in the summers of 2008. Tigers share the river with the giant Asiatic elephants

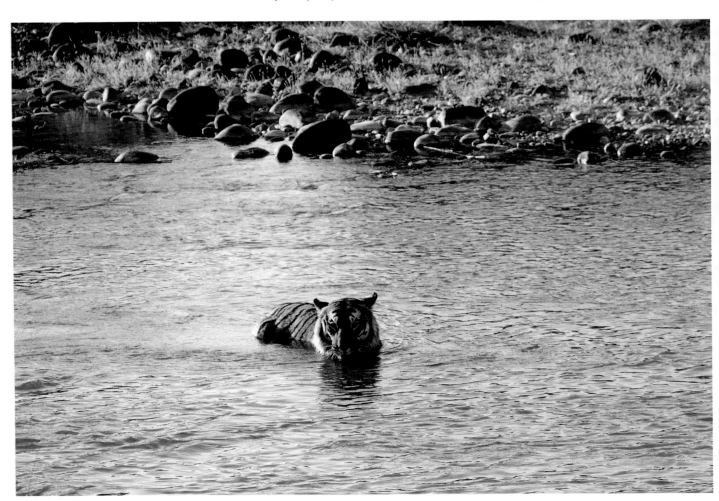

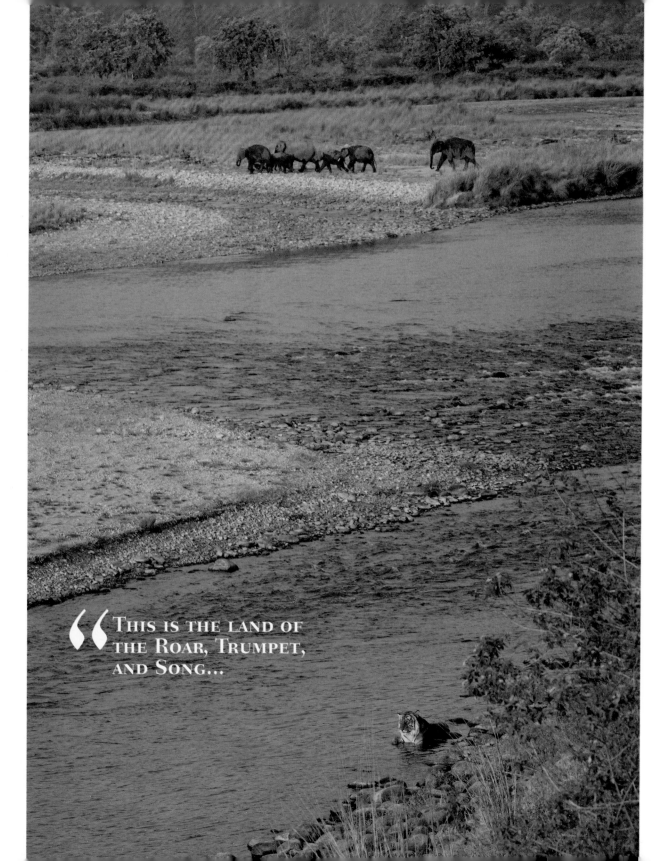

> This is the land of the Roar, Trumpet, and Song...

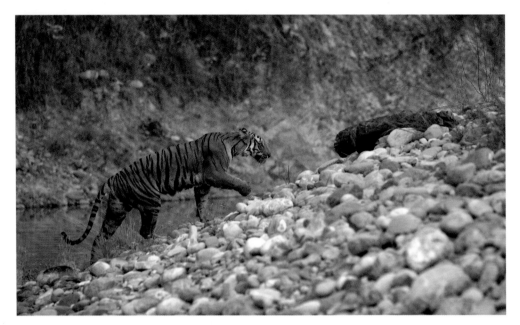

one can constantly feel the presence of a tiger nearby. Aptly known as the land of the roar, trumpet, and song, there are occasions when one actually gets to experience all the three aspects together in one photographic frame, perhaps in the form of a tiger crossing the sparkling Ramganga river with elephants walking along the distant horizon and a pied kingfisher or a Pallas's fish eagle hovering above, searching for a meal in the river.

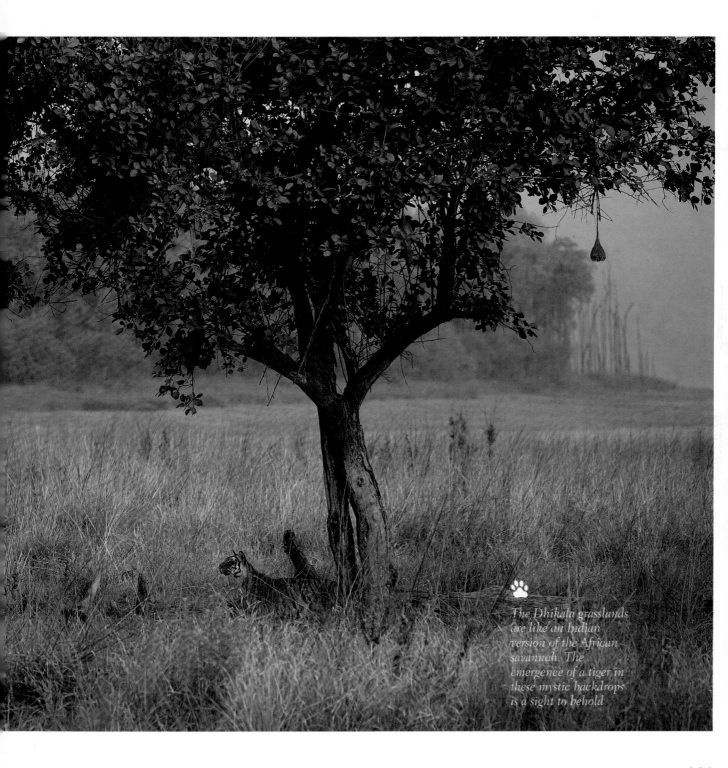

The Dhikala grasslands
are like an Indian
version of the African
savannah. The
emergence of a tiger in
these mystic backdrops
is a sight to behold

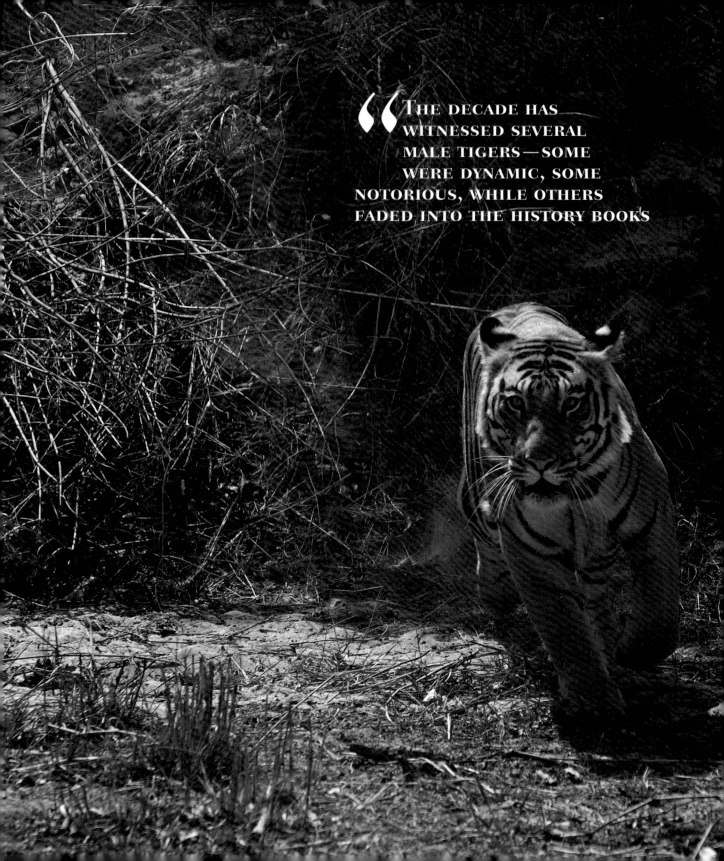

"THE DECADE HAS WITNESSED SEVERAL MALE TIGERS—SOME WERE DYNAMIC, SOME NOTORIOUS, WHILE OTHERS FADED INTO THE HISTORY BOOKS

MIGHTY MALES

The pursuit of tiger mothers would be unimaginable without also encountering dominant male tigers, who play a key role in ensuring the safety and proper upbringing of cubs. Over the course of my journey, I came across several male tigers—some were dynamic and charismatic, some were notorious, while others faded into the history books post a brief period of fame.

Male tigers normally control expansive territories and mate with multiple females, fathering several litters in the process. While the characteristics of males in certain of parts of India that I have covered, like Kanha, Pench and Tadoba, matches with their behavioural traits, shrinking forest covers and disruptions in corridors that historically connected forests have confined males to smaller territories. This has further been aggravated by a skewed male–female ratio in certain parks. In recent years, in parks like Ranthambhore, it has been observed that some of the male tigers mate with just one female and father her cubs. Some dynamic, young male tigers in Ranthambhore and Bandhavgarh were unable to carve their own territories and moved out of the core areas of the parks post maturity.

BANDHAVGARH

B2

He was second only to Machali (from Ranthambhore) when it came to popularity and became a global brand for Bandhavgarh during his prime. Taking control of Bandhavgarh's tiger kingdom from his legendary father Charger, B2 ruled a massive area of the park for years and fathered numerous cubs during his term. He was the sole survivor from his mother's litter and his unchallenged reign etched his name in history as one of the most powerful tigers Bandhavgarh has ever seen. My encounters with the late B2 during my early Bandhavgarh years were always special; he will continue to live in our collective memory for years to come.

BELOW AND FACING PAGE
Early in the morning, B2 was caught walking through Andhiari Jhiriya during the spring of 2009

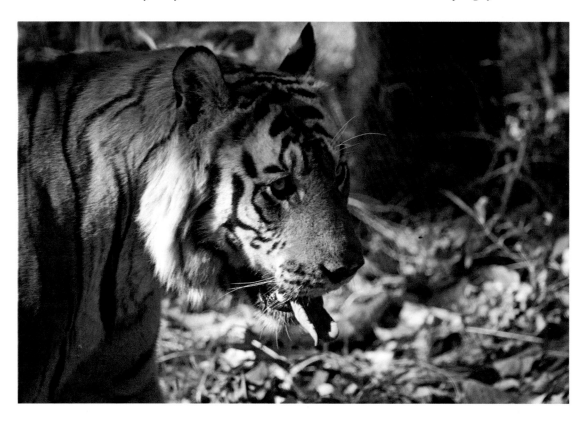

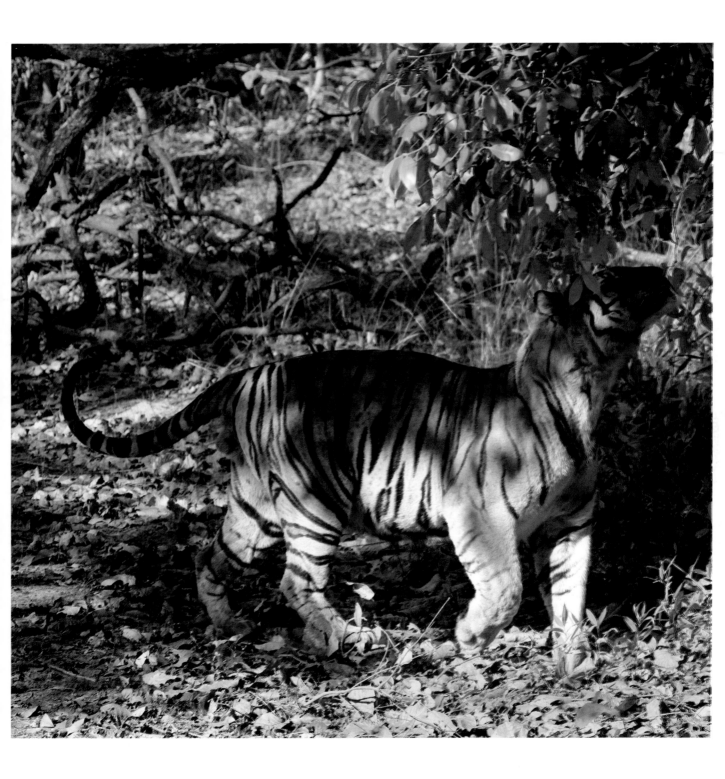

BAMERA

Bamera continued the family lineage from his father B2 but his rule was not as enduring as his predecessors. During his reign, he displayed the characteristics of a dominant male by fathering cubs from multiple females at a time, including the first litters of Vijaya and the Banbahi female. Expectations were high from Bamera as his father and grandfather had ruled Bandhavgarh for many years. Intruding males not only trimmed down the area he controlled but also shortened his rule and dented his bloodline by killing a lot of his cubs.

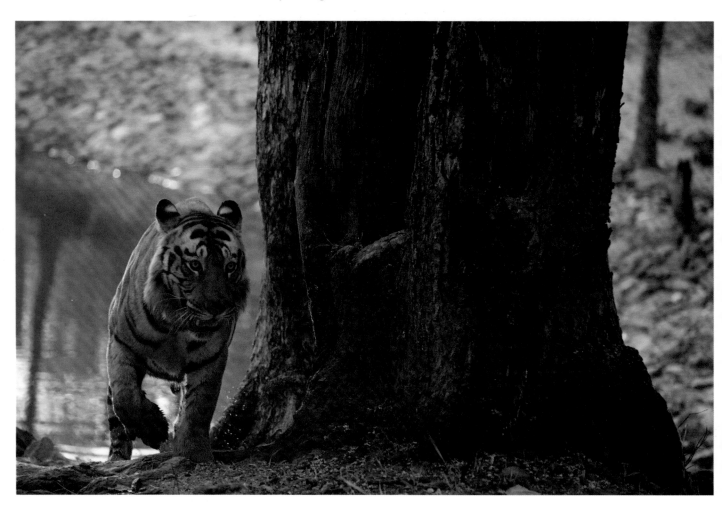

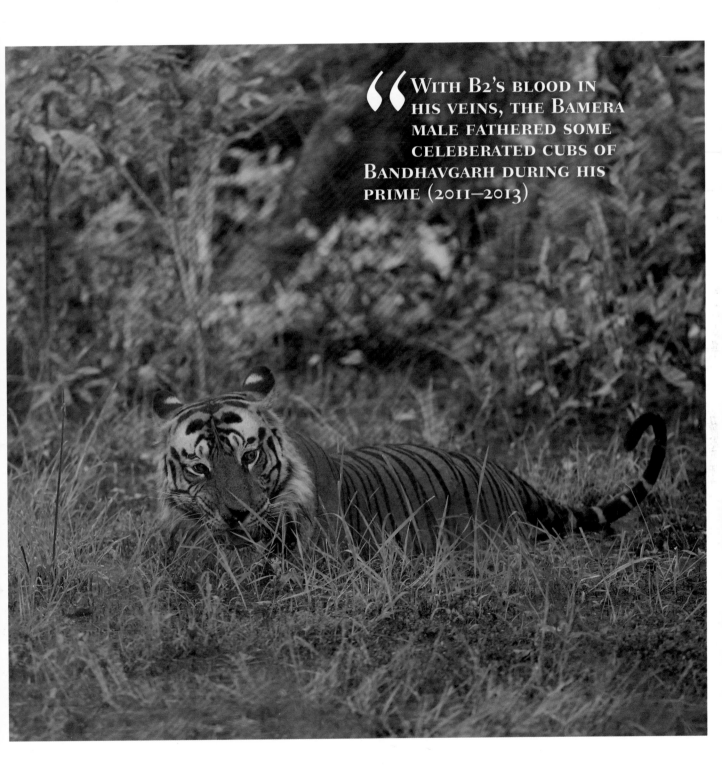

"With B2's blood in his veins, the Bamera male fathered some celeberated cubs of Bandhavgarh during his prime (2011–2013)

RANTHAMBHORE

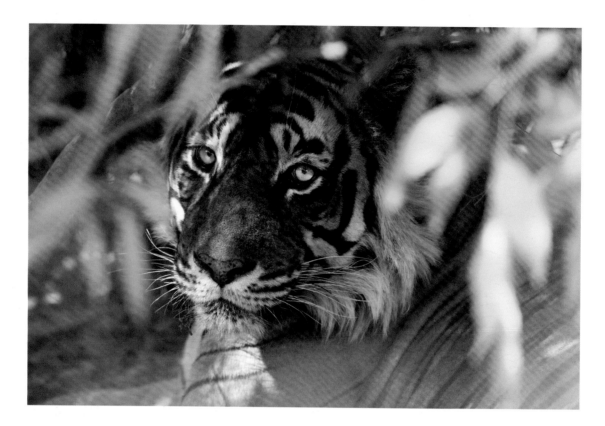

Ustad (T24)

He was one of the gentlest tigers I have encountered, for his tolerance of people was always very high. His territory coincided with the pilgrim path to the Ganesh temple inside Ranthambhore Fort; he slept peacefully as thousands of pilgrims walked past him time and again. From a tourist's perspective, he was a tiger one could bank on as he would spend long hours sleeping in his favourite hideouts, and game drives could be planned as per his movements. I have fond memories of Ustad as a carefree and bold male tiger. The father–son relationship between him and Sultan (from the first litter of Noor [T39]) resulted in some great moments to document as a photographer.

ABOVE AND FACING PAGE
The bankable Ustad (T24) rests during peak summer of 2013 after a heavy meal

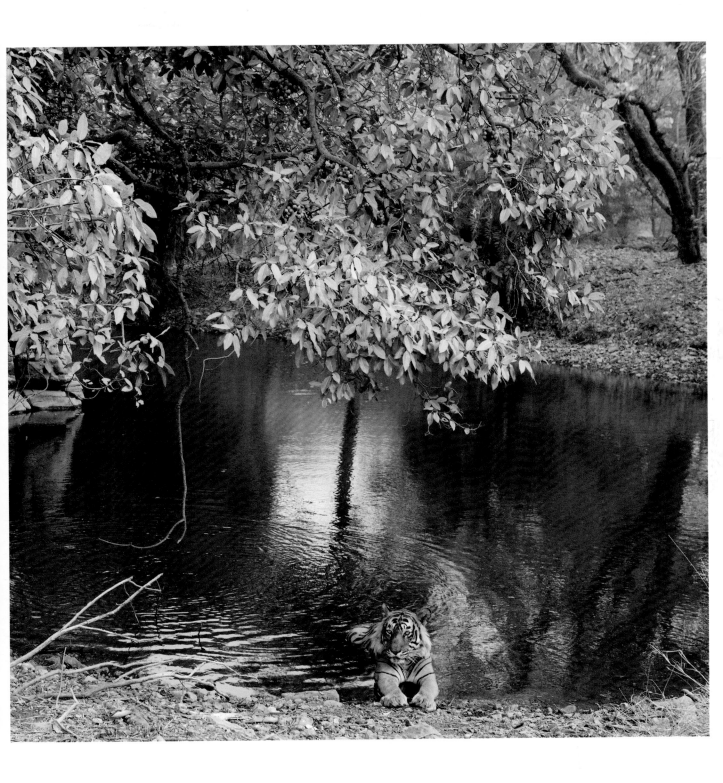

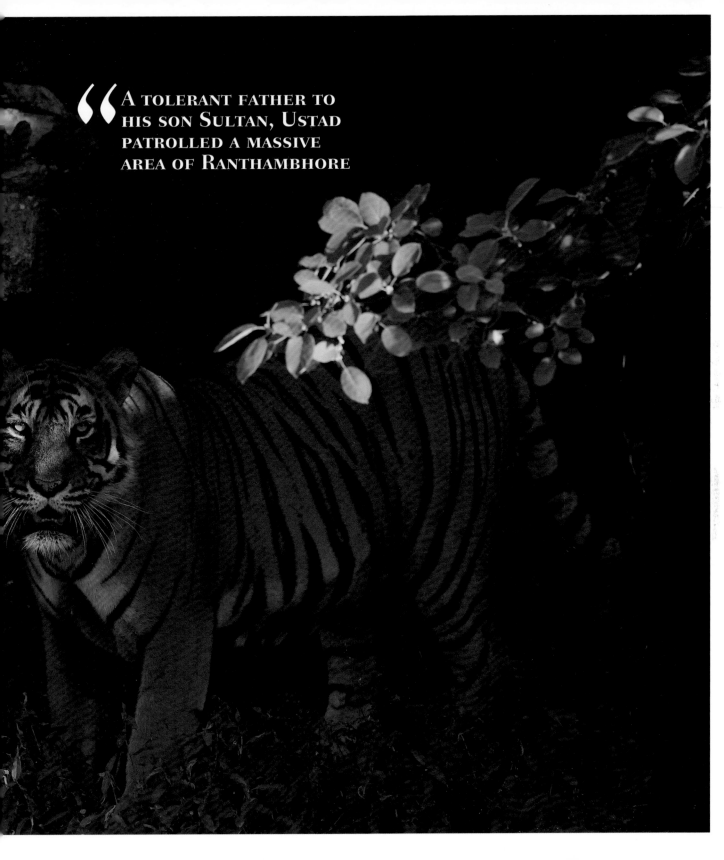

"A TOLERANT FATHER TO HIS SON SULTAN, USTAD PATROLLED A MASSIVE AREA OF RANTHAMBHORE

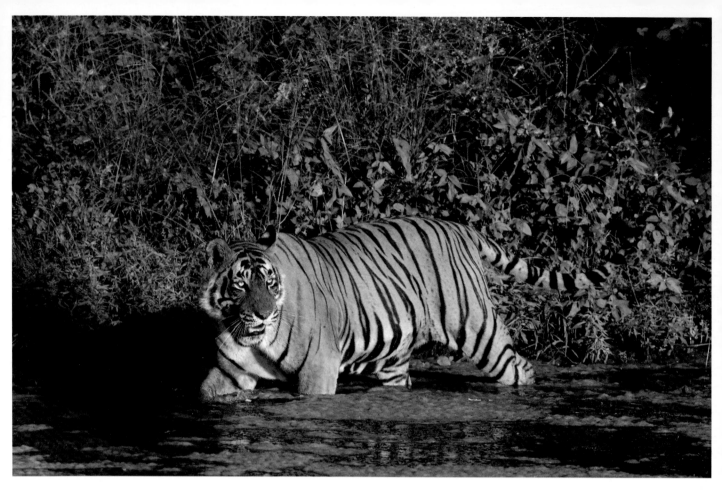

Ustad hit the headlines in the summer of 2015 when he was found guilty of killing a forest guard in Ranthambhore, and was removed from the forest to be put in an enclosure in Udaipur. His story became international news and is a subject of debate till date. However, one positive that may be drawn from the entire incident is that, for the first time, people of the country came together for an animal as India took to the streets to conduct peaceful protest marches and rallies for its national animal. The Ustad incident showcases that, despite the fact that we are also part of this never-ending race for development at the cost of our natural wealth, offline, online, and television media has led to a surge in the level of awareness amongst the citizenry of India pertaining to tiger conservation and the plight of the Indian tiger doesn't go completely unnoticed.

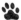

ABOVE AND FACING PAGE
Various moods of Ustad (T24) in Ranthambhore during the monsoon of 2014

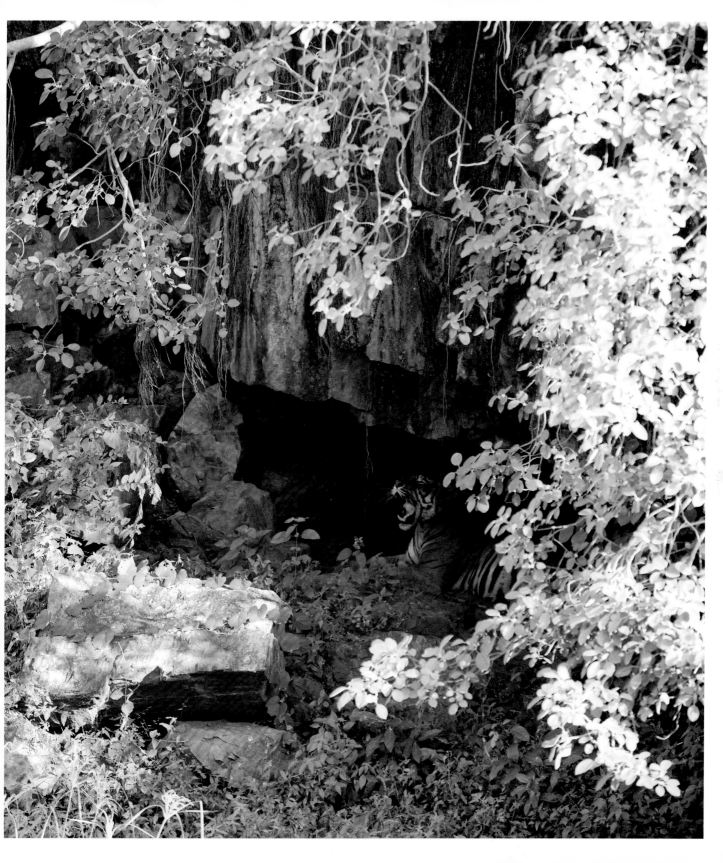

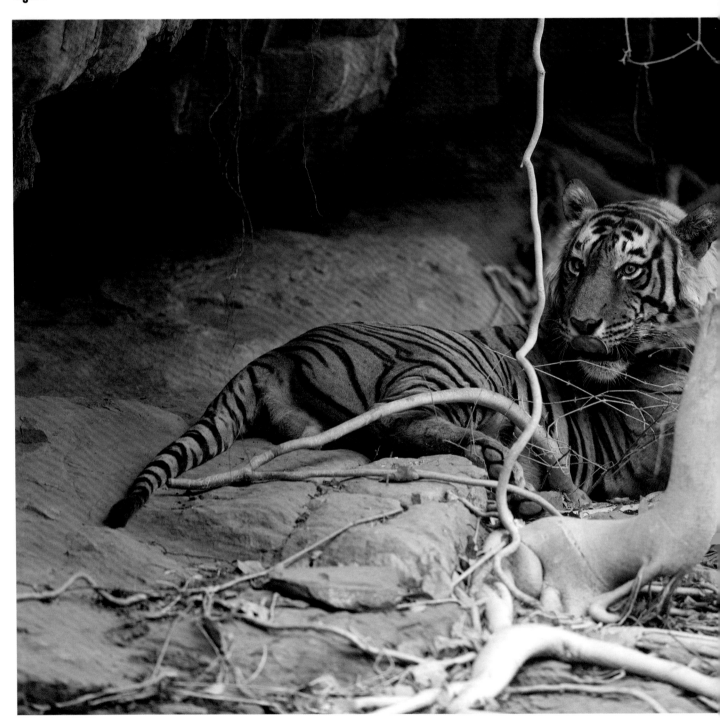

T57

Till the summer of 2015, he was a very shy tiger residing in the fringe areas of Ranthambhore. I still recall missing a game drive during which one of my overseas clients spent an exclusive hour with this impressive specimen. Those images of a muscular tiger with piercing eyes will forever remain etched on my heart.

After the departure of Ustad (T24), T57 inched closer to his territory and today occupies a significant area of Ranthambhore. Life for him has been easy till now as there were no fights or bloodshed for territory acquisition. There were apprehensions that the massive male might harm the two male cubs of Noor (T39) in the absence of their father Ustad, but, curiously enough, he accepted the family. After the separation of Noor and her cubs, T57 mated with her and is now father to three female cubs. He is also currently fathering the cubs of T60, and, with two mates, has a very promising future in Ranthambhore.

T57 rests outside a cave, curled up amidst banyan roots, during the summer of 2016

STAR (T28)

With a star-shaped mark atop his left eye, Star has played a key role in recent years, his romantic alliance with Krishna (T19) resulting in the revival of young tiger blood around the lakes. While his mate has been crowned the queen of the lakes and hogs most of the limelight, he prowls the ruins and forests of the area and is the undisputed ruler of the lakes of Ranthambhore. Though Star's visits to the lakes are infrequent, his stately gait with the Ranthambhore Fort in the background is a sight to behold. I remember photographing him in his typical regal pose at the window of Rajbagh palace. To think that the structures built by maharajas to hunt tigers are now used by the tigers themselves is incredible in itself.

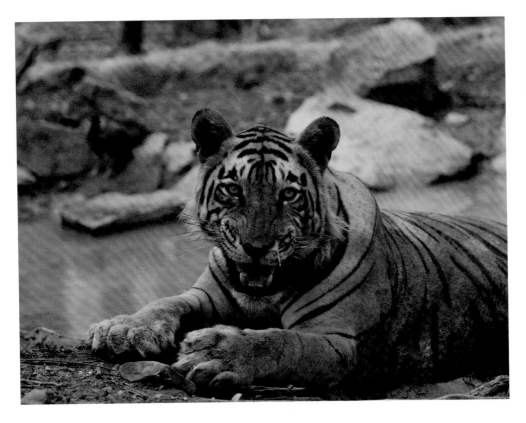

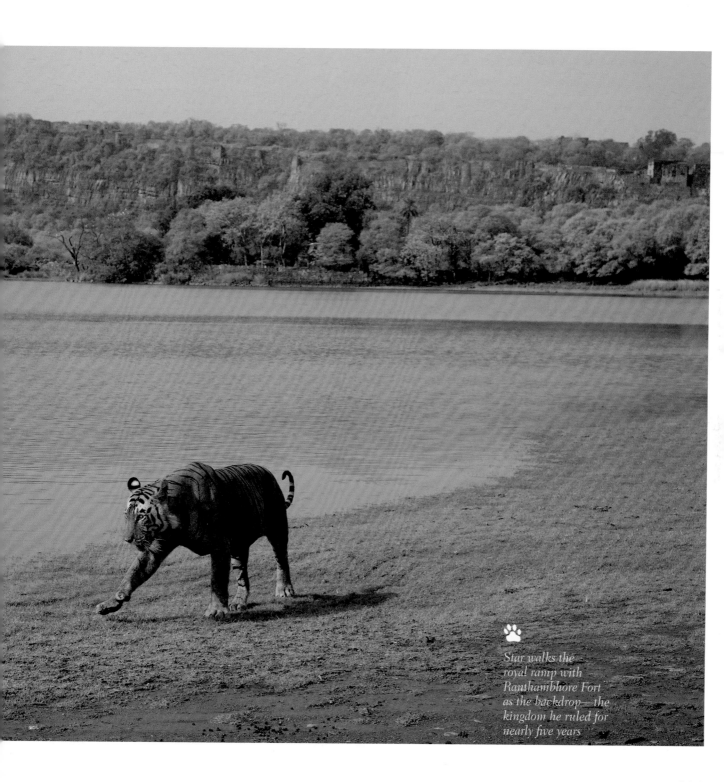

Star walks the
royal ramp with
Ranthambhore Fort
as the backdrop—the
kingdom he ruled for
nearly five years

ZALIM (T25)

Contrary to his name (which in Urdu means cruel), he became well-known for fathering his orphaned cubs and raising them to maturity. This is probably the rarest tiger behaviour documented in Ranthambhore in the last decade, showcasing a male tiger's attachement to his cubs. Post the unfortunate death of his mate T5, Zalim was left with two orphaned cubs. While the forest department of Ranthambhore set up a network of camera traps and artificially fed the young cubs, ensuring their survival, Zalim took on the role of a mother by protecting his cubs from intruding tigers. His epic encounter against Sundari (T17) was filmed; his aggression was enough to keep the young Sundari away from the cubs. However, his attempts at expanding his territorial network around the lakes went in vain, and even his forced attempt to mate with the queen Krishna (T19) was not sufficient to gain him entry to the prime tiger real estate of Ranthambhore.

> ZALIM STOLE THE LIMELIGHT FOR FATHERING HIS ORPHANED CUBS — A RARE TIGER BEHAVIOUR DOCUMENTED IN RANTHAMBHORE

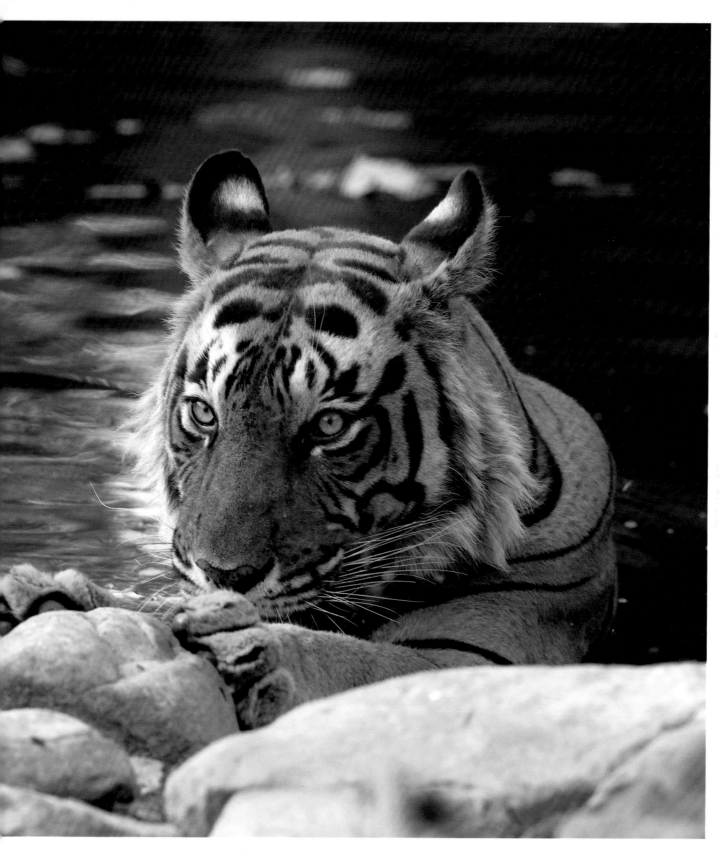

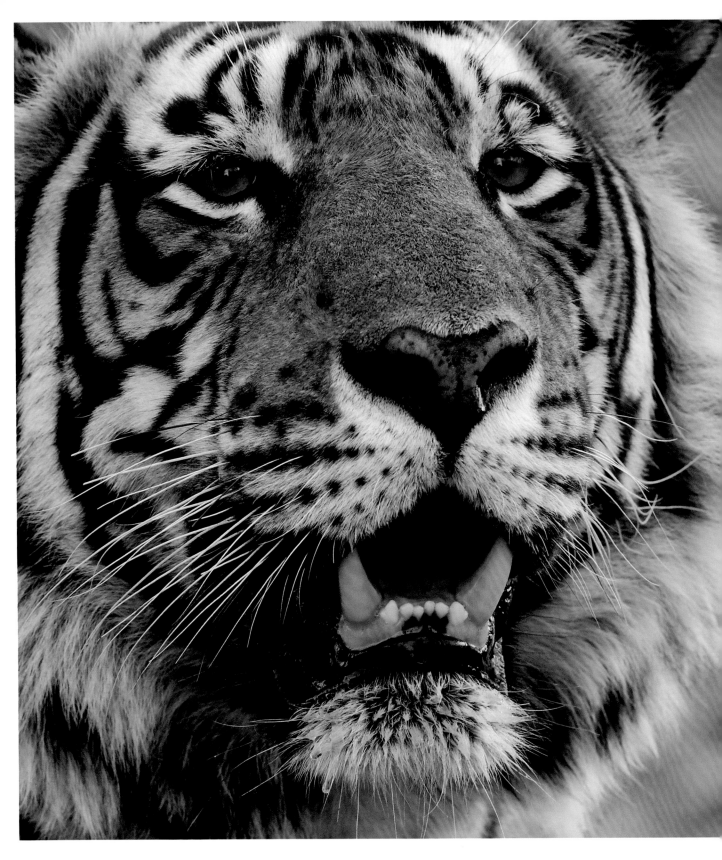

ROMEO (T6)

In my opinion the most handsome male tiger of Ranthambhore, Romeo patrolled some lush green parts of this dry deciduous forest. He shared territory with his mate T41 and they courted amidst some picturesque terrains of the park. In June 2014, he indulged in an act that turned out to be a milestone in behavioural documentation. Male tigers normally rely on the females for sustenance. One evening, T6 charged at a female blue bull in broad daylight and subdued his prey in lethal style. The next morning, when photographers rushed to the area, he was seen feeding on the blue bull kill. Romeo then pulled out the foetus of the apparently pregnant blue bull and roamed about the dhonk forest with the foetus hanging from his mouth.

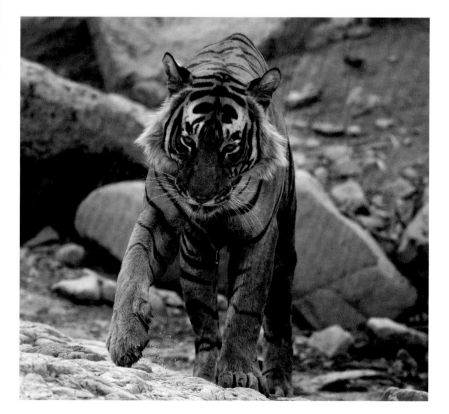

Romeo, in his prime, emerges from a pool during peak summer of 2011

EXTREME LEFT
A portrait of Romeo during the summer of 2013

CORBETT

DIWANI RAM

The expansive and tough terrain of Corbett makes it difficult to identify individual tigers. Many of the tigers in Corbett change territories post monsoon and may retreat into the core area of the park. In recent years, a notorious male has recieved the moniker of a forest guard he killed. This imposing specimen from the Terai region controls a large area overlooking the Ramganga and absolutely detests human presence. Watching Diwani Ram walk on the open flood-banks of the Ramganga is a picture-perfect sight. His reputation does precede him; as soon as he walks out on the road, he is given the respect he deserves.

I have had a few brief encounters with this male tiger in the recent past. Diwani Ram's sheer size and proportions ensured that he prominently stood out against the varied backdrops of Corbett. In a terrain where a tiger appears more like a rock when seen from a distance, I managed to sight and get a few long shots of him. I think the relatively sparse stripe density around his shoulders and legs makes him easily recognisable even when seen from long distances.

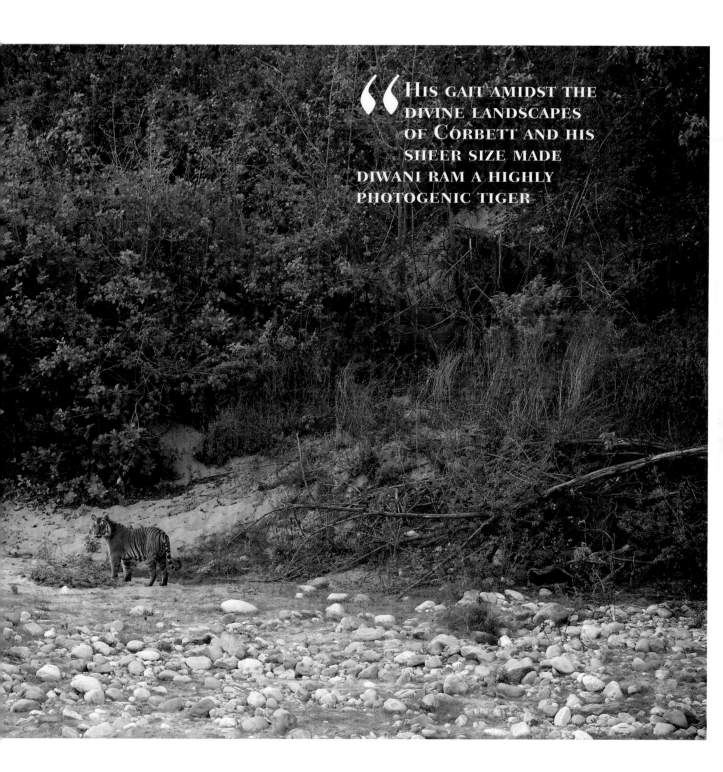

"His gait amidst the divine landscapes of Corbett and his sheer size made Diwani Ram a highly photogenic tiger

KANHA

MUNNA

Perhaps the only cat in the world with the word 'cat' emblazoned across his forehead, Munna has enduringly paraded through the sal forests of Kanha in grand style. Though one of the most photographed tigers of the park in recent years, Munna is now past his prime; during his reign as a dynamic male, he patrolled a massive area and fathered cubs with multiple females. His flamboyant walks amidst dense forests, with rays of light filtering through the leafy blinds, have time and again given me the opportunity to experiment with some unique perspectives.

The majestic Munna during some of his morning walks in the 2011–2014 period

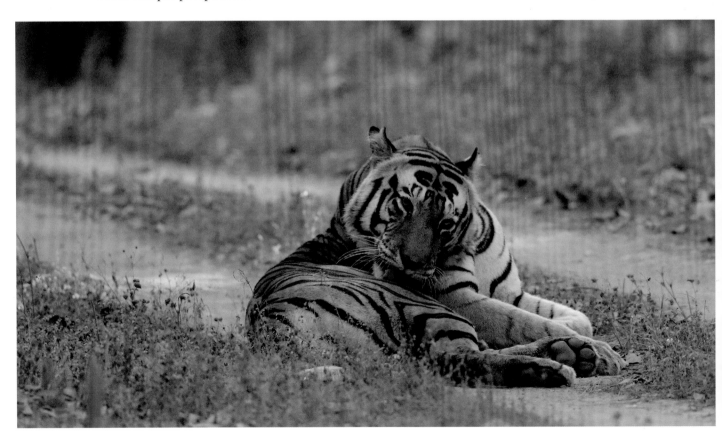

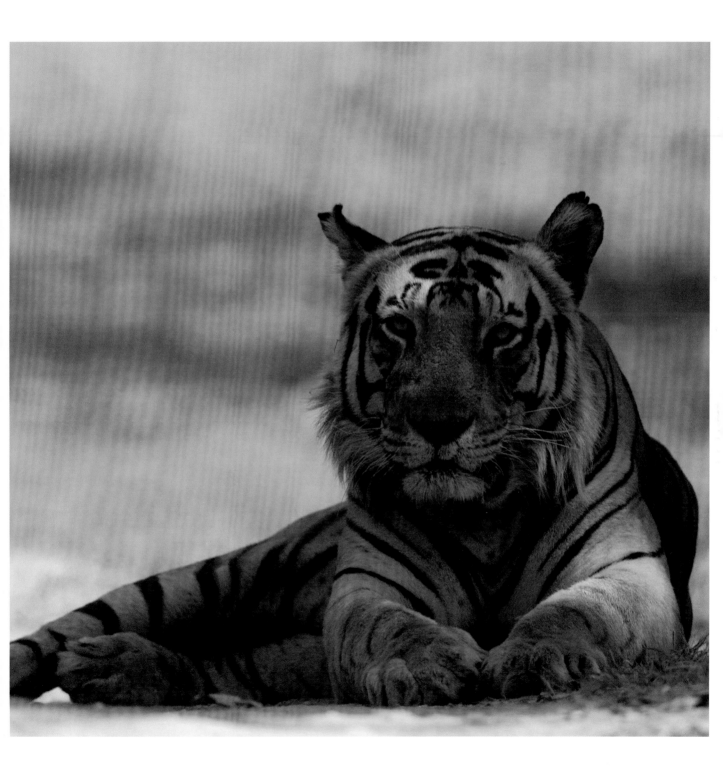

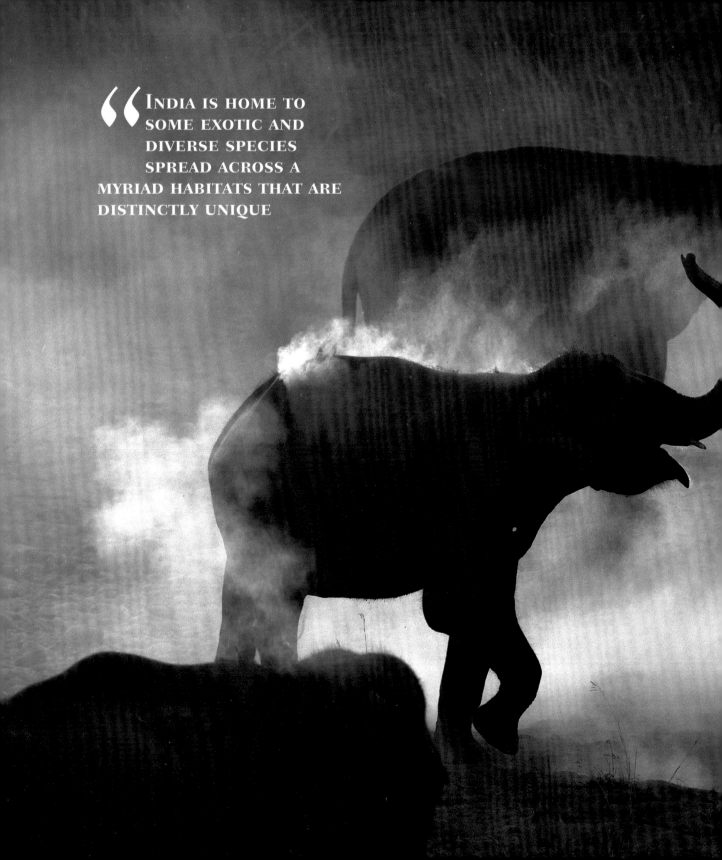

"INDIA IS HOME TO SOME EXOTIC AND DIVERSE SPECIES SPREAD ACROSS A MYRIAD HABITATS THAT ARE DISTINCTLY UNIQUE

DENIZENS OF THE TIGER KINGDOM

Dense sal and teak forests, open grasslands, rocky terrains, pristine riverbeds, dry deciduous vegetation, swamplands, and marshy mangroves—the tiger forests of India feature various environs, and keep changing their forms and colours one season to another. These diverse habitats are home to a plethora of species and complete the tiger ecosystem.

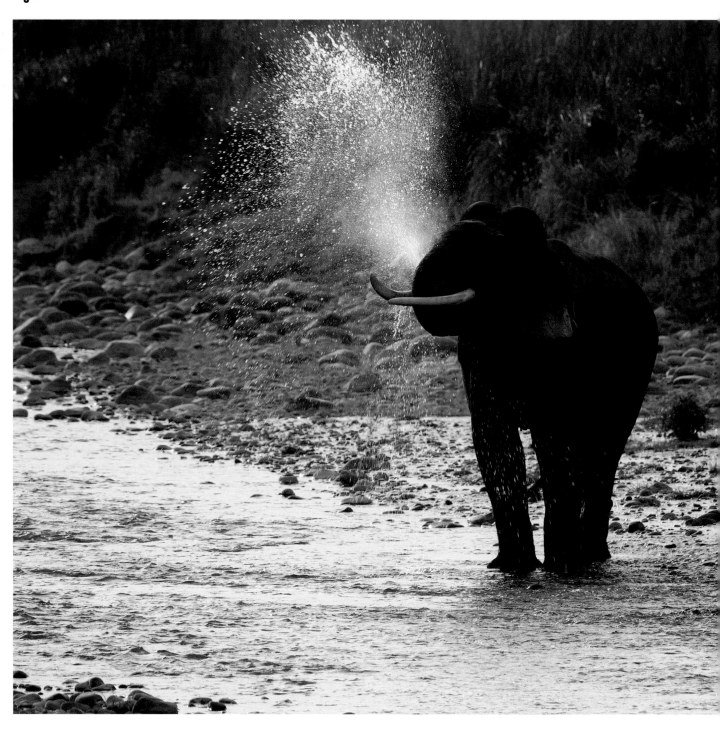

The early morning mist in forests like Kanha, Kaziranga, and Corbett is distinctly different from that of the swampy mangroves of Sunderbans. The colourful sal leaves and mahua blooms of Bandhavgarh are unique; as are Asiatic elephants bathing merrily in the shining blue waters of the Ramganga in Corbett. The Indian one-horned rhino in the grasslands of Dudhwa and Kaziranga complements the black panther, a character straight out of *The Jungle Book,* but is a rarity in the forests of Western Ghats and Central India.

ABOVE
A stream flowing through a dense monsoon forest on the outskirts of Corbett National Park

LEFT
A tusker taking a bath in the Ramganga river in Corbett National Park

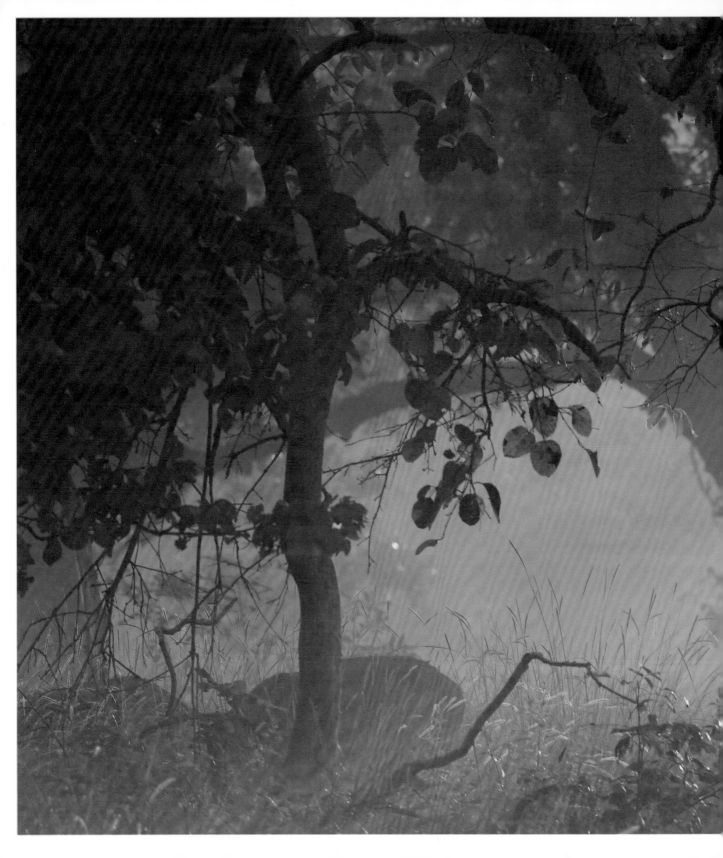

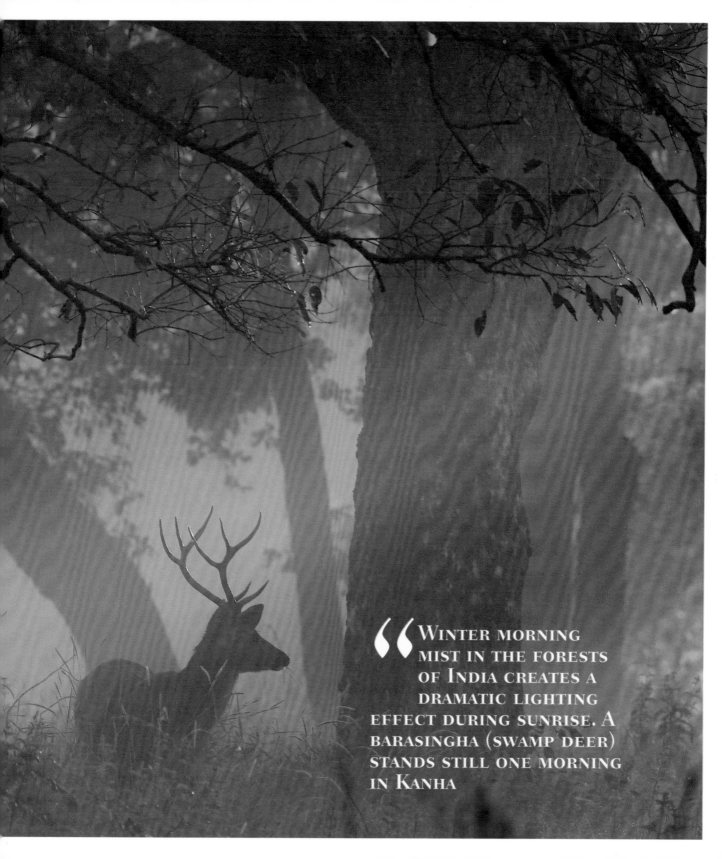

"Winter morning mist in the forests of India creates a dramatic lighting effect during sunrise. A barasingha (swamp deer) stands still one morning in Kanha

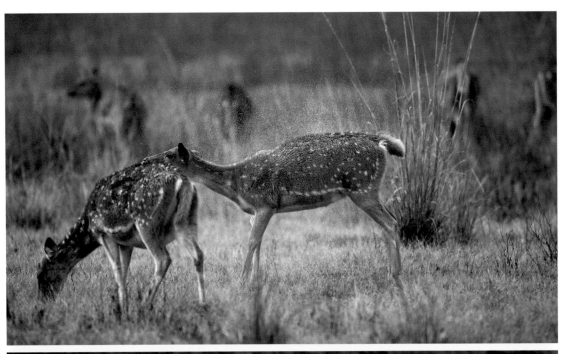

The dynamics of herbivores keeps changing as well, from barasingha (swamp deer) flooding the grasslands of Kanha and Dudhwa to chinkaras (Indian gazelles) in the dry deciduous forests of Ranthambhore. Even the commonly seen spotted deer (cheetal) and sambar look unique when grazing in different habitats across the country. The lesser seen Indian hog deer in Corbett and Kaziranga is a grassland species while blue bulls (nilgai) are widespread.

A herd of barasingha during the rains in Kanha

FACING PAGE
(both) Spotted deer getting drenched in Kanha rains and a hog deer in the swamps of Kaziranga

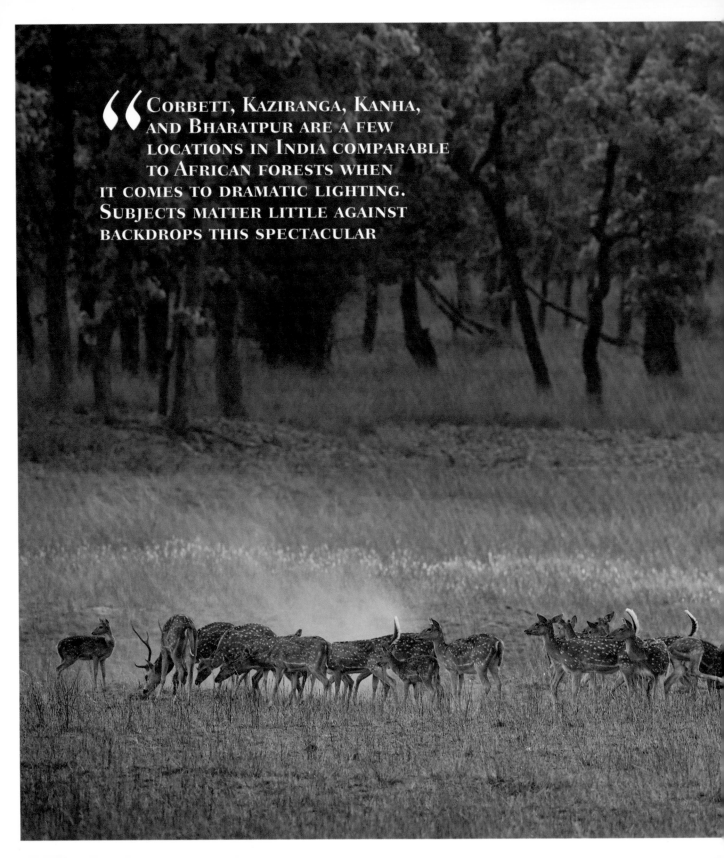

"Corbett, Kaziranga, Kanha, and Bharatpur are a few locations in India comparable to African forests when it comes to dramatic lighting. Subjects matter little against backdrops this spectacular

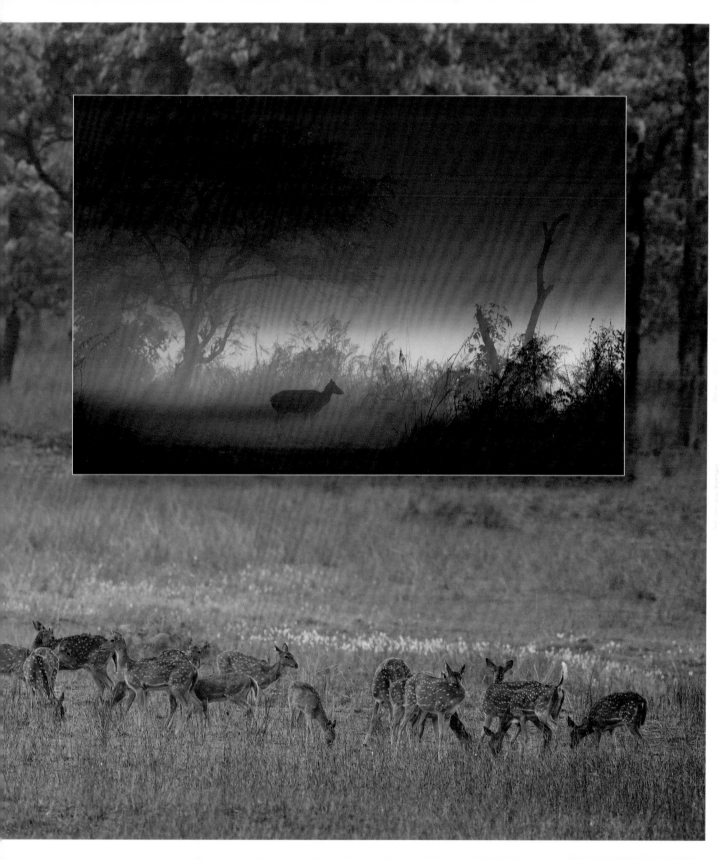

With 16 species of cats, India is home to around 40 per cent of the global cat species. Leopards are directly in competition with tigers when it comes to prey, and, being the weaker of the two species, are far more shy and elusive. The elusive nature of some cats is inversely proportional to their size. Smaller cats, such as jungle cats, leopard cats, fishing cats, rusty spotted cats, and caracals, inhabit tiger habitats in some parts of India.

A leopard cub peeps out of a rock face in Pench National Park

FACING PAGE
A leopard in a monsoon forest in Nagarhole, Karnataka

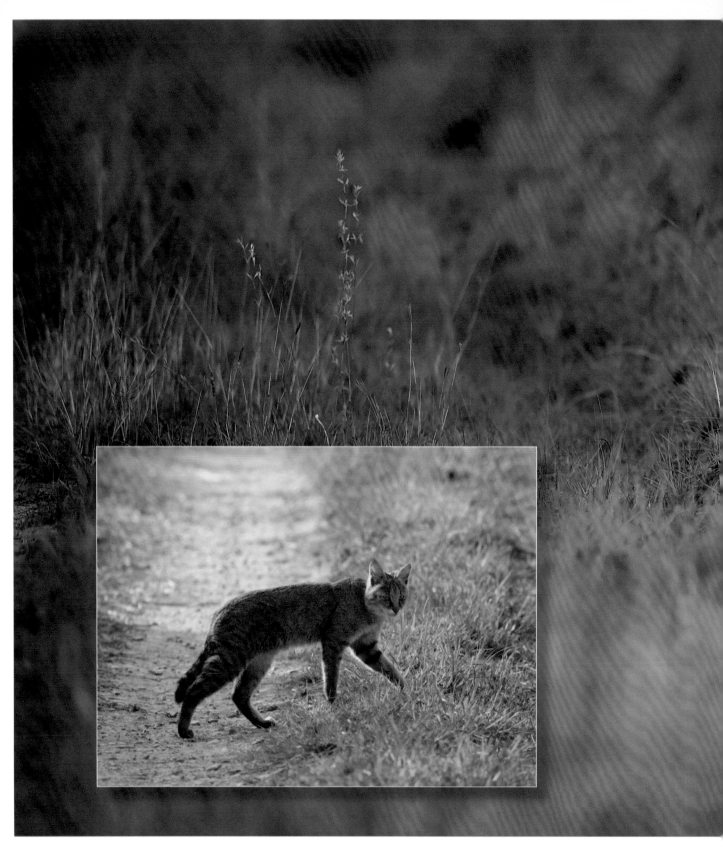

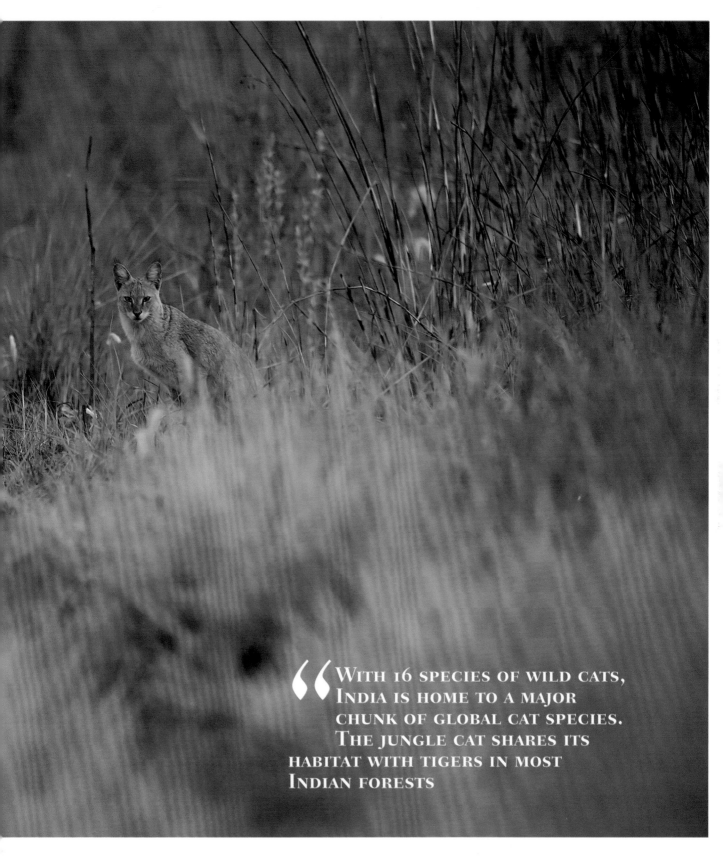

> With 16 species of wild cats, India is home to a major chunk of global cat species. The jungle cat shares its habitat with tigers in most Indian forests

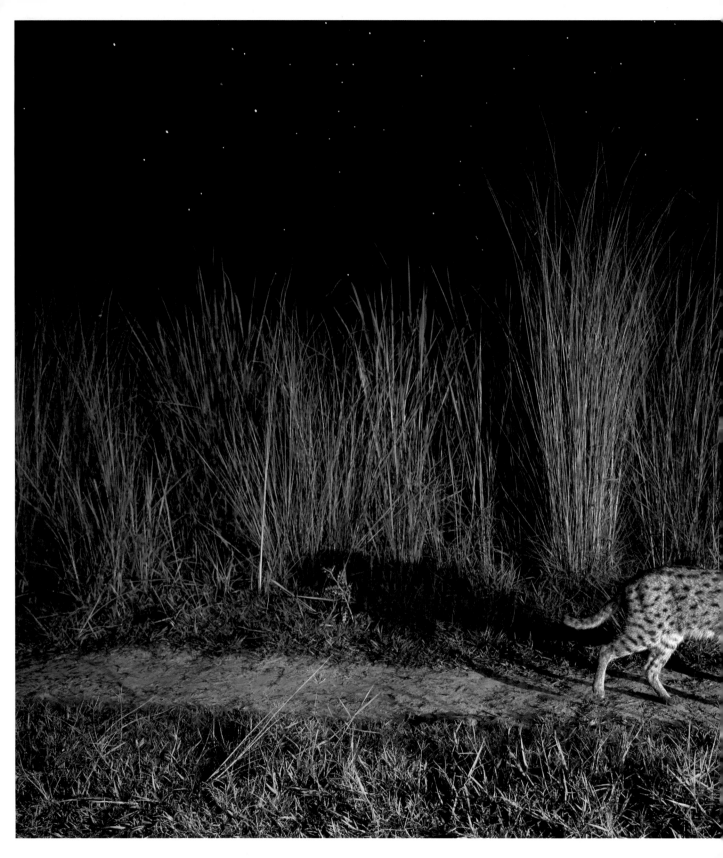

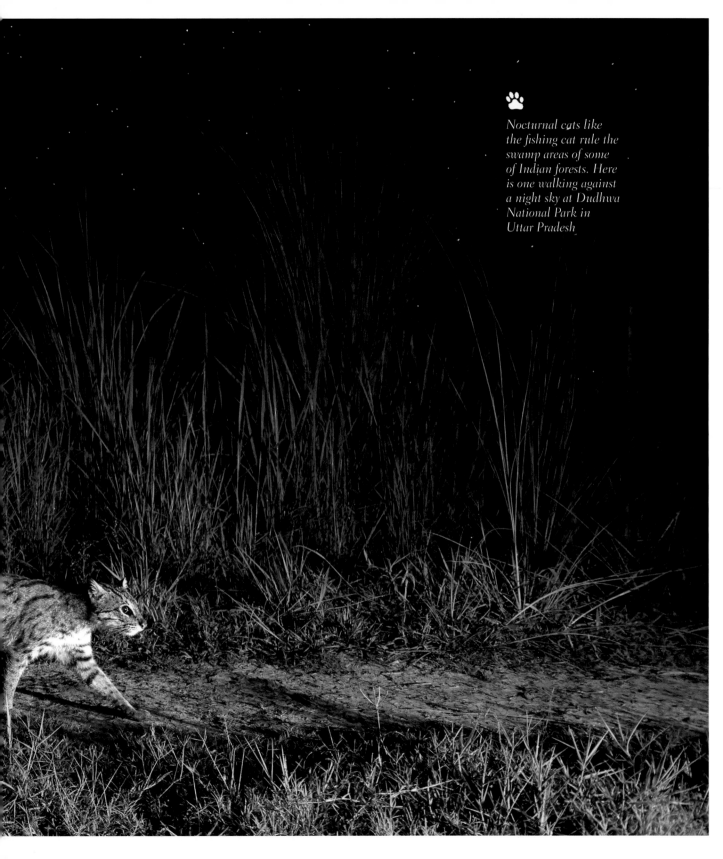

Nocturnal cats like the fishing cat rule the swamp areas of some of Indian forests. Here is one walking against a night sky at Dudhwa National Park in Uttar Pradesh

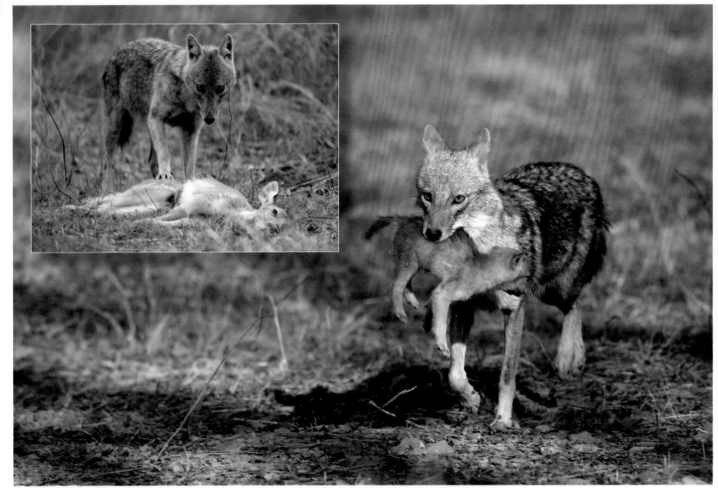

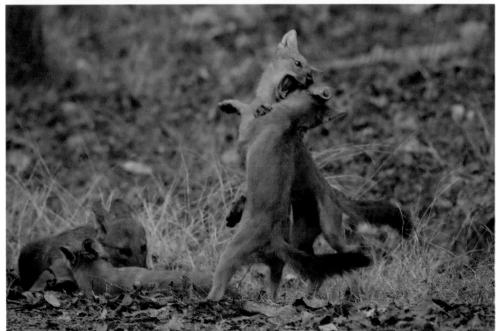

(above) Jackals are cunning predators. A jackal mother carrying a pup in Ranthambhore with another one guarding his kill in Pench (inset); (below) Wild dog pups playing in Pench National Park

Other species include the Indian dholes (wild dogs), jackals, the Indian gaur, smooth-coated otters, rhesus macaques, langurs, gharials, and mugger crocodiles. Not to forget the riverine ecosystem in the form of fishes in the Himalayan rivers, along with some common and rare amphibians and reptiles that emerge during the monsoons. The biodiversity of India is par excellence and there are still species waiting to be discovered and photographed in the wild.

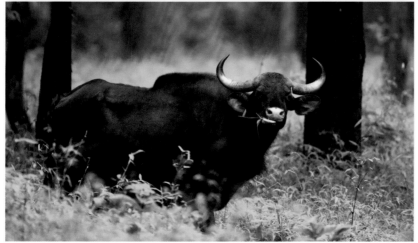

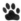

(above) A swarm of flies on the back of a wild buffalo in Kaziranga; (left) An Indian gaur in the lush green monsoon forests of Tadoba

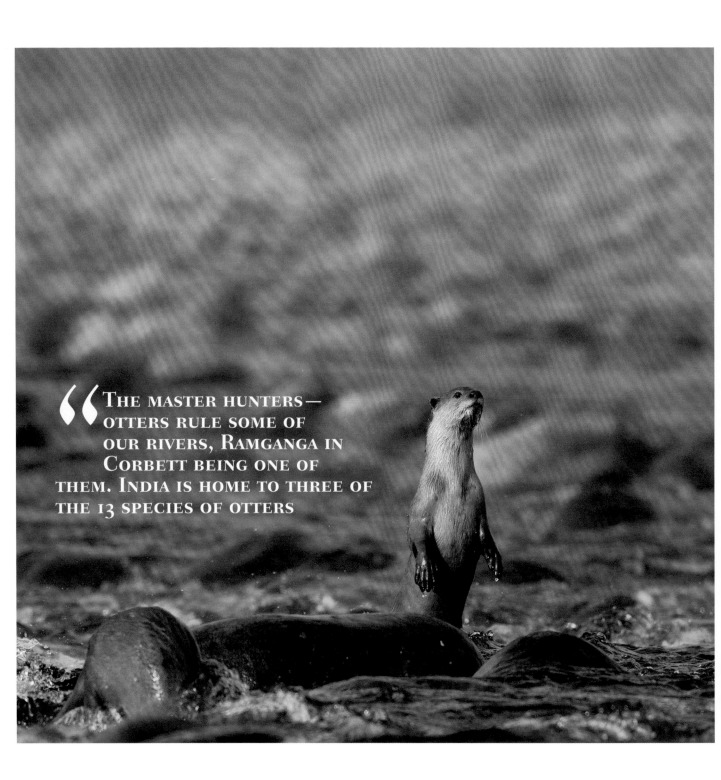

"THE MASTER HUNTERS—
OTTERS RULE SOME OF
OUR RIVERS, RAMGANGA IN
CORBETT BEING ONE OF
THEM. INDIA IS HOME TO THREE OF
THE 13 SPECIES OF OTTERS

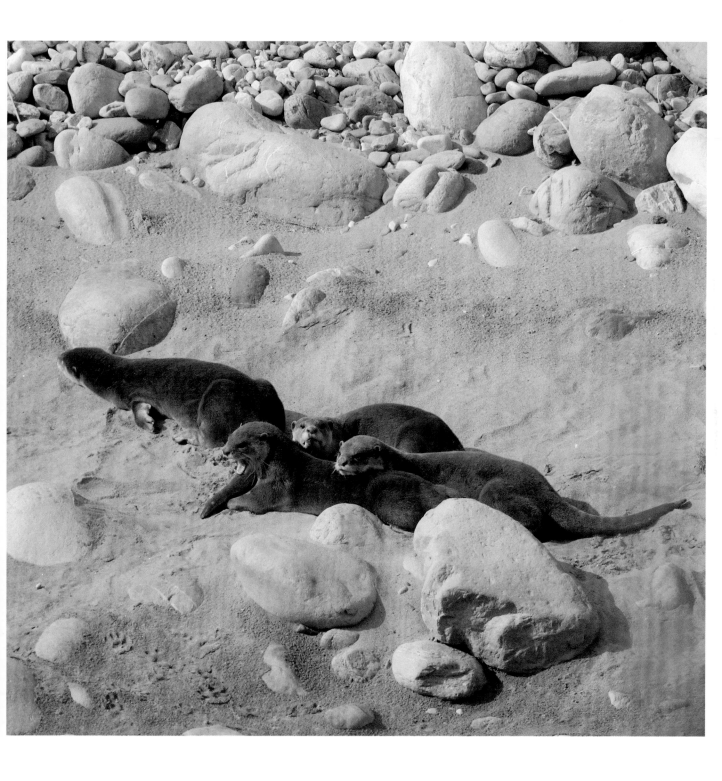

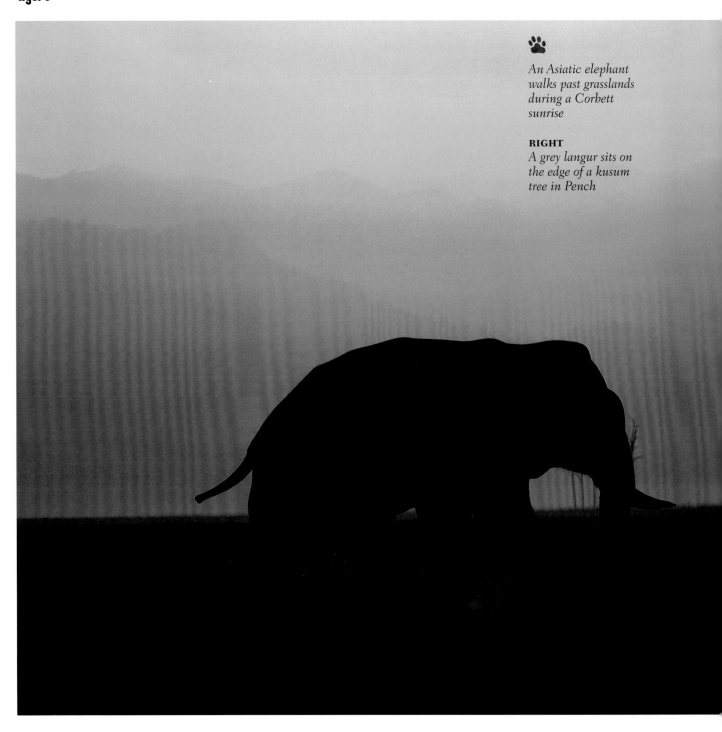

An Asiatic elephant walks past grasslands during a Corbett sunrise

RIGHT
A grey langur sits on the edge of a kusum tree in Pench

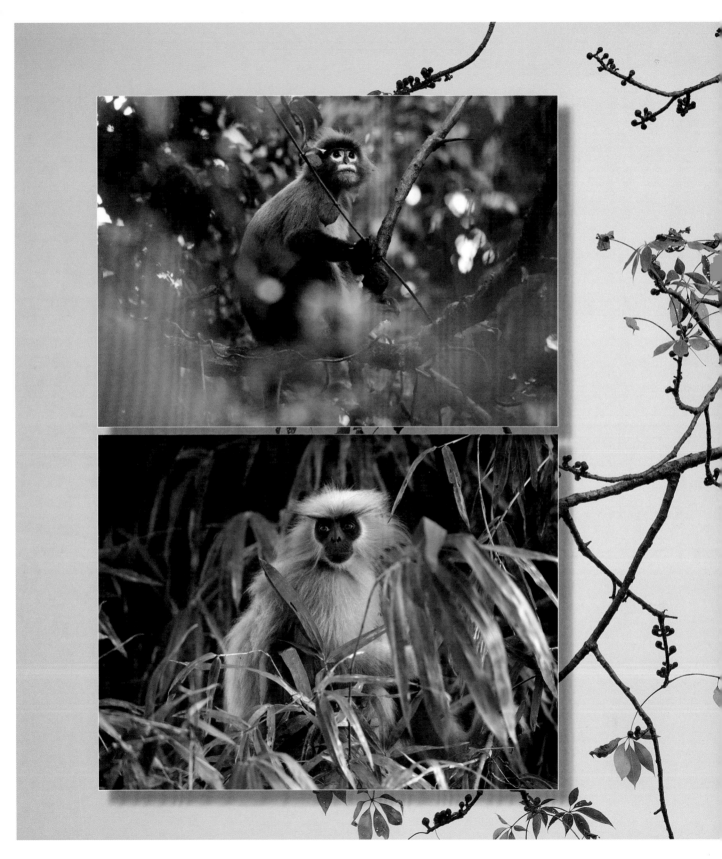

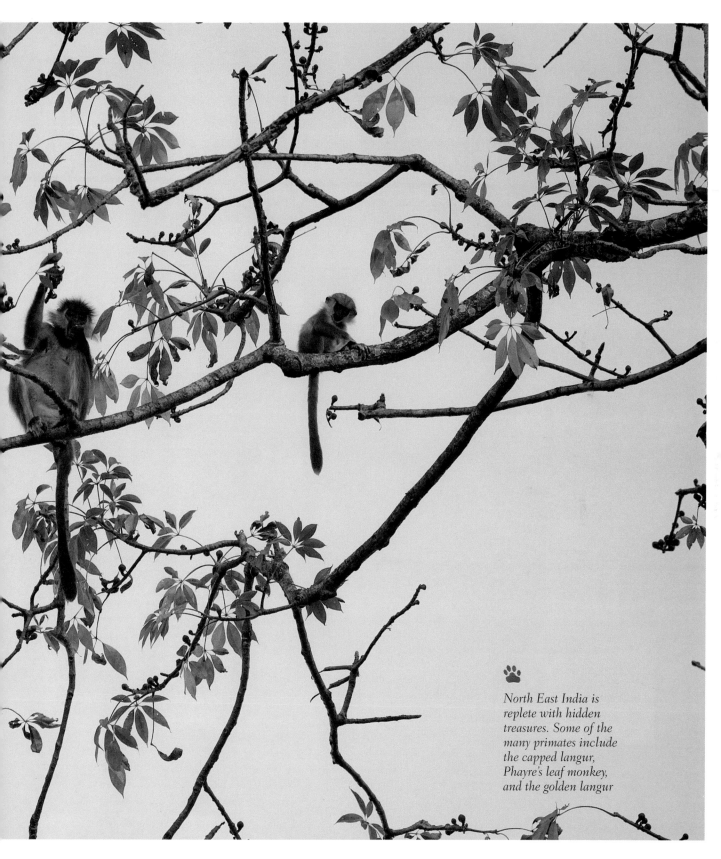

North East India is
replete with hidden
treasures. Some of the
many primates include
the capped langur,
Phayre's leaf monkey,
and the golden langur

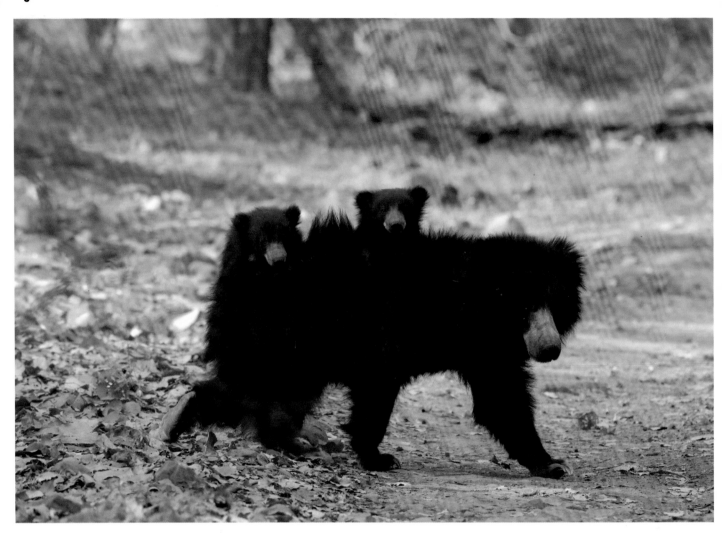

My photographic journey in search for tigers took me to some of these varied habitats, and, in addition to tigers and the other denizens of these forests, the uniqueness of each habitat made the photographic visuals more appealing. Every day and each month a new chapter is written in the green book, and that is what makes traversing through these apparently same old forests so different and refreshing. Nothing remains the same as the forest itself keeps offering new flavours in terms of light, colour, and the wildlife it harbours.

A sloth bear mother giving a piggyback ride to her small cubs in Ranthambhore

FACING PAGE
The Indian one-horned rhinoceros dazzles in forests like Kaziranga, Manas, and Dudhwa

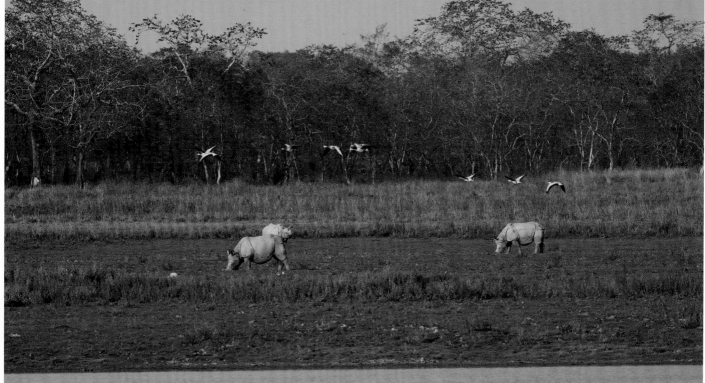

"THE BIODIVERSITY OF NORTH EAST INDIA'S FORESTS IS UNIQUE IN ITSELF. TIGERS ARE ELUSIVE IN THESE WOODS, AS ARE A LOT OF OTHER SPECIES LIKE THE RED PANDA OF THE EASTERN HIMALAYAS

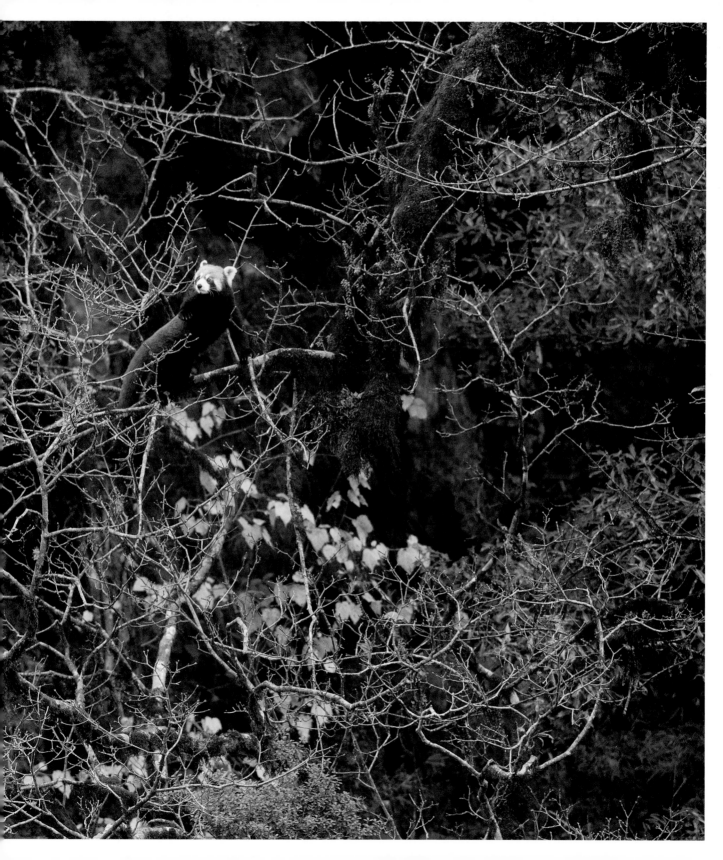

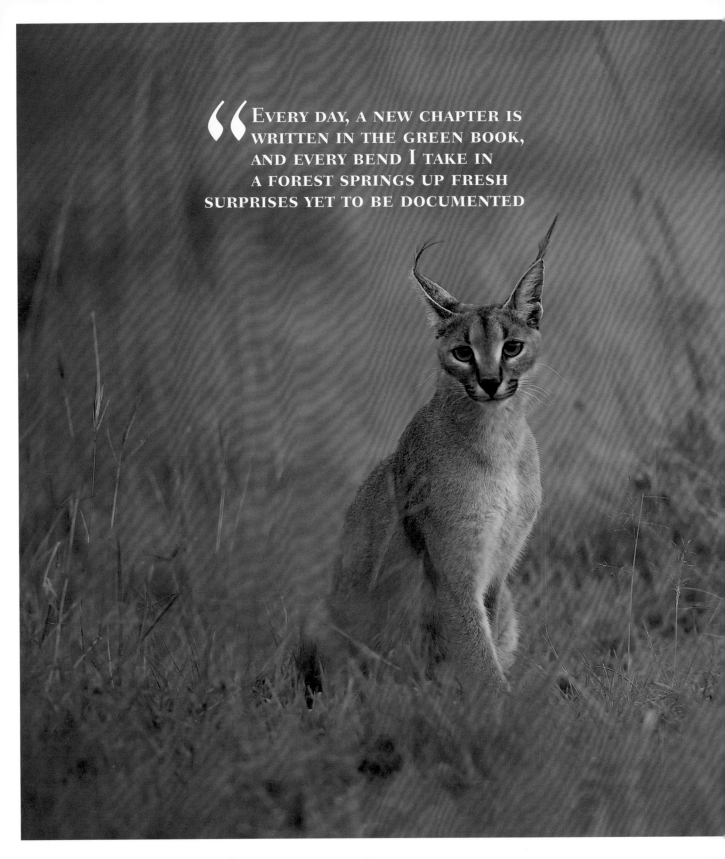

"EVERY DAY, A NEW CHAPTER IS WRITTEN IN THE GREEN BOOK, AND EVERY BEND I TAKE IN A FOREST SPRINGS UP FRESH SURPRISES YET TO BE DOCUMENTED

Photographing wildlife in a dry deciduous forest, such as Ranthambhore for instance, is unique across seasons. Post the monsoon showers the forest turns lush green with heavy undergrowth; these colours fade away as winter approaches to give way to vibrant reds and yellows of the dhonk. Towards the end of spring the forest turns brown, till the first rains in June turn it into a carpet of green yet again. With every passing season there is freshness in the wildlife one encounters as well. Tigers, for instance, look bright and vibrant in their winter coats but shed the same as summer approaches, as do herbivores like the sambar.

Understanding the peculiarities of the various tiger habitats is a must for every wildlife photographer as the subjects are more or less the same throughout the length and breadth of our country; it is only the habitat that distinguishes an image. This last section of the book is an attempt to showcase the diversity of Indian forests and its dwellers. We take immense pride in the rapid development of our country across industry segments; the fact that India features in the global investment map does indicate that we are on the right track. However, as Indians, do we also take pride in our natural resources? Most of this development has come by way of exploiting the natural wealth that Mother Nature has bestowed on us. India has a rich natural history and I feel helpless in seeing this wealth vanish in front of me year on year. The question arises, how to strike a balance? This is for us to think about as this loss will be irreparable and we for sure don't want our future generations to suffer because of the dent in equilibrium caused in our lifetime.

FACING PAGE
(above) An Asiatic elephant walking on the banks of the Ramganga in Corbett National Park; (below) A porcupine caught on a camera trap in Dudhwa Tiger Reserve

"OVER THE YEARS, SHIVANG HAS
BROKEN A LOT OF STANDARD
TIGER PHOTOGRAPHIC RULES
TO SHARE HIS UNUSUAL AND
THOUGHTFUL PERSPECTIVES OF THE
STRIPED JEWELS OF INDIAN FORESTS

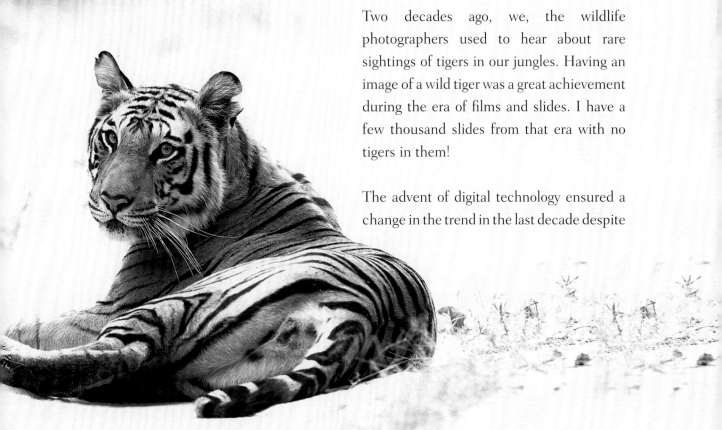

AFTERWORD
Art Amidst Stripes: Creativity in Tiger Photography

Two decades ago, we, the wildlife photographers used to hear about rare sightings of tigers in our jungles. Having an image of a wild tiger was a great achievement during the era of films and slides. I have a few thousand slides from that era with no tigers in them!

The advent of digital technology ensured a change in the trend in the last decade despite

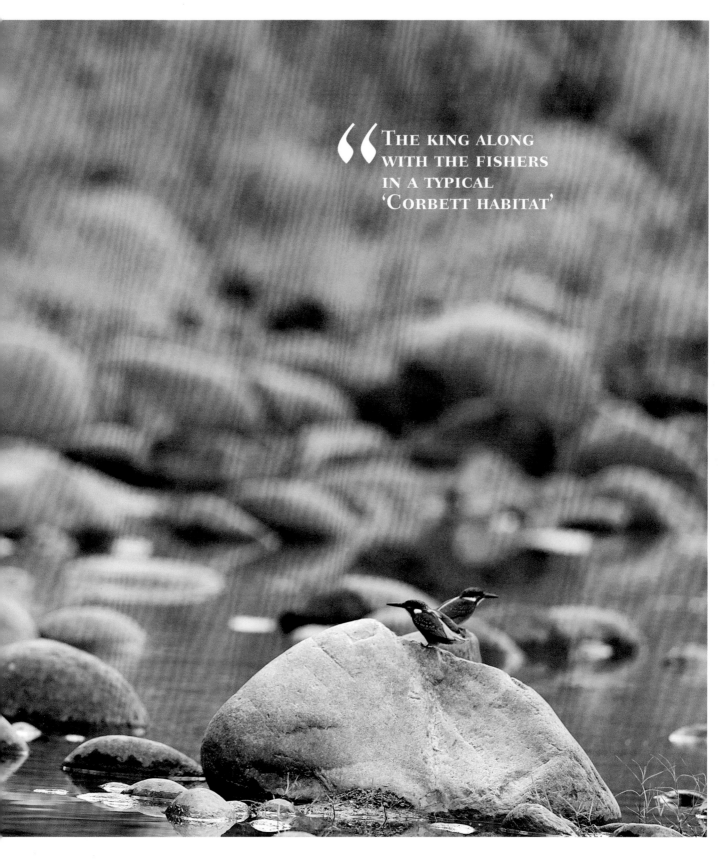

"THE KING ALONG
WITH THE FISHERS
IN A TYPICAL
'CORBETT HABITAT'

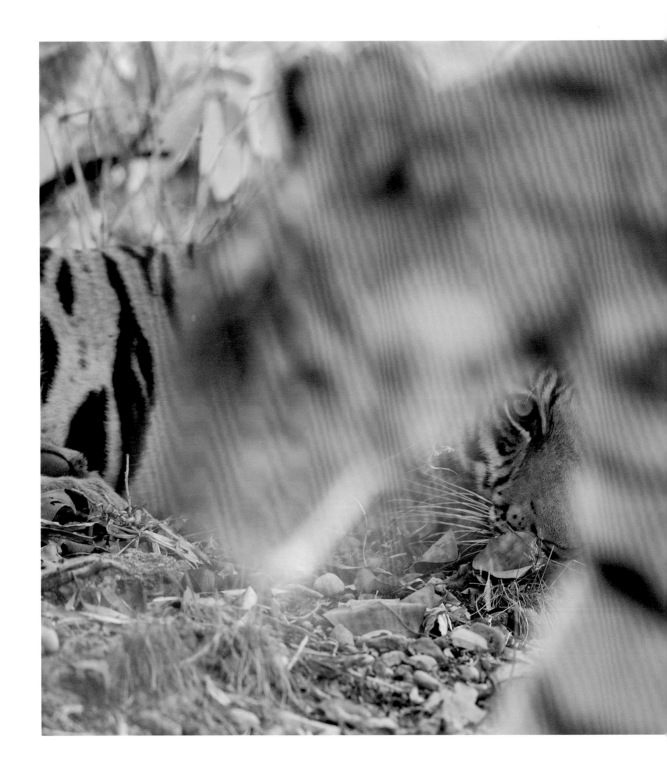

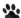

The phrase 'vanishing stripes' is regularly used from a conservation perspective. Here is an attempt in Bandhavgarh to depict the same

the declining tiger population; the volume of tiger images being produced in the country has been booming like never before. A lot of aspects have contributed to this exponential growth—increase in awareness, affordable technology to photograph tigers, social media and peer pressure. We have had a few most-photographed tigers like Machali in Ranthambhore and quite a few popular brand ambassadors in various parks.

Today, as I scroll down my timeline on Facebook which is full of friends from the wildlife and photography circuit, all I see is tons of tiger images pouring in. It's great to see the awareness, which these images are creating around India's national animal, and the magnetic pull which the specie has for tourists and photographers from all corners of the globe. However, as a photographer, unfortunately, I think most of the images don't offer any bit of freshness. The same tiger surrounded by 50 other photographers from a 360-degree perspective at the same place and at the same time! Big lenses pointed at this majestic cat and 100 camera bodies around that tiger recording the same images.

So where does tiger photography lack in India? Why are tiger images not being

An abstract depiction of a tiger cooling himself in a pool in Ranthambhore

able to perform at an international stage despite the massive volume of images being created on a daily basis? I feel it is mainly because of lack of creative vision and a lot of similar work been done by thousands of 'tiger photographers' in India. There is a huge scope of seeing the tiger as a subject from a creative and artistic perspective and not just relying on a 500mm or 600mm lens to produce a crisp and sharp portrait. Does sharpness really always matter? At times, blurry visions may be more thought-provoking than a simply sharp image. How many of us make an attempt to stop, think for a second and try develop the art of seeing which I feel is prerequisite to any form of photography.

Shivang shared similar sentiments about tiger photography during one of my discussions with him in Corbett a few years back and we had an in-depth talk about this issue. To my utter surprise, over a period of few years after that discussion, he continued to come up with very unique and refreshing perspectives of these gentle cats. Personally I had been waiting to see images of tigers, which artistically and abstractly convey its character, agility, threats and its home—the jungle—in general. The faint reflection of a few stripes through the green

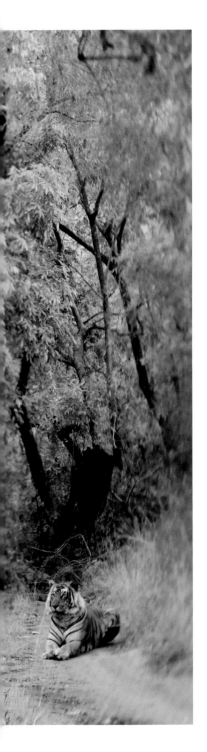

bushes becomes so meaningful and leaves an impact on your mind. The spotlit tiger walking towards darkness with beautifully raised paw silently delivers a strong message. These are images which do not need an expansive conservation narrative. They are visuals, which have the capability of conveying a compelling story on their own.

It is very hard to think differently when a tiger is in front of your vehicle during a game drive amidst cracking sounds of shutters firing at 10 frames per second or more in neighboring safari vehicles. Your mind goes blank and you forget the basics of photography because you are mesmerised by the beauty and charmed by the majestic cat. It is only when you master the art of keeping yourself calm and treating the tiger as any other subject that you end up creating images which look unique and fresh. Over the years, Shivang has broken a lot of standard tiger photographic rules to share his unusual and thoughtful perspectives of the striped jewels of Indian forests. Induction of wide-angle blurs using a tilt and shift lens, for example a piece of glass primarily used for shooting architecture, on subjects like tigers has resulted is a fresh images which give a new dimension to showcasing the habitat of a tiger.

A tiger in Ranthambhore staring into an uncertain future. That is the story of wildlife sandwiched amidst shrinking forest cover

Seeing this body of work, I am hoping that tiger photographers in India would be inspired to think deeper into their imagery and consider depicting India's pride in a more creative manner. The time has come where we should think beyond sharp portraits and merely wait for natural history moments and create conceptually strong images of tigers.

Ganesh H. Shankar

Ganesh H. Shankar is arguably India's most iconic figure in nature photography. His artistic creations of nature in its various forms through the medium of photography have helped him create the most unique portfolio of images in India. He has mastered black-and-white photography in the country and pioneers the concept of 'creative nature photography' amongst Indian photographers. To view his portfolio visit *www.naturelyrics.com*

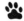

FACING PAGE
A Ganesh Shankar masterpiece representing tiger tourism in India

"TIGER PHOTOGRAPHY IN INDIA HAS COME A LONG WAY IN THE PAST DECADE. THERE IS STILL A LONG WAY TO GO AND PHOTOGRAPHERS NEED TO DON THE THINKING CAP TO TAKE THE IMAGERY OF THIS FASCINATING CAT TO THE NEXT LEVEL

ACKNOWLEDGEMENTS

My photographic journey would be incomplete without some highly inspiring political leaders with a strong will to promote and conserve wildlife, and the support of some of the most hard-working forest officers, my team of expert field assistants, leading naturalists, and guides/drivers across the forests of India.

I started my career in Corbett National Park 14 years back and the support of Mr Rajiv Bhartari, former Field Director, Corbett Tiger Reserve, was key during that time. Piyush Joshi has been a friend and business associate for this very long period and I have many pleasant memories of working together with him during the initial days of Camp Wild Adventure—a period that proved critical in shaping my wildlife career. Not to forget the contribution of guides and drivers like Faim Ansari, Irfaan, and Zakir Hussain, who have been my field companions for so many years in Corbett. Sumantha Ghosh from Vanghat has been a tremendous

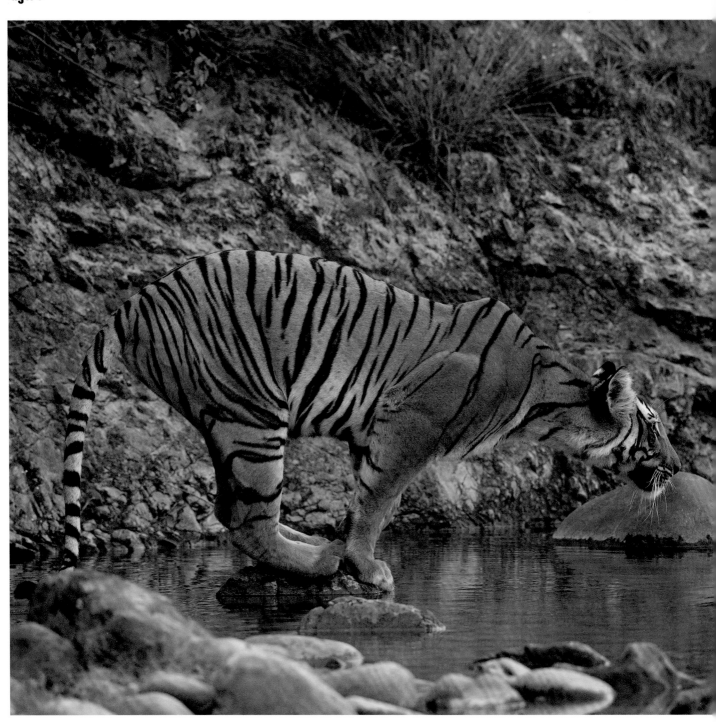

friend, always standing beside me as a key support during my Corbett projects.

Bandhavgarh has always been a forest I have loved to work with and the entire Vijaya journey would have been incomplete without the support of Mr Rajwardhan Sharma and my field team of Narayan Burman, Dinnu, Parshuram Pandey, Lala, Kamta, Sonu and the extremely talented mahouts Neelam and Bhursa.

I would like to congratulate the hard working team at the Ranthambhore forest department led by Mr YK Sahu (CCF, Ranthambhore) and Mr Sanjeev Sharma (ACF, Ranthambhore) and would like to thank the forest department for all their guidance and support. Thanks to Shammi Quereshi for his hospitality support and my field team led by Shakir Ali with whom I have spent those countless field hours in the park over the years. Not to forget Sunil Shrivastava, Raees Alam, Hansraj Gujjar, Rajendar Gujjar, Hemraj Meena, Hemraj (Canter)—you all are terrific field guides and a great boon for photographers.

Moving on to Tadoba, I will always remember the fun-filled field sessions with Bandu Mankad and Neelkanth. Thanks to the guidance and support of the visionary Mr Ganpati Garad, Field Director, TATR, who has played a key role in regulating tourism in the park. I would also like to mention my Pench team led by Shourabh Ghosh from Kohka Wilderness Camp and my guide Anil Raut and Dinesh Makhija from Kanha National Park.

During my career, I have worked and interacted with eminent wildlife filmmakers who have taught me a lot about the nuances of camera work and it was sheer pleasure learning from Mr

Paro in Corbett, balancing herself on a small stone before leaping into her private pool

Mike Pandey and Mr S. Nalla Muthu. Thank you both for the opportunities you have given me over the years. I would also like to express my gratitude to Mr Ben Cranke for teaching me the nuances of camera trap photography and helping me carve out a new path in the creative sphere.

It was a great pleasure and honour to work with the Government of Uttar Pradesh in the recent years under the guidance of the Honourable Chief Minister Mr Akhilesh Yadav, Mrs Abhilasha Yadav (wildlife photographer), Mr Anurag Yadav, and Mr Faraz Alvi. Your passion for the wildlife of your state is impressive and has played a key role in putting Dudhwa and other key locations of Uttar Pradesh on the world tourism map. The Dudhwa camera trapping project was possible because of the support of the Uttar Pradesh forest department and I would like to thank Mr Sanjeev Saran (Principal Secretary, Forests), Mr Rupak Day (CCF), Mr Sunil Choudhury (Field Director, Dudhwa), and Mr Mahaveer Koujalagi (DFO, Dudhwa) for their proactive support in the project. Special thanks to the hardworking field team of Shantanu Prasad, Sourav Mondal, Mridulkanti Kar, and Rizwan for the execution of this project.

This book wouldn't have been possible without the support of Shardul Bajikar, who helped me with the content review and shared his expert views on the same, and Dhritiman Mukherjee, who has always given me direction at every critical crossroad of my career.

Heartiest thanks to my family, especially my parents and my wife Kahini Ghosh Mehta, who is also my business partner at Nature Wanderers; my friends—Abhishek Bhalla, Ankur Srivastava, Ritesh Andley, Umesh, Pankaj Arora, and Kovid Sharma; all my

current and former colleagues; our lovely set of Nature Wanderers' clients; and friends and peers in the photographic fraternity for the constant encouragement and strength you have given me by standing with me during tough times and helping me sail through.

Last but not the least, a special note of thanks to the Niyogi Books team—Mr Bikash and Mrs Tultul Niyogi for believing in my work; Siddhartha Banerjee and Nabanita Das for bearing with my hectic travel schedule and your entire help in editing and designing this book.

The images contained in this book have all been shot with Canon gear. I thank Canon India for their continued support and encouragement over the past decade.

Illustration Credits

Camera trap images (Dudhwa Tiger—p. 28, Fishing Cat—p. 323, Porcupine image–p. 338)—Shivang Mehta/Abhilasha Yadav/ Government of Uttar Pradesh/Team Uniques (erstwhile)
Vijaya image (inset, p. 32)—Sandeep Dutta

INDEX

(note: page numbers in italics denote images; human names and T#s indicate name or identity of tigers in the reserved forests)